Lenore Tawney

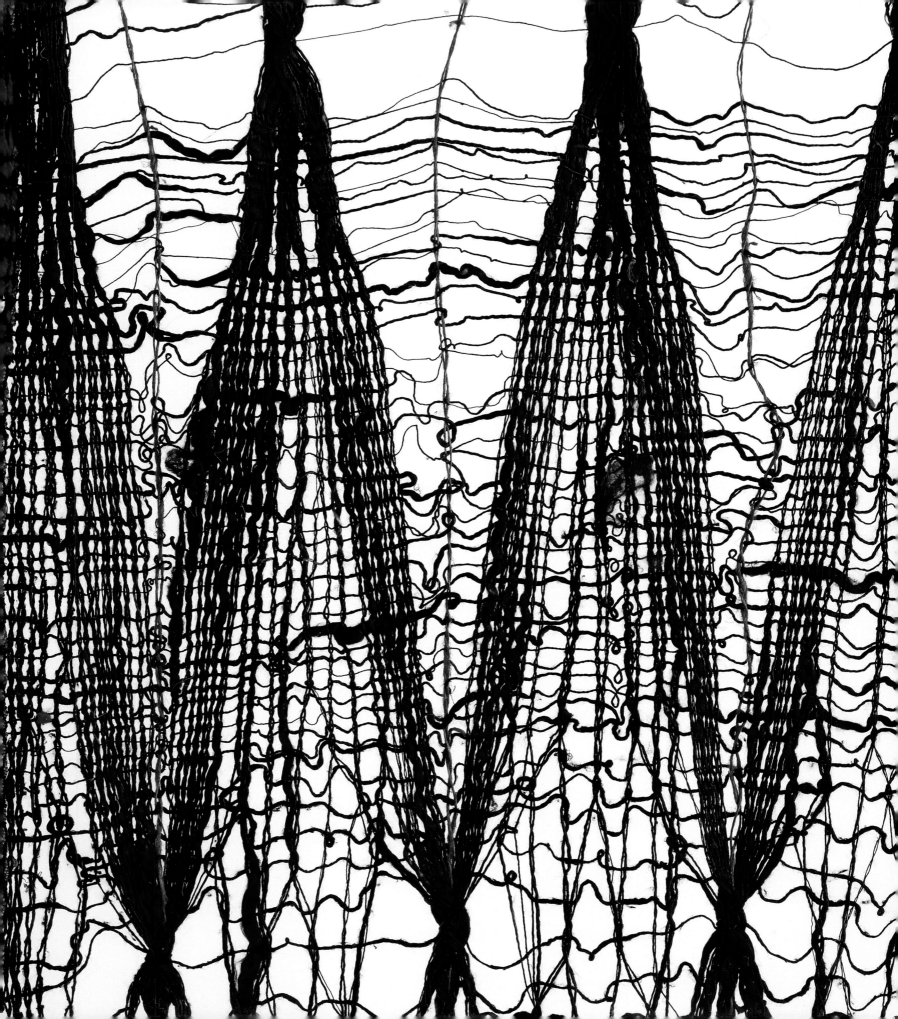

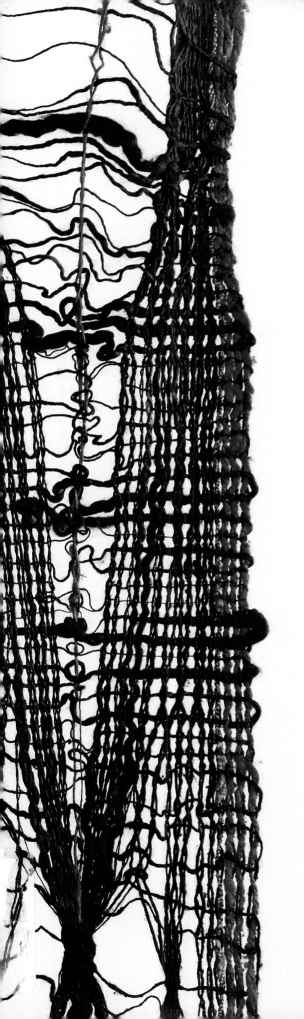

Lenore Tawney
Mirror of the Universe

John Michael Kohler Arts Center
Sheboygan, Wisconsin

in association with
The University of Chicago Press
Chicago and London

Contents

Preface and
Acknowledgments
SAM GAPPMAYER
6

Foreword
KATHLEEN NUGENT
MANGAN
10

Waiting like a Fern

Mirror of the Universe
KAREN PATTERSON
22

Student *1945 to 1960*
GLENN ADAMSON
46

The Archive *Ephemeral and Eternal*
MARY SAVIG
88

Technical Analysis *Lost and Proud*
DR. FLORICA ZAHARIA
98

Back to the Source

Sculptor *1961 to 1970*
GLENN ADAMSON
106

The Archive *The Waters below the Firmament*
MARY SAVIG
154

Technical Analysis *The Bride*
DR. FLORICA ZAHARIA
170

Weaving Infinity

That Other Sea

Seeker *1970 to 1980*
GLENN ADAMSON
176

The Archive *That Point Is the Point*
MARY SAVIG
206

Technical Analysis *Dove*
DR. FLORICA ZAHARIA
216

Sage *1980 to 2007*
GLENN ADAMSON
222

The Archive *This Cage of Bones, & Blood, & Flesh*
MARY SAVIG
240

Even Thread [Has] a Speech
SHANNON R. STRATTON
254

Technical Analysis *Written in Water*
DR. FLORICA ZAHARIA
272

Afterword
KATHLEEN NUGENT
MANGAN
278

Chronology 284

Bibliography 291

Contributors 296

Index 298

John Michael Kohler
Arts Center
Board and Staff 302

Preface and Acknowledgments

Coinciding with the John Michael Kohler Arts Center's 2019 exhibition series, also titled *Lenore Tawney: Mirror of the Universe,* this catalogue celebrates the life of Lenore Tawney (1907–2007) and the complex body of work that is her legacy. Explored in the following pages, Tawney's oeuvre spans fiber-based works, sculpture, drawing, collage, and a remarkable home and studio collection. Since the 1970s, the John Michael Kohler Arts Center has championed the study of artist-built environments for their ability to visually express underrepresented histories.

Over the past few decades, we have been proud to acquire elements of home environments created by artists such as Ray Yoshida, Mary Nohl, and Loy Bowlin, which have all been on display to the public at the Arts Center. *Lenore Tawney: Mirror of the Universe,* in both catalogue and exhibition form, uses the lens of artist-built environments to understand Tawney's work and environment in a new way. Thanks to a generous gift from the Lenore G. Tawney Foundation with support from the Kohler Foundation, Inc., Tawney's studio environment will now be a major part of the Arts Center's legacy, as many of her studio elements will make their permanent home at our new facility, the Art Preserve, opening in 2020.

In approaching this catalogue, we sought collaborators who could pursue diverse approaches to the material, from the art historical to the speculative, and in this way each of the authors brought a new perspective to the life and work of Lenore Tawney. We are grateful to our colleagues for their generosity in lending their expertise to the catalogue: Glenn Adamson, senior scholar at the Yale Center for British Art; Kathleen Nugent Mangan, executive director of the Lenore G. Tawney Foundation; Mary Savig, curator of manuscripts at the Smithsonian's Archives of American Art; Shannon R. Stratton, independent curator; and Dr. Florica Zaharia, conservator emerita of the Metropolitan Museum of Art. In addition to contributing new writing to the catalogue, Kathleen Nugent Mangan, Mary Savig, and Shannon R. Stratton also participated in the curation of the exhibition series under the direction of our former senior curator Karen Patterson.

Such an endeavor would not be possible without many collaborators both within and outside our institution. The enormous undertaking of producing the exhibition series and catalogue *Lenore Tawney: Mirror of the Universe* has been made possible through the efforts of dozens of individuals and organizations. It is a testament to the publication and series that we received generous support from the Andy Warhol Foundation for the Visual Arts, Kohler Trust for the Arts and Education, Lenore G. Tawney Foundation, Wisconsin Arts Board, and Arts Center members. The donation of major portions of Tawney's studio environment by the Lenore G. Tawney Foundation substantially enhances the Arts Center's ability to directly engage with the concept of the artist's studio

as an artist-built environment and speaks to the Foundation's commitment to sharing Tawney's work with new communities. We are grateful for the expertise and enthusiasm Kathleen Nugent Mangan has shared with us in the development of both this catalogue and the exhibition series.

The exhibitions in this series span four of the Arts Center's galleries and extend out onto the grounds. For this series, our main gallery hosts *In Poetry and Silence: The Work and Studio of Lenore Tawney,* in which Karen Patterson, with the support of Kathleen Nugent Mangan, underscores the relationship of the artist's space to her artwork by surrounding studio components with a retrospective of Tawney's key works. Adjacent to this exhibition, gallery space is filled by Tawney's monumental sixteen-foot-high, twenty-four-foot-wide, and eighteen-foot-deep textile piece *Cloud Labyrinth* (1983), accompanied by footage of a 1979 performance inside another work from Tawney's Cloud series. In a separate exhibition, *Ephemeral and Eternal,* Mary Savig investigates Tawney's extensive archive and ephemera from the collection of the Smithsonian's Archives of American Art and the Lenore G. Tawney Foundation. Connecting Tawney's work to that of contemporary artists in *Even Thread [Has] a Speech,* Shannon R. Stratton explores Tawney's lasting impact on eight living fiber-based artists. As a group, the series offers a full view into her body of work along with the personal and historical context for that work.

Assembling this catalogue brought back many colleagues we have worked with on previous publications including the catalogue's producers, photographer, and editor. It was a pleasure to collaborate with Lucia|Marquand again. Another round of thanks is owed to partner Adrian Lucia and his team, including Melissa Duffes, editorial director; Ryan Polich, design director; Kestrel Rundle, editor; Meghann Ney, designer and image manager; Leah Finger, production manager; and Jeremy Linden, production coordinator. Rich Maciejewski's striking photography of Tawney's work will allow readers to see it like never before. Tanya Heinrich's careful editing allowed us to weave together the authors' many voices into a powerful statement about Tawney and her work.

Virtually every department within the Arts Center has supported the development of this project. Credit for the success of the catalogue and exhibitions first and foremost belongs to the exhibition curator, Karen Patterson. She directed the entire Tawney exhibition series in addition to contributing to this catalogue, and her close work with the many collaborators on both projects characterizes her commitment to producing quality scholarship in the domain of artist-built environments.

Many thanks also go to the rest of the Arts Center Exhibitions and Collections Department for combining their abundant talents to produce the Lenore Tawney exhibition series and support this catalogue project. Valerie Lazalier, curatorial projects manager,

provided a high level of coordination to help bring together the many elements of the exhibition series and this book. Registrar Peter Rosen worked closely with the Lenore G. Tawney Foundation to bring the majority of the loans for *In Poetry and Silence* to the Arts Center for catalogue photography while planning for the move of the studio elements to the Art Preserve in 2020. Former Associate Registrar Leonard Cicero also adeptly coordinated loans with the eight contemporary artists included in *Even Thread [Has] a Speech*. Associate Curator Laura Bickford supported the exhibition series with her considerable research, writing, and planning skills. Preparators Matthew Hannah and Sean Heiser, led by Head of Exhibitions and Collections Management Jonas Sebura, skillfully and carefully installed the wide array of media that makes this exhibition series so special.

Further thanks go out to Associate Director Amy Horst for her leadership in bringing together the Lenore G. Tawney Foundation and the Arts Center in this timely partnership. Passionately guided by Curator for Public Programs Ann Brusky, the Public Programs Department has developed tremendous community programming, performances, and curricula related to the exhibitions. The entire Operations Department unsparingly shared their time and expertise to support the series and related events. Special thanks go to Lisa Schultz, special projects coordinator, and Patricia DuChene, media relations coordinator,

Arts Center staff installing *Written in Water* for photography.

who also aided the publication by carefully reviewing content throughout the proofing stages.

We are also grateful for our board of directors, volunteers, interns, and patrons who have earnestly supported the Arts Center's mission of generating a creative exchange between artists and the public. Our volunteer Board of Directors, led by President Tony Rammer, worked tirelessly throughout the year for the success of this and many other projects. For the success of the exhibition and this catalogue, I am grateful to everyone on the Arts Center team.

Looking to the future, our collaborators' research from this publication and the exhibitions will be highlighted in a panel discussion hosted by the Arts Center in October 2019 that will enhance both scholarly and public understanding of Tawney and her work. The publication of this catalogue is a tremendous milestone made possible by countless people and communities, and we look forward to the next major milestone when many significant elements of Lenore Tawney's studio will be made available to the public alongside those of more than thirty other artist-built environments at the Art Preserve.

SAM GAPPMAYER

Director
John Michael Kohler Arts Center

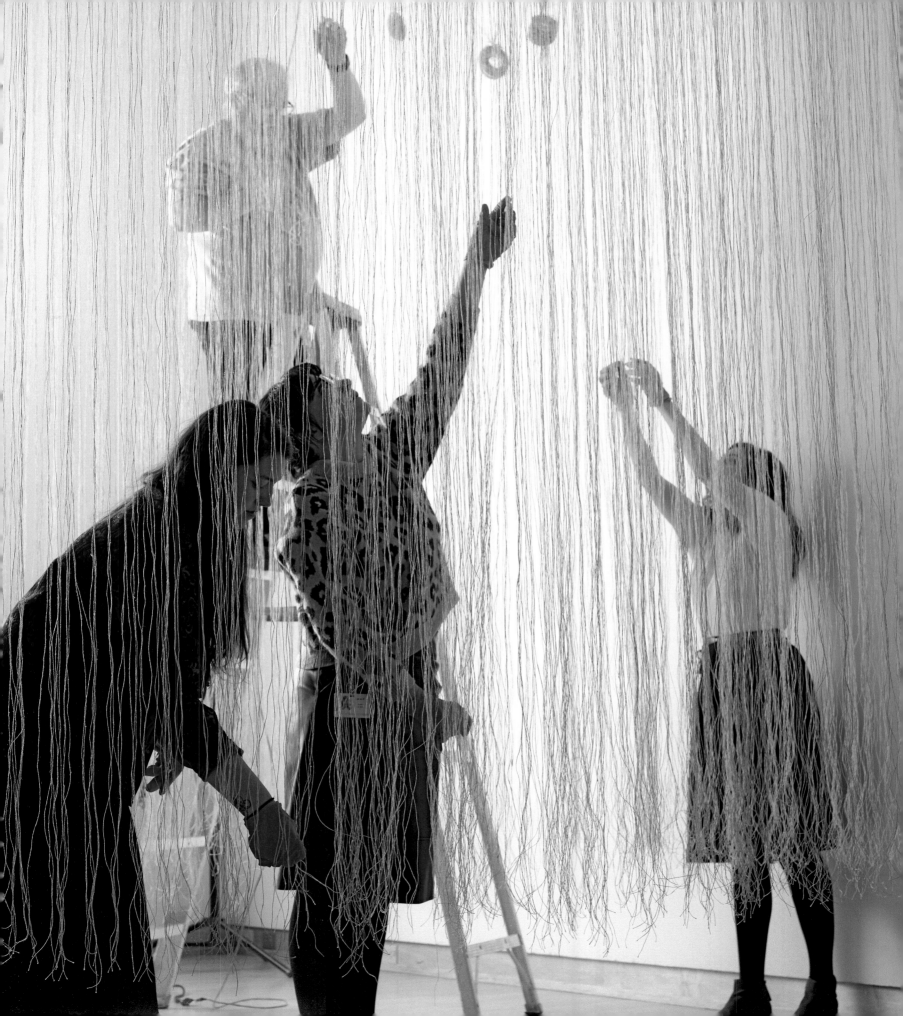

Foreword

KATHLEEN NUGENT
MANGAN

Why Lenore Tawney? Why the John Michael Kohler Arts Center? Why now? The viewer may wonder about each of these things when considering the work of this New York artist, born over a century ago in Ohio, on view in Sheboygan, Wisconsin, today. What are the threads that connect the artist and the institution? What might one discover by stepping into Tawney's world?

I took that step over thirty years ago, from a gray Manhattan street into the world of Lenore Tawney. On that day in 1987, Tawney met me at the door, dressed entirely in white. She was tiny, just five feet tall, with clear blue eyes and hennaed hair cut in a short bob. The loft where she lived and worked was all white as well—open, expansive, and bright. I was there to begin research for a retrospective exhibition at the American Craft Museum (now the Museum of Arts and Design), but Tawney had other ideas. "I thought we'd blow bubbles today," she said, and producing a small vial of soap bubbles from the pocket of her smock, she twirled through the space, followed by a cloud of bubbles.

That was Lenore—catching her visitor off guard, changing the dynamic. And as my eyes followed her, that magical space came into focus. The loft had an ethereal quality, a sense of spirituality reflective of Tawney's deep reverence for and poetic response to materials. The space was filled with time-polished river rocks, bleached bones, feathers, eggs, objects collected during travels around the world, and chests

in which each drawer held a small assemblage. Her works were hung throughout—weavings, collages, and sculptures, all of which incorporated elements of the environment. Each object had been carefully, sensitively placed, all part of a whole. To enter that studio was to step into a cabinet of wonders. And overseeing it all, from a wall high above, was a protective talisman—the carved wooden figure of an angel, who, like Tawney, was dressed entirely in white.

That loft, Tawney's last, was her ninth studio since her move to New York, and the environment had been decades in the making. Thirty years earlier, in 1957, at the age of fifty, she left behind a comfortable life in Chicago—a home, possessions, and friends—to work as an artist in a cold-water loft on Coenties Slip. Tawney, who described herself as an "all or nothing" person, had come to New York to devote "all" to her work. "I left [Chicago]," she reflected in a journal entry, "to seek a barer life, closer to reality, without all the *things* that clutter & fill our lives. I left friends whose preconceptions of me held me to their image of me.... The truest thing in my life was my work. I wanted my life to be as true. Almost gave up my life for my work, seeking a life of the spirit."[1]

This shift was poignantly captured by Tawney's friend Evey Riesman in the 1960s: "As she talks and leads me into her huge loft, I think of her as she used to be. I think of... her crowded, rich apartment with antiques, plants, paintings and rugs.... I see in a glance

Tawney in her studio on West Twentieth Street, New York, 1985. Photo by Paul J. Smith. Lenore G. Tawney Foundation, New York.

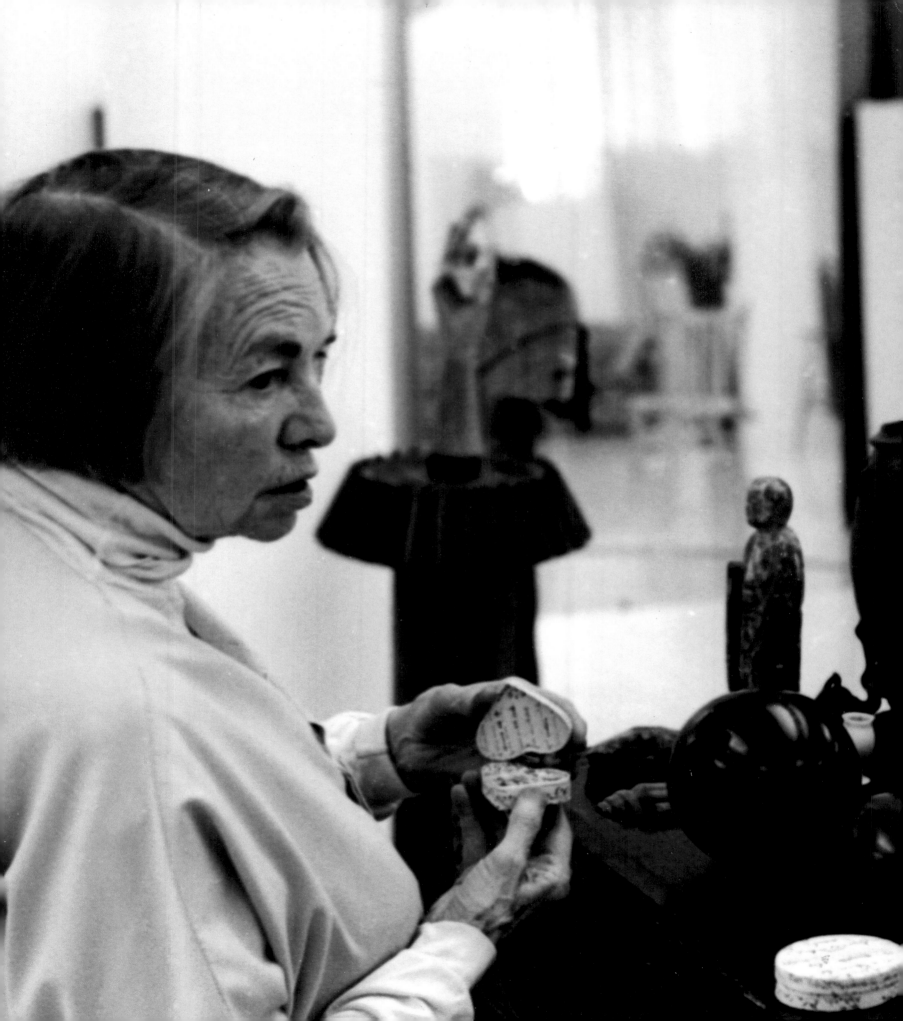

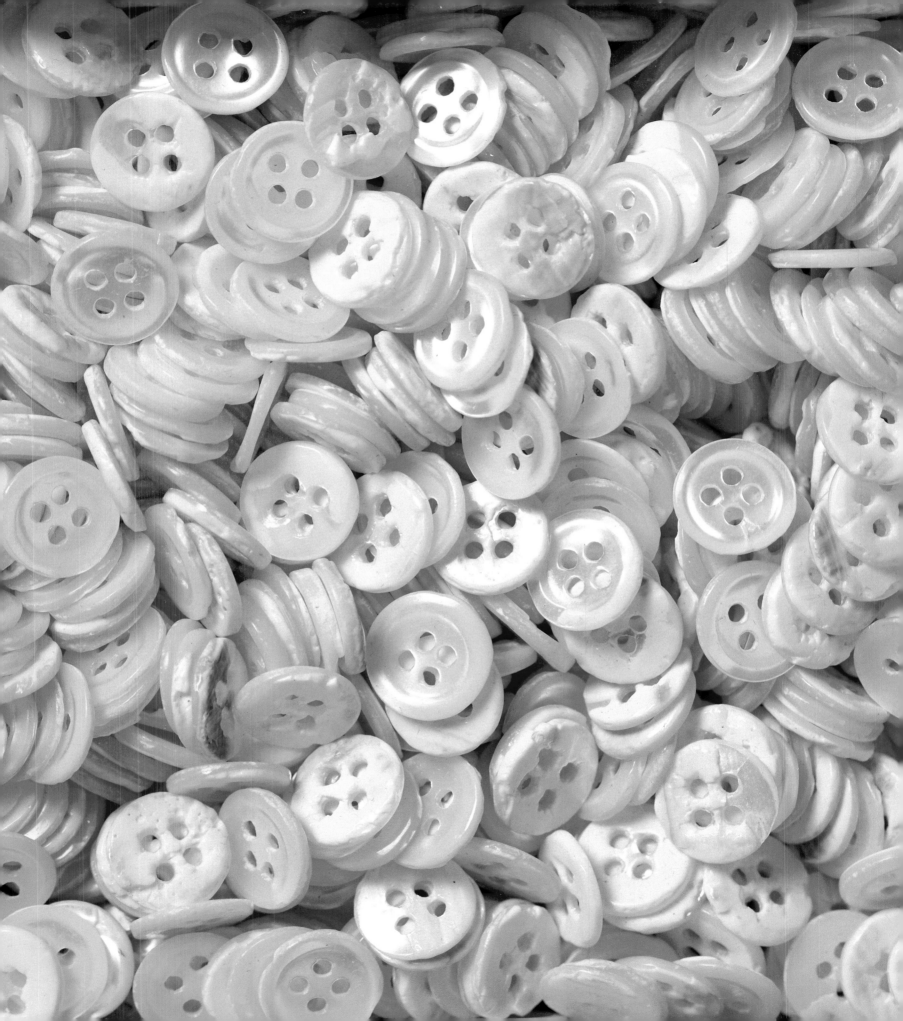

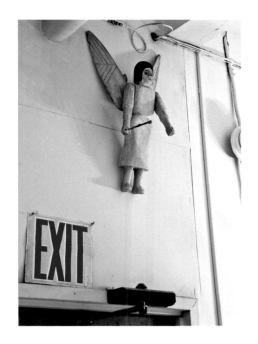

she has left that life behind, she has stripped herself bare. As she leads me over to the divan where we sit, she tells me the place was filthy, that she cleaned it up herself and painted it white....And this room which is a place to work, but hardly a place to live in perhaps explains—her work has taken over and become her life."[2]

Riesman's description of Tawney's loft at 27 South Street presents an early iteration of the signature environment that Tawney built (and rebuilt) throughout her career—a spare white space, filled with feathers, shells, and work. Tawney's earliest studios were not legal living spaces, and several of the buildings were soon to be demolished, necessitating the frequent moves that repeatedly disrupted her work. None of her loft residences in New York had previously been residential, and each one required building out from scratch. In their openness and tranquility, and the unexpected juxtaposition of seemingly disparate elements within, these spaces had much in common. Each studio represented the collage of a lifetime.[3]

Tawney's work, like her environments, was realized through accumulative processes—weaving warp and weft to create new forms, combining found elements in collage and assemblage. "My desk is usually a terrible mess, with layer upon layer," she stated in a 1978 interview (above right).[4] "When I'm working and I need something, my hand just goes to that place wherever it is—under whatever it is. That's why in my studio I have a *lot* of things around: yarn, bones, feathers, egg shells, stones, even the mail and magazines that come in, I use everything." As sources of inspiration, materials for use, and autobiographical notations, Tawney's collections were a significant part of her practice. And always, the white-clad angel (above left) presided over all.

The retrospective exhibition begun on that day in 1987 opened at the American Craft Museum in 1990 (page 16). Lenore had become a close friend as we worked together on the show, and I continued to work with her afterward, until her death in 2007 at the age of one hundred. Just a year before that, she received an unusual inquiry from Leslie Umberger, then senior curator at the John Michael Kohler Arts Center. At that point, Umberger had been researching the work of Wisconsin artist Albert Zahn for several years, and collecting it on behalf of the Arts Center. She had chanced upon a portrait of Tawney in a 1957 issue of *Craft Horizons* (pages 17, 60).[5] Taken almost half a century earlier in her Chicago studio, the photo showed Tawney seated at the loom. Behind her, with a piece of yarn in its outstretched arm, was the angel, a "marvelous work" by Albert Zahn. Did Tawney still have the angel, Umberger wondered? Indeed, she did.

The Arts Center, Umberger explained, had a unique permanent collection, specializing in the work of "artists who transformed their homes into entire art environments. Albert Zahn was one such artist."[6]

ABOVE LEFT Albert Zahn angel hanging in Tawney's studio on West Twentieth Street, New York, 2008. Lenore G. Tawney Foundation, New York.

ABOVE RIGHT Tawney's desk in her studio in Quakertown, New Jersey, 1977. Lenore G. Tawney Foundation, New York.

FACING PAGE Buttons from Tawney's studio. John Michael Kohler Arts Center Collection, gift of the Lenore G. Tawney Foundation and Kohler Foundation Inc.

FOLLOWING SPREAD Tawney's studio on West Twentieth Street, New York, 1985. Lenore G. Tawney Foundation, New York.

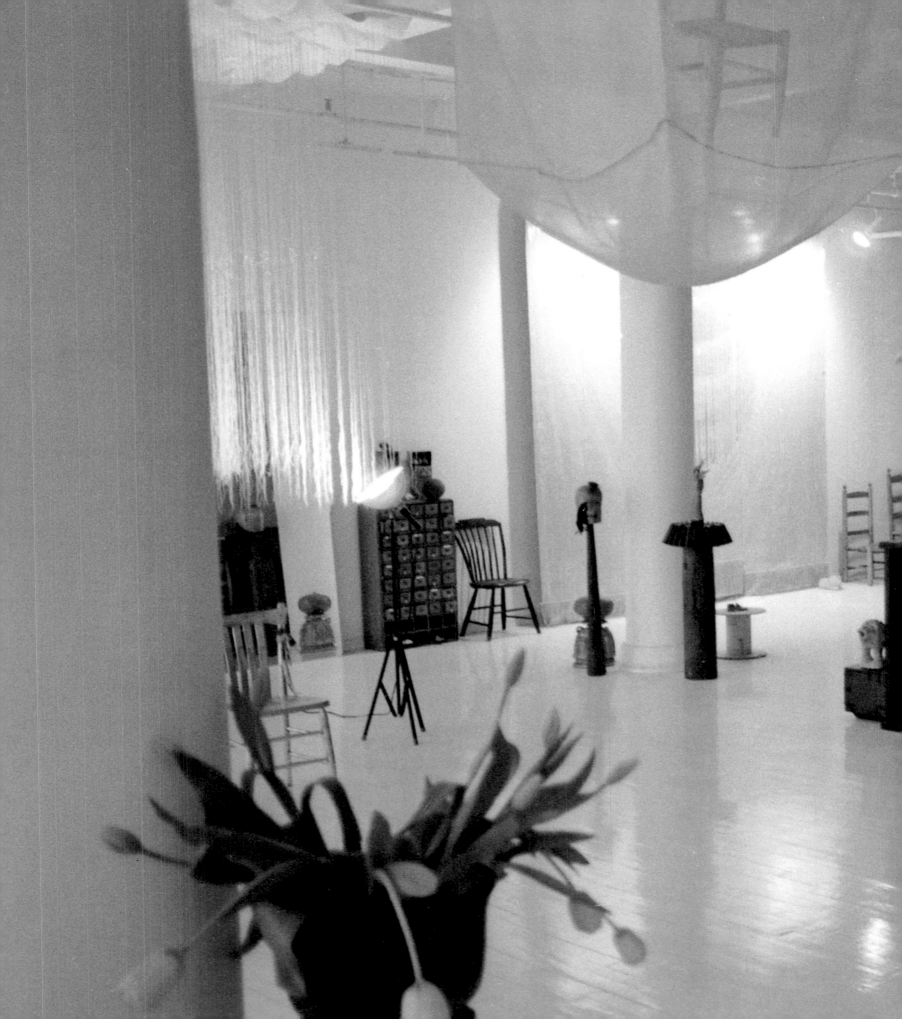

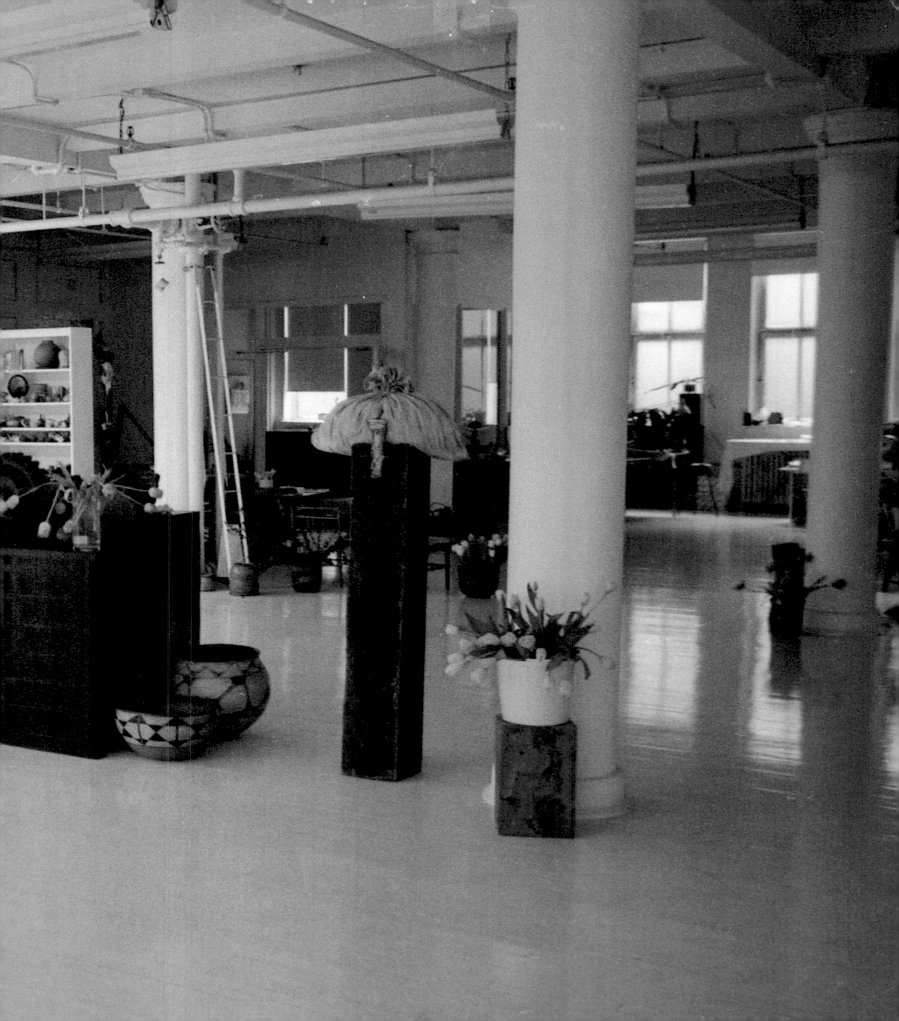

Tawney (left) with
Kathleen Nugent Mangan,
American Craft Museum,
1990. Lenore G. Tawney
Foundation, New York.

FACING PAGE Tawney in
her studio on East Cedar
Street, Chicago, 1957. Photo
by Aaron Siskind. Lenore G.
Tawney Foundation,
New York.

When she visited Tawney's loft to see the Zahn angel, Umberger discovered that Tawney was another. And so it was Tawney's "guardian" angel that introduced her to the Arts Center. The Lenore G. Tawney Foundation later gifted the angel to the Arts Center's outstanding collection of Zahn's work, and it is now pleased to place Tawney's highly personalized studio environment with the Arts Center's collection of artist-built environments.

What might one learn by stepping into Tawney's personal world today? To have the courage to be true to oneself. To follow one's own path. To slow down. To see. To look at the commonplace objects in the world around us with fresh eyes, to appreciate their beauty, and to hold them in wonder.

1. Lenore Tawney journal (30.10), entry dated December 4, 1967, Lenore G. Tawney Foundation archives (hereafter "LGTF").

2. Evelyn Thompson Riesman, "Lenore Tawney," unpublished typescript, 1967, LGTF, 16.1.

3. In the late 1970s, Tawney's studio was in the Quakertown, New Jersey, home of fellow artist and friend Toshiko Takaezu.

4. Quoted in Jean d'Autilia, *Lenore Tawney: A Personal World* (Brookfield, CT: Brookfield Craft Center, 1978), n.p.

5. Margo Hoff, "Lenore Tawney: The Warp Is Her Canvas," *Craft Horizons* 17, no. 6 (November/December 1957): 14–19.

6. Leslie Umberger, email to the author, 2006.

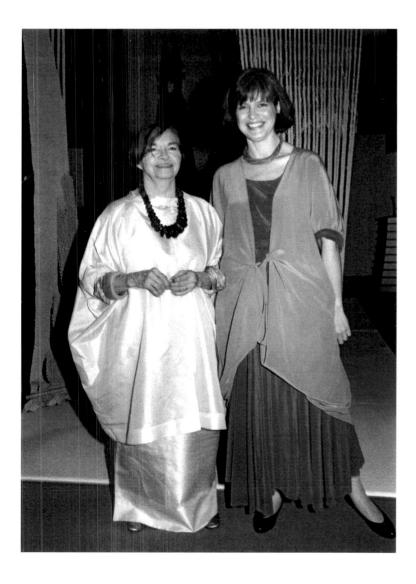

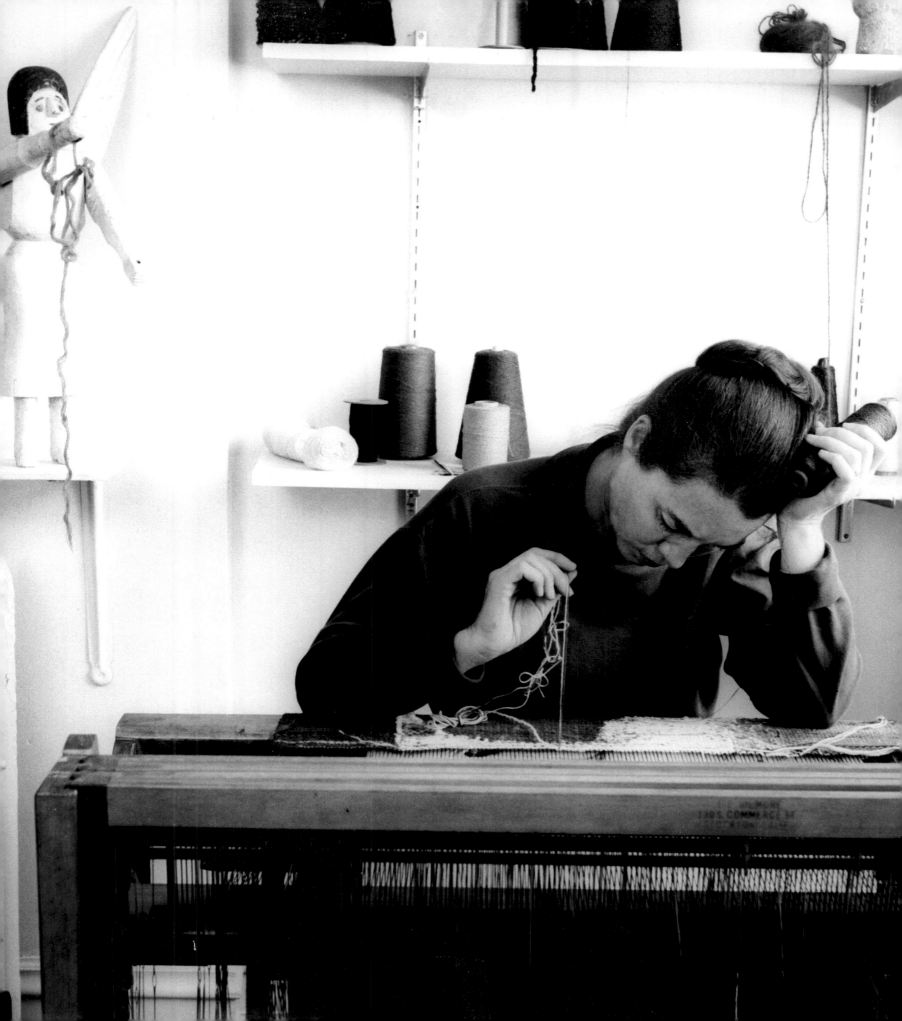

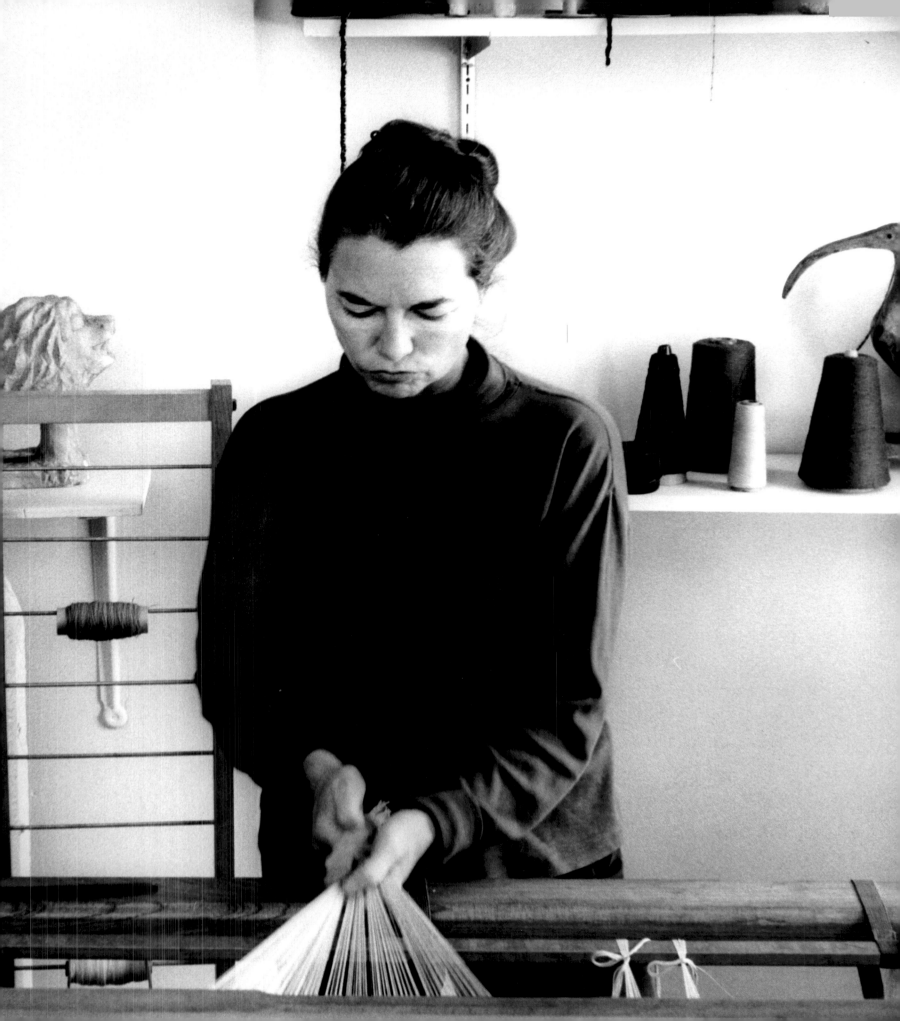

"Lenore Tawney's practice models an approach to working with fibers that is commanding and almost threatening, but in a sensual manner. This, for me, is a departure from what I see as an emphasis in fiber art made by women on the quiet, subtle, and unassuming. Tawney works with minimal visual information, but in a way that produces strong affect as opposed to evoking coldness and distance. Her work also moves away from simply emphasizing or romanticizing the labor process that went into producing it, resulting in works that feel urgent, deliberate, and fast-paced."

— JESSE HARROD

Artist included in
Even Thread [Has] a Speech
(page 263)

Tawney at Chicago
studio, 1957.

Waiting like a Fern

Mirror of the Universe KAREN PATTERSON 22

Student *1945 to 1960* GLENN ADAMSON 46

The Archive *Ephemeral and Eternal* MARY SAVIG 88

Technical Analysis *Lost and Proud* DR. FLORICA ZAHARIA 98

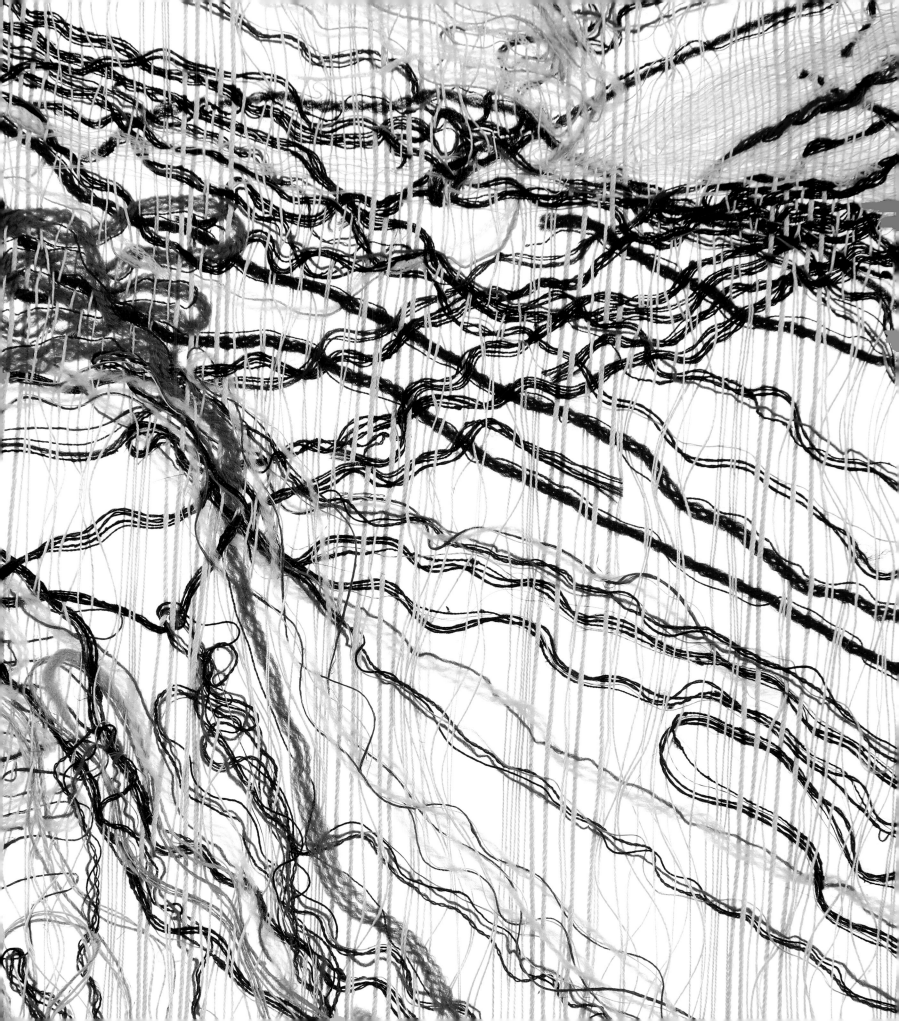

Mirror of the Universe

KAREN PATTERSON

"Often the place where an artist lives is remarkably like the work that is made there."

In this opening sentence of the poet James Schuyler's profile of Lenore Tawney in the November/December 1967 issue of *Craft Horizons* and his words that follow, he eloquently describes the artist's Spring Street loft, noting its "sense of light and quiet, of occupied space, but so occupied that there is plenty of room to move around."[1]

In other words: graceful and hushed, holding space, with room to breathe.

Tawney had lived in that studio for only a year. In the preceding decade she had occupied a series of Lower Manhattan loft spaces: first on Coenties Slip, then South Street, on to Thomas Street, and then Beekman Street. Despite the movement, each space so clearly reflected the artist's sensibilities. So distinctly mirrored her universe.

Tawney's spaces were manifestations of her experiences, stand-ins for her life. Equally as enigmatic and shrouded in mystery as the artist, they don't easily give us the answers we want. But they are so very hers. Just like her, the things in her studio are "dynamic agents of the spiritual: they provide a sense of plentitude, a healing place of respite," as curator Leesa Fanning describes the encounter with the spiritual in contemporary art.[2] The way she arranged the skeins of thread, or gently lined up beach stones by size, or tucked away a small seahorse in a chest of tiny drawers—she

allows us "to see anew as if for the first time." Somehow making us feel alone, insignificant, but also profoundly connected. As appreciators of her work, we see the consistent sense of devotion, the great care in every detail. This precision has an embedded element of undoing, of letting go. Why so disciplined? How so free? Tawney has never explicitly told us the root of this meticulous approach, this deep conviction for both structure and reverence. We can trace her steps through the various homes and studios she cultivated, and yet she still feels far away from us. She wasn't necessarily self-effacing; Tawney simply didn't find value in explaining herself. She lived a life of interiority and veneration. Explaining the steps of her journey would diminish the light.

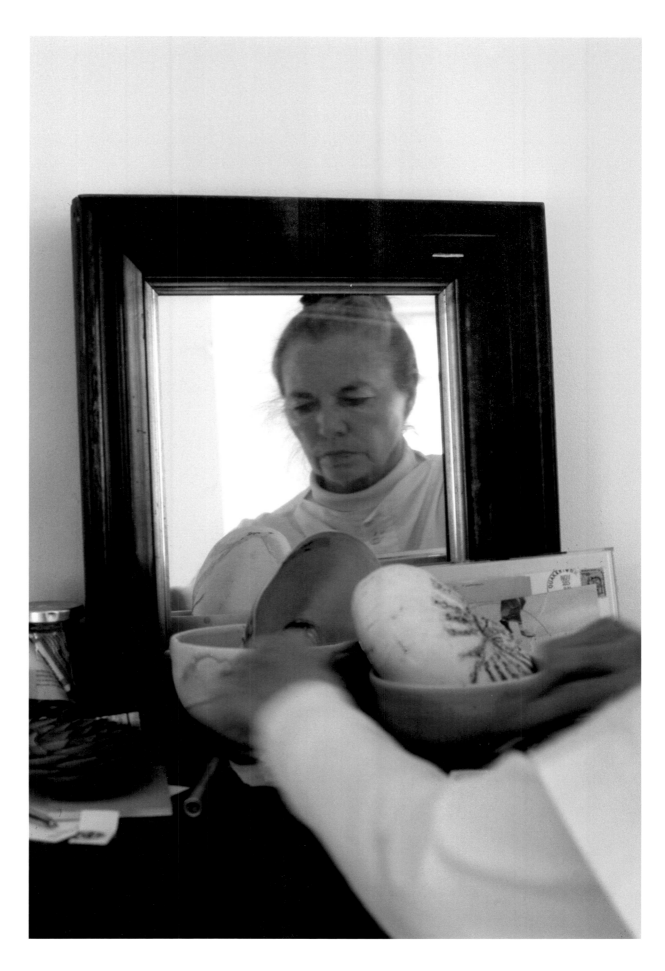

The way that her works change the shape—the texture—of a room places new demands on us. They feel partially immersive, which makes us want to both get closer and yet maintain a respectful distance. They emanate intimacy, inspire contemplation, heighten awareness, and increase a sense of *presentness*, which is exactly what weaving insists upon. She has shown us process without providing the instructions.

We can look for clues in the places she gravitated toward—and escaped from—and in the landscapes she witnessed and later embodied. We can wonder where she first saw these things, why they haunt her work, and what they might symbolize. We trace a philosophical distilling throughout the years—water, the ever presence of water, is eventually refined to become line, movement, and light.

> I mean, I'm communicating something, but I'm not sure what it is and neither is the recipient.[3]

In her home and studio, Tawney held everything she needed to be an artist devoted to a spiritual journey. Once she decided to commit to an artist's life, she plunged in. There was no time for a work/life balance. Only life that could be folded into art worked for her, only art that could be looped back as life made sense.

Life intertwined itself in art. Life was threaded, cut, placed, constructed, inscribed, and then offered to us as art. The poignant moments, the closest people, the exhilarating travels—all show up. Whether it is the artifacts she collected, the art she traded, the items she gathered, or the work she produced, everything holds something. Something about her and the path she is on. I scan through images of her spaces in search of answers.

I look at photos of Tawney's various studios, and I want to gather only what matters. I want to paint the floors white. I want beautiful specimens within arm's reach, things from nature that perfectly express how fragile it all is. I don't want to justify it. I don't want to explain it. I just want to find the deepest of values and meanings. To spend hours, days, months sitting quietly on the floor, tediously separating threads, setting the loom, only to mischievously commandeer the machine's purpose for my own.

In the last ten years of Tawney's life, she gradually lost her eyesight—a destabilizing experience for anyone, but for someone who had spent the majority of their life looking inward, it is completely poetic. I picture those final years as a retrospective of the interior. Looking back at past events and perhaps seeing them as only abstract forms. As light. As feathers. As water.

Tawney in her studio on West Twentieth Street, New York, 1991. Photo by Cori Wells Braun. Lenore G. Tawney Foundation, New York.

FACING PAGE Detail of *The Bride*, 1962.

In the forty years prior, she was building content for her mind's eye.

In those hours spent constructing those monumental, enveloping, delicate, defiant forms, Tawney was thinking about life. Not necessarily her life, but life itself: the possibility of existing. With all the material conditions of life around her, her trajectory was always inward. Seeking a way to direct things into the world, her sculptures can be seen as journal entries. Weave toward the center—the source—instead of left to right. Leave room between the threads, to let the light in. Gently tie the shells brought back from Mexico here. Push the small yellow feathers through there. Let it feel so big that it's overwhelming. That you have to look to the sky.

"Spiritual" seems too vague a term to apply to Tawney. Perhaps because the word, as with "authentic," seems to be coopted by campaigns of "healthy living," or "fitness," or "me time" and just loosely, lazily stands in for anything meaningful. And indeed, her pursuits were self-centered, in the truest sense of the word. Yet the works of art she produced feel so benevolent, as though she is giving us the gift of introspection. Reminders of mystery. She did the work of showing us what water *feels* like. In her thousands of gathered threads, she is telling us that there is more for us. Stop trying to force it. Just work through it. Spend the time. Make it impractically big. Impossibly delicate. Tie thirteen thousand threads to a canvas support so that the world can be reintroduced to awe. What is peace in the face of chaos? What did it mean to Tawney to be human?

I look at the sheer impossibilities of the work that she made at that loom, the way the thread seems to be pushed across the warp, and a rush of existential questions come to my mind: How do we want to live? If I slow down, will I be able to dig in? Can one really be lost and proud? Is that the goal? Does my routine serve a spiritual fulfillment, or does it avoid one? Am I doing enough? Too much? I look through the space in between the threads and wonder if the center will hold. I immediately want to live more calmly, because I'm suddenly aware that there is beauty—joy—in the futility of it all. I want a more measured existence. But I also want the center to hold.

> Well, that was because I didn't study and no one told me, "You can't do this." So I did those things and it was thrilling. You know the first time you do something that you think is just going to fall apart when you take it off the loom—that was the first open one. But I thought, Well, I don't have to show it to anybody. That made me feel a little bit freer in working. You know this feeling that somebody's going to see it is binding; it holds you.

I wonder what piece she is referring to here. It could be *Lost and Proud* or *Egyptian Girl* (pages 47, 59) or any of the works she made in the late 1950s. Or maybe the one she is talking about did, in fact, fall apart. I hope she is referring to *Seaweed* (pages 28–29, 110). The way the silk threads move through the piece, it's as if they were left there by the tide. Because it's true, anything deposited by the tumult of the sea always seems to land at the exact right spot, the precise way it should. *Seaweed* feels at peace, aglow, content, prescient. It feels stripped bare yet bountiful. What must it have felt like to *finish* that piece and to just know that it is right? Thrilling.

I look at *St. Francis and the Birds* (page 48), and I think about how she knew she wasn't ready to fully commit to her practice at the time of its creation when she was in Chicago. This early work is so unlike the weavings she would later make. It almost says too much. Leaves little to wonder. But she was nonetheless weaving. And it was nonetheless about nature and its patron saint. I think that this is an early gesture of protecting what is vulnerable, what matters most. At this moment in her life, she had seen and experienced snippets of the artist's life, and perhaps started to think that art making would be the ultimate safeguard, the best protection. But she couldn't do it. Not yet.

> So I studied with [Alexander Archipenko] that whole summer and that was a real turning point for me because, working all day, you know, you really just thought about high points, when you're just completely with what you're doing. It's like almost ecstasy sometimes. And when I went back to Chicago, I wanted to do that. But I had bought a building, you know like this sort of, all run down, and I was fixing that. It seemed that I had to devote my whole self to sculpture; I couldn't do it half way, so I gave it up.

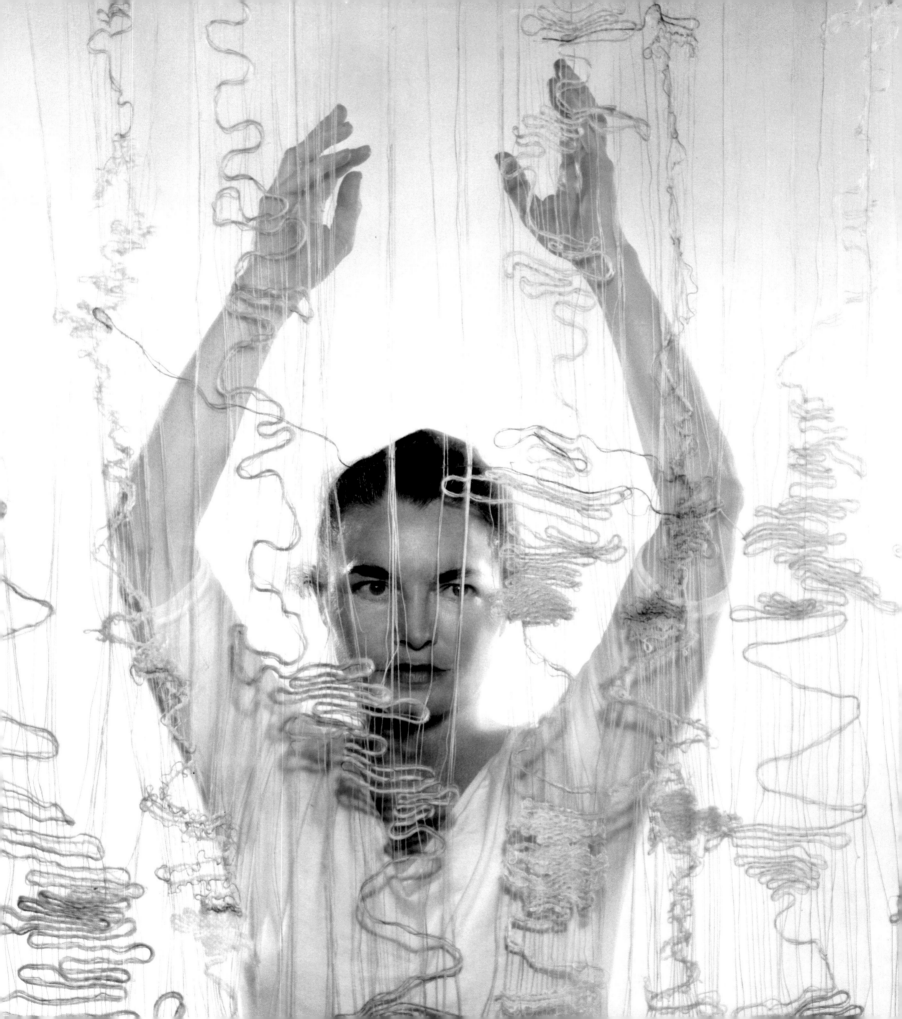

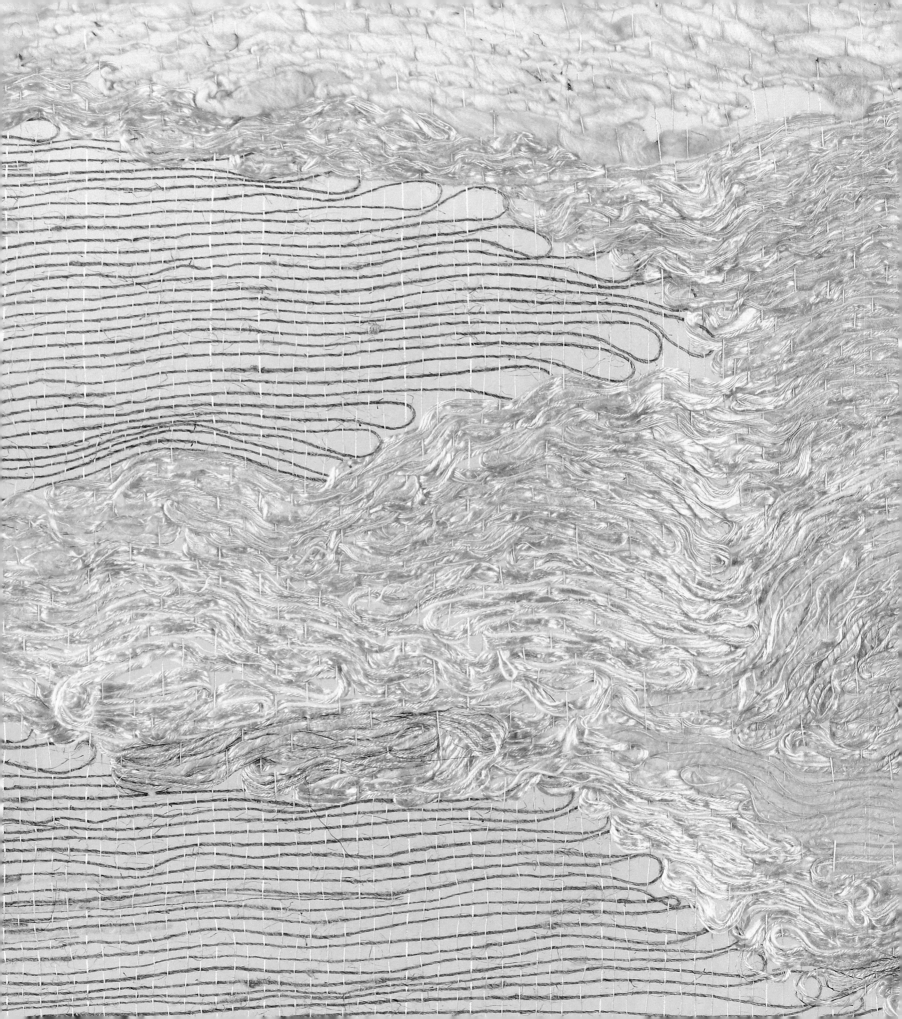

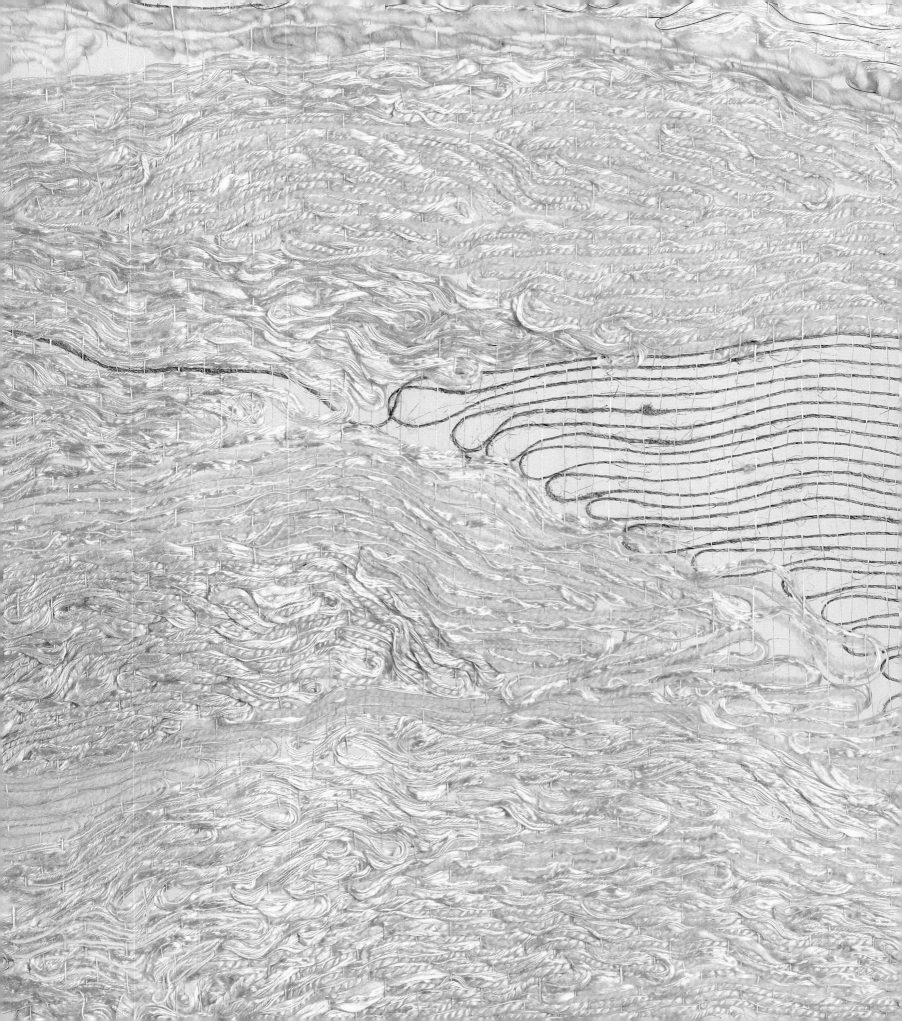

She didn't give up. Instead, she continued to make impossible pieces, because she thought no one would see them. It wasn't for them, anyway. I look at how tender the glass appears, holding the works that they were asked to protect, how important the task is.

> I felt in Chicago I was sort of held. You know when you're in a place a long time, your friends hold you into the sort of mold; they think you're this and you can't drag yourself out of it. I came here and I took a loft which was, oh, a terrible loft. It was in the building [Jack] Youngerman was living in. But I took it and I left everything in Chicago. I just brought a couple things. I brought this and a refrigerator and my cat and my loom. And I didn't know whether I'd stay, but I stayed. I immediately felt free.

I wonder what it was that she did first when she arrived in New York. Are there clues in the works that she made in those early years? I think about that time in her life and I, too, want to make a big life change and feel the need to completely surrender myself to something larger than me. And to know that there is something bigger to catch me. I want to create so much structure in my life that all that's left is intuition and instinct. I want to tell a curator that I thought we would blow bubbles today. As if that is a small clue to how I'm feeling.

The first place she landed in New York had to be on the water. The titles of her works revisit this element:

> *Little Spring … Cloud Labyrinth … Written in Water … Dark River … Shrouded River … Waterfall … Seaweed.*

Some of Tawney's works appear as views of the earth and its waterways from millions of miles away, while others dip down to gently follow the contour of a current. Tawney's practice was so in tune with the qualities of water, so clearly a relinquishing of control in the face of some larger force, yet in equal measure this wanting to harness its power. Her works feel as intrinsic as our own relationship to nature and give off the same sense of uneasy comfort. Water is the source of everything—everything—and it is to be

revered. How does one take that on? It's so easy to be subsumed by the roar of waves, and then silenced as we make small, seemingly insignificant imprints in the sand. How we hope the current might carry us gently, carefully, if we are careful and gentle in turn. It's a tenuous balance. Small gestures in the wake of vastness. Threading the loom, arranging the rocks, inserting each feather, one by one. As if to say, I see you, Mother Earth, I am with you. The calm of mist after rainfall. Or how utterly brand-new everything feels after a snowfall. How quiet. How wild. Tawney was never without a shore: the Great Lakes, the rivers surrounding Manhattan, fingers of land reaching out into the Atlantic Ocean. With clouds in the sky.

> So there I was right on the river, looking at the river and the boats and the lights of Brooklyn. Behind me there was only this wall and there all these pigeons and birds with wings flapping, and outside were the gulls on the river. So I had birds all the time, the birds in the back and they were on the windowsills and then the gulls and the boats. It was as if New York was at my back. Then in the winter you saw every change of the weather down there; you were more aware of it than when you're uptown because you'd see the ice and the wind and it would come through my skylights, some of it. I had a stove for heat, and sometimes when the wind was blowing hard, I couldn't get the fire going and it was very cold. But it was beautiful. I had the floors sanded, and it was like a dance floor.

Water sustained her. It was *the* source material.

> I did a series from a quotation I read like "from his footsteps flowed a river," and I just, maybe there are a few here, all flowing lines like water. And they're also like threads, the lines, they're very like threads.

I wonder about what Tawney saw as her eyesight was failing, because her work feels so interior. So essential. In these woven forms, she's harnessed the vitality of an experience, of a moment. Caring more about the routine, or rhythm of making. The peace of

mind. Of achieving the feeling of being in tune with *it*. To transform something from raw material to an art form, you have to tap in and sync up. I think she tuned in to all her experiences and remodeled them for hours on end in the studio. There is nothing left to explain. Little else to see. Tawney is asking us to take the time to experience space, so we can hold it. Notice how things shift, wither, grow, tilt, fall, dance.

What was she seeing in her mind's eye? Was it more tangible, like the places she visited and the studios she had created?

> But it was very controversial, what I said, and everybody got sore and angry and took sides, and I just said that we had to follow our own inner being.

A particular passage by the writer Alice Munro has always haunted me, and I think about it in terms of Tawney: "In your life there are a few places, or maybe only the one place, where something happened, and then there are all the other places."[4]

I want to know if the studio was the place where something happened for Tawney, or if the studio was the place where she could finally be free enough to think about the other places where something happened. In what ways did the lakeshore cling to her? Did she know it at the time, or was it only in hindsight that she understood the ways in which her trips to Peru reverberated throughout her life? Did the sharp horizons of the Midwest graft themselves onto her life such that she involuntarily gauged time as being *before* and *after* she saw the vast expanses of wheat fields? For the longest time, did her birthplace of Lorain, Ohio, on the shores of Lake Erie, seem like any place, or even no place? But then, suddenly, she sits on the floor parsing out thread; is she shot back to the specific sounds of industrial chatter from her first job sewing buttons on men's suiting? When the loom is really clattering, is she thinking about that time in Penland, North Carolina, with Toshiko Takaezu, getting a ride to the weaving studios that looked out onto the Blue Ridge Mountains and asking the driver to stop so she could scoop up a dead bird from the road, and by the time she arrived the whole experience was so overwhelming that she needed to lie down?[5] Did she notice the ways in which she physically shrunk or

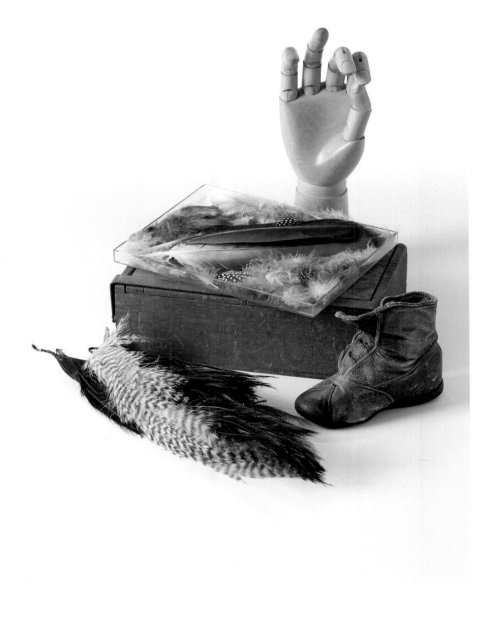

Group of Tawney's studio objects. John Michael Kohler Arts Center Collection, gift of the Lenore G. Tawney Foundation and Kohler Foundation Inc.

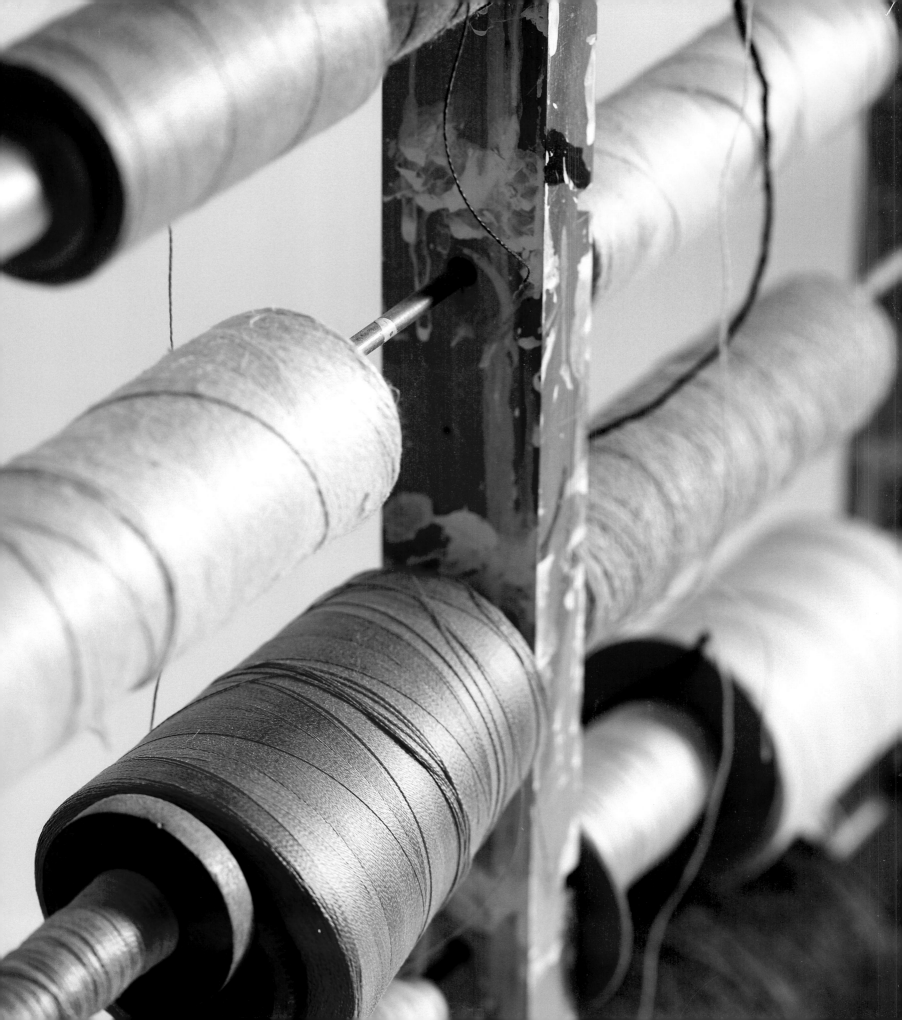

expanded when she thought about Chicago? Before New York. Back to that place. Where things changed. Breathe in, breathe out. Shuttle to the left, and to the right. Open the mind, clear the heart.

Throughout her life, Tawney fell in and out of places. From the lakefronts of Lorain and Chicago to her last carefully appointed studio, on West Twentieth Street in New York City—and the many travels along the way—there were reasons for her to stay, and even more motives to keep going.

I look at *Shield IV* (page 267), and I feel the urge to travel more, to see more. I want to think about what I saw more. She managed to capture both the haze and brilliance of the sun in those pieces. Surely, when she traveled to Mexico and Peru, she learned about the intricately woven textiles patterned on the backstrap loom. She would have seen cloth that was sometimes decorated with embroidery, freehand painting, or inlaid feathers, shells, small bells, and other ornaments. Textiles printed with pottery stamps and cylinders, blankets and garments with elaborate fringes and tassels.[6] Were Mexico and Peru important places for Tawney? In those works, she netted the radiance, the luminosity of a place. So yes, we know that these regions mattered to her. But I think the idea of being with a landscape, or within a place, surrounded by inspiration, was paramount.

And then was the goal to put that feeling out into the world? Slowly, carefully?

> They came out like that. They were done mainly—I began just to do them. You know, it's like it came out from the inside as I worked. I had to keep on with this until it was finished. You can't just start a thing and go away for six weeks and come back because then you're not in that. You have to just go with it till it's done. So there were landscapes in those first ones.

I look at *In Utero* and *Drawing in Air VI* (pages 37, 232, 233), and I think about balance. And ebullience. That things are possible. Things grow and die and come back to life. Irreverently drawing in air was exactly what she was doing. I look at *A Dry Cry from the Desert* and *Celestial Messenger* (pages 97, 189) or any one of the chests of drawers holding delicate,

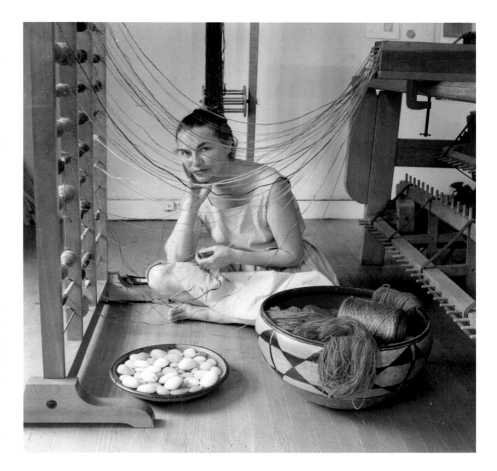

diaphanous, careful little things (pages 204, 205). Eggs, shoe forms, shells, quills, gloves, gauze, and I try to guess how these things came to her. Things that are so needed but also quickly discarded. Surely many of these things are gifts from friends who understood her—or understood that part of her. Others she must have found on her many trips. To Paris, Beirut, Egypt, Lebanon, Greece, Jordan, Syria, Japan, Thailand. When asked about the goals of her travel, she replied, "I like to be [somewhere] for a certain period to get the feeling."

Tawney had a fondness for wooden shoe forms, delightfully suggestive shapes that conjure thoughts of both balance and motion, of standing still or active excursions. Feet are essential to yoga and acupuncture, two of Tawney's particular interests. For Tawney, these shapes were symbolic of her journeys abroad as well as her personal introspection and inner journeys. She covered the foot sculptures in the pages of old books, fashioning walking stories, walking poems, and walking prayers. *Persian Poet* (c. 1984–86) was coated in calligraphic grandeur. In *Book of Foot* (1996),

Tawney in her studio on Coenties Slip, New York, 1958. Photo by David Attie. The LIFE Picture Collection/Getty Images.

FACING PAGE Detail of Tawney's spool rack, n.d. John Michael Kohler Arts Center Collection, gift of the Lenore G. Tawney Foundation and Kohler Foundation Inc.

FOLLOWING SPREAD Untitled (rug), 1959; wool; 89 × 19½ in. Lenore G. Tawney Foundation, New York.

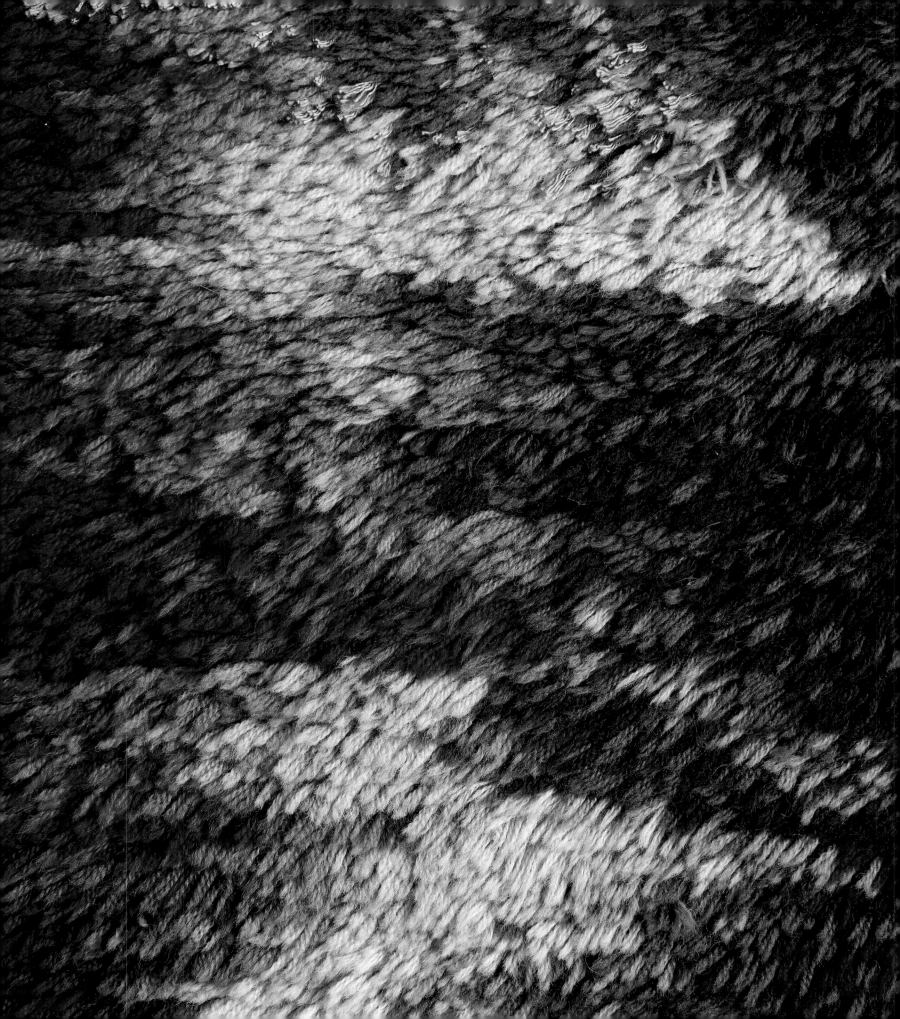

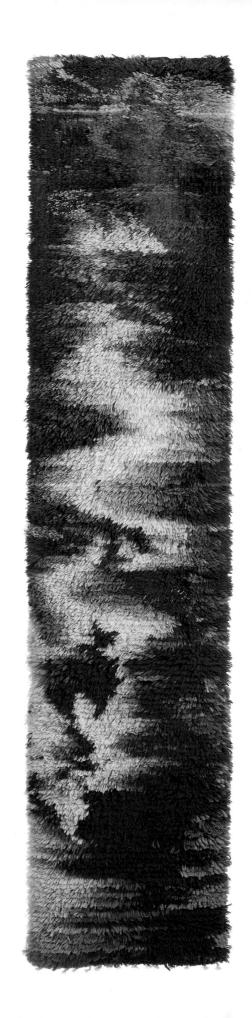

a foot form is propped, sole out, in a narrow open box attached to the ball of the foot, a form reminiscent of a butterfly. *Celestial Messenger* was adorned with an animal jawbone outfitted with wings, allowing Tawney's feet to take metaphoric flight (page 189).[7]

I look at the photo of Lenore Tawney with the Albert Zahn angel carving overhead (page 17), and I feel gratitude. That angel brought Tawney to Wisconsin, whether she set foot in this state or not. The son of German immigrants, Albert Zahn was just fifteen when his family sailed from Pomerania to Maryland in 1879. They continued west to begin their new life in the southern Door County town of Forestville, Wisconsin. There they were in the company of many other northern Europeans who were comfortable in the climate and the rural surroundings, so similar to that of their homeland. A lover of nature and wildlife, Zahn spent most of his time in the outdoors, farming on 160 acres of land that he purchased near Baileys Harbor. With the help of his wife, Louise, he built their home and barns and established a dairy farm.

As a youth, Zahn had enjoyed carving and working with wood. In the forest surrounding their home, cedar, pine, and walnut trees were plentiful, so he had the material to pursue that interest. He created furniture adorned with carvings of animals and birds and fashioned decorative objects for the interior and exterior of the home.

A self-taught artist, he possessed a devoted reverence for the birds, creatures, and woods around his home. His carvings were a result of many hours of careful observation, of close looking at nature. He carved weathervanes, figures, and tree forms that adorned the roof, porches, and front yard of the house. He named his home "The Bird House," and it became a Door County attraction.

Leslie Umberger, former senior curator at the John Michael Kohler Arts Center, describes how her research into Zahn ultimately connected her to Lenore Tawney:

> In 2003 I organized the Arts Center's first exhibition of Zahn's marvelous work, but it was a few years later while working on the project *Sublime Spaces & Visionary Worlds* that I had a fortuitous chance encounter. Looking through an old issue of the

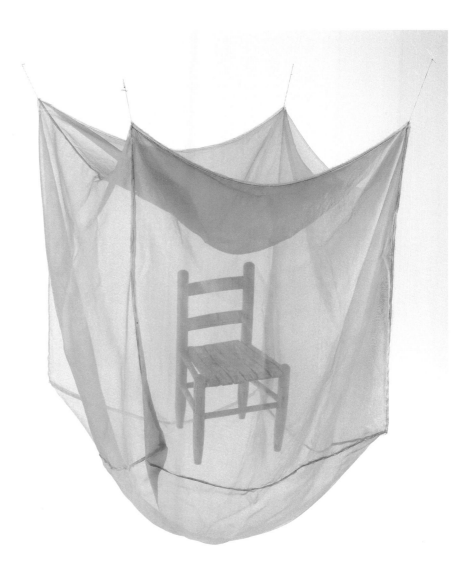

magazine *Craft Horizons*, I saw an article about Lenore Tawney. It was the photograph opening the article that really stopped me—it was a black-and-white image of Tawney working at her loom. The weaver was surrounded by spools of yarn and perched over her shoulder, gazing down from an adjacent shelf and offering a stray piece of yarn, was one of Zahn's sculptures, a dark-haired angel in a white dress. When I contacted Tawney to ask about the wooden angel, it opened another door altogether. I would learn that Lenore Tawney's predilection for soft shapes

In Utero, 1985; mixed media; 25 × 11½ × 11¾ in. (chair only). Lenore G. Tawney Foundation, New York.

FACING PAGE *Little Spring*, 1962; linen; 48 × 23½ in. Lenore G. Tawney Foundation, New York.

Tawney's studio on West
Twentieth Street, New York,
c. 1982. Lenore G. Tawney
Foundation, New York.

When you first walked into Tawney's studio, you were greeted by rows of glass shelves. Carefully lined up on these shelves are all her words, all her worlds—ceramic pots by dear friend Toshiko Takaezu, delicate works by Ferne Jacobs, southwestern Native American pottery, pre-Columbian artifacts, blown glass from Italy, a crystal skull, small wooden carvings, smooth stones, a wasp nest, bird skulls, fishing lures, and lots of other little wonders. And every once in a while you see small Tawney works. She has inserted herself into the larger, bigger narrative of life. Of friendships, of travel, of wonder, of history, of life, and of death. The only way to mirror your universe is to strip it bare to its most essential fragments and then refract it, to weave it back together.

Tawney's journey seems like a constant push toward undoing. Not an unraveling, but a growing reverence for impermanence. A careful respect for the fragile balance of life. Perhaps there were events in her life that were so tectonic in nature, that explaining them might revive their power. So instead of talking about the loss, she channeled it. Instead of dissecting the ways in which she changed in her life, she started over; she pieced together the fragments for us all to see. As a result, Tawney's work seems to hover at the periphery and hit us at our core all at once. She is both digging in and keeping us at bay. Because this was her own singular path. She nurtured and sustained an inimitable interiority that manifested itself in such mysterious things that dreamily balance things that can crumble with things that can't help but endure. There is such energy with these works. A calm vibrancy emanating from all the structures she set up for herself. Structures designed to usher in a surrender. To leave the warp open. To craft a life and live in a place that safeguards an innermost self and nurtures a life that feels clear, full, and light. In her own way, on her own time. How can such a clear vocabulary, such a static mechanism, produce so many unknowns? Attentive performance of simple actions. The shifting and the focusing of attention to pay attention.

She chose things that at one time had life, something that has experienced a cycle, of life of death of transformation, of rebirth. Mammal to bones, birds to eggs. Flax to thread. Water in all the seasons, on all the shores.

and colors had fed her own kind of art environment, a visually choreographed gathering of eclectic parts. Tawney's hushed New York loft stood in stark contrast to Zahn's bright, handcrafted Northwoods house, yet both had carefully shaped a home space, following personal vision into a realm apart from the larger world.[8]

Unlikely kindred spirits, both artists had a unique reverence for the spiritual and a desire to reflect that devotion in their homes and in their art.

> But you have to lose that completely and then you're free. Then you're in touch with that inner thing that wants its own way and this is the only way original work is done. I mean it comes if you let it, and I think everyone has the possibility if they get down deep enough, to do what is their own.

Unique, singular voices and vocabulary. This is what mattered. Don't replicate; there is not enough time. The goal—the only goal—should be clarity of thought, of voice, and of body.

WAITING LIKE A FERN

This publication is designed with Lenore Tawney's multivalent approach to life and work in mind. Although traditionally chronological, each section weaves integral voices and perspectives. Glenn Adamson's in-depth biographical material is the warp of this book as he carefully plots out the key developments of Tawney's life. Mary Savig weaves in Tawney's writings, postcards, notes, and related written material. Dr. Florica Zaharia lends her decades of expertise and friendship with Tawney to illustrate the technical processes involved in her enigmatic weavings. Shannon R. Stratton sensitively traces Tawney's influence on eight contemporary artists. And lastly—but most importantly—Kathleen Nugent Mangan's guiding light is evident throughout this publication. As someone who spent many years working with Lenore, and as the only person invited to blow bubbles with her, Kathleen has imparted her understanding of the artist in so many ways to the contributors to

this volume, and she opens and closes this publication by telling us what it was like to truly know Lenore.

Tawney on Long Island, New York, 1961. Lenore G. Tawney Foundation, New York.

1. James Schuyler, "Lenore Tawney," *Craft Horizons* (November/December 1967): 21.

2. Leesa Fanning, "Encountering the Spiritual in Contemporary Art," Yale University Press Blog, June 19, 2018, blog.yalebooks .com/2018/06/19/encountering -the-spiritual-in-contemporary -art/.

3. Oral history interview with Lenore Tawney, 1971 June 23, Archives of American Art, Smithsonian Institution, Washington, DC. All subsequent Tawney quotations derive from this source.

4. Alice Munro, "Face," in *Too Much Happiness* (New York: Alfred A. Knopf, 2009).

5. Edwina Brindle, phone conversation with the author, November 21, 2018.

6. Original research provided by Curatorial Fellow Leah Parkhurst.

7. Donna Seaman, "All of a Piece," in *Identity Unknown: Rediscovering Seven American Women Artists* (New York: Bloomsbury, 2017), 388.

8. Leslie Umberger, correspondence with the author, January 11, 2019.

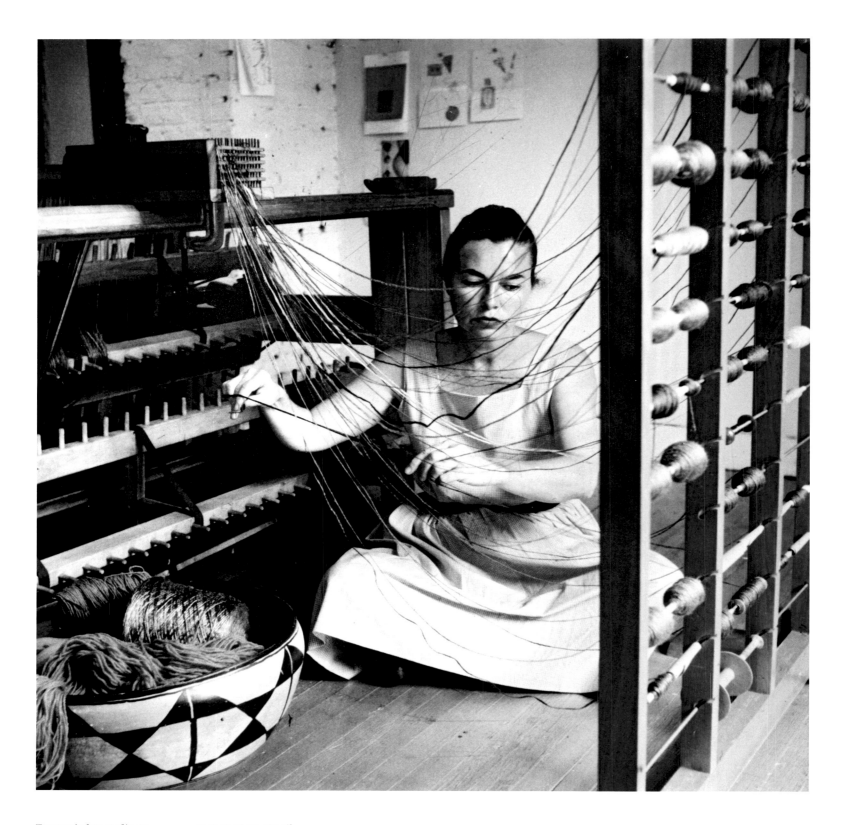

Tawney in her studio on
Coenties Slip, New York,
1958. Photo by David
Attie. Lenore G. Tawney
Foundation, New York.

FACING PAGE Detail
of Tawney's studio on
South Street, New York,
c. 1958. Lenore G. Tawney
Foundation, New York.

WAITING LIKE A FERN

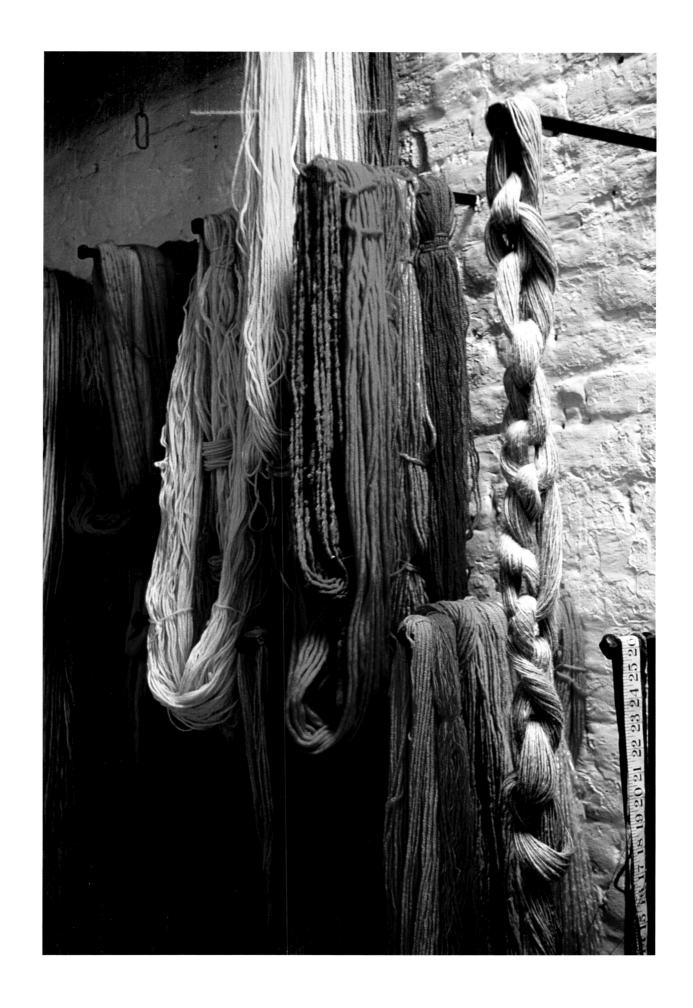

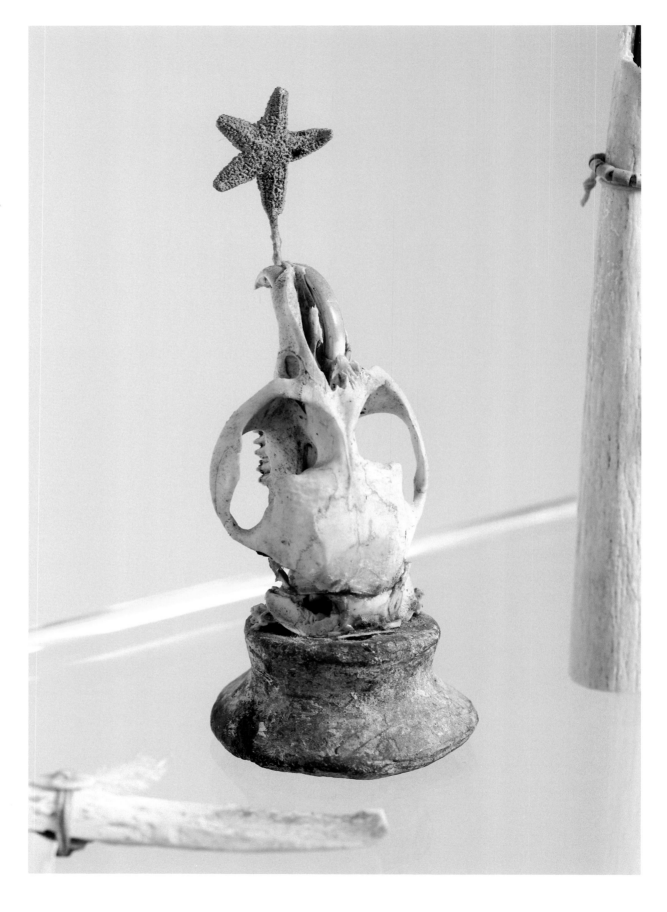

Mother Goddess, 1970; mixed media; 4¼ × 1¾ × 1¾ in. John Michael Kohler Arts Center Collection, gift of the Lenore G. Tawney Foundation and Kohler Foundation Inc.

FACING PAGE AND FOLLOWING SPREAD Shelves from Tawney's studio on West Twentieth Street, New York, n.d. John Michael Kohler Arts Center Collection, gift of the Lenore G. Tawney Foundation and Kohler Foundation Inc.

WAITING LIKE A FERN

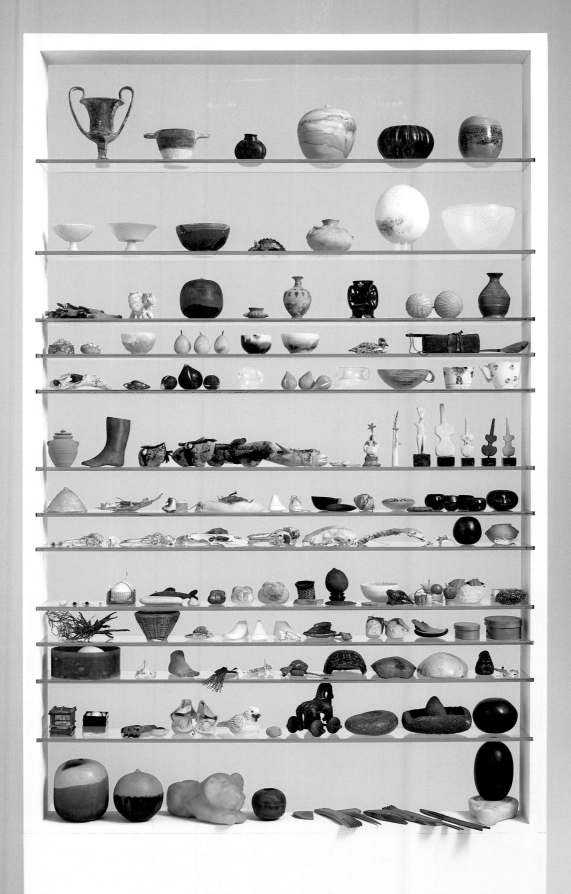

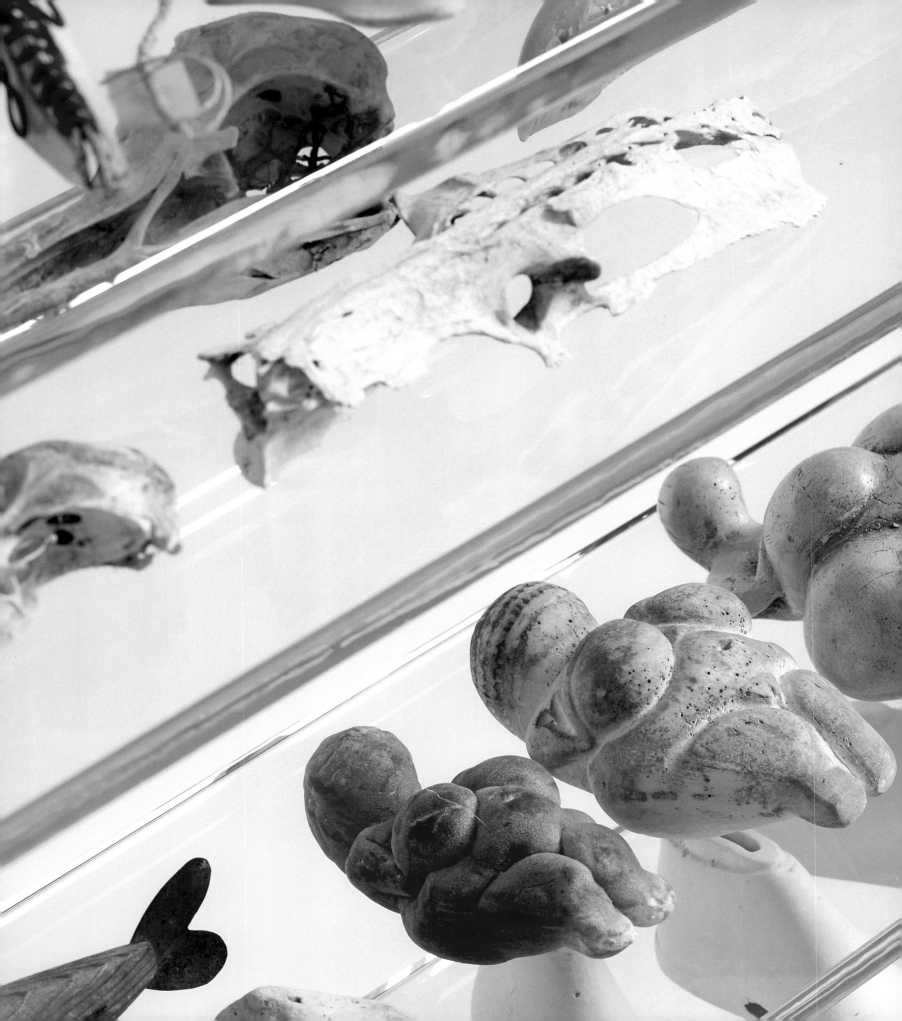

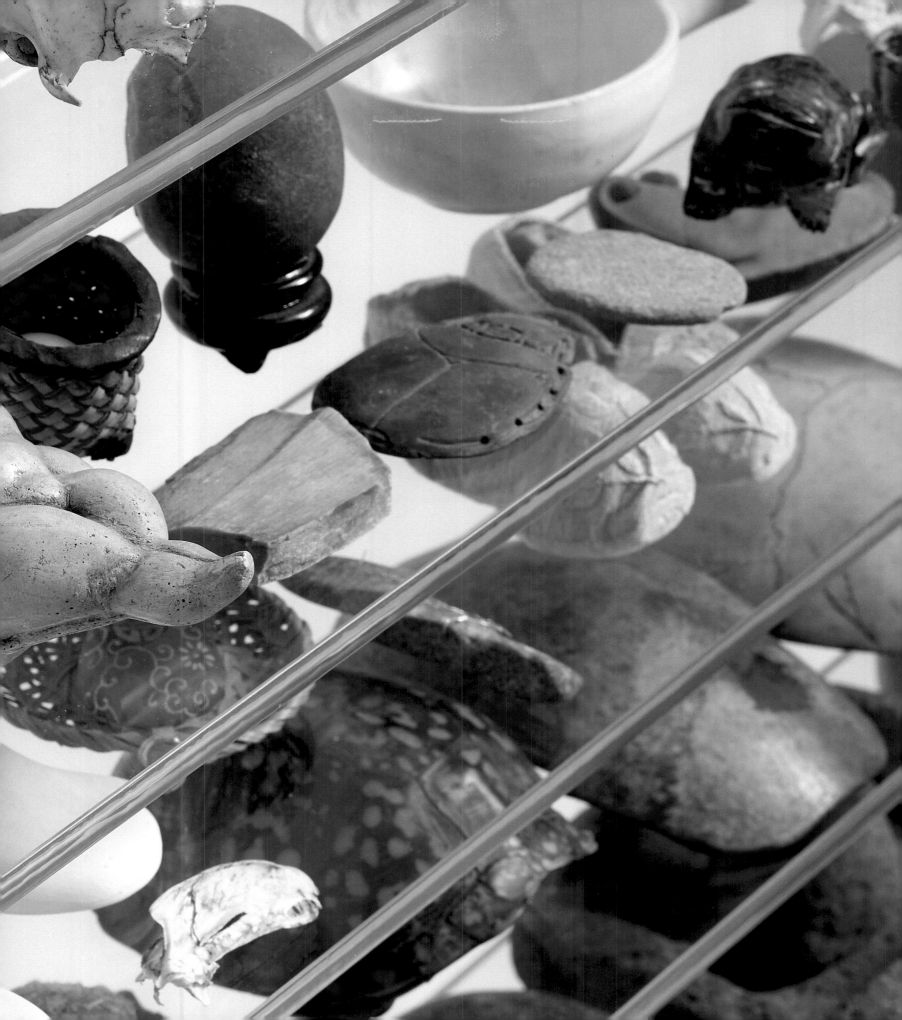

Student
1945 to 1960

Lenore Tawney was born on May 10, 1907. Or was it 1925? For much of her life, she circulated the significantly later year as her date of birth. This was not just a decorous rounding down. From the beginning of her career as an artist and all the way until her retrospective at the American Craft Museum in New York in 1990, she claimed to be a full eighteen years younger than she was.

This serves as an apt point of entry to the world of Lenore Tawney. A woman of great imaginative power, she constructed her own reality through sheer force of will. Temporality was a medium in which she lived elastically. Though her works are extremely varied in format, medium, and intention, all were achieved through the art of accumulation; they are gathered as much as made. Their creation demanded persistence and deep care, or, as Tawney preferred to say, "devotion." Describing the execution of one particularly labor-intensive body of work, for which she hand-tied thousands of feathers using tiny threads, she commented, "You have to forget time entirely—and live in eternal time."[1]

This still doesn't quite explain why she would falsify her date of birth, however. When first setting out on my research for this catalogue, I became curious about this matter of chronological drift. So I asked Kathleen Nugent Mangan, who should know. It was she who curated the aforementioned retrospective, and it was also Mangan who finally insisted on publishing Tawney's true date of birth, to the artist's initial displeasure. She is now executive director of the Lenore G. Tawney Foundation. In answer to my question, Mangan told me: "Her medium and her sex, she couldn't do anything about. Her age, she could."[2] It is a bracing reminder that this artist, whose preeminence as a modern sculptor is now so self-evident, faced a veritable trident of discriminatory attitudes when she started out. There was not a single forum in the United States, and few in Europe, in which textiles were regularly presented as fine art (tapestries designed by prominent artists were an exception that proves the rule). The Feminist movement in the arts was more than twenty years away. And Tawney did, in fact, get a late start. While she attended one of the

Lost and Proud, 1957; linen, silk, and wool; 43 × 51½ in. Lenore G. Tawney Foundation, New York.

1. Quoted in Jean d'Autilia, *Lenore Tawney: A Personal World* (Brookfield, CT: Brookfield Craft Center, 1978), n.p. In this same interview, conducted by d'Autilia, Tawney commented, "Some people can only think of the patience. They say 'How can you have so much patience?' It's not patience. I'm not just patiently doing it, because I love to do it. It's done with devotion. It's just working. My work is my pleasure, it's my life, it's what I live for."

2. My own study of Tawney's life and career is deeply indebted to many conversations with Kathleen Nugent Mangan, and to her crucial survey *Lenore Tawney: A Retrospective* (New York: Rizzoli International Publications in association with American Craft Museum, 1990).

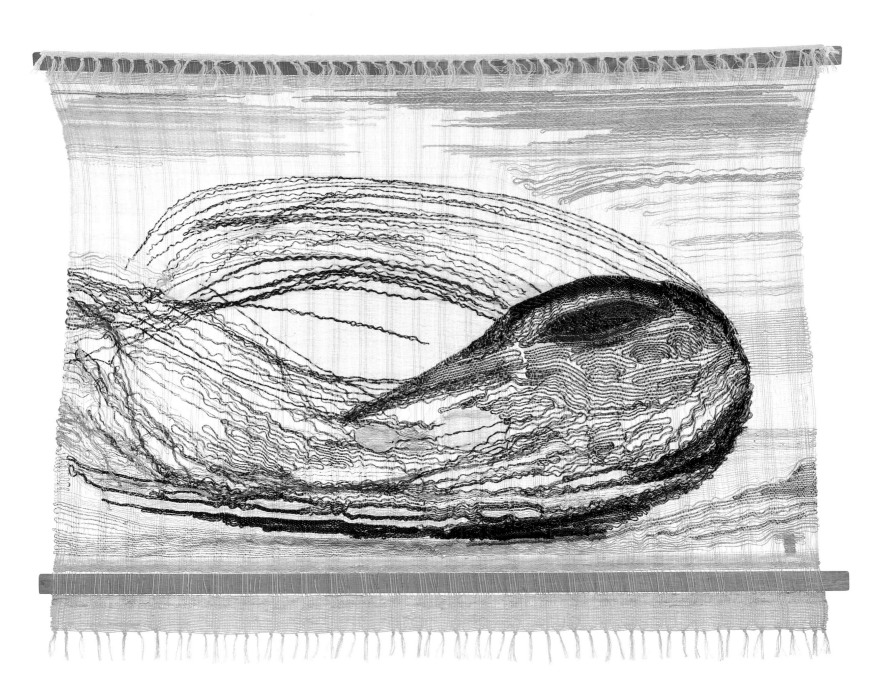

States' premier art schools, the Institute of Design in Chicago, she did not arrive there until she was almost forty. Subtracting eighteen years from her biography was like resetting the clock.[3]

We might also hazard that in making her age adjustment, Tawney was figuratively erasing some times in her life that she preferred to forget. Tawney made few recorded statements about her upbringing in Lorain, Ohio, or her early life. Her descriptions tended to be either sketchily idyllic—roaming among wildflowers on the shores of Lake Erie—or casually dismissive. The town had "a shipyard and a steel mill and that was it," she stated in 1971. "Never had any touch of art in Lorain."[4]

From what can be pieced together, there was little about the childhood of Leonora Gallagher (her birth name) that was predictive of her later life. She was sent to a convent school, where expressive pursuits—whether embroidering her own sleeves, or dancing ballet—were discouraged.[5] Though she had lifelong respect and affection for her mother (at right, top), a "farm girl from Ireland" who taught young Lenore to sew, her father was difficult, possibly an alcoholic. Tawney's first pictorial tapestry, made in 1954, depicted *St. Francis and the Birds* (facing page); she later reflected that "in some way the figure referred to her father and certain forgivenesses that were called for before she could go further."[6]

Tawney did have two early work experiences that may have been helpful for her later career, first as a seamstress in a menswear factory and then, following her move to Chicago in 1927, as a proofreader for

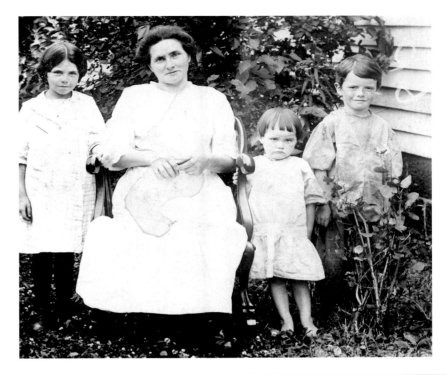

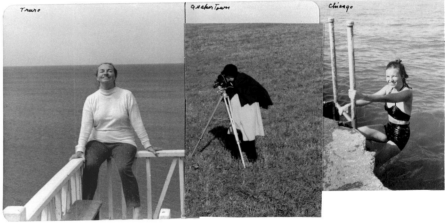

3. Toward the end of her life, Tawney commented, "I was already fifty years old and realized I'd be considered too old to establish myself as an artist in New York. I said I was thirty. I looked young, so everyone accepted it.... What is the truth of age anyway?" Lenore Tawney, *Autobiography of a Cloud,* unpublished manuscript, comp. Tristine Rainer and Valerie Constantino (New York: Lenore G. Tawney Foundation, 2002), 2. Rainer was a friend of the artist and Constantino her studio assistant. Unless otherwise noted, the

Autobiography consists of journal entries and transcribed interviews, which are likely paraphrased rather than exact quotations.

4. Oral history interview with Lenore Tawney, 1971 June 23, Archives of American Art, Smithsonian Institution, Washington, DC (hereafter "Tawney interview, AAA").

5. Eleanor Munro, *Originals: American Women Artists* (New York: Simon & Schuster, 1979), 326.

6. Paraphrased in Munro, *Originals,* 328.

TOP Tawney (left) with her mother and siblings, Lorain, Ohio, c. 1913. Lenore G. Tawney Foundation, New York.

BOTTOM Detail of collage (Chicago), n.d.; photographic print collage; 3½ × 7 in. Maryette Charlton papers, circa 1890–2013. Archives of American Art, Smithsonian Institution, Washington, DC.

FACING PAGE *St. Francis and the Birds,* 1954; wool; 32½ × 17½ in. Lenore G. Tawney Foundation, New York.

a publisher specializing in court opinions. She stayed in the latter job for fifteen years, eventually becoming head of the department. Neither of these jobs would have held much joy for a searchingly artistic soul, but they did bring Tawney into intimate contact with textiles and text, the two mediums that would be most important for her later work. Apart from that, we know frustratingly little of her life experiences in her twenties and most of her thirties; she seems to have wanted it that way.

The period was also marked by two relationships with men, each of which was harrowing for very different reasons. A first marriage ended so unhappily that Tawney never mentioned the gentleman's name in later life. This experience was succeeded by a happy liaison with the scion of a prosperous family in Urbana, Illinois. George Busey Tawney was a psychologist who was conscripted into the army when (or perhaps shortly after) the couple married in 1941. Tragically, he fell ill a little more than a year later. At first Lenore cared for him at home, but over her vociferous protests, he was placed in a military hospital, and died there, only thirty-one years old.[7]

With George's passing, Tawney retained ownership of his estate, including a considerable land holding; these independent means would ultimately shield her from commercial considerations over the course of her career. Unlike many of her peers, she did not need to teach, or create production work, in order to make ends meet. This was a decisive factor in enabling her to conduct her life in the way that she did. For the moment, though, she was all but paralyzed with grief. Tawney moved in with her supportive in-laws in Urbana, and attempted to find a new direction. A lapsed Catholic, she was browsing in her father-in-law's home library and discovered (in fact, borrowed and never returned) two books by the religious leader Swami Vivekananda, who had played a key role in establishing the Hindu religion on the international

stage at the turn of the century.[8] The experience of reading Vivekananda proved to be formative, laying down the pathway to her later enthusiastic embrace of Indian spiritualism.

Tawney had already taken some evening classes at the School of the Art Institute of Chicago prior to her move to Urbana, and in the wake of George's death she enrolled in an occupational art course at the University of Illinois. She found the therapeutic aspects of the curriculum uncomfortably close to the experience of caring for her late husband, however, and withdrew from the course, but the seeds for a more serious pursuit of art were planted. At the suggestion of her in-laws, she next went to Mexico for a period of six months—the first of many inspirational trips abroad—and then returned to Chicago. By now, she had decided upon art as a career, and in the fall of 1946 she took up a studentship at the Institute of Design.

She was not alone. The school, founded as the New Bauhaus in 1937 by László Moholy-Nagy, had struggled through the war years; in 1942, there were only twenty-five full-time students. But just as Tawney arrived, the enrollment had exploded to 360, many of the students returning soldiers with support through the GI Bill.[9] The institute's faculty boasted an extraordinary array of well-known European émigrés, some with connections to the original Bauhaus in Germany. Moholy-Nagy himself made an impression on Tawney. On one occasion he asked the students to sign their name, and then to make a large-scale drawing of their own signature, remapping what had been an instinctive movement.[10] In retrospect it seems an apt metaphor for the way that Tawney exerted her authorship; she always respected her initial impulses, but enacted them through time-consuming and laborious means.

Tawney spent only one year at the Institute of Design, but the experience opened some important doors for her. Like all students there, she was exposed

7. Tawney recounted this story to her close friend Ferne Jacobs. Jacobs, interview by the author, December 29, 2017.

8. Chicago was an important site in this story, which may explain the elder George Tawney's interest in the books.

Vivekananda delivered a cycle of speeches in the city in September 1893, at the World's Parliament of Religions, held during the World's Columbian Exposition. Tawney's edition, preserved in the archives of the Lenore G. Tawney Foundation, New York (hereafter "LGTF"),

was *The Complete Works of Vivekananda,* 3rd ed. (Mayavati, Almora, Himalayas: Advaita Ashram, 1923).

9. Marisa Bartolucci and Lloyd C. Engelbrecht, "Filip, Moholy, and the Legacy of the Chicago Bauhaus," in *Richard*

Filipowski: Art and Design beyond the Bauhaus, ed. Maria Bartolucci (New York: Monacelli Press, 2018), 47.

10. Tawney interview, AAA. Tawney's recounting of the story also is quoted in Munro, *Originals,* 326–27.

to a variety of media, in the spirit of the old Bauhaus *Vorkurs* (introductory course); across this interdisciplinary range she would have been asked to focus intently on questions of form, texture, and materiality. She developed a long-standing bond with one of the drawing and painting teachers, Emerson Woelffer, and his wife, Diana, and spent time in the weaving workshop, too, getting her first lessons at the loom from Marli Ehrman.[11] Though less well known today than Anni Albers, Ehrman was cut from similar cloth. She had received her diploma at the Bauhaus in 1927, the midpoint of its Dessau years, and understood handweaving primarily as a prototyping process for industry.[12] Her work was well regarded, attracting attention from the design curators at the Museum of Modern Art, New York, and the Walker Art Center's Everyday Art Gallery, in Minneapolis.[13]

Tawney had other friends in the Chicago art world, too, including three who would prove decisive for her career: the painter and printmaker Margo Hoff, the filmmaker Maryette Charlton, and the curator and critic Katharine Kuh. Hoff would eventually write the first serious assessment of Tawney's work, pub-lished in *Craft Horizons* magazine in 1957, and help her get her first major exhibition.[14] Charlton, as a docent at the Art Institute, met Tawney in the 1930s. She would eventually point her in the direction of the artists' colony at Coenties Slip, in New York, and capture precious footage of Tawney in an ultimately unsuccessful attempt to make a film about her. Charlton's papers, now in the Archives of American Art, Washington, DC, are one of the most valuable repositories of information about Tawney's career. Kuh, who had run a progressive gallery in Chicago prior to becoming the Art Institute's first curator of modern painting and sculpture, would be a reliable and perceptive critical supporter.[15] All three of these women were well connected in the arts; they were also extroverts, which Tawney definitely was not, and so they would function as important advocates for her for decades to come.

In the short term, however, Tawney's most important Chicago affiliation was with the Ukrainian-

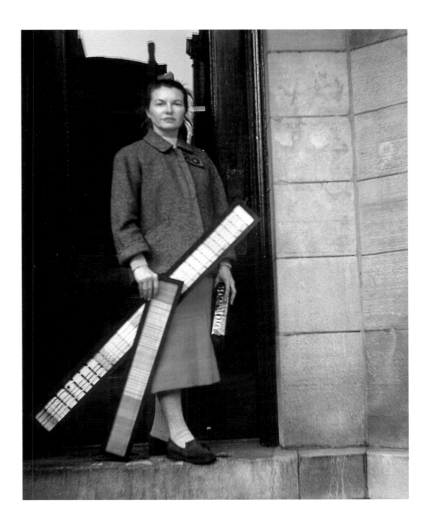

Tawney at her studio on East Cedar Street, Chicago, c. 1947. Lenore G. Tawney Foundation, New York.

11. Woelffer taught at the Institute of Design from 1945 to 1950, sharing a painting and drawing class with Moholy-Nagy. He also taught at Black Mountain College in North Carolina, as did Diana Woelffer and Marli Ehrman. Michael Reid, *Convergence/Divergence: Exploring Black Mountain College and Chicago's New Bauhaus/ Institute of Design* (Asheville, NC: Black Mountain College Museum and Arts Center, 2015), 14.

12. Moholy-Nagy had initially invited former Bauhaus weaving instructor Otti Berger to come to Chicago, but after making it to London she returned to Croatia to attend her sick mother, was captured, and died in Auschwitz. In addition to Ehrman, the institute's weaving workshop also had as an assistant teacher Else Regensteiner, who succeeded her as the head of the textile program. Another German émigré, Regensteiner had no prior weaving experience before taking up her position but went on to study with Anni and Josef Albers at Black Mountain, and to have a long career in the medium. Reid, *Convergence/ Divergence*, 6, 12, 22. See also Sadye Tune Wilson, *Else Regensteiner: Biography of a Weaver* (Nashville: Tunstede Press, 1997).

13. Ehrman said that her "main interest lies in industrial designing, namely to develop fabrics on the hand loom with power loom production in mind…partly done in the hand weaving studio, partly in cooperation with the mill." Ehrman, quoted in "Fabrics," *Everyday Art Quarterly* (Walker Art Center, Minneapolis) 25 (1953): 14.

14. Margo Hoff, "Lenore Tawney: The Warp Is Her Canvas," *Craft Horizons* 17, no. 6 (November/ December 1957): 14–19.

15. See Katharine Kuh, *My Love Affair with Modern Art: Behind the Scenes with a Legendary Curator,* ed. Avis Berman (New York: Arcade, 2006).

born artist Alexander Archipenko, a longtime ally of Moholy-Nagy's who was brought in to teach sculpture at the Institute of Design. Tawney was so engaged by his course that in 1947 she followed Archipenko to his summertime atelier in Woodstock, New York, and then continued working as his studio assistant back in Chicago. It is possible that the two had a romantic affair; certainly, Tawney had a strong reaction to her proximity to him. "Everybody who was a student of Archipenko's worked the way he did. He wanted you to do that, and that's why eventually I had to leave him," she said. At the same time, while helping to execute one of his figural sculptures, she felt she "had what I think of as my first ecstatic experience. It was reaching a state of being where there is nothing but the work."[16]

When Tawney did leave Archipenko, she did so in no uncertain terms. She was remodeling a house in Chicago at the time, and while it was in a state of

disrepair she took the opportunity to hold some raucous events: "I had wonderful parties with a famous jazz pianist. Everyone came and drank a lot. And I destroyed all my sculpture.... There was a place where you'd open a door and there were no stairs. I threw it all down in the hole, just down into the cellar."[17] Though this act sounds more instinctive than premeditated, Tawney could not bear to make derivative work; the trio of works that survived her purge (at left) do suggest that she had been operating firmly in Archipenko's manner. The quasi-figural, softly contoured shapes might also be compared to the "hand sculptures" that Institute of Design students were asked to make as tactile form exercises upon arrival.

Following the break with Archipenko, Tawney embraced weaving as her primary medium. While she was still remodeling the house, she bought a second-hand loom and started to experiment with it, a friend showing her how to set up the warp.[18] The weaver Jack Lenor Larsen, who met Tawney at a conference in Urbana around this time (and would remain an important presence in her life), recalls that her earliest weavings "gave no clue that she had studied modern art. They were wearable suitings without color, gray and brown."[19] The fiber artist Claire Zeisler, who knew her in these years through the Institute of Design, later commented that the shawls Tawney wove at this early stage exhibited the first sign of her artistic personality, with alternating bands of woven and raw thread.[20] Her table mats, executed in coarse black jute and white horsehair, were selected for a 1955 *Good Design* show, sponsored by the Museum of Modern Art, at the Chicago Merchandise Mart.

A hiatus in her artistic practice, however, ensued. Margo Hoff noted that Tawney's "friends are never surprised to hear her announce suddenly that she will leave on a trip to California, New York, Europe, or elsewhere for an indefinite period."[21] Perhaps she was thinking of Tawney's sudden move in 1949 to Paris,

16. Quoted in Munro, *Originals*, 327.

17. Munro, *Originals*, 327.

18. Tawney, *Autobiography of a Cloud*, 4. The house renovations were planned by A. James Speyer and George Danforth, disciples of Mies van der Rohe; Tawney retained the property until 1969. Lenore Tawney to Marna Johnson, postcards, November 3, 1961, and May 26, 1969, LGTF. The Marna Johnson papers are housed at the LGTF.

19. Jack Lenor Larsen, interview by the author, November 29, 2017. Larsen rode from Urbana back to Chicago with Tawney,

in the company of Margo Hoff. He recalls that Tawney "had a good loom, and not much in the way of possessions except some good clothes.... It was an English basement, one-person studio. Two or three rooms. It wasn't large and it wasn't fancy. She lived and worked in it."

20. Oral history interview with Claire Zeisler, 1981 June, Archives of American Art, Smithsonian Institution, Washington, DC.

21. Hoff, "Warp Is Her Canvas," 19.

where she would be based for a year and a half.[22] The jeweler Merry Renk arrived soon thereafter, taking up lodgings just next door; she, too, had studied at the Institute of Design under Moholy-Nagy (like another great figure in midcentury American jewelry, Margaret DePatta), and had cofounded a gallery in Chicago called 750 Studio, which had shown some of Tawney's first weavings. The two women became fast friends and then travel partners, journeying together through Spain, Morocco, and Algeria. (The trip back en route from Spain, however, was cut short when their car hit a tree, Tawney behind the wheel.[23])

We know that the visit to Morocco had an immediate impact on Tawney's textiles, thanks to an item that appeared in the *Chicago Tribune* society column in 1952. The short piece yields valuable insight into the trip, and the sort of work that Tawney was making upon her return to Chicago:

> A soft woolly rug—Moroccan in style, but nothing a Moroccan has ever seen—is about to grace an apartment on Cedar Street. It all came about when Lenore Tawney visited the land of the Moors last year. In the Arab sections of the towns she toured, she saw workers huddled together in small rooms making many beautiful rugs, but none to fit her fancy. Now she's home and surrounded by heaps of yarn, creating her own "Moroccan" rug. Warm rusty reds, natural tones, shocking pinks, and black are some of the hues that are being worked into designs that tell a story. Particularly outstanding is a bright pink tree, that has on its shaggy branches clusters of sequins. To the uninformed it looks like a miniature Christmas tree, but the baubles are meant to be flowers copied from an especially handsome rug seen in Africa.[24]

At this point, two years pass without recorded incident. Art critic Eleanor Munro, who interviewed Tawney in 1977, came away with the impression that this period in Chicago after living abroad was digressive, her commitment to making textiles only part-time: "I thought I might be able to get away with that," Tawney said.[25] She was not yet ready to adopt the absolute creative focus that would characterize the remainder of her career. In 1954, though, there was a breakthrough. She learned that Martta Taipale was to offer a workshop at Penland School of Crafts, in North Carolina, and decided to attend (page 54).

It was a fortuitous connection. Taipale was another émigré, from Finland, a maker of modernist-inflected tapestries. By midcentury, there was a well-established tradition in Europe in which manufactories secured cartoons from leading avant-garde painters and rendered them as weavings. What Taipale did was quite different, however. She worked out the basic contours of her images in paint on wood panel, but she improvised at the loom. She treated her threads like slow-motion brushstrokes, breaking the regular grid of the weave, channeling vectors to define the contours of her figures. The effect is reminiscent of the stark outlines of German Expressionism, and so, too, is the emotional pitch of Taipale's work. Most of her subjects were religious; back in Finland, ecclesiastical commissions had been her primary outlet.

North Americans proved receptive to these unusual tapestries—more so than her fellow Finns.[26] In 1952, the great weaver and industry consultant Dorothy Liebes wrote an admiring piece about Taipale's work, with its "earthy, primitive look," professing it "a delight to realize the great sympathy between us in our approach to weaving, regardless of the vast difference between her work and mine."[27] This collegial praise was doubtless welcome, but the truly significant support for Taipale came from a singular and somewhat

22. Tawney confided to oral historian Paul Cummings, who conducted her interview for the Archives of American Art, that an affair with a married man partly prompted her move: "I had to get away from a person. I mean, he was married and I didn't want to go on with it, so I left, and I just couldn't come back." Tawney interview, AAA.

23. Oral history interview with Merry Renk, 2001 January 18–19, Archives of American Art, Smithsonian Institution, Washington, DC.

24. Elizabeth Rannells, "Have You Heard?," *Chicago Tribune*, March 2, 1952.

25. Quoted in Munro, *Originals*, 327.

26. "The American public was actually the discoverer of Martta Taipale, and is still today an appreciative admirer of her art. From the Finnish point of view it is a pity that most of her best work has been bought by Americans." Toimittanut Oili Mäki, *Taide ja Työ / Finnish Designers of Today* (Porvoossa, Finland: Werner Söderström Osakeyhtiön Kirja—Ja Syväpainossa, 1954).

27. Dorothy Liebes, "Tapestries by Martta Taipale," *Craft Horizons* 12, no. 5 (September/ October 1952): 18, 19.

eccentric woman named Eleanor Hartshorne Richards. A wealthy New Yorker who had been widowed in 1929, Richards was passionate about materials and process, keeping her own sheep to produce high-quality wool; on one occasion she even tried to spin her poodle's fur.[28] She was a key early patron of Jack Lenor Larsen's as well—he says that she once arrived at Cranbrook Academy of Art in Michigan with her flock in tow.[29] According to him, it was Richards who brought Taipale to America from war-torn Finland. She also bought a large number of Taipale's works, which remain with her descendants today.[30]

Thanks to Richards's patronage, Taipale became securely established in America—she did her weaving at her patron's house on the Upper East Side of Manhattan—and thus in a position to take up the workshop at Penland. Tawney worked with her there for about seven weeks in September and October 1954, making two tapestries to Taipale's designs. About half-

way through making the second and more ambitious of the two, she introduced her own color scheme, initially with some trepidation. But her instructor encouraged her. Though Taipale's English was limited, Tawney found her to be "a warm and wonderful person and an inspiring teacher. She said, 'Color is like music,' and I could see color soaring like gothic arches in the sky."[31]

Following the Penland workshop, though, Tawney departed from Taipale's manner, just as she had from Archipenko's. She had learned what she could by executing someone else's work. Back in Chicago, she started weaving her own designs. The first was the aforementioned *St. Francis and the Birds,* which she kept throughout her life. (It was shown on numerous occasions, including in commercial galleries, but was never offered for sale.) The work follows Taipale's precedent rather closely, in its palette, religious subject matter, and overall feeling of an Expressionist woodcut translated into thread. Three birds—the

28. Handwritten note by Richards's daughter, Pam Richards Brooks, dated December 2003, collection of Ted Killiam.

29. This occurred prior to Larsen's own time at Cranbrook, but the story was passed down to him when he was a student there. Larsen, interview by the author, November 29, 2017.

30. Ted Killiam, interview by the author, December 23, 2017. I am grateful to Mr. Killiam, grandson of Eleanor Hartshorne Richards, for generously sharing information and source material about Taipale. The family also

retains two early works by Tawney, whom Richards presumably met through Taipale.

31. Quoted in Hoff, "Warp Is Her Canvas," 16.

WAITING LIKE A FERN

inaugural appearance of one of Tawney's most frequent motifs—flocking round the saint, two blue and one red, are reduced to bare hieroglyphs. The sketchy rendering of the saint's halo is a flash of one of her most important insights, that thread could be used as an intuitive drawing medium, not just for preplanned construction.

Tawney's encounter with Taipale, by her own later reckoning, marked the true beginning of her career. She told the weaver Warren Seelig that she had seen (in his elegant paraphrase) "not only the potential of woven cloth to be a filter of light but also a natural and organic process where threads could be loosely built up as a surface in a sedimentary way."[32] Motivated to explore these possibilities, she set to work. Her productivity blossomed. Though she was working in a painstakingly slow medium, by February 1955 she already had a one-person show at the Chicago Public Library. A short notice about the display reflects the interdisciplinary orientation of the Institute of Design: "In this form of art she has found a place where design, drawing, and sculpture can all be put to use."[33] Shortly after, she presented work at the Palmer House hotel, showing *St. Francis and the Birds,* a copy of a Taipale design, and functional objects like table mats, neckties, and eyeglass cases.[34]

We can measure the distance that Tawney was in the midst of traversing in three photos, taken over a period of thirteen years (at right).[35] The first, from a 1951 French driver's license, shows her with a diamond pin glimmering at her collar; she wears mascara. In a second portrait, taken for a 1955 passport photo, she is still very much the well-presented woman of the 1950s, her hair in a bow, wearing lipstick and a string of pearls at her neck. We might be able to read

32. Warren Seelig, "Thinking Lenore Tawney," in Kathleen Nugent Mangan, Sid Sachs, Warren Seelig, and T'ai Smith, *Lenore Tawney: Wholly Unlooked For* (Baltimore: Maryland Institute College of Art, 2013), 19.

33. "Library Shows Mrs. Tawney's Tapestry Art," *Chicago Tribune,* February 6, 1955.

34. Eleanor Jewett, "Old Town Shows Art of Resident," *Chicago Tribune,* September 30, 1956;

"Palmer House Galleries," flyer, April 23–May 21, 1955. Tawney showed at Palmer House alongside Peggy Beck (later Evans), who also was represented by Marna Johnson, Tawney's first dealer. The same year Tawney also showed in the Midwest Designer-Craftsmen's annual show at the Art Institute.

35. I am indebted to Kathleen Nugent Mangan for pointing to these documents as indicators of Tawney's increasing professionalization.

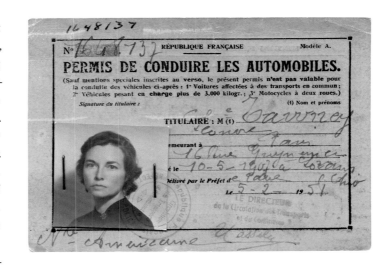

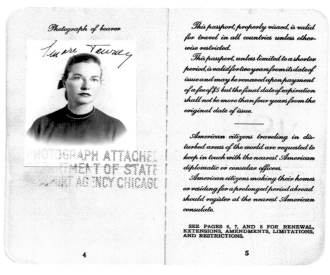

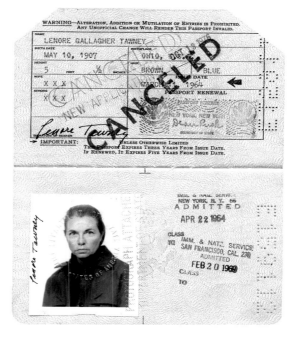

Tawney's 1951 French driver's license and passport photos from 1955 and 1964. Lenore G. Tawney Foundation, New York.

FACING PAGE AND
PAGE 58 *Birds and Flower,*
1955; linen and wool; 57 ×
24 in. Lenore G. Tawney
Foundation, New York.

her as more confident, but more significantly, she is now listed as an "artist-designer." Though subtle, a shift was under way, and it would eventually find her completely transformed. By the time of her next passport photo, taken in 1964, all trappings of middle-class domesticity are gone. Wearing work clothes, without makeup, she is a study in determined professionalism.

In the mid-1950s, that fully formed identity as an avant-gardiste was still in the future, but Tawney had undeniably reached a turning point. She became remarkably productive, making thirty-six tapestries in the three years from 1955 to 1958, along with an unknown number of functional pieces.[36] In 1956 Tawney was included in her first significant national show, the inaugural exhibition at the Museum of Contemporary Crafts, New York, entitled *Craftsmanship in a Changing World.* The exhibition placed her alongside other leading lights of American textiles, including Anni Albers, Lili Blumenau, Roy Ginstrom, Trude Guermonprez, Mariska Karasz, Jack Lenor Larsen, Dorothy Liebes, and Kay Sekimachi.[37] The following year, the museum presented a fuller representation of her works—six tapestries—in its first textile exhibition, *Wall Hangings and Rugs.*[38] Tawney could not have known it at the time, but the institution would prove to be the most important platform for her creativity, thanks largely to Paul J. Smith. He was a craftsman from Buffalo, and joined the staff in 1957 as an organizer of traveling exhibitions; he would go on to be assistant to the museum's third director, David Campbell, and assume the directorship himself in 1963 following Campbell's untimely death.[39]

Smith was himself included in *Craftsmanship in a Changing World,* for his wood turnings, which Camp-

bell had seen at the New York State Craft Fair in Ithaca. Smith therefore had a chance to view Tawney's works in the show, and remembers being struck by their unconventional construction: "They were not badly crafted, but they were vulnerable…fragile."[40] What Smith was seeing was Tawney's first artistic breakthrough, which has come to be known as "open-warp tapestry," or, more prosaically, "finger weavings." In a radical extension of Taipale's way of drawing with her threads, Tawney had adopted a method that was technically additive, but conceptually subtractive. Rather than binding the vertical warp threads to regular horizontal wefts, she instead treated the warps as a ground, inserting the wefts loosely by hand, rather than side to side with a shuttle. Sometimes she also inserted other materials, like feathers or reeds. Using this inefficient but extremely adaptable technique, she could build up dense areas of figuration, trace sinuous individual lines, or simply leave the warps hanging free. If Taipale's tapestries (and Tawney's emulations of them) were akin to densely worked oil paintings, these new works were more like watercolors, evocative and light in touch.

Two of Tawney's works were included in *Craftsmanship in a Changing World.* One, *Birds and Flower* (facing page), was a relatively conventional nature tapestry with a collage-like composition, suggesting the influence of Japanese scroll painting. The second was the five-foot-high *Egyptian Girl* (page 59), whose open structure was described by the museum's curator, Dominique Maillard, as "an experiment in weaving tapestry. The artist here left some threads just hanging in the middle of the fabric without weaving them into the fabric."[41] Based on a sketch Tawney had made in Luxor on her travels through Greece, Lebanon, Jordan,

36. "Art Appreciation Series," *Arts and Activities,* May 1958, 25.

37. Museum of Contemporary Crafts, *Craftsmanship in a Changing World* (New York: Museum of Contemporary Crafts, 1956). Else Regensteiner, from the Institute of Design, was also included. For the early history of the Museum of Contemporary Crafts, see Glenn Adamson, "Gatherings: Creating the Studio Craft

Movement," in *Crafting Modernism: Midcentury American Art and Design,* ed. Jeannine Falino (New York: Museum of Arts and Design, 2011).

38. Museum of Contemporary Crafts, *Wall Hangings and Rugs* (New York: Museum of Contemporary Crafts, 1957). The show's sixteen artists also included Trude Guermonprez, Jack Lenor Larsen, Marianne

Strengell, and Toshiko Takaezu (who was then weaving rugs). The selection of Tawney's works included *Family Tree* and *Bound Man.*

39. Prior to Campbell, the museum had been directed by Herwin Schaefer (who oversaw planning prior to its opening) and Thomas Tibbs (1956–60). On Smith's career and curatorial vision, see Sarah Archer, "Making Sense of a Biennial

of 'Makers,'" *Hyperallergic,* October 1, 2014, https: //hyperallergic.com/152435 /making-sense-of-a-biennial-of -makers/.

40. Paul J. Smith, interview by the author, December 1, 2017.

41. Quoted in Cynthia Cox, "Crafts Museum Is 'Done by Hand,'" *Courier-Journal* (Louisville, KY), September 29, 1956, 10.

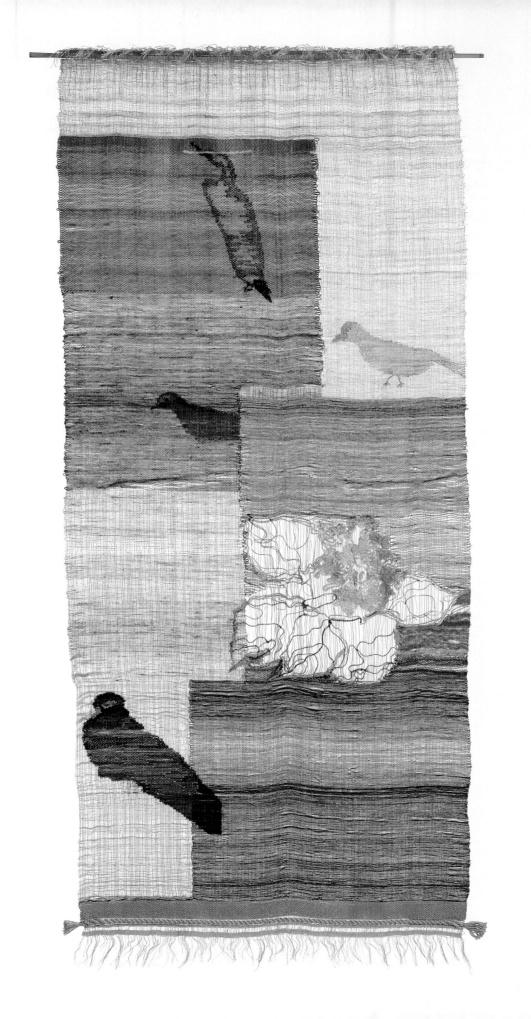

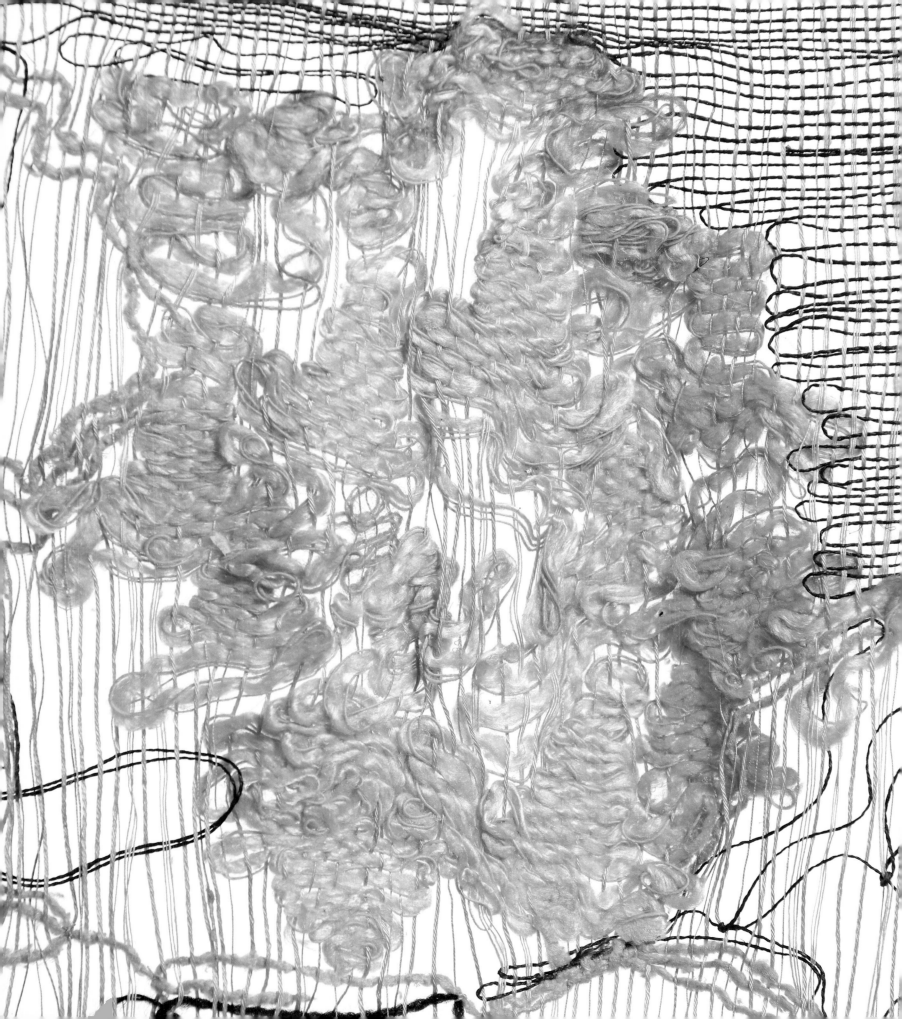

Syria, and Egypt in 1956, *Egyptian Girl* is manifestly painting-like.[42] Though mounted on two lengths of bamboo at top and bottom, Tawney has also depicted a frame around the four edges. A single figure dominates the composition, facing away from us, arms held aloft as if in tribute or triumph. She holds a piece of cloth in front of her, letting it hang from her hands. The textile medium is here used to depict itself, in a celebration of weaving's primordial (and female) origins. The narrow width of the cloth and the way it correlates to the figure's body also prompt thoughts of the historical backstrap looms that were just beginning to be explored by contemporary weavers in the 1950s.[43] The range of effects that Tawney achieved in *Egyptian Girl,* what a painter might call her "mark making," is extraordinarily diverse. Even in the densest areas of weave there are curved forms, suggestive of a stratigraphy seen in cross-section. Within a breathtaking fall of unsupported warp threads to the figure's right, Tawney has inserted several pictorial incidents, which could be read as clouds, a pyramid in the distance, and a flowing river (the Nile?), or could simply be seen as abstract.

Tawney's open-warp tapestries were something genuinely new in the medium. The reader might well wonder why—after millennia of textile production—she was the first to adopt such an apparently simple technical innovation. The answer is that, just as Paul Smith says, these works were extremely fragile. Because they had not been beaten into a fixed weave, the wefts could slide up and down within the composition, or even slither out of the tapestry altogether. The unwoven warps could easily snap or fray. Tawney understood this, of course, but she was so taken by the artistic possibilities of the technique that she decided to embrace its ephemerality. A note in one of her earliest journals, jotted down at 5:00 a.m. on a May morning in 1957, captures the effect she was after:

> fine filaments like spider web spinnerel
>
> picture hanging in ctr as in space

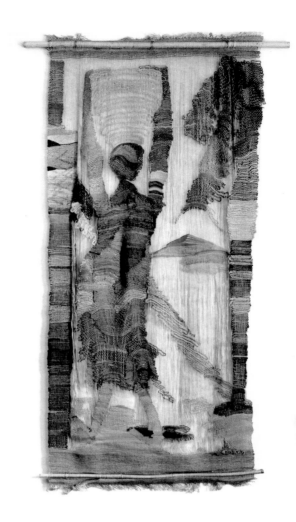

Egyptian Girl, 1956; mixed media; 60 × 36 in. Lenore G. Tawney Foundation, New York.

> add fine silver thread here & there
>
> glint of rain
>
> spark of early morning[44]

While making the first of the open-warp tapestries, a polychromatic work incorporating feathers called *Family Tree,* she recalled: "I thought to myself, it won't be any good. Then I thought, but I don't have to show anybody; it's just for myself. And I felt so free! I did as I wanted. And then when I took it off the loom and threw it on the floor I felt that tiny click near the heart that meant: it was not bad."[45] A decade before Eva Hesse and other so-called Process artists experimented with instinctive but

42. "Lenore Tawney: Her Designs Show Imaginative Departure from Traditional Tapestry Techniques," *Handweaver & Craftsman* 13, no. 2 (Spring 1962): 9.

43. Tawney has been credited as one of the figures who revived interest in the backstrap loom, alongside Anni Albers and Sheila Hicks as well as the archaeologist Junius Bird of the American Museum of Natural History, New York. "Back-Strap Weaving: An Age-Old Craft Revisited," *Los Angeles Times,* June 23, 1968.

44. Lenore Tawney journal (30.1), entry dated May 19, 1957, LGTF.

45. Quoted in Munro, *Originals,* 329.

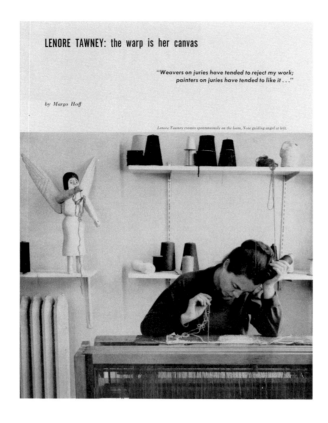

discolored, giving the works the feeling of faded slides or decaying biological specimens.[47]

Even those who understood the importance of the open-warp weavings had to accept their fragility; Paul Smith reports that Aileen Osborn Vanderbilt Webb, the visionary patron of the postwar craft movement, acquired one but it eventually unraveled.[48] Another early collector wrote an apologetic letter, explaining that she had to refuse to lend her weaving to exhibitions "not [out of] lack of generosity but concern for the fragility of it."[49] Other people, less admiring, found Tawney's works bewildering. What kind of textiles were these? As she later put it, the works "caused quite a controversy. No one had done this kind of weaving. I left some of the warp open and it looked precarious.... It's against the rules, and those people who go by the rules were against it."[50]

The 1957 *Craft Horizons* article played up this controversy. On the opening page (at left), a portrait of the artist by the photographer Aaron Siskind was accompanied by a quote by Tawney: "Weavers on juries have tended to reject my work; painters on juries have tended to like it."[51] The line, clearly intended to be confrontational in the context of a crafts magazine, was echoed in the article's subtitle, "The Warp Is Her Canvas." In another stark portrait from the late 1950s, this by the fashion photographer Yousuf Karsh, Tawney is seen in visionary mode, with her arms folded across the top of her spool rack, gazing into the middle distance as if peering into the future (facing page). *Shadow River,* one of the open-warp weavings glazed by the Higginses, hangs in front of her, its bold curvilinear forms juxtaposed with strong verticals.[52] Apart from its medium, it is entirely characteristic of the period's abstract art; it compares closely to the early veil paintings of Morris Louis, done in 1954, for example.

self-destructive forms, Tawney was doing the same in thread.

There was a downside, of course. Many of the early open weavings do not survive. Others are shadows of their former selves. Tawney did experiment with sandwiching the works between glass sheets, and was assisted by her fellow Chicago "designer-craftsmen" Frances and Michael Higgins in the attempt. The objective was to protect the threads, and perhaps also to convey the idea that they were floating in a pure optical space (an aesthetic that was central to 1950s abstraction).[46] Unfortunately, these intentions have been thwarted by the passage of time. The glass was itself fragile, of course, and sometimes cracked. In other cases, the adhesive used between the panes has

46. On opticality in postwar art, see Caroline A. Jones, *Eyesight Alone: Clement Greenberg's Modernism and the Bureaucratization of the Senses* (Chicago: University of Chicago Press, 2006). Tawney first noted her interest in fused glass sheets for her hangings in 1958. Journal (30.1), entry dated June 26, 1958, LGTF.

47. Tawney wrote to Marna Johnson that the weavings could "be put into a glass box if anyone wanted to go to that trouble. I think they are better the way they are, as they were made." Tawney to Johnson, December 1, 1961, LGTF.

48. Paul J. Smith, interview by the author, December 1, 2017.

49. Loraine (Mrs. Richard J.) Gonzalez to Maryette Charlton, September 27, 1962, Maryette Charlton papers, circa 1890–2013, Archives of American Art, Smithsonian Institution, Washington, DC.

50. Quoted in d'Autilia, *Personal World,* n.p.

51. Hoff, "Warp Is Her Canvas," 14. See pages 17 and 18 for the original images in the article.

52. *Shadow River* (also known as *Shadow*), shown in Tawney's 1961–62 exhibition on Staten Island, cracked at some point during transport and has not been exhibited since, prior to the present exhibition.

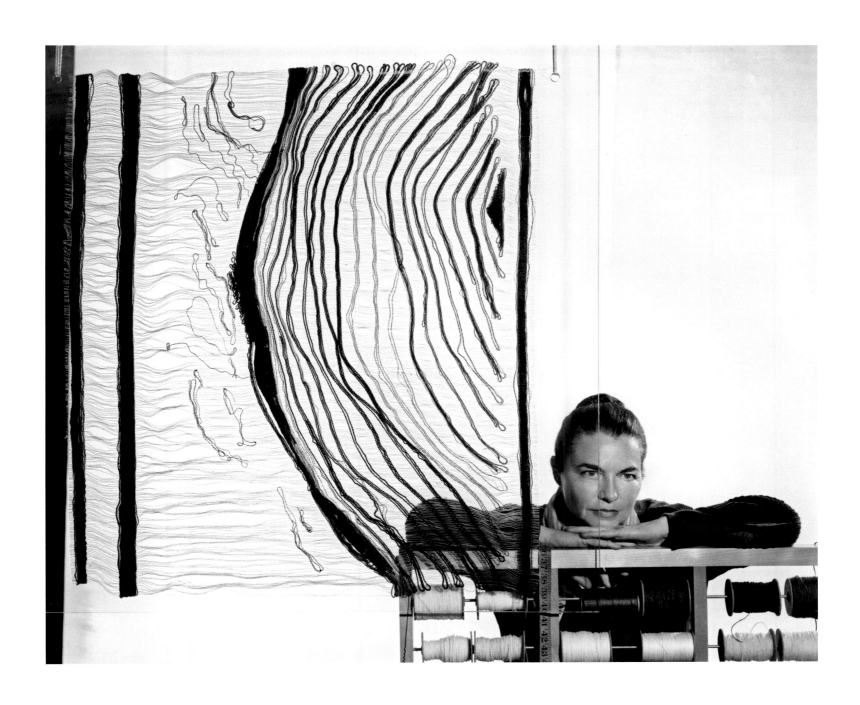

Tawney with *Shadow River*,
1959. Photo © Yousuf Karsh.
Estate of Yousuf Karsh,
New York.

In the *Craft Horizons* article, Hoff recounts Tawney's battles with the weaving establishment, writing that she represented "a kind of revolt going on in the United States against craftsmanship dictated by traditional methods and the limits of the tool."[53] Though she had been included in the Midwest Designer-Craftsmen Show at the Art Institute of Chicago in 1955, presumably with a tapestry in Taipale's manner, her open-warp works were not accepted by the jury in 1956, when the annual exhibition was held in Milwaukee. The following year, when the show returned to Chicago, Hoff herself was on the jury, and Tawney submitted three works. Only one—*Egyptian Girl*—was accepted. According to Hoff, the sole weaver on the jury, Dorothy Liebes, was opposed even to that.[54]

Hoff was a modernist painter herself, and we should take this into account when assessing the article; Tawney may not have intended to fire a salvo across the bow of the weaving community, at least not quite so aggressively. On the other hand, the two women were close friends—they had known each other since the 1930s, initially through classes at the Art Institute of Chicago. So it seems likely that Tawney was at least comfortable with the article's uncompromising rhetoric, which was one of the earliest avant-garde statements in the pages of *Craft Horizons*. (Rose Slivka, who turned the publication decisively toward progressive fine art, did not take up editorship until 1959.) The profile's most direct precedent was a similar article from a year earlier on the ceramicist Peter Voulkos, who, as it happens, was also on the jury for the 1957 Midwest Designer-Craftsmen show.[55] (He contributed a truculent statement to the catalogue about the timidity of the entries.) Though quite different in their personalities and aesthetic interests, Tawney and Voulkos would often be bracketed together in years to come, exemplars of radical change in their respective disciplines. Both adopted a "reskilling" approach, in which the tenets of their craft were not so much abandoned but thrown open to question, and they did so more or less simultaneously.[56]

Tawney and Voulkos also shared another experience in 1957: the inaugural conference of American craft held at Asilomar in Pacific Grove, California, that June. This was a catalytic event for the emergent craft movement because it established new networks between makers and built up a sense of common cause. As Paul Smith summarizes it, "Suddenly people were able to find out that someone else was doing something they felt passionately about. There was an element of soul searching: what I'm doing is something that's really right."[57] For both Tawney and Voulkos, however, there was also a feeling of conflict. Asked to join panels focused on their respective mediums, they clearly felt completely at odds with the tenor of the discussion. Tawney read out a prepared statement, which is unfortunately lost but was briefly paraphrased in the conference proceedings:

> There must be freedom of design or spirit. The ways of attaining this are various and personal. Each must find himself and then express himself in his own way. Often one is helped by other media—architecture, sculpture, painting, music, poetry. A broad knowledge of aesthetics may be of great help in finding ourselves. Above all…you must please yourself completely.[58]

Tawney's ideal of individualistic expressionism made for a sharp contrast with the other three speakers on the textile panel, Anni Albers, Jack Lenor Larsen, and Roy Ginstrom, all of whom placed emphasis on technical experimentation and collaboration

53. Hoff, "Warp Is Her Canvas," 15.

54. Hoff, "Warp Is Her Canvas," 15; Art Institute of Chicago, *Midwest Designer Craftsmen 1957* (Chicago: Art Institute of Chicago in association with Midwest Designer-Craftsmen, 1957), n.p.

55. Conrad Brown, "Peter Voulkos," *Craft Horizons* 16, no. 5 (September/October 1956): 12–18.

56. See Glenn Adamson and Barbara Paris Gifford, eds., *Voulkos: The Breakthrough Years* (London: Black Dog Publishing in association with Museum of Arts and Design, 2016).

57. Smith, interview by the author, December 1, 2017.

58. American Craftsmen's Council, *Asilomar: First Annual Conference of American Craftsmen*, proceedings (Minneapolis: American Craftsmen's Council, 1957), 89. The dealer Jean d'Autilia later recorded Tawney's somewhat different summary of her words at Asilomar: "We must go into ourselves and work from that Essence. There was some rejection of my statement. A few thought I meant to go inside to all the garbage and work out of that! Of course I meant that you go to that pure center of yourself. It's a place of purity, like crystal." D'Autilia, *Personal World*, n.p. See also Tawney interview, AAA.

with industry. Despite the friction, Tawney did emerge from Asilomar with new alliances. It was there that she first encountered Toshiko Takaezu, who would become her dearest friend among American crafts-people. The two women displayed their work side by side in an exhibition associated with the conference, the first of numerous juxtapositions of their work, and formed such a quick friendship that they returned back east in each other's company.[59] Tawney also rees-tablished her connection with Larsen; they danced so enthusiastically one evening that they almost pitched over into the swimming pool.[60]

In 1957, then, Tawney had established herself as an unconventional presence on two national plat-forms: the pages of *Craft Horizons* and the confer-ence at Asilomar. The same year, she would create her most progressive work yet, *Bound Man* (at right). It is a haunting depiction of suffering that strikes the same Existential chord that resonated in so many Abstract Expressionist works, or the attenuated sculptures of Alberto Giacometti. As in *Egyptian Girl*, Tawney exploits the potential for fiber to represent itself: the man is tied to a board or tree with long black cords, which are themselves freely integrated wefts. Of all the tapestries she made in the 1950s, *Bound Man* was the most indicative of her future direction, fore-shadowing the twisting anthropomorphism of her breakthrough "woven forms." Its importance was immediately recognized, as the work was acquired by the Museum of Contemporary Crafts in 1958, and also shown in the American Pavilion of the Brussels World's Fair.[61]

Bound Man was an anomaly in Tawney's work of the late 1950s. Her preferred imagery was a far more digestible repertoire of fruit, trees, and, most often, birds. On a technical level, all the open-warp tapes-tries were experimental, but unless one was a stickler for proper weaving technique, they did not necessar-ily constitute challenges to mainstream taste. *Lost*

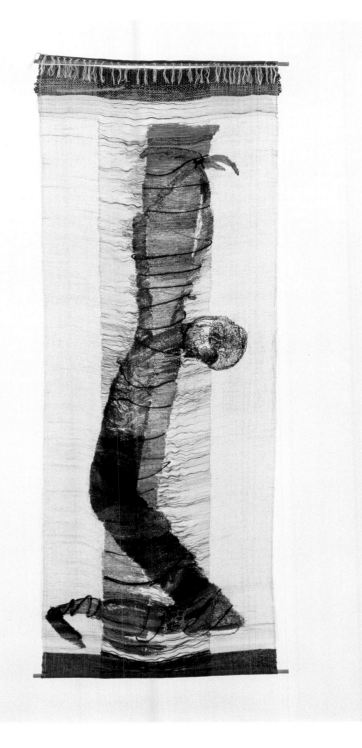

59. Tawney, *Autobiography of a Cloud,* 7. The exhibition is pictured in *Los Angeles Times,* August 25, 1957.

60. Larsen, interview by the author, November 29, 2017; Tawney interview, AAA.

61. Following repairs by Tawney after unspecified damage, *Bound Man* was hung in the museum's lunchroom. Tawney to Johnson, February 11, 1959, LGTF. Mention of the piece's presentation at Brussels is in "Lenore Tawney," *Handweaver & Craftsman,* 8.

Bound Man, 1957; wool, silk, linen, and goat hair; 91 × 36 in. Museum of Arts and Design, New York, purchased by the American Craft Council, 1958.

FOLLOWING SPREAD *Night Bird,* 1958; linen, silk, and wool; 89 × 19½ in. Lenore G. Tawney Foundation, New York.

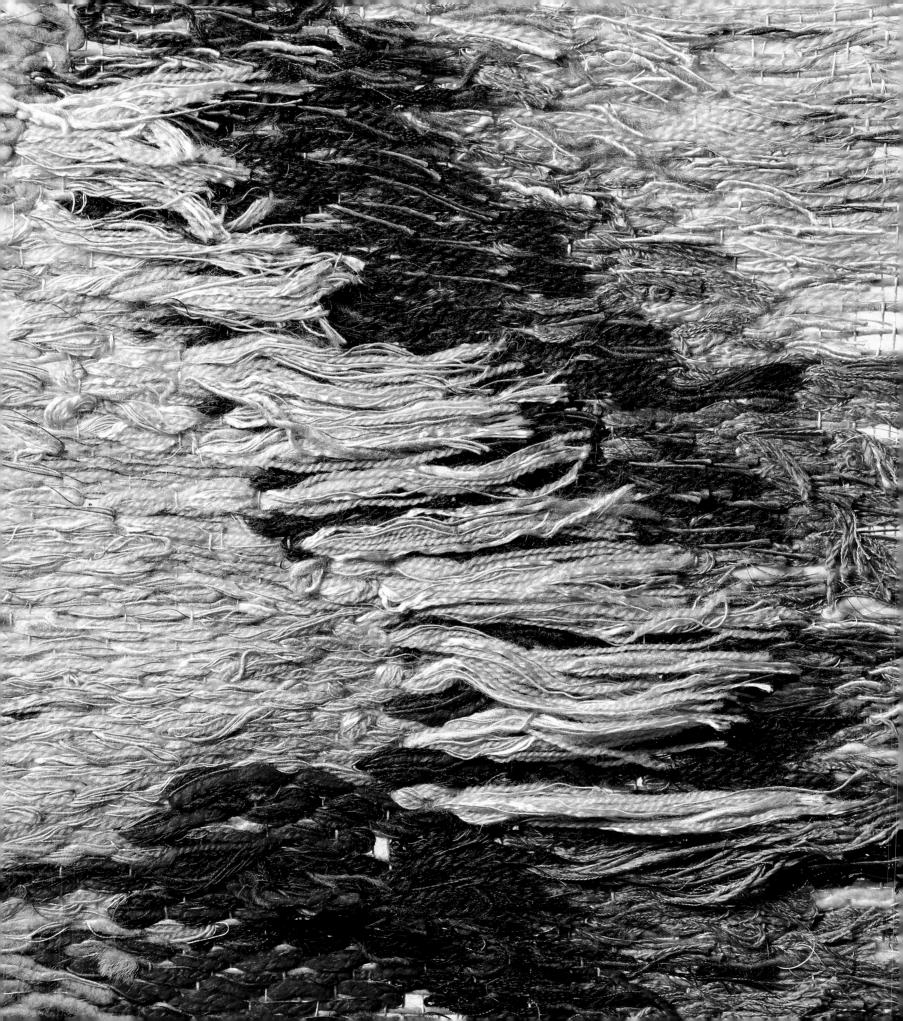

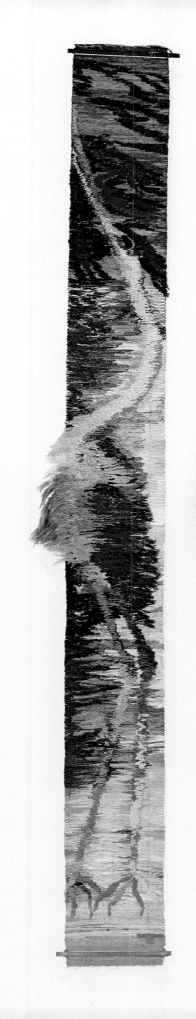

and Proud (page 47) is a good example. It has almost no areas of tight weave to give it substance; the weft threads move through the fabric with reckless abandon, evoking a quick pen sketch; indeed, she depicted the same motif in ballpoint in a journal (page 98). One cannot help interpreting it as an allegorical self-portrait, particularly given Tawney's frequent later use of birds as personal avatars. The teasing title—a play on the phrase "lost and found," implying that wandering free is an enviable state—reinforces this connotation of independence.[62] Yet the work could also be taken at face value: just a shorebird, nestled in its own wings. Works like *Lost and Proud* were thus somewhat equivocal. Experienced weavers could immediately appreciate their unconventionality; observers without specialist expertise at least noticed the weavings' fragility, perhaps interpreting it as a kind of anti-functionality. Implicitly, Tawney's open-warp tapestry asked far more of its owners and viewers than a conventional flat weaving did—it demanded an unusual level of care simply to keep it intact. Even so, it was possible to interpret most of what she was making simply as attractive decor.

This multivalence, and the inherent tension built into it, is demonstrated by Tawney's relationship with Marna Johnson, her first dealer, who ran a gallery in Chicago specializing in decorative arts.[63] Johnson energetically promoted Tawney not to fine art collectors and museums, but to magazine editors, department stores, and interior decorators. She stressed the popular accessibility of wall hangings as an artistic genre, writing in a decorators' trade publication

that "the appeal is not only to the collector with an already-developed artistic appreciation. Any home-maker…can start his own personal collection with a signed, original 'painting in yarns.'"[64] From the very first, Tawney seems to have been a little discomfited by the commercial aspects of this situation—"I have gone over the prices again this morning," she wrote to Johnson in October 1957, "and revised some up, some down. As you know this is the most difficult part of the operation."[65] That hint of concern would soon bloom into outright distress, though initially Tawney was reasonably attentive to business matters, working closely with Johnson as her dealer attempted to position the work in high-profile contexts. "Am working on another Arbor, beautiful color," she wrote in one typical note. "Will have to spend 2 days putting on new warp…then I have to think about doing the two big waterbirds that America House took order for, promised in February, each about 4 weeks work. If you think these prices need adjusting please let me know."[66]

The results of all this activity are beguilingly incongruous. In magazine features, Tawney's works were sometimes featured alongside other contemporary weavers, but more often in interiors populated by eclectic folk crafts and curios or revivalist decorative arts.[67] In 1959, for example, open-warp tapestries by Tawney were set alongside Louis XVI reproductions at Trend House, a showroom operated by Marshall Field in Chicago.[68] Johnson also successfully placed examples in Marshall Field's restaurant, and in the showrooms of the furniture company Dunbar—not exactly redoubts of modernism.[69] Even in 1962, well

62. An entry in one of Tawney's journals helps to elucidate the title: "To be humble and found, in the unworldly sense, as opposite lost and proud." Journal (30.3), entry dated June 1, 1959, LGTF.

63. In addition to Tawney, Johnson represented the work of Martta Taipale, Alice Kagawa Parrott, Peggy Beck (later Evans), Ulla-May Berggren, Majel Chance (later Obata), and Cynthia Schira. She did not have a formal gallery and showed the work in her apartment.

64. Marna Johnson, "Tapestry Renaissance," *Chicago Market News*, June 20, 1961, 12.

65. Tawney to Johnson, October 30, 1957, LGTF. The same note reveals that Tawney's work was for sale at America House, the New York store that Aileen Osborn Vanderbilt Webb had founded during the war; decorators were an important clientele base there, and received 10 percent off retail. Tawney's prices ranged from $35 for wearable stoles up to $390 for *Bound Man*.

66. Tawney to Johnson, n.d. (probably 1958), LGTF.

67. The *Cincinnati Enquirer*, for example, combined her work with Mexican wooden figures, a Chinese basket set on a Philippine stool, a Swedish leather-bound basket, a Danish hand-carved bowl, a Japanese musical instrument, a Spanish ivory chessman, English nutcracker figures, and "a quaint mechanical planetarium of brass." "Old Combined with New," *Cincinnati Enquirer*, September 6, 1959, 34.

68. Abbey Johnson, "Touches of Red Brighten Decor of Trend House," *Chicago Tribune*, July 16, 1959; Anne Douglas, "Try Something Different in Artistic Wall Hangings," *Chicago Tribune*, January 29, 1961. Though Trend House largely favored historicist styles, they did occasionally show the work of other modern designers like Edward Wormley and Dorothy Liebes. Elizabeth Hillyer, "Field's Trend House Sets Pace in Elegance, Style," *Chicago Tribune*, August 25, 1966.

69. "Lenore Tawney," *Handweaver & Craftsman*, 8–9.

into Tawney's more explicitly avant-garde period, she was featured in "you-can-do-it" articles in *House Beautiful,* which showed her making an open-warp tapestry on a backstrap loom. Caption texts praised Tawney's work for its "thick-and-thin, come-and-go quality, a kind of naturalness, as if it had happened by itself," and Jack Lenor Larsen contributed a sensitive profile of her in the same issue.[70] But the step-by-step instructional shots positioned her work within the conventional framework of hobbyist literature. Tawney struggled to reconcile herself to the feature: "I thought it was an invitation to copy," she wrote to Johnson, "which is simply a deadening of the consciousness. Now I think of it as teaching. Teaching a method which they will first imitate, to get the feel of the *way* into their tissue and muscles. Then, when this is *inside,* it can begin to come out, *as their own,* and not from me."[71] One wonders what she may have thought when informed that the Campfire Girls had ordered five thousand reprints.[72]

Meanwhile, Johnson was working with interior decorators to place works in private homes. In November 1959 she asked Tawney to create some salable tapestries on nature themes, with "neutral tones," and also mentioned that she was trying to arrange a show at Chicago's Fairweather Hardin Gallery.[73] Tawney had evidently had enough: the pressure to deliver work, and to satisfy commercial imperatives, was more than she could bear:

> I am quite disturbed that you have been trying to sell me to F. Hardin. We are friends, they know my work and if there is to be any more to it, that is entirely up to them. I want no pressure, no selling, nothing. In fact I object to any kind of pressure, even the slightest....When the time comes I shall have a full show somewhere. But I am not ready and I don't want *anything* said or done to promote

it. At present I am in a slow place and not in a hurry....I can't stand pressure and I hate being sold. If I am to have a show I must work quietly for a long time and *keep* them. How can I have a showing with no work. My mind is whirling with these thoughts.[74]

A week later Tawney, now "in a calm mood," wrote again, in beautiful poetic language. She sounds suddenly self-possessed, ready to commit to an artistic journey of a wholly different order from that she had undertaken the previous decade:

> Have just come from a ride on the ferry on this most beautiful sunny warm Sunday morning. As I watched the water, spray, the birds following the boat I thought of the leaf. I want to be under the leaf, to be quiet until I find my true self. I am on the way but it is a slow, somewhat harrowing process, to shed the hard coruscations of false social personality, conscious and unconscious, the fears and taboos buried so deep it is like digging in the primordial ooze to find them. Until I can be free, something like a bird, each day a new life fresh unplanned I must stay under the leaf.

She concluded the letter by thanking Johnson for all her promotional efforts, but firmly repeated her point: "I want to take the natural path, calm and sweet. I need a year or two to work quietly through."[75]

Tawney had discovered in herself a new philosophy. Many artists in the 1950s were trying to "shed the hard coruscations of false social personality," as Tawney described it, often deploying ideas from psychoanalysis in the attempt, as she did here. Her desire to create a slow art is somewhat reminiscent of Marcel Duchamp's critique of the increasing speed and commodification of art, an "abundant production," as

70. Jack Lenor Larsen, "Lenore Tawney—Inspiration for Those Who Want to Develop Their Artistic Potential," as well as "Explore the Nature of Thread" and "You Can Learn to Weave Without a Loom," *House Beautiful,* March 1962, 158–61, 175–77.

71. Tawney to Johnson, October 16, 1961, LGTF.

72. Johnson to Tawney, March 19, 1962, LGTF.

73. Johnson to Tawney, November 12, 1959, LGTF. Fairweather Hardin Gallery was founded 1947 in Evanston, Illinois, and moved to Chicago in 1950s; it was one of the city's impressive complement of female-run galleries, alongside Katharine Kuh's and Johnson's own. The proprietors were Sally Fairweather and Shirley Hardin.

74. Tawney to Johnson, November 17, 1959, LGTF.

75. Tawney to Johnson, November 24, 1959, LGTF.

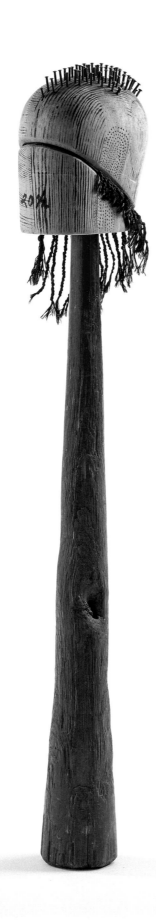

he put it in a 1964 interview, "that can only increase mediocrity."[76] It also recalls the precept of Leonardo da Vinci, cited by Tawney in her journal in 1961: "If thou wouldst be an artist, forsake all sadness and care, save for thy art."[77] But the vivid poetic imagery she used in her letter to Johnson—her idea of being "under the leaf," so that a "new life fresh unplanned" could emerge of its own accord—conveys an intimacy and naturalism that is quite unique to her.

Well, almost unique. By 1959 Tawney's closest artistic confidant was no longer Margo Hoff; it was the painter Agnes Martin. And it is possible to see, in the note she wrote to Johnson, lineaments that the two women were working out together. Martin wrote a poem right around this time, using strikingly similar language:

> The underside of the leaf
> Cool in shadow
> Sublimely unemphatic
> Smiling of innocence.[78]

Back in that crucial year of 1957, Tawney had undertaken a great change in her life, moving from her comfortable residential neighborhood in Chicago to the isolated and unforgiving environs of a former dockland in New York City. This was where she and Martin met: Coenties Slip, site of a then obscure, now fabled artists' community. In a remarkable journal entry written a decade later, Tawney described her relocation as a purposeful embrace of austerity and autonomy:

> I left [Chicago] to seek a barer life, closer to reality, without all the *things* that clutter & fill our lives. I left friends whose preconceptions of me held me to their image of me. In N.Y. I came closer to the gutter. I lived on the street of the bums, the down and outers.

All unconscious—not all. The truest thing in my life was my work. I wanted my life to be as true. Almost gave up my life for my work, seeking a life of the spirit. Gradually (it took years) I came to see one had to live one's life in this world and that out of this flowed the work. I am still coming back to living life.[79]

Coenties Slip, abandoned by its once-thriving dockyard trade, was just what Tawney was looking for. The artist Fred Mitchell had been the first to move there, in 1954, attracted by the cheap rents and large work spaces. He was an early pioneer of "loft living," a phenomenon that would eventually transform New York's real estate market and its creative class alike.[80] Soon, in addition to Martin (who moved to the Slip in 1957, the same year as Tawney), Robert Clark (later Indiana), Jack Youngerman, Ann Wilson, and James Rosenquist would all be among the artists on the Slip. It would never be an easy place to live. To visit one of the loft studios one had to shout up from the street below, like a medieval traveler requesting permission for the drawbridge to be lowered.[81] Most of the buildings lacked hot water and heat, and they were zoned only for commercial use. The artists found themselves harassed and eventually evicted.[82]

Youngerman (who, like Martin and Kelly, showed at Betty Parsons Gallery in New York) and his wife, the French actress Delphine Seyrig, rented out a whole building, No. 27 Coenties Slip. In fall 1957 he sublet one of the loft spaces to Tawney, and another to Martin. A few months later, though, all the residents were evicted by the city's buildings department. This turned out to be a stroke of luck for Tawney, as she moved around the corner to 27 South Street, a former sailmaker's loft. It was the quintessence of the postindustrial sublime, boasting a shaft fully three stories in height complete with an operational hoist (page 115). Tawney occupied

20½, 1958; mixed media; 45 × 5¼ × 6¼ in. Lenore G. Tawney Foundation, New York.

76. Marcel Duchamp, interview by Calvin Tomkins (1964), in *Marcel Duchamp: The Afternoon Interviews* (New York: Artbook, 2013), 25.

77. Journal (30.2), entry dated July 30, 1961, LGTF.

78. Dieter Schwarz, ed., *Agnes Martin: Writings* [*Schriften*]

(Ostfildern, Germany: Edition Cantz in association with Kunstmuseum Winterthur, Switzerland, 1992), 15.

79. Journal (30.10), entry dated December 4, 1967, LGTF.

80. Mitchell was well ahead of his time (and for that matter, so was Tawney). It was not until

the 1970s that a significant residential market existed for postindustrial buildings. See Sharon Zukin, *Loft Living: Culture and Capital in Urban Change* (Baltimore: Johns Hopkins University Press, 1982), 60.

81. Judith E. Stein describes the experience of visiting Rosenquist's studio in *Eye of the*

Sixties: Richard Bellamy and the Transformation of Modern Art (New York: Farrar, Straus and Giroux, 2016), 144–45.

82. Whitney Museum of American Art, *Nine Artists/ Coenties Slip* (New York: Whitney Museum of American Art, 1974), n.p., exh. brochure.

two floors, one of which she used as a studio, the other as a living space.

The setting affected her deeply. Back in 1974, the art historian Stephanie Barron enumerated several tendencies shared among the Coenties Slip group, among them an interest in found objects prevalent in the neighborhood, an antipathy to painterly expressionism, and a muted palette—black and white, or subtle monochrome—chosen to emphasize "problems of form."[83] Taken together, these traits amounted to an important precedent to Minimalism. All can be found in Tawney's work in the period from 1957 to 1962, when she lived on the Slip. She also shared the group's general inclination toward quiet concentration. Unlike the uptown Expressionists, who fraternized enthusiastically, spitballing about philosophy in rough bars, the Coenties Slip group were focused in their energies and private in their habits. Martin put it well: "We all had the same kind of velocity."[84] A local newsletter noted, "Perhaps the most impressive quality about the group is their seriousness. Refreshingly unlike the residents of most Bohemias, they spend little time talking about their work, most of their time actually engaged in it."[85]

Kathleen Nugent Mangan has said, "It's hard to think of anywhere in New York today as out of the way. But Coenties Slip in 1957 was another story."[86] An anecdote from these years, related by Tawney to Marna Johnson, gives a sense of that distance. It involves a team from *House Beautiful* arriving to do a photo shoot at Tawney's loft studio on South Street. The feature, which appeared in the January 1960 issue, quoted Tawney as saying: "Knowing all the official ways doesn't necessarily stultify a person, but it can. A little ignorance (or innocence) leaves you freer to try, to see, to pioneer. It leaves you freer, as a child is free."[87] The coverage was initiated at the behest of the

magazine's editor, Elizabeth Gordon, who was deeply interested in historic and contemporary textiles, and she acquired both finished and demonstration pieces from Tawney, such as *Reflections* (facing page).[88] Tawney had previously been to the magazine's offices, and was amused by the scene: "All the important women wear hats. It's like a tea party. The hats grow in size according to position. Gordon's hat was huge."[89]

A month later, Tawney wrote to Johnson to describe "the sequel of the Hats," as the team from *House Beautiful* arrived at her studio to take photographs. Gordon, who arrived first, left her cab waiting and "bravely climbed to the 5th floor in her high heels, *but she had left her hat in the office.* I gave her a glass of icewater and told her to sit by the window where she would get the breeze if there happened to be one." Another female staff member arrived, hat in place. Tawney concluded, "The rule must be that only Miss Gordon may remove her hat during office hours, but only *outside* the office.... This is all I have been able to piece together of the story of the hats."[90] This little vignette reveals Tawney's sense of humor, but also the degree to which she had definitively distanced herself from the normative culture of the 1950s, particularly the etiquette expected of middle-class women. It is instructive to compare Tawney's confident satire to the anxiety-provoking conformism that Sylvia Plath felt so keenly, and described in her autobiographical novel *The Bell Jar* (1963): "We saw the girls from the magazine moving off in a row, one cab after another, like a wedding party with nothing but bridesmaids."[91]

Tawney was increasingly encamped outside the mainstream. Though she continued to work with Marna Johnson on commissions, she sometimes issued cryptic instructions (on one occasion telling her not to show two recently completed weavings together, "just

83. Stephanie Barron, "Giving Art History the Slip," *Art in America*, March/April 1974, 80–84.

84. Agnes Martin, interview by Irving Sandler, *Art Monthly*, September 1993, 9.

85. Faye Hammel, "Bohemia on South Street," *Lookout*, December 1957, 4–5. The *Lookout* was a publication of

the Seamen's Church Institute of New York.

86. Kathleen Nugent Mangan, interview by the author, December 13, 2017.

87. "A Break-Through in Weaving: Open Tapestries," *House Beautiful*, January 1960, 57.

88. Textiles, Gordon wrote, "are excellent indicators of the metabolic health of the

technical and artistic aspects of a society." *The Wonders of Thread: A Gift of Textiles from the Collection of Elizabeth Gordon* (New York: Cooper Union Museum, 1964), n.p. Gordon also avidly collected embroideries by Mariska Karasz and bought work from Martta Taipale. Gordon would later give her collection to the Cooper Union Museum, New York, marked by an exhibition in

1964. Along with the rest of the Cooper Union collection, Gordon's gifts are now in the Cooper Hewitt, Smithsonian Design Museum, New York.

89. Tawney to Johnson, August 15, 1959, LGTF.

90. Tawney to Johnson, September 12, 1959, LGTF.

91. Sylvia Plath, *The Bell Jar* (New York: Bantam, 1963), 7.

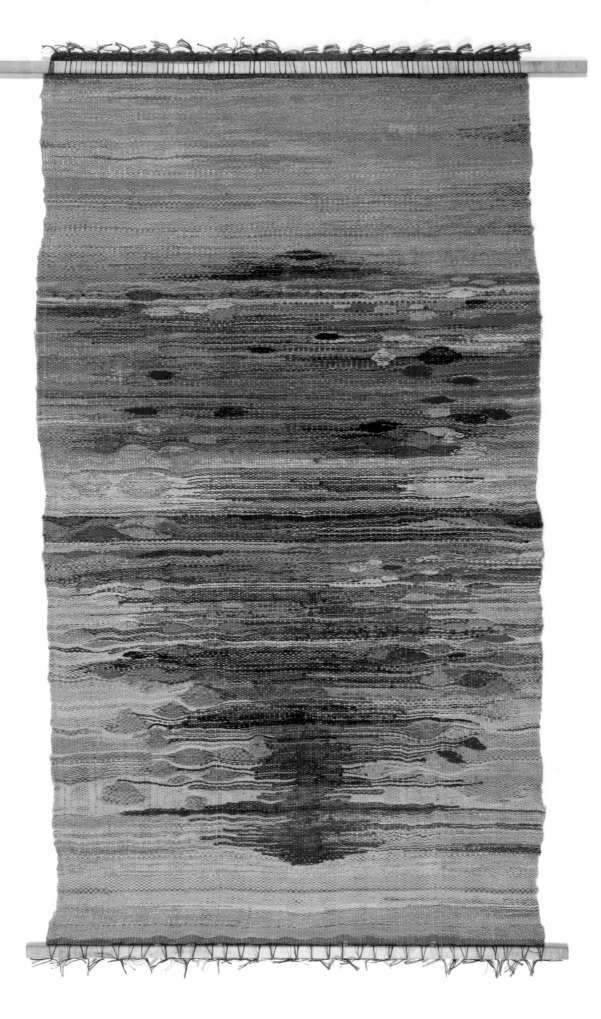

Robert Indiana, *666*
postcard to Tawney (recto
and verso), postmarked
June 6, 1966; pencil
and ink on paper; 3¼ ×
5½ in. Lenore G. Tawney
Foundation, New York.

as day and night are separated")[92] and in 1962 scolded her dealer for presenting her work in the wrong terms: "I do not consider my work to be merchandise, even highclass merchandise, and it should not be sold as such, or even as decoration. It isn't decoration."[93] It was no easy task to achieve this paradigm shift. Jack Youngerman recalls that she was an "outlier" even in the colony on the Slip, candidly admitting that at the time, he did not see the relevance of what she was doing, simply because she was working in textiles.[94] Youngerman also says that while Tawney spent a good deal of time with Martin, she did not necessarily mix with the other artists that frequently. For example, while her proximity to the abstract painter Ellsworth Kelly has often been mentioned by art critics, they seem to have had very little exchange with each other.

Tawney did collect works by other artists who lived on the Slip or had connections there, including Robert Indiana, Youngerman, and the sculptor Chryssa, a close friend of Martin's.[95] She forged a lasting connection with Indiana; his use of bold lettering, which

92. Tawney to Johnson, January 27, 1962, LGTF. By 1965 Tawney was flatly turning down domestic commission opportunities that had any specifications attached, as when one of Johnson's clients requested that she make an open-warp weaving of a certain dimension and color scheme: "If I start out with a preconception that is not my own how can my work be any good. Also I know that I cannot force my hands and my inner being back along the path that I trod five years ago. That is to be crushed between two stones. . . . This is the last time I expect to explain why I can't do a commission." Tawney to Johnson, April 15, 1965, LGTF. Infuriatingly to Johnson, Tawney later did agree to make new works with no stipulations of any kind via Fairweather Hardin, which turned out to be for the same client.

93. Tawney to Johnson, March 22, 1962, LGTF.

94. "I have to confess that I didn't immediately appreciate [Tawney's weavings], for obvious reasons," Youngerman recalls. "I think the same reasons why many people didn't, and why it took her a little time for her to be recognized, and the importance of her working in this medium—doing art in what until then was considered a craft. . . . So when I first saw them I admired the way that they had been made—but I didn't recognize as much in them as I did later. . . . I think there was more acceptance of a woman artist than anywhere else. However I think in general, as a woman and as a weaver, she was maybe the most 'outlier' of all of us on Coenties Slip. The rest of us were working with paint on canvas, and except for Agnes Martin, we were men." Jack Youngerman, interview by the author, December 11, 2017.

95. Tawney to Katharine Kuh, postcard, April 12, 1979, Katharine Kuh papers, 1875–1994, bulk, 1930–1994, Archives of American Art, Smithsonian Institution, Washington, DC (hereafter "KK/AAA").

would eventually bring him such fame, was inspired by stencils that he found when cleaning out her sail loft.[96] Like Tawney and Martin, Indiana also found uses for the remnants of the shipping industry—heavy beams, ropes, spikes—that could be found in the neighborhood. Indiana kept up a friendly correspondence with Tawney for many years after the two had both moved on to other settings (facing page).

Tawney's connection with Martin, however, was by far the most consequential during her years on Coenties Slip. There has been much speculation about the nature of this relationship, both on a personal and professional level. Tawney reportedly paid medical bills for Martin during this time, and acquired her works (several of which Martin subsequently borrowed back and destroyed, to Tawney's great dismay).[97] Tawney also donated Martin's 1963 painting *White Flower* to the Solomon R. Guggenheim Museum in New York.[98] That same year, Martin created a luminous gold painting called *Friendship* that could be interpreted as a tribute to Tawney, and also wrote her an extraordinary letter of thanks for an unspecified act of generosity:

> Dear Lenore
> I am not going to be able to tell you *anything* really. You have made this day the turning point in my life. It means an enormous opportunity for me. Now I can take my time and really get to work. The whole scene is changed. There is no way to grasp the size of it. There is no way for me to get hold of it at all.
>
> I do not think you will be able to imagine even a small part of the enormous changes in my position.

> Any expression of gratitude is like the soundless sound. It is going to be like the waves over and over again. —Forever is not to [*sic*] long.
>
> I think it is the "real thing."
> Agnes[99]

We do not know exactly what prompted this uncharacteristic outpouring of gratitude on Martin's part. It may have been simply a gift of money, which would have allowed her to continue working, or it may relate to the Guggenheim gift.[100] What is certain is that the two women had a deep and abiding connection. Tawney lived with Martin when she was in transition from one loft apartment to another in late 1962 and early 1963.[101] The fiber artist Ferne Jacobs, a great friend of Tawney's in later years, recalls hearing a story from 1967, after Martin had moved to the Southwest. Tawney flew out to see her, and the two women traveled together to Big Sur, California, then through Death Valley and Las Vegas to Flagstaff. At one point, they were in their van together and Martin suffered one of her episodic bouts of depression, and Tawney held her head in her lap to calm her down.[102]

Ann Wilson, one of the other artists who lived in the neighborhood, has said that Martin and Tawney had a romantic liaison, raising an intriguing parallel to the closeted male couple Robert Rauschenberg and Jasper Johns (who lived just a stone's throw away).[103] This is credible, in the sense that Martin was certainly gay, and Tawney is not known to have had any male partners following her departure from Chicago, and did form a series of strong personal attachments to women. In her Coenties Slip years, she was close with the famously bisexual writer Anaïs Nin, who bought from Tawney a

FOLLOWING SPREAD
Untitled, 1961; rayon and wool; 63 × 22⅜ in. Lenore G. Tawney Foundation, New York.

96. Barbara Haskell, *Robert Indiana: Beyond Love* (New York: Whitney Museum of American Art, 2013), 158n84.

97. An image of one of the lost paintings is preserved in a film made by Maryette Charlton at Tawney's South Street studio. Charlton film, reel 7, LGTF.

98. This gift was anonymous and remained so until recently, when the Guggenheim recognized Tawney's generosity in the credit line for *White Flower* in its 2016/17 Agnes Martin retrospective.

99. Agnes Martin to Tawney, October 25, 1963, LGTF.

100. My thanks to Kathleen Nugent Mangan for her suggestions regarding this document. For further discussion see Suzanne Hudson, *Agnes Martin: Night Sea* (Cambridge, MA: MIT Press/ Afterall Books, 2016), 68–70.

101. Tawney to Johnson, postcard, January 15, 1963, LGTF. Tawney commented, "Agnes continues to worry her friends enormously. I shall be glad to be away from her and her problems for a while."

102. Jacobs, interview by the author, December 29, 2017. Tawney's last documented meeting with Martin, seemingly after a long period without contact, was in September 1984.

Tawney to Kuh, postcard, September 10, 1984, KK/AAA.

103. Nancy Princenthal, *Agnes Martin: Her Life and Art* (New York: Thames & Hudson, 2015), 73ff; Jonathan Katz, "Agnes Martin and the Sexuality of Abstraction," in *Hide/Seek: Difference and Desire in American Portraiture,* ed. Jonathan Katz and David Ward (Washington, DC: National Portrait Gallery, 2010), 176.

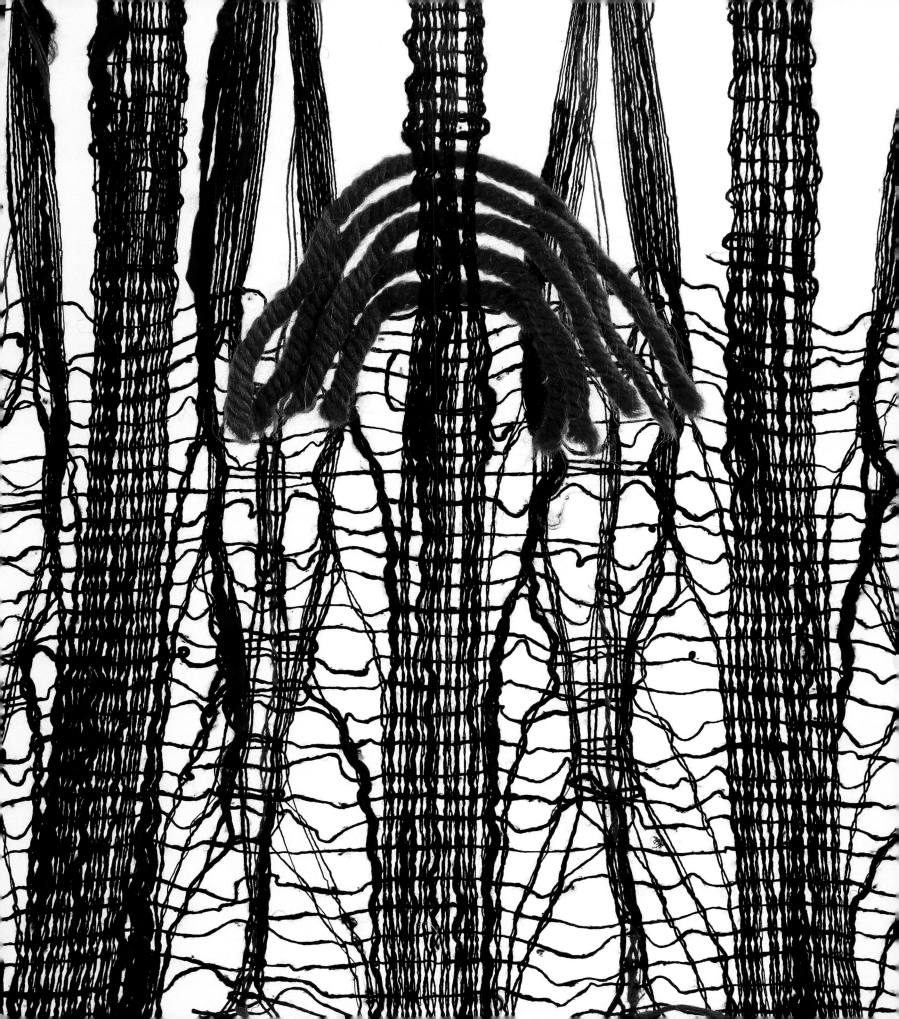

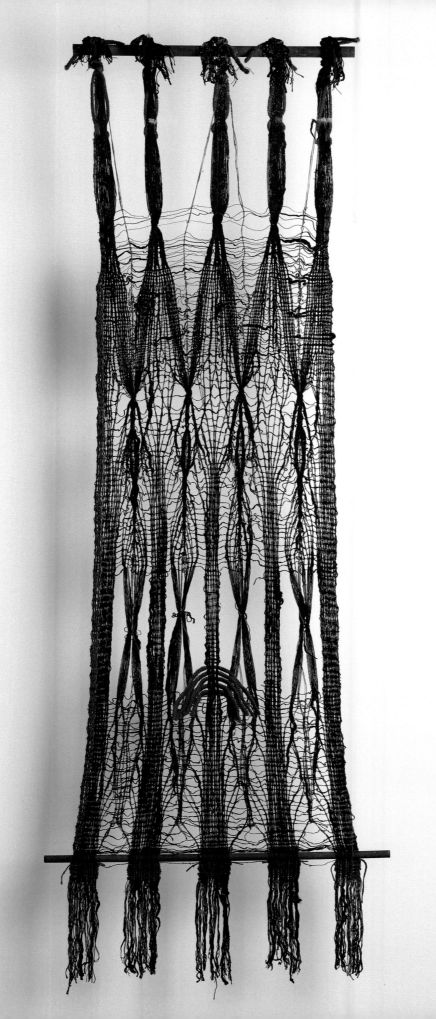

Nativity in Nature, 1960; linen, wool, and silk; 126 × 150 in. Installation view, The Interchurch Center, New York. Lenore G. Tawney Foundation, New York.

nine-foot-high "double weaving," two separate planes of fabric attached at the top. ("I had it hanging like a tent so you could walk under it," the artist told Marna Johnson. "It was like being under water or in shade of trees with sun coming thru."[104]) However, not a single close friend of Tawney's that I have interviewed believes that she had a sexual relationship with Martin, or indeed any other woman. It is, of course, difficult to prove this negative, particularly given the veil that gay men and women of this generation necessarily drew over their sex lives. It probably makes sense to respect that privacy.

A more fruitful question, perhaps, is that of Tawney and Martin's mutual artistic influence, again a topic of speculation in previous critical assessments of both artists. The fact that Martin started painting grids just at the time when her closest friend was a weaver has proved irresistibly suggestive to art critics and historians. Martin herself flatly rejected the idea that her work referred to textile structures ("Oh, don't give me that.... Somebody undercutting me, saying it was like weaving"), though it must be said that she tended to downplay her influences.[105] Whatever one makes of that, the two artists definitely shared artistic interests. They read and discussed texts together, including Alban Butler's *The Lives of the Saints* (1756–59) and the writings of St. Teresa of Ávila, the woman so memorably immortalized in marble by Gianlorenzo Bernini in a state of ecstatic spiritual transport.[106] Tawney commented of these historical visionaries, "Of course, we couldn't hope to emulate them, but we could be inspired."[107]

It was probably in this area of spirituality that the two artists found most common ground. In 1960 Tawney was commissioned to make a tapestry for the new Interchurch Center in Manhattan, a cross-faith agency building backed by the Rockefellers that served as the headquarters for the National Council of Churches, representing several Protestant denominations as well as the Greek Orthodox church.[108] When the innovative tapestry was initially rejected and returned to Tawney's studio, Martin wrote a letter of support for the work. She chose her words carefully. Arguing that the tapestry should be seen as representative of a "post-Renaissance" spirituality, she ended on a half-daring, half-encouraging note: "That which is new, with the support of those who can appreciate it, slowly gathers force."[109]

104. Tawney to Johnson, March 9, 1959, LGTF.

105. Quoted in Joan Simon, "Perfection Is in the Mind: An Interview with Agnes Martin," *Art in America*, May 1996, 88.

106. Butler's *Lives of the Saints* was the subject of a later Ann Wilson performance work performed in 1977; among the dancers was Andy de Groat, who also collaborated with Tawney.

107. Quoted in Benita Eisler, "Profiles: Life Lines," *New Yorker*, January 2, 1993, 76. See also Marcelle Auclair, ed., *Teresa of Ávila* (New York: Image Books, 1959).

108. The building, colloquially known as the "God Box" by its staff, cost $21 million. "Interchurch Center Opens Doors in N.Y.," Associated Press, June 3, 1960; Frank DeGregorie, curator, Interchurch Center, New York, interview by the author, January 10, 2018.

109. Agnes Martin, "Explanation of the Tapestry by Miss Tawney," undated manuscript [c. 1960], LGTF. Martin's letter reads in full: "This tapestry illustrates how Christ came into the world as holy spirit and light and love as by a miracle. Nature in its heavy dark mystery is penetrated from above by heavenly blessing accompanying the spirit of love. Mary is not a mortal only but a spiritual being already lifted out of nature. This tapestry emphasizes the miracle of the direct penetration of the spirit of God into the world. Religious art through the Renaissance (approximately 700 years) has accented the importance of human response to nature. This tapestry is to be considered post-Renaissance, the content being nature illustrated by the holy spirit. That which is new, with the support of those who can appreciate it, slowly gathers force."

Entitled *Nativity in Nature* (facing page), Tawney's work does not depict the birth of Christ, but rather the introduction of the divine presence into the material world. In the center of the tapestry, a broad bolt of purple represents this revelation. Gathered around are shorebirds (a common motif of Tawney's in these years) and a pair of owls, who gaze out at the viewer in seeming acknowledgment. Though not an open-warp structure, the tapestry is nonetheless executed in an unusual mix of techniques. Each of its three thirty-six-inch panels is coarsely woven, with wefts of varying materials and thicknesses freely integrated. After completing the weave, or possibly while executing it on the loom, Tawney introduced further elements using large-scale embroidery techniques. Thick and thin yarns may traverse as much as two or three inches in an individual stitch. The results look vulnerable—if not as fragile as her open-warp pieces—but also richly textured. Frederick Dunn, the architect of the modernist chapel at the Interchurch Center, also was supportive of Tawney, writing that the work "has all the dignity of a Byzantine mosaic, which dignity owes much to the simple drafting of the figures."[110] The Interchurch Center did indeed accept the tapestry in the end, placing it in the chapel's entrance hall, or narthex—directly across from an impressive set of double doors. It remains there today.

Clearly, *Nativity in Nature* does not have the iconography typical to an ecclesiastical project; the Interchurch Center felt obliged to explain, in its own literature, that the tapestry was not just slapdash but had been made with "deliberate indefiniteness of outline for greater poetic expression."[111] Even so, the project was unusual for Tawney in being so explicitly religious; her only other commission of this kind came in 1963, when she made an ark veil for the Solel Synagogue in Highland Park, Illinois, an entirely abstract rhythmic composition. The spiritualism that she shared with Martin was bound up not in images but in the work of the studio: a secular and personal space, but one that they nonetheless found at once transcendent and intensely personal. For both, repetition served as the experiential infrastructure of practice. What they shared was daily rhythm: each line, each thread marked a moment of self-presence. So what

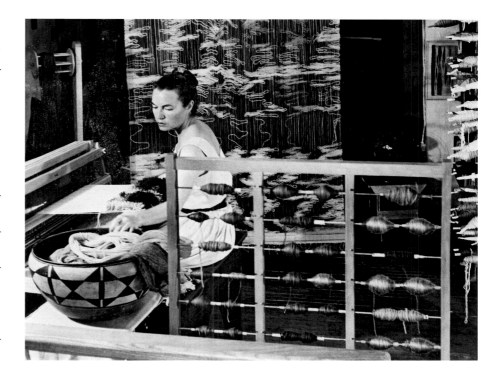

linked the two was not really the grid *per se* (indeed, Tawney's work was distinguished by its break from conventional rectilinearity). Rather, it was their way of working that proceeded in parallel. During their time on the Slip, both artists committed to a meditative practice, a refusal of immediate gratification both symbolic and actual. The humane quietude of Martin and Tawney's work—"the natural path, calm and sweet," as Tawney had put it—was a path they were each walking alone, together.

Tawney's time in Coenties Slip is well documented in photographs, which is not surprising, given the picturesque loft setting, the patterns and colors of her textiles, and her own photogenic presence. Perhaps the best-known image of her, taken by David Attie in this period, shows her seated at the loom (above). Her hair is up "in a dancer's twist," as writer Donna Seaman notes, and the whole scene does have a choreographical feel to it.[112] She is literally surrounded by the tools of her trade: a rack of spools in the foreground, more yarns and threads in a storage unit behind her, the work in progress in front of her, an Acoma Pueblo bowl piled high with yarn to her left, which she reaches into as if drawing from a well. The open-warp tapestry work

Tawney with *Yellows* in her studio on Coenties Slip, New York, 1958. Photo by David Attie. Lenore G. Tawney Foundation, New York.

FOLLOWING SPREAD
Floating Shapes, 1958; linen, silk, and wool; 49 × 42 in. Lenore G. Tawney Foundation, New York.

110. Frederick Dunn to Charles van Anden, August 31, 1960, LGTF.

111. Brochure, The Interchurch Center, New York, n.d., LGTF.

112. Donna Seaman, *Identity Unknown: Rediscovering Seven American Women Artists* (New York: Bloomsbury, 2017), 370.

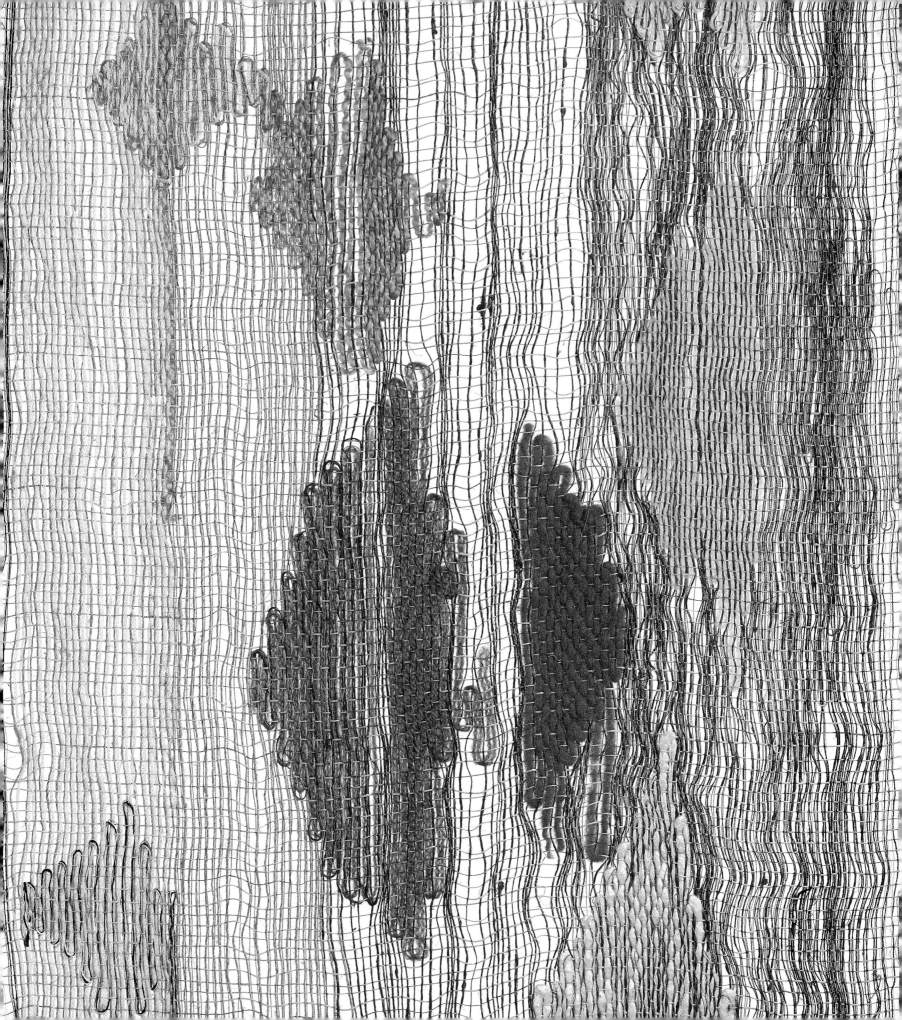

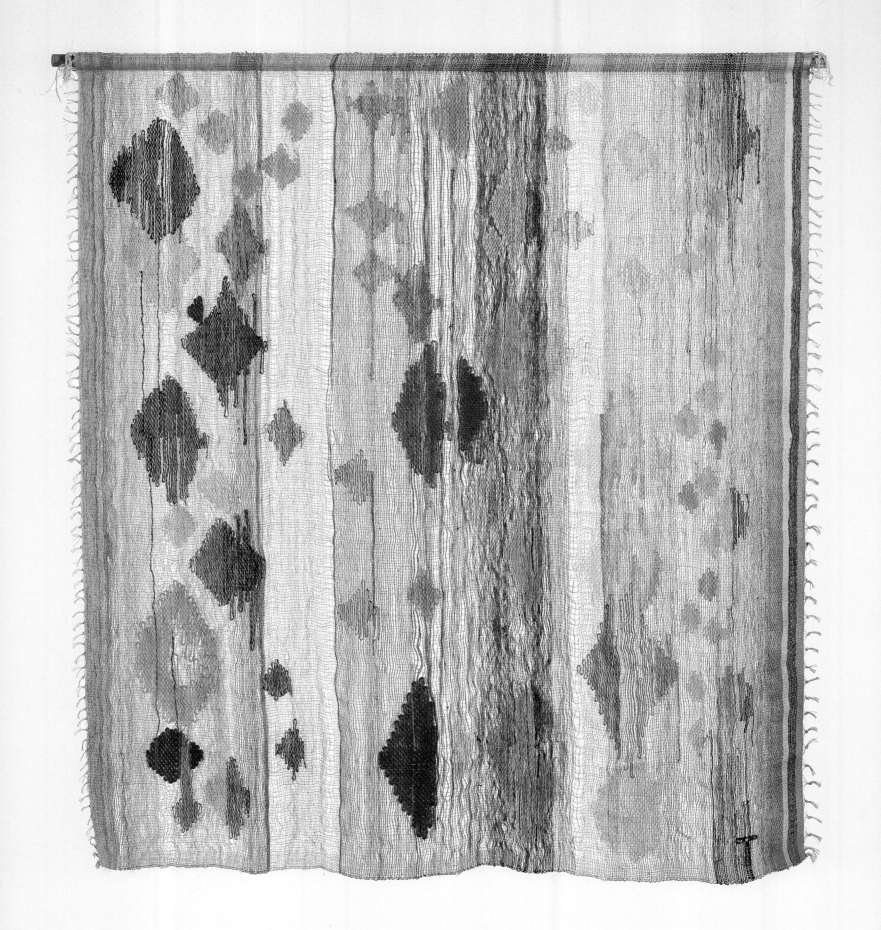

Tawney with *Yellows* in her
studio on Coenties Slip, New
York, 1958. Photo by David
Attie. The LIFE Picture
Collection/Getty Images.

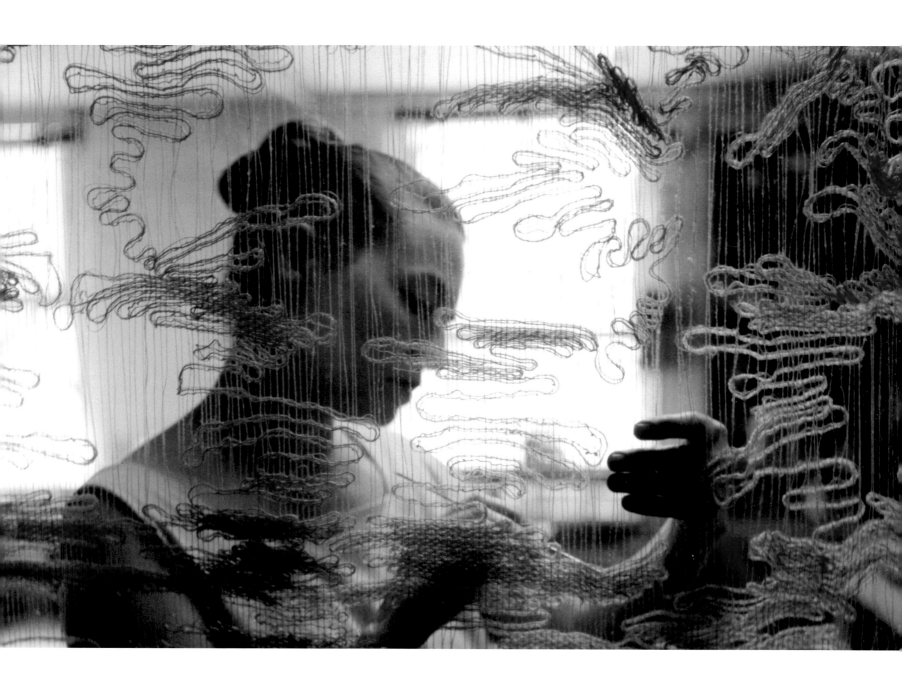

WAITING LIKE A FERN

called *Yellows* (1958) hangs in the background, framing her perfectly. As an image of complete immersion in the medium, it is bettered only by another Attie photo from the same shoot (facing page). Here Tawney is at work on *Yellows,* or at least miming that activity. Her upraised hand could just as easily be holding a paintbrush, except of course that no painting is transparent like this weaving. Caught in a rainfall of wriggling golden warps, her concentration is total. She is entirely in the world of the work.

Another image, taken three years later, shows Tawney at work on *Vespers* (page 83), an experimental gauze weaving of a type that she came to see as "intermediate," or transitional.[113] In this type of structure (also known as a leno weave), often seen in historic Peruvian examples, the warps are twisted together, as in a braid. Each twist binds a weft fast. This allows for additional space to be left between wefts while holding them in place, and hence a more open overall weave structure.[114] In the South Street portrait, rather than being contained in the weave, Tawney is standing to one side of it, and her gesture is not so much painterly as musical, that of a harp player. The work is hung high (the diminutive artist stands on a step stool) and extends up past the limit of the frame. Light cascades downward, throwing *Vespers* into stark silhouette against the unfinished brick wall. This is an image less about immersion and more about verticality, mastery, aspiration. The weaving exists in free space, and dominates that space; though still planar, it hangs down into the loft as dramatically as a bronze sculpture might spring up from the floor.

This shift in the photographic narrative echoes the differences between *Yellows* and *Vespers* as works of art. Color has vanished (the photo is monochrome, and so nearly is the work), as has intuitive, yarn-by-yarn composition. *Vespers* is assertively structural. Tawney had just learned how to execute gauze weaves from Lili Blumenau, attending classes that the highly technical German weaver offered in her New York apartment.[115] These were the last lessons Tawney would ever require. *Vespers* pointed the way toward a new group of sculptures, so singular in their conception that she coined a new phrase to describe them: "woven forms." In them she employed not only gauze techniques, but also an expansive vocabulary of rep and slit weave, twining, braiding, and knotting.[116] Many of these works would exploit a new technical invention of Tawney's, which allowed her to once again reinvent the medium, but this time without sacrificing its physical integrity. Tawney was a student no longer. From now on, others would learn from her.

PAGES 82, 84, AND 85 *Vespers,* 1961; linen; 82 × 21 in. Lenore G. Tawney Foundation, New York.

PAGE 83 Tawney with *Vespers,* 1961. Photo by Ferdinand Boesch. Lenore G. Tawney Foundation, New York.

113. Quoted in d'Autilia, *Personal World,* n.p. The first known weaving in this direction, now lost, was called *Number One* and was included in the Staten Island show. Alice Adams, "Lenore Tawney," *Craft Horizons* 22, no. 1 (January/February 1962): 39; "Lenore Tawney," *Handweaver & Craftsman,* 7.

114. See Lili Blumenau, *Creative Design in Wall Hangings* (New York: Crown, 1967), 150.

115. See Lili Blumenau, *The Art and Craft of Hand Weaving* (New York: Crown Publishers, 1967). On Blumenau's influence as a teacher, see Elissa Auther, *String Felt Thread: The Hierarchy of Art and Craft in American Art* (Minneapolis: University of Minnesota Press, 2010), 13. Tawney attended the classes for three months in the fall of 1961, and produced thirty works using the new techniques by the following February. "Lenore Tawney," *Handweaver & Craftsman,* 7.

116. Rep weave is a warp-faced plain weave, with no wefts visible on the front. It creates a dense effect that Tawney often used in contrast to gauze structures. In slit weaving, apertures are opened in the weave by turning the weft back at regular intervals, producing a series of internal selvages.

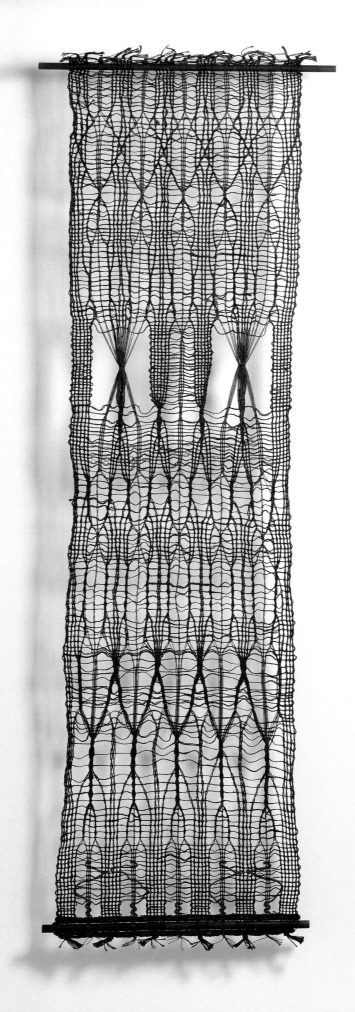

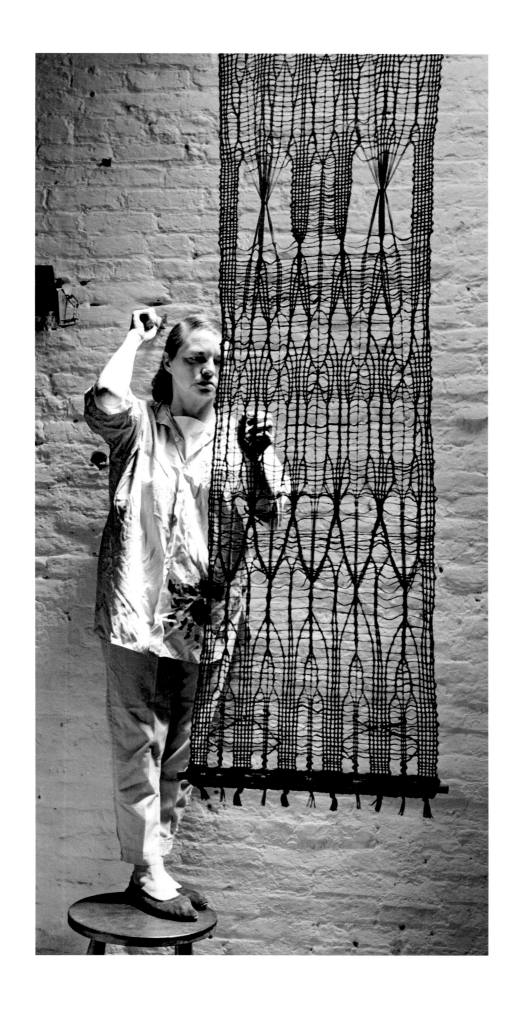

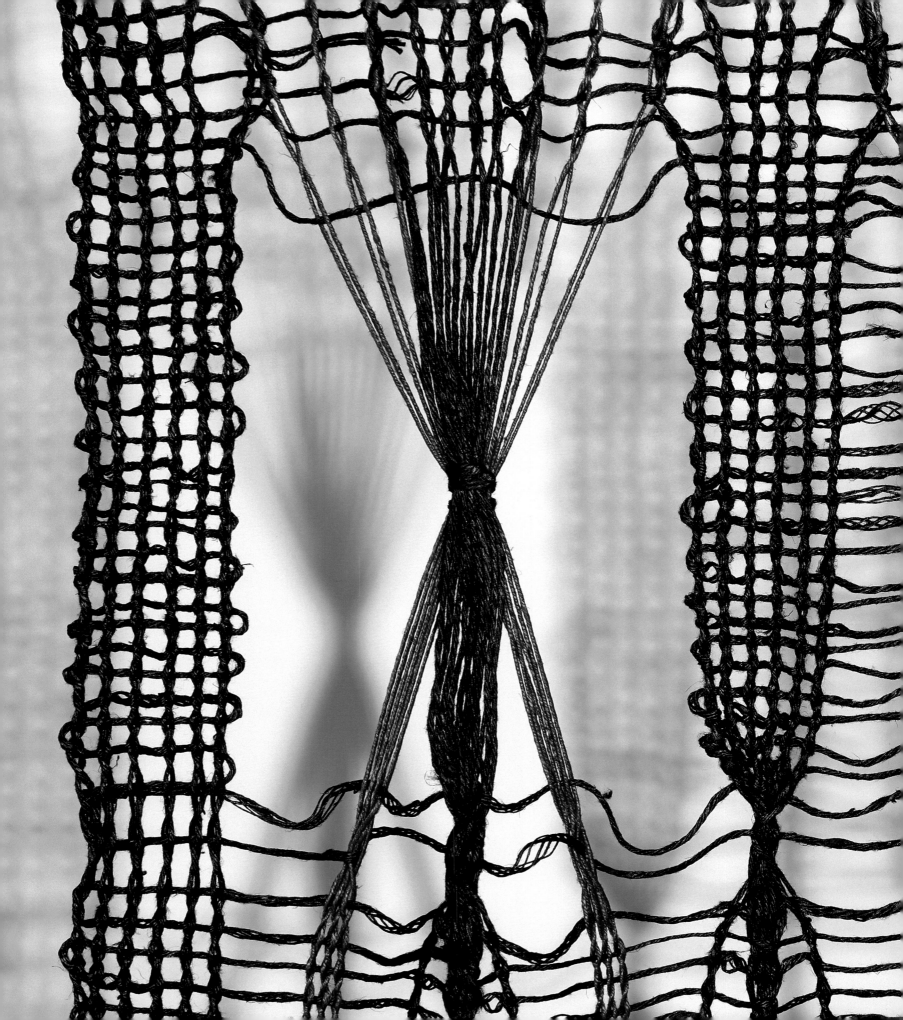

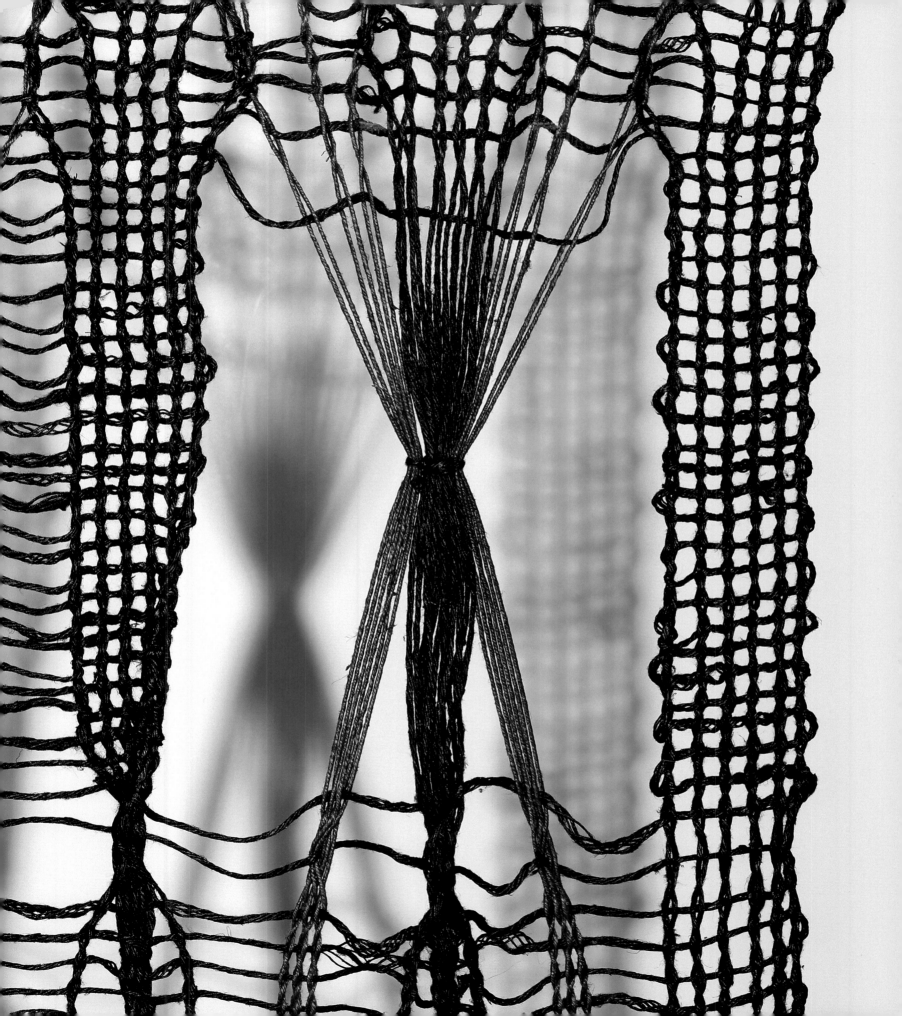

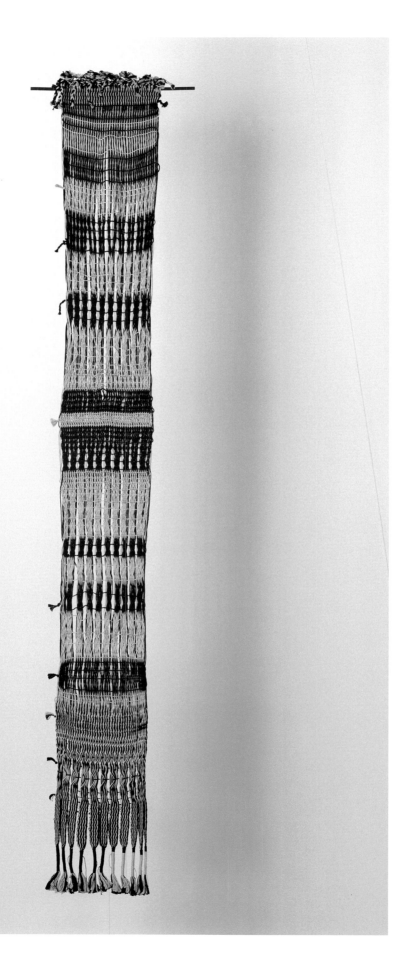

The Judge, 1961; linen; 124 × 14 in. Lenore G. Tawney Foundation, New York.

FACING PAGE *Waiting like a Fern*, 1969; mixed media; 10½ × 10½ in. (framed). Lenore G. Tawney Foundation, New York.

The Archive
Ephemeral and Eternal

MARY SAVIG

"Ephemeral & eternal." These words appear on a list of evocative phrases Lenore Tawney carefully compiled in her journal, a distillation of terms and idioms from the writings of nineteenth-century theosophist Helena Petrovna Blavatsky (facing page). The list, found in Tawney's personal papers, is an emanation of her studio practice.[1] We can imagine the artist seated at a desk, committing her thoughts (and the thoughts of others) to paper, rendering the ephemeral into the eternal.

Artists' manuscript collections, also referred to as their papers or archives, typically comprise primary source documents such as biographical materials, correspondence, photographs (professional and informal), journals, notes and other writings, interviews, project files, sketches and sketchbooks, scrapbooks, and the like. Such resources offer firsthand accounts and personal perspectives on particular moments in an artist's life, sometimes illuminating private gestures and moods, bringing clarity to the historical record. Tawney's extensive archives chronicle the evolution of her artistic practice but also map the contours of her everyday life and intimate friendships, providing fascinating insight into her conceptual frameworks.

The archives, however, much like the artist herself, are elusive. They evade conventional systems of organization and proceed with their own logic. Like her intricate fiber artworks, they require us to enter a labyrinth, to follow lines and look between and across those lines. Indeed, Tawney immersed herself in her work by following a line. In her 1971 oral history interview for the Archives of American Art, the artist describes her intuitive process as one centered on linearity:

> I have to be so concentrated in order to keep within my outline....I have to be with this line, like this, it's like meditation, you have to be with the line all the time, you can't be thinking of anything else because you think you'll go right on outside your line.[2]

This line of meditative focus runs parallel to the lines that run through all her creative ventures, from lines of woven thread to lines of words in letters and postcards to friends. Even the way she sourced small stones for her collages and mail art, like a 1975 postcard to her friend Maryette Charleton (page 90), can be seen as following this line, zeroing in on the essence of form:

> I use stones that are so small you can hardly see them to pick them up on the beach. Of course you can see them when I put them in a circle. Well, when I'm picking up stones on the beach, you know I'm down on my hands and knees and you can't imagine how many people come over and they look and they can't see and they say, "What is it?" They think I'm

Journal (30.1),
c. March 1967. Lenore G.
Tawney Foundation,
New York.

the artist is one who suddenly says some-
thing only conceivable as silence
Falling, they are carried into the heart of the world
countless roots forever silent, drinking
full of darkness, like a mountain
The Germ in the Root
Boundless plane of the circle
Light in darkness & darkness in light
It proceeds from without inwardly
The Germ is invisible & fiery
The Root is coal
The Rootless Root
Thread-soul (pilgrim)
The sun's outward robes
Cessation
Invisible forces
Ephemeral & eternal
Symbolon (one composed of two) - Plato
A ray
Knotted to the cosmic
Penos, pene, penion (the thread wound upon a bobbin,
 the woof, web, fabric
Waterfall of the flames
A cataract reversed, shooting upward
Knotted with fire & hail
Secret joy
Swish of fire

What is the Supreme Deliverance? (dharma)
"It is the absence of all views & all
imagination, the cessation of that
mental activity which creates illusions."

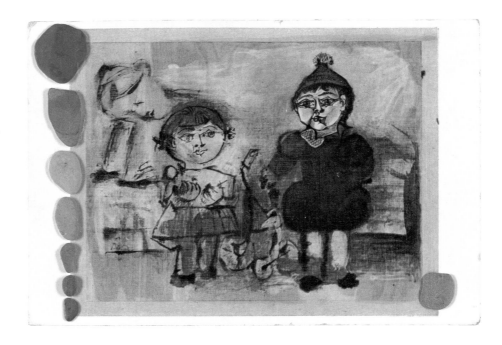

picking up something valuable and finding very marvelous things, which I am.[5]

With her devotion to discovery and making, Tawney embraced more than just creating art; her everyday life was the source of her creative labor. "My work is my pleasure, it's my life, it's what I live for," she explained in a 1978 interview.[4] As Tawney collected, commingled, and crafted, she collapsed the boundary between her life and her art. Therefore, her correspondence, photographs, and journal writings are inextricable from the other cultivated facets of her studio environs—her library of books, works in progress, and various arrangements and assortments of rocks, feathers, eggs, animal skeletons, and buttons. This is especially evident in the experimental artist books she made in the 1980s. In one example, Tawney cut out a square window from each page of a blank journal to create an interior box that cradles a rodent skull; another such carved book houses a bird foot (pages 91, 92). Many of the pages are layered with snippets of text and writing from various sources, much like her collage work. What distinguishes her books are the inclusion of personal letters she received. Numerous clippings feature the salutation "Dearest Lenore," as well as single words—"hope" is one sweet example—and occasional signatures, remnants of things that drew Tawney's interest and of the people she held dear. While the collage elements represent the fragmentation of the original sources (and hence the loss of their content), their sacrifice culminates in a document that is truly Tawney.

Tawney's archives are uniquely calibrated around her own interests and achievements. Her financial independence freed her from the need to teach (or otherwise hold a job), or to answer to patrons, which allowed her to fully commit all aspects of her life in service of her art. This measure of self-sufficiency allowed her to exert control over her image across media, as well; Tawney understood the power of presentation. Her evolving sense of self is traceable through her journal entries and correspondence. She tended to muse and self-reflect in a journal-like manner in her correspondence to close friends like Charlton or Toshiko Takaezu, in some cases even transcribing her journal entries into her letters. Likewise, she possessed a magnetic physical presence, evident in the many photographic portraits of her. She was the primary source of everything in her midst.

Because of the very personal nature of Tawney's papers, they do not merely reflect her artistic legacy but rather refract her complex—and at times contradictory—identities as an artist, friend, woman, reader, wife, manager, thinker, collector, gatherer, weaver, sculptor, traveler, and seeker. But the archives are not just a repository of source materials that document her life; they also offer a landscape of the materials she cultivated as a daily source of inspiration for

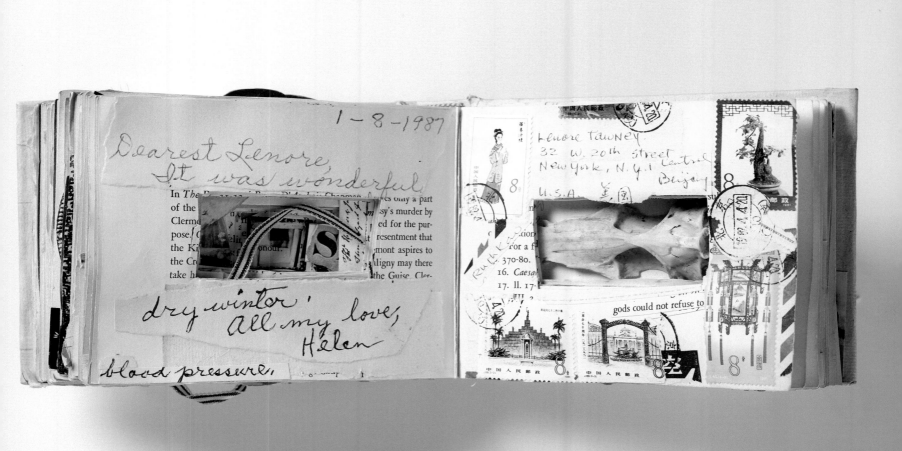

Artist book with rodent skull, c. 1985; mixed media; 4 × 5¾ × 3½ in. (closed). Lenore G. Tawney Foundation, New York.

Artist book with bird foot,
c. 1985; mixed media;
5¼ × 4¼ × 2¾ in. (closed).
Lenore G. Tawney
Foundation, New York.

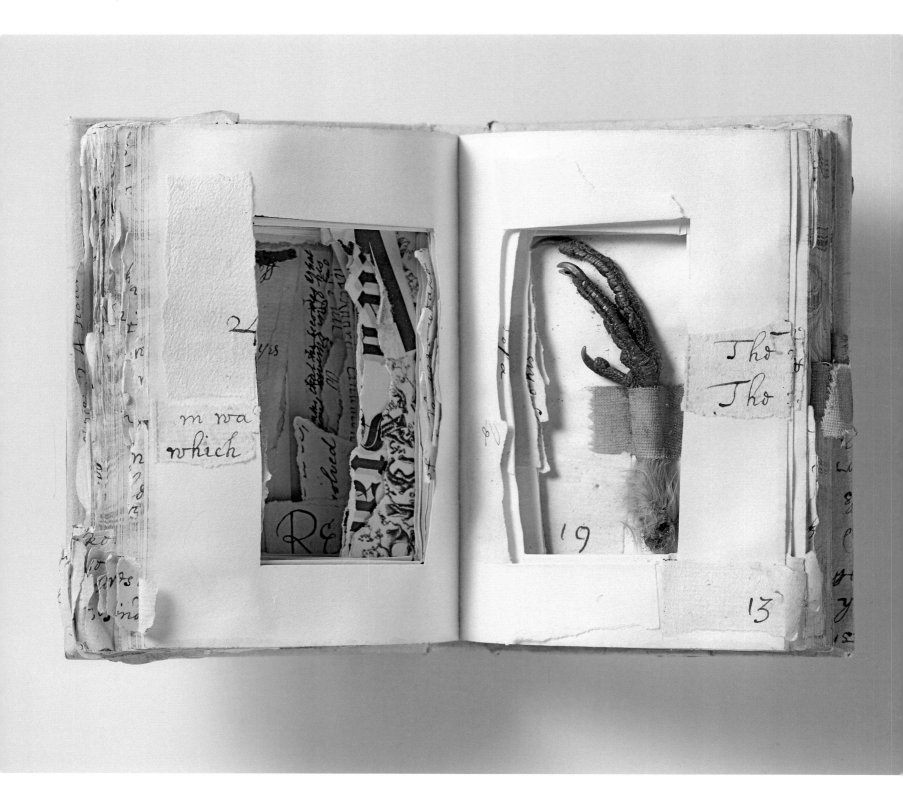

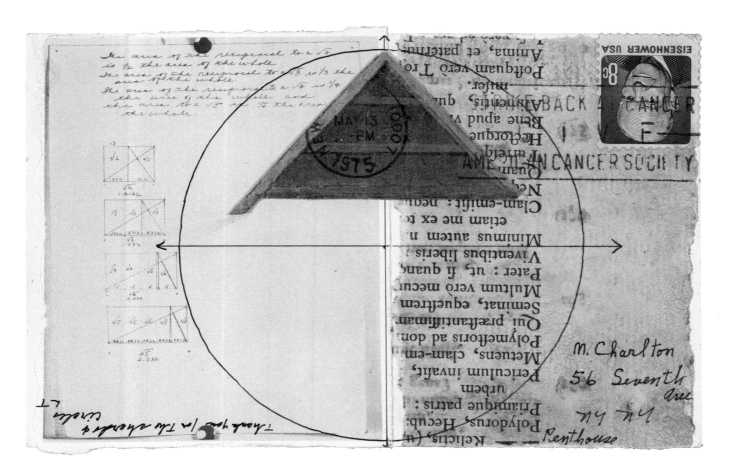

her art. With this in mind, her archives can be seen as circular in their formation and use by Tawney.

The archives are also a crossroads for the ephemeral and the eternal. There is a tension between what has been saved and what has been lost. Some moments were never material to begin with, and some records were destroyed (purposely or by accident). The records that survive are uneven—as all archives are—but they nevertheless offer invaluable insight into the artist and will be treasured, studied, and preserved in perpetuity. The ways in which we might better understand Lenore Tawney through the lens of the archives echo a frequent motif in her artworks: a cross inside a circle (above). In Tawney's words, "I saw this line of the cross—the horizontal line—as the linear horizon line, and the upward line that crossed it was the line of eternal time. Linear time and eternal time are the arms of the cross. Where the two meet in the middle is the moment of being. It's the moment of awareness if you are aware. Eternal time is always there."[5]

1. The Lenore Tawney papers are currently held at the Lenore G. Tawney Foundation, New York. They are an intended gift to the Smithsonian Institution's Archives of American Art, Washington, DC.

2. Oral history interview with Lenore Tawney, 1971 June 23, Archives of American Art, Smithsonian Institution, Washington, DC (hereafter "Tawney interview, AAA").

3. Tawney interview, AAA.

4. Quoted in Jean d'Autilia, *Lenore Tawney: A Personal World* (Brookfield, CT: Brookfield Craft Center, 1978), n.p.

5. D'Autilia, *Personal World*.

Mail art postcard to Maryette Charlton, postmarked May 13, 1975; mixed media; 4 × 6 in. Maryette Charlton Papers, circa 1890–2013. Archives of American Art, Smithsonian Institution, Washington, DC.

Shining in Vacant Space,
1975; mixed media; 11½ ×
9⅛ × 1 in. (framed).
Lenore G. Tawney
Foundation, New York.

FACING PAGE *Feather
Music,* 1967; mixed media;
5½ × 2 × 4 in. Lenore G.
Tawney Foundation,
New York.

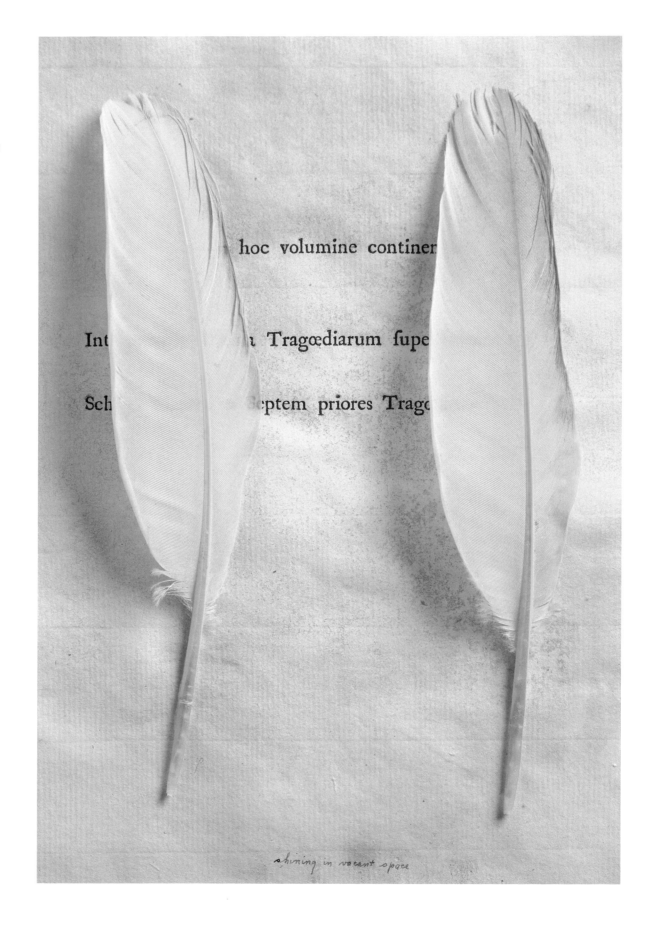

WAITING LIKE A FERN

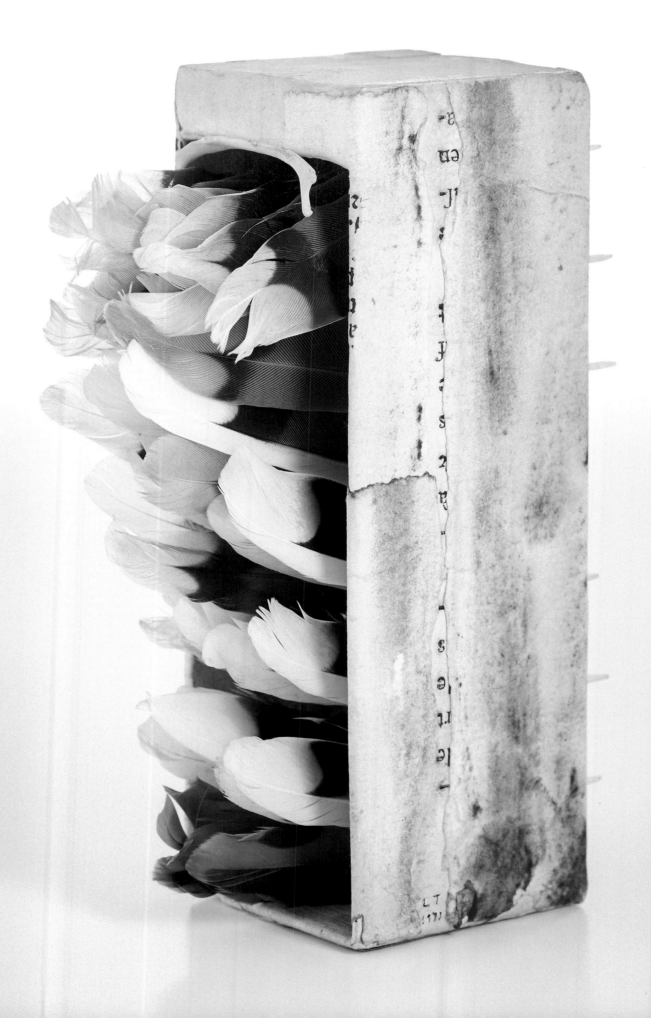

A Dry Cry from the Desert, 1970; mixed media; 9½ × 5½ × 4¾ in. Lenore G. Tawney Foundation, New York.

FACING PAGE *Udjat*, 1968; mixed media; 2⅜ × 7¼ × 5½ in. Lenore G. Tawney Foundation, New York.

Technical Analysis
Lost and Proud

DR. FLORICA
ZAHARIA

Technically, Lenore Tawney's *Lost and Proud* is an unconventionally woven tapestry, dominated by the visibility of the warp throughout the entire piece and by the nonhorizontal weft—an approach that allowed the artist to attain a remarkably close relationship between drawing and weaving.[1] Tawney's extraordinary talent and expertise with weaving techniques freed her to break the conservative rules of the medium and create a work loaded with artistic values. Furthermore, she manipulated every possible element of the weaving to provide depth: a vertical linear effect made by alternating at regular intervals warp threads of various thicknesses, an unevenly exposed warp made by sporadically missing the binding point between warp and weft, extreme variation of weft thickness and density, an open weave, contrasting light and dark colors, and a shadow effect evident during display.[2]

The lines of Tawney's source drawing are replicated with the discontinuous weft, which is rarely perpendicular to the warp. When reaching an outer line of the motif, the weft is not binding in the conventional ways but moves eccentrically, following the contours of the form.[3] When during the weaving process not every desired line was falling into place, or if its orientation was too abrupt, the artist used a needle to insert additional lines between the warp threads.

The greatest challenge in a predominantly nonhorizontal weft weave is to create a bidimensional, rectangular surface. The area woven with this tech-

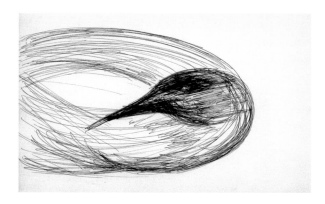

nique should be surrounded by weaving that compensates for its dimensionality—otherwise, the weaving surface gains an undesired topography and uneven width. In conventional tapestry, the compensation is achieved by weaving discontinuous horizontal weft. Tawney did that here, but she also introduced the solution of the exposed, unwoven warp. This and the use of the open weave are the elements that defined the technique Tawney named "open warp."

Pen drawing relating to *Lost and Proud*, in a journal (30.1), n.d.; ink on paper. Lenore G. Tawney Foundation, New York.

FACING PAGE AND FOLLOWING SPREAD
Details of *Lost and Proud*, 1957.

Techniques: tapestry and needlework.

1. In conventional tapestry weaving, the warp is completely covered by the weft.

2. Usually, tapestry warp is made of a single type of thread, while Tawney used threads of various thickness and plied them in both *Z* and *S* directions.

3. Commonly used tapestry weaving techniques are dovetailing, slit, and single and double interlocking. Non-horizontal weft, also called "eccentric weft," is found in various weaving traditions but not as a technique that dominates the overall surface, as seen in this piece.

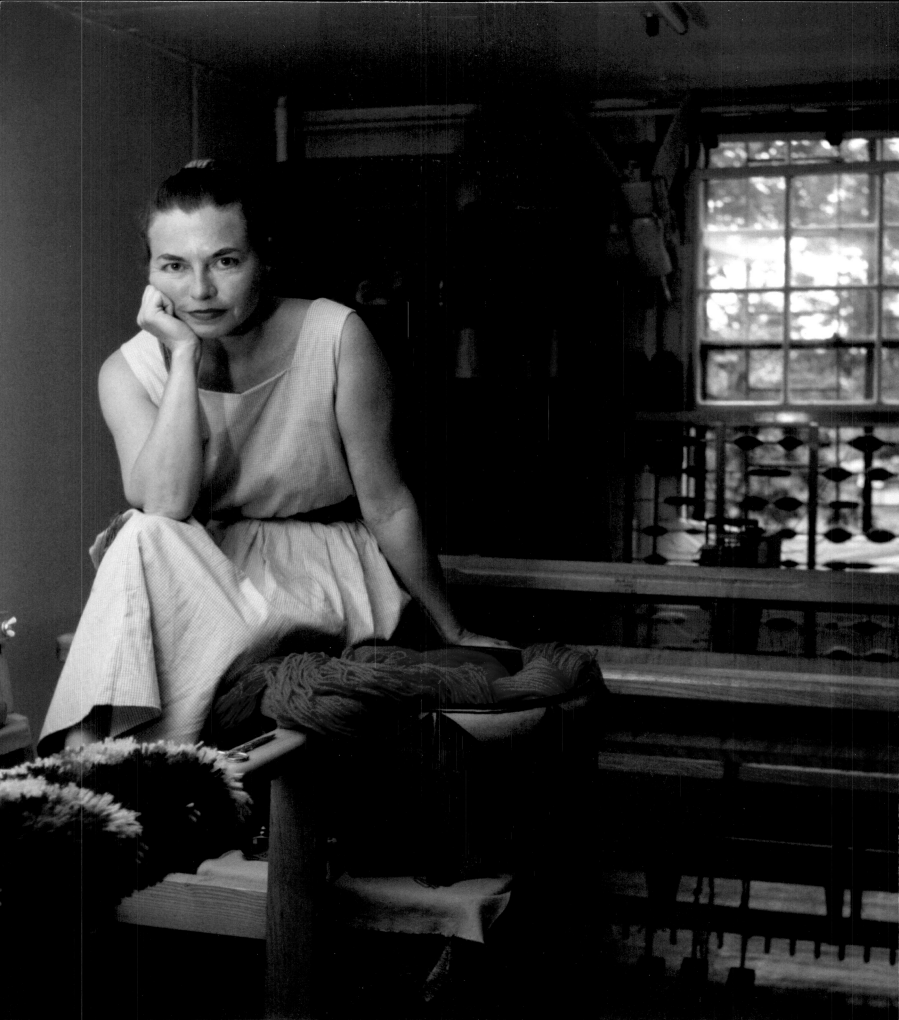

*"I visited Lenore in her New York studio
many times, first as part of a school visit
in the early 1970s when I was a student
at Cranbrook. She was in her late
nineties at the time of my last visit. Her
lifelong passion for art and commitment
to a textile language were always deeply
inspiring and motivating to me as an
artist, and continue to inspire my
students now. Her concepts and content
are so brilliantly realized in the delicacy
of material line in weavings and
installations, drawings and collage—
both intimate small-scale works and
magnificently large and spatial pieces.
Maybe we are in a time now when her
work can be more fully recognized
within a thoroughly contemporary art
context, recognizing the intersections of
textiles, sculpture, and drawing."*

—ANNE WILSON

Artist, professor of fiber and materials studies,
School of the Art Institute of Chicago

Tawney at Coenties Slip
studio, 1958.

Back to the Source

Sculptor *1961 to 1970* GLENN ADAMSON 106

The Archive *The Waters below the Firmament* MARY SAVIG 154

Technical Analysis *The Bride* DR. FLORICA ZAHARIA 170

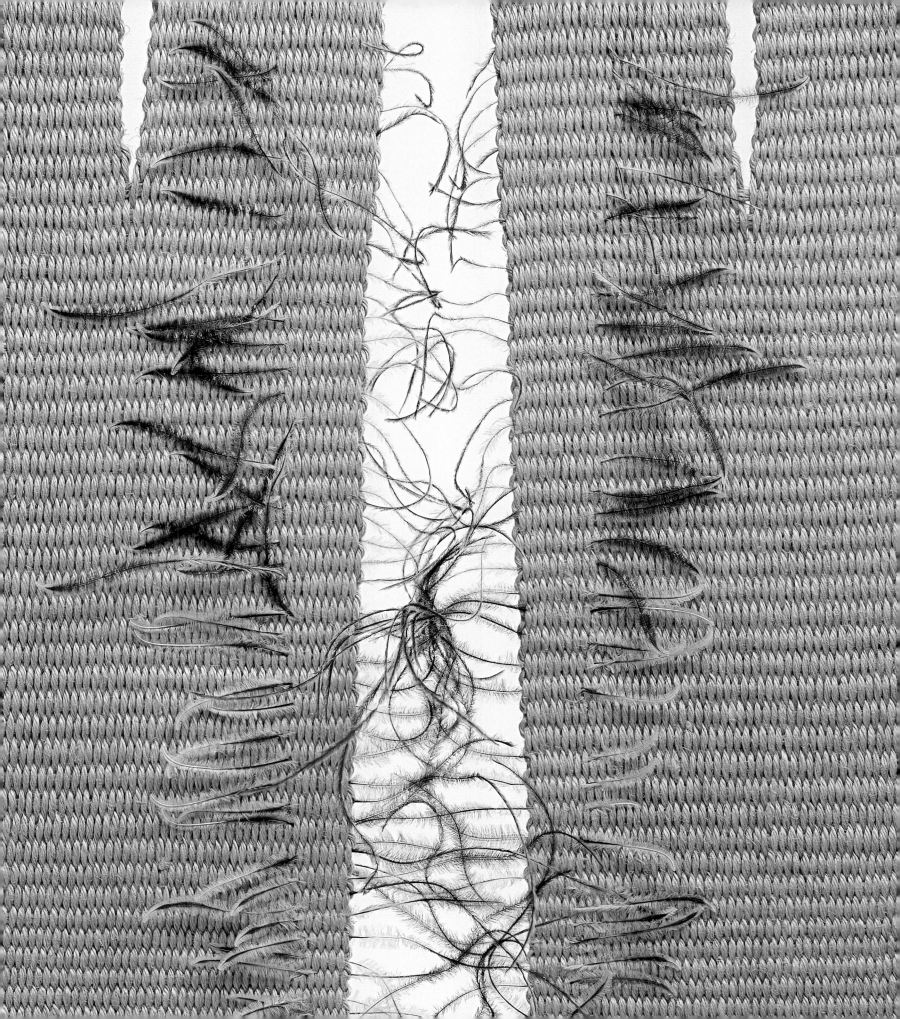

Sculptor
1961 to 1970

GLENN ADAMSON

Staten Island seems like an unlikely place to launch a major artist's career. An overwhelmingly residential bedroom community for Manhattan, it had little claim to art world attention in the early 1960s and has little more than that today. But Lenore Tawney had two important connections to the place. The first was through her friend Margo Hoff, who was in contact with James Coggin, curator at the Staten Island Institute of Arts and Sciences (now the Staten Island Museum), and suggested the idea of an exhibition to him.[1] The second was that Tawney absolutely loved the Staten Island Ferry. Living right on the water on Coenties Slip, she formed a powerful relationship with the East River. The ferry was "my favorite diversion," she wrote to her dealer Marna Johnson, "and always inspiring. At dusk the birds are like a celebration over the water, wheeling, turning, crying."[2]

As she considered the daunting opportunity before her—a retrospective, just as she was arriving at her mature work—she thought of placing her works in the water one by one and watching them float away. "The river," she said to herself, "will take them where they need to go."[3] This image is classic Tawney. It might remind us of Heraclitus, of letters sent in bottles, of Chinese poets on riverbanks tossing away leaves of calligraphy to be carried downstream. Given how learned she was, she may indeed have had one or more of these things in mind when forming the image. But it was also a response to her immediate environment, of journeys on the ferry, of days in the studio spent gazing out at the water, listening to the gulls, where she felt that "it was as if New York was at my back."[4]

The exhibition opened on November 19, 1961, and ran through the following January. Officially, it was sponsored by the Staten Island Institute's Section of Handicrafts—and here it is worth noting that this was not just an art museum but an institution with large natural history and anthropology collections, too, dating back to 1881. The museum was well aware that interest in Tawney's work would not necessarily be "limited to the concern of our craftsmen and our crafts public," for "the images in her work come from a deeply felt awareness of human life and nature."[5] Some visitors may have noticed the correspondences between

The Bride, 1962; linen and feathers; 138 × 13 in. Lenore G. Tawney Foundation, New York.

1. Hoff's role in introducing Tawney to the museum was acknowledged by James Coggin in his curatorial statement in *Lenore Tawney* (Staten Island, NY: Staten Island Museum, 1961), n.p.

2. Lenore Tawney to Marna Johnson, September 12, 1959, archives of the Lenore G. Tawney Foundation, New York (hereafter "LGTF"). The Marna Johnson papers are housed at the LGTF.

3. Quoted by Ferne Jacobs, interview by the author, December 29, 2017.

4. Oral history interview with Lenore Tawney, 1971 June 23, Archives of American Art, Washington, DC (hereafter "Tawney interview, AAA").

5. "Weavings by Lenore Tawney," *Staten Island Institute of Arts and Sciences: The New Bulletin* 11, no. 3 (November 1961): 25–26.

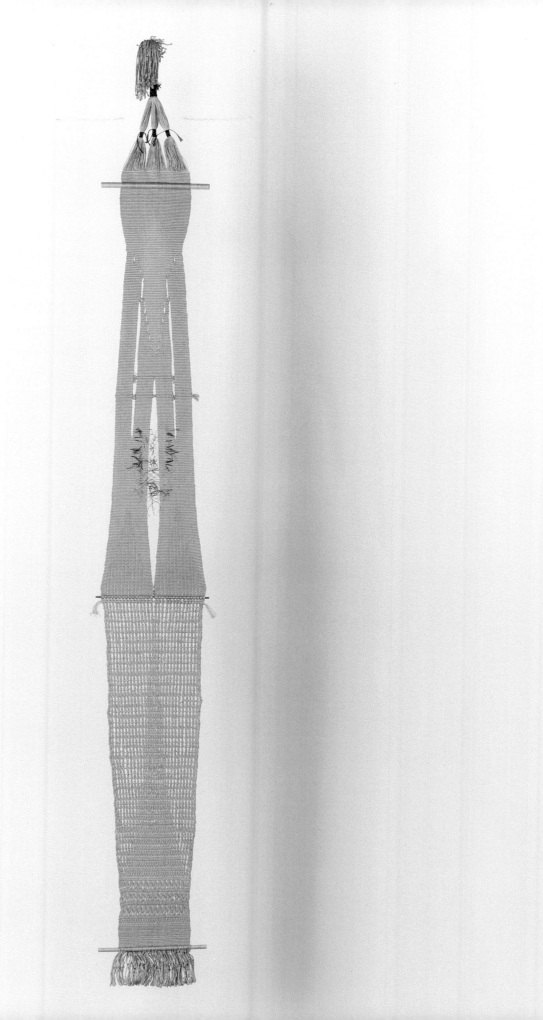

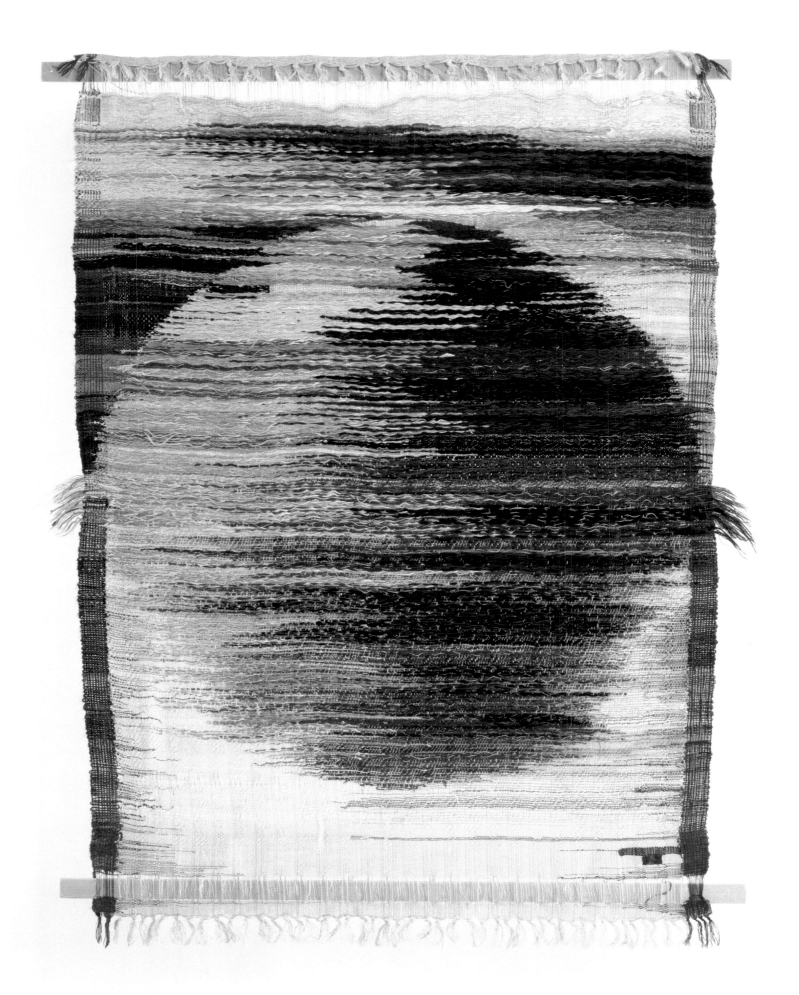

Tawney's work and the Institute's Native American artifacts, with their close stitching and feather ornamentation. No one could have missed the tremendous artistic range of the show, "the scope of her imagination and the…astonishing variety of texture, color and techniques," as a weaving magazine admiringly put it.[6] There were early tapestries like *St. Francis and the Birds* (page 48); diaphanous vertical open-warp hangings, some with glorious color, like *Landscape* (1958), others in restrained near-monochrome, such as *Wild Grass* (1958) and *Seaweed* (page 110); many depictions of birds, some with prominent feather inclusions; shaggy hangings of ritualistic implication like *Primal Garment* (1961); abstractions like *Reflections* (page 71) and *Jupiter* (facing page), which projected a serene, celestial majesty; and an astonishing open-warp weaving called *Flight* (1961), with boldly slashing X forms in orange, red, and black—as close as Tawney ever got to Abstract Expressionism.

The great document of the Staten Island show was a short essay in the accompanying brochure written by Agnes Martin. It has the distinction of being Martin's first published text (in fact, one of few she ever published, apart from interviews), and it provides powerful insight into both Tawney's work and the relationship between the two women. The text reads, in full:

> Lately we have been seeing new expression in many new media, and that is expected; but to see new and original expression in a very old medium, and not just one new form but a complete and new form in each piece of work, is wholly unlooked for, and is a wonderful and gratifying experience.
>
> With directness and clarity, with what appears to be complete certainty of image, beyond primitive determination or any other aggressiveness, sensitive and accurate down to the last twist of the smallest thread, this work flows out without hesitation and with a consistent quality.

It is impossible to describe the range of expression in this work. The expression in one square foot of any piece cannot be hinted at. But it can be said that trembling and sensitive images are as though brought before our eyes even as we look at them; and also that deep, and sometimes dark and unrealized feelings are stirred in us. But most of all, considering range, we must remark that the image is complete in each piece of work—nothing is ever repeated, not a color not a pattern not a twist.

There is penetration.

There is an urgency that sweeps us up, an originality and success that holds us in wonder.

Art treasures indeed, this work is wholly done and we can all be proud.

"Borrowing equally from the rhythms of the Bible and Gertrude Stein," as her biographer Nancy Princenthal puts it, Martin describes Tawney's weavings in language that could just as easily be applied to her own.[7] The works are intense and ineffable, infused with such feeling that even "one square foot" contains multitudes. There is a fascinating turn in the text where Martin shifts from the theme of solidity—an ancient medium deployed with directness, clarity, and certainty, "without hesitation and with a consistent quality"—to a more personal and unstable set of associations. The images Tawney has created are "trembling and sensitive," and may prompt an upwelling of "dark and unrealized feelings." Though these two passages may initially seem to contradict each other, together they ring true. It was precisely the duality between the objective and subjective, the raw fact of thousands of neatly manipulated threads combined with an undercurrent of raw feeling, that made Tawney's breakthrough work so remarkable.

This dialectic is reinforced by two other lines in Martin's text, which deserve close attention. One is her surprising claim that "nothing is ever repeated, not a color not a pattern not a twist." The other—which follows immediately—is the simple declaration, "There is penetration."[8] These two thoughts appear to ignore the

6. "Lenore Tawney: Her Designs Show Imaginative Departure from Traditional Tapestry Techniques," *Handweaver & Craftsman* 13, no. 2 (Spring 1962): 6.

7. Nancy Princenthal, *Agnes Martin: Her Life and Art* (New York: Thames & Hudson, 2015), 75.

8. In her original handwritten draft, preserved in the LGTF, Martin had included the lines "Such freshness is hard to realize. Hard to believe" between these two quotes. Her decision to cut them emphasizes the juxtaposition.

Jupiter, 1959; silk, wool, and wood; 53 × 41 in. Museum of Arts and Design, New York, gift of Johnson Wax Company, through the American Craft Council, 1977.

PAGE 110 *Seaweed,* 1961; linen, silk, and wool; 120 × 32 in. Lenore G. Tawney Foundation, New York.

PAGE 111 *The Megalithic Doorway,* 1963; linen; 204 × 28 in. Lenore G. Tawney Foundation, New York.

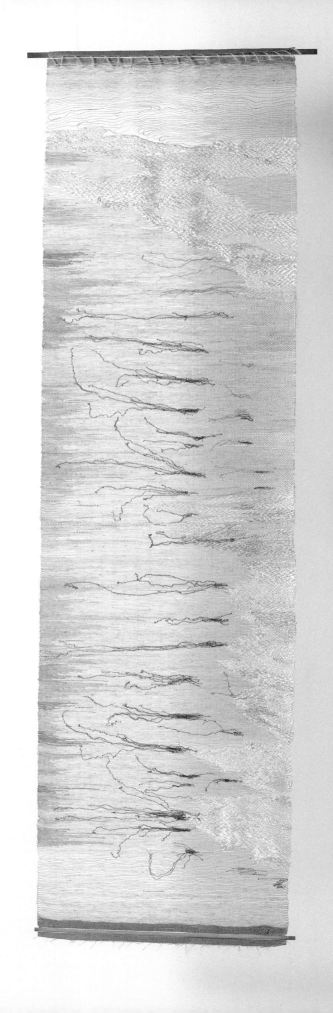

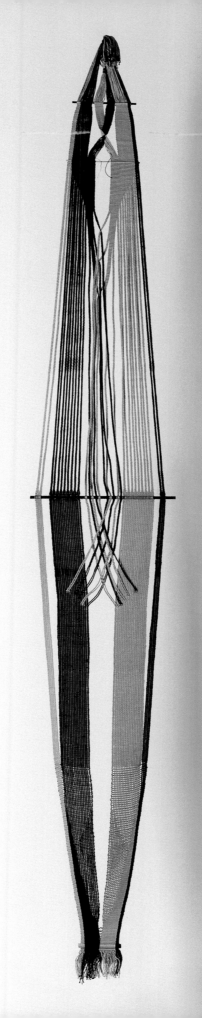

nature of the textile medium. Both carry an implication of immediacy, or "urgency," as Martin puts it. Instead of emphasizing seriality, as one might have expected, she insists on singularity within the apparently continuous weave. Shades of Heraclitus again: there is in Tawney's work a constant awareness of the now. For Martin it is this absolute uniqueness of any one moment in time, any one bit of material, that yields "penetration." It would be wrong to ascribe a sexual or gendered connotation to this word. Rather, we should imagine an imaginative and spiritual journey, in which transcendence enters into materiality as such. Martin had used similar language in her description of Tawney's Interchurch Center commission: "Nature in its heavy dark mystery is penetrated from above."[9]

Of the works that Tawney showed in Staten Island, the one that most completely sustains Martin's interpretation is the majestic *Triune,* an approximately nine-by-nine-foot tapestry created in the spring of 1961 (facing page). The title is borrowed from Christian theology and refers to the nature of the Holy Trinity, in which three entities (Father, Son, Holy Spirit) are held to be identical with the one true God. Tawney, raised Catholic, would have been well aware of church teachings on the Trinity as a "mystery" that can only be comprehended through faith. *Triune* alludes to this Christian theme in no uncertain terms, with a bright cross executed in white silk at the center of a blazing field of blue, purple, and red wools (some of which were hand-spun and dyed by Tawney's friend Alice Kagawa Parrott).[10] It would have been perfectly appropriate as an ecclesiastical commission.[11] For Tawney, however, *Triune* was not simply about Christian iconography. In her journal she noted that "the circle from whose center radiate the four arms of the cross, in which the opposites are at rest" was a universal symbol, found as early as the Stone Age.[12] It also had a personal meaning for her, concerned with temporality: "I saw this line of the cross—the horizontal

line—as the linear horizon line, and the upward line that crossed it was the line of eternal time.... Where the two meet in the middle is the moment of being. It's the moment of awareness if you are aware. Eternal time is always there."[13]

This comment was made in the 1970s, at a time when Tawney was heavily involved in meditation practice, and it may partly reflect that later perspective. Even so, the parallelism between her account and Martin's interpretive text is striking; both emphasize a collapse of the diachronic into the synchronic, temporal duration into the ever present. Within this conceptual framework, each intersection of warp and weft bears the weight of an expansive realm of experience and awareness. It is a way of thinking that compares closely with other (male) artists of the time, particularly Barnett Newman and Clyfford Still, but utterly without their grandiosity. Instead, Tawney's way of thinking is grounded in the making process, which is understood as a microcosm of experience itself. This is, of course, what craft is all about. Years of training are present in each motion of the skilled hand, "down to the last twist of the smallest thread" (to quote Martin again).

Triune exemplifies this principle, and also diagrams it. The central motif is built from innumerable intersections of warp and weft—a cross of crosses—centered within concentric circles, suggestive of a mandala. Tawney has "blurred" the composition, switching the color of the wefts and varying their extension slightly in consecutive picks. The result looks almost like a television tuning in or perhaps an ikat textile. Thematically, we might interpret this compositional flicker as emphasizing the textile's coming-into-being, the process by which all those threads combine into a single image. As Tawney wrote in a private notebook in 1964, finding the center of a cross "is the age-old sign of the meeting of opposites—the naval [sic] of the world—[that] leads into experience of the

9. Agnes Martin, "Explanation of the Tapestry by Miss Tawney," undated manuscript [c. 1960], LGTF.

10. "Lenore Tawney," *Handweaver & Craftsman,* 7.

11. Tawney did send *Triune* to an ecclesiastical exhibition in Birmingham, Michigan, in the fall of 1961. Tawney to Johnson, May 5, 1961, LGTF. It was also included in *Contemporary Handweaving IV* at University of Nebraska Art Galleries in Lincoln, which opened October 8, 1961.

12. Lenore Tawney journal (30.2), undated entry [1961?], LGTF. Tawney is here quoting an unlocated source.

13. Quoted in Jean d'Autilia, *Lenore Tawney: A Personal World* (Brookfield, CT: Brookfield Craft Center, 1978), n.p. On another occasion, Tawney recorded a related thought: "There is timelessness, the unending present, eternal duration, but not past and present (duality)." Journal (30.8), undated entry [1964?], LGTF.

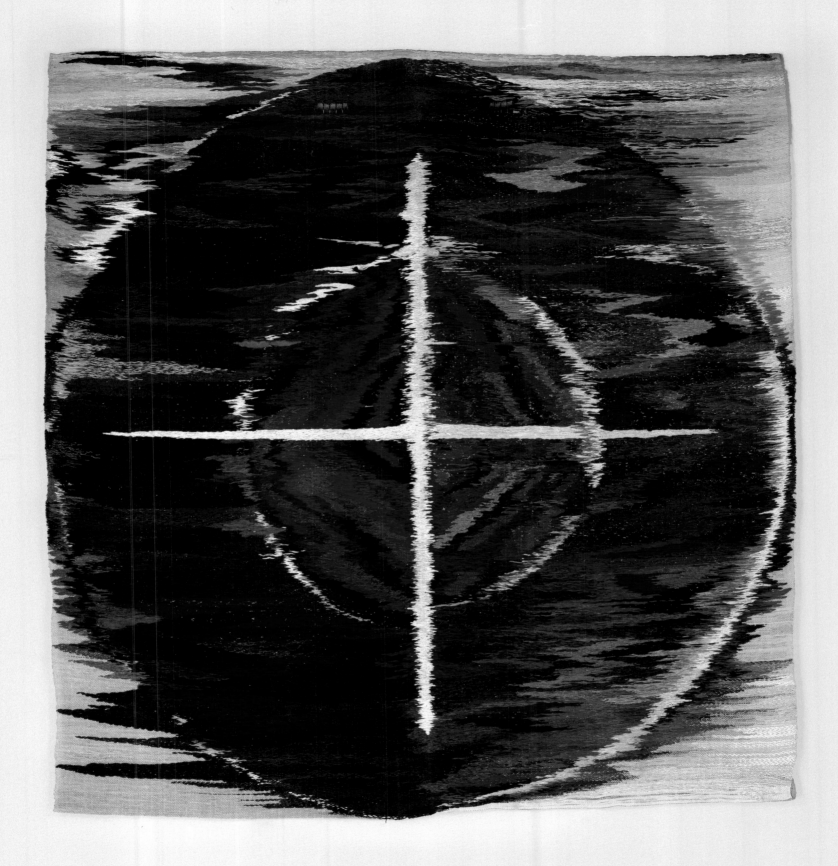

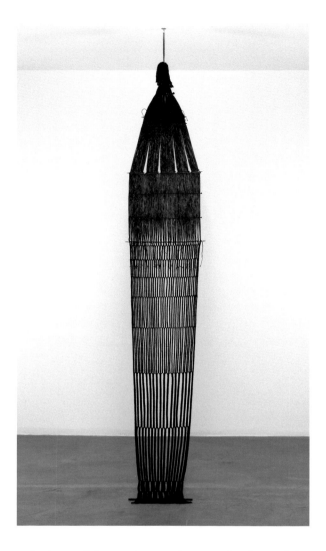

Dark River, 1962; linen and wool; 164 × 22½ in. The Museum of Modern Art, New York, Gretta Daniel Design Fund. The Museum of Modern Art/Licensed by SCALA/Art Resource, NY.

point beyond time and space, into a region beyond the conflict of the opposites."[14] *Triune* was Tawney's first really successful binding of materiality and transcendence, a duality that would guide her work for years to come.

The experience of seeing so much of her work at once, in the Staten Island exhibition, was transformative for Tawney. As art critic Eleanor Munro wrote in an important 1979 profile of the artist, "While it was on the walls—that time of reassessment for many artists—she launched herself into the production of

images of a wholly new order." She then quoted Tawney: "I began to order a great deal of black and white linen thread. I only knew I wanted to weave forms that would go *up*."[15] And so, up she went. In 1962 she made the masterwork *Dark River* (at left), which would soon be acquired by the Museum of Modern Art, despite the fact that the institution's galleries could not accommodate its nearly fourteen-foot height. (They have never been able to show it, though it has been lent out to exhibitions elsewhere on several occasions.[16])

The same year, Tawney made a monumental work with the terrific title *Untaught Equation* (facing page), fully twenty-seven feet tall. That was a little less than the height of her sail loft's vertical shaft, and also a numerological match to her address, 27 South Street (though she would soon be evicted).[17] Making it in the August heat was a huge challenge, even at this most productive stage of Tawney's career: "It is very heavy, black and takes my strength," she wrote to Marna Johnson. "It has miles (it seems to me) of very fine (3 strands) of black and white linen."[18] In the end it was completed in a little less than six weeks, "on [a] Saturday, as darkness fell."[19] First shown at the Seattle World's Fair in 1962, it has not been seen intact for some years—Tawney displayed it outdoors hanging from a tree at the Benson Gallery in Bridgehampton, New York, on Long Island, in 1967, with predictable results for its condition. Though still extant it is currently disassembled; surviving photographs and films indicate its original composition. Primarily executed in black and blue linen, the main section is a huge rectangular form, hanging from a series of simple unworked skeins of thread. A long white element cascades downward from the piece's upper register, and a loose, labial fringe in purple and black protrudes at the midpoint—eerily prescient of later works by Claire Zeisler and the Polish fiber artist Magdalena Abakanowicz. Tawney described the motif in unusually visceral terms: "The slit is like a wound and the braids are like issuing blood."[20]

14. Journal (30.8), entry dated August 7, 1964, LGTF.

15. Eleanor Munro, *Originals: American Women Artists* (New York: Simon & Schuster, 1979), 329.

16. The work was selected for acquisition by Mildred Constantine following a studio visit, her first exposure to Tawney's work. Tawney to Johnson, December 12, 1962, LGTF.

17. Tawney interview, AAA.

18. Tawney to Johnson, August 1, 1962, LGTF.

19. Tawney to Johnson, August 21, 1962, LGTF.

20. Tawney to Johnson, August 1, 1962, LGTF.

While sheer height did announce new ambition on Tawney's part, there were two other factors that really distinguished her works of 1961 and 1962 from those she had made before. The first was their reduced palette. Her output was now almost entirely in black and natural linen yarns, of the type normally used for rug warps—a striking departure from the richly polychromatic and texturally varied works she had made in preceding years. While Tawney never explained this choice, it seems likely that she viewed it partly as a sign of seriousness, and partly as a way to emphasize formal structure.[21] Several of the artists around her in Coenties Slip, including Agnes Martin, Jack Youngerman, and Ellsworth Kelly, had also been working at large scale, and mainly in black and white. For each of them, the combination of spatial extension and the elimination of color was a way to establish new pictorial qualities, which were visually immersive but without chromatic "push-pull" effects. Tawney's motives were not that different. Her elimination of color placed exclusive emphasis on her work's scale, silhouette, construction, and internal contrast—its essential presence.

The second of her major shifts at this time was the manipulation of warp threads, such that they skewed out of the usual vertical arrangement. This was made possible by Tawney's use of an "open reed," her own invention. The loom's reed, or batten, is the component that holds the warps taut, evenly spaced, and in alignment. Tawney had been thinking about rupturing this system since 1958, when the "idea of weaving in volume floated up to consciousness." The question was how to achieve it. She noted down several structural ideas at that time, among them: "Weave each warp toward a central point where all are woven together, then out again to separate, to no weaving."[22] This is exactly what she did in 1961. The technical

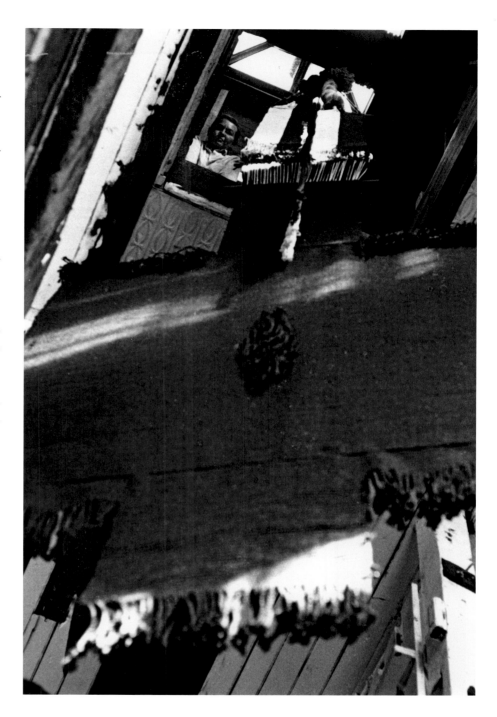

21. Jack Lenor Larsen says that he suggested the use of black and white linen to Tawney, having recently observed the New York City–based weaver Alice English working in those materials at Haystack Mountain School of Craft in Maine. Larsen, interview by the author, November 29, 2017.

22. Journal (30.1), entry dated June 26, 1958, LGTF. Amazingly, the entry continues: "Warps are beautiful in themselves. Leave one hanging of multiple warps unwoven except at top and bottom for poles and perhaps a vague line running through each," a description that comes close to her later Cloud series, realized fully two decades later.

Tawney with *Untaught Equation* in her studio on South Street, New York, 1962. Lenore G. Tawney Foundation, New York.

FOLLOWING SPREAD *The Path*, 1962; linen and gold; 90½ × 24½ in. Lenore G. Tawney Foundation, New York.

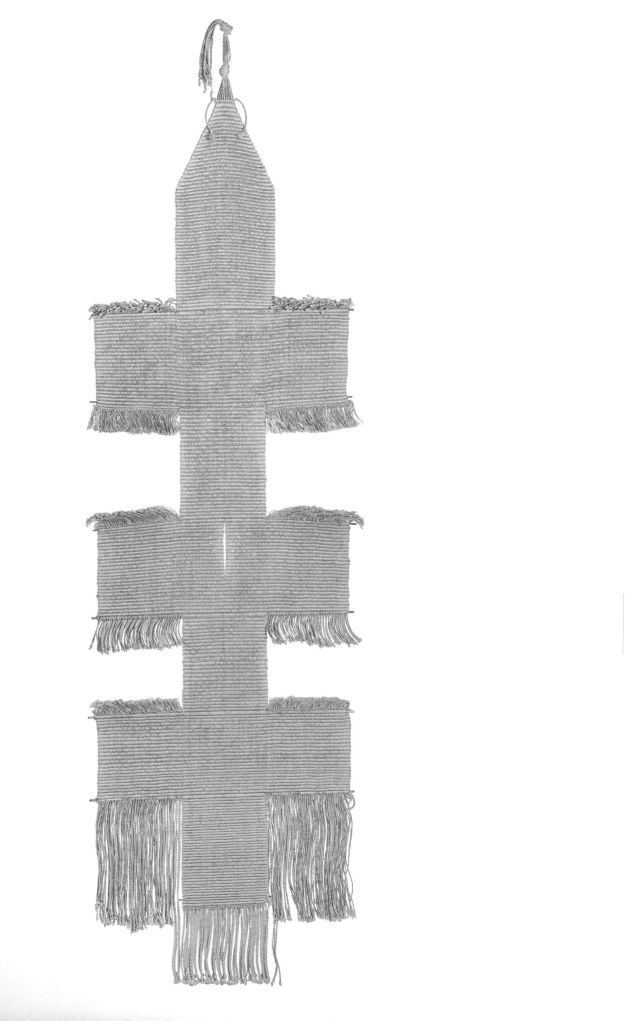

breakthrough was a steel reed with a removable wooden top, which gave her access to the threads. Using this device, she was able to weave with the warps in one position, open the reed, shift their position, pull them taut again, and then keep weaving. This made it possible for the warps to be held constantly in tension but to travel through the finished textile at diagonals. In effect, Tawney introduced an entirely new compositional axis to weaving.

The aforementioned 1962 hanging *Dark River* (sometimes known as *The River*) is an excellent example of open-reed weaving in action. All the warps are gathered at the top in a single point, and hang loose in a topknot. Below that extremity they spread downward, still very closely spaced and in a widening angle. In this upper tier of the work, the wefts are densely packed in a close approximation of plain weave. Then Tawney's previous innovation, open-warp construction, asserts itself. Still fanning outward and downward, the warps float free of any horizontal element for about twelve inches until they arrive at *Dark River*'s widest section, a square of open warps regularly divided into thirds by single wefts. Finally, the lower two-thirds of the weaving unfurl in a tremendously satisfying progression.[23] Using the open reed, Tawney created multiple-warp elements in an adaptation of the Peruvian gauze technique she had learned with the help of Lili Blumenau in 1961, gently sloping inward toward the center, with periodic "joints" made by introducing weft threads. These sections are graduated in their length so that the steadily narrowing width of the textile is offset by a vertical extension of each compartmentalized section. The overall effect is supremely elegant, a marvel of complexity and formal unity. It also beautifully captures the quality of flow suggested in the title. Though Tawney claimed that, like all her work, *Dark River* had taken form "through its own inner necessity," she also felt that she had

tapped into her surroundings while making it: "The changing ways, the current, the surface. I knew what it was going to be, and I think I knew it was the river. I had it inside, and I think that when it is there on the inside it seeps through to your mind. It is an inner landscape that I am doing."[24]

Tawney indeed felt a tremendous sense of discovery while making *Dark River* and other related works. "The weaving just grows and keeps coming," she later said. "It's all inside of me. It was really thrilling—I used to sing and dance all by myself, there at night sometimes. I'd get up very early and work all day."[25] She worked in solitude at this time, speaking to Martin frequently but mainly on the phone. (She was pleased to discover that her friend and neighbor was also working on pieces with a river theme, equally responsive to the flow of water outside her South Street loft's window.[26]) When Jack Lenor Larsen invited Tawney to accompany him on a trip to Africa, the sort of travel she pursued eagerly at other times in her life, she turned him down: "I didn't know whether I'd have it when I came back."[27]

Her intensity paid off. In 1962, at the midpoint of this remarkably generative period, she was rewarded with another one-person show, this time at the prestigious Art Institute of Chicago, whose decorative arts department then had a program featuring prominent craftsmen (others exhibited that year included enamelist Kenneth J. Bates, potters Alix and Warren Mackenzie, and weaver Roy Ginstrom; Sheila Hicks had a show there in 1963).[28] Meanwhile she explored the full ramifications of her new technique, in the process creating a wholly new vocabulary for the medium. In combination with her earlier open-warp method, the open reed allowed her to vary not just the density of her compositions but also their directionality. Typically beginning from a tightly bound top, her works would splay downward in triangles and trapezoids,

23. For further discussion of the construction of *Dark River*, see Mildred Constantine and Jack Lenor Larsen, *Beyond Craft: The Art Fabric* (New York: Van Nostrand Reinhold, 1972), 272.

24. Quoted in Rose Slivka, "The New Tapestry," *Craft Horizons* 23, no. 2 (March/April 1963): 18.

25. Quoted in d'Autilia, *Personal World*, n.p. Similarly, in a later interview, Tawney recalled, "When I was doing the woven forms, I was dancing with joy all the time. They were so spontaneous. I didn't know what they were—they just kept going higher and higher. I thought, No one will ever show

these, they're too tall for a gallery so I'll keep going." Maureen Orth, "The Cosmic Creations of Lenore Tawney," *New York Woman*, May/June 1987, 66.

26. Munro, *Originals*, 330.

27. Quoted in d'Autilia, *Personal World*, n.p.

28. The exhibition, *Woven Forms by Lenore Tawney*, ran from October 6 to December 2, 1962. It included fifteen works, among them *Fountain, Innocent Song, Inquisition, The King*, and *Primal Garment*, as well as smaller works. Johnson to Tawney, October 12, 1962, LGTF.

usually resolving into a more standard square or rectangular unit, but sometimes zigzagging in overlaps from top to bottom. "Instead of one weft thread going through from one side to the other, there are two threads, one from each side," Tawney explained. "These separate and the separate parts again separate and perhaps again. It is like breathing; it expands and contracts. This is what gives it form."[29] Often, horizontal metal rods act as demarcations and strengthening elements. Sometimes Tawney would add blocklike extending arms to define the registers of each form; one such composition, *The Path* (pages 116, 117), looks like the architectural plan of a cathedral; unusually, it has a detail of applied gold leaf in the center, perhaps signifying enlightenment.[30] Wherever threads hung loose, she attended to them carefully, using a variety of wrapping and knotting techniques to add a sense of visual closure. In discussing these finishing graces, she often noted the influence of Peruvian weavings, as well as braided Egyptian wigs that she had encountered in the Metropolitan Museum of Art in New York. Closer to home were the tugboats she could see out her loft window, with impressive coils and knots of rope along their sides.[31]

Lekythos (page 121), now on long-term loan to the Tate Modern in London, is one of many singular achievements of this crucial period. A work of remarkable lightness, it refers to water imagery, like *Dark River,* but in a more classical mode. The ancient Greek lekythos is a tall, slender pouring vessel, often embellished with figural paintings. Tawney borrowed the word for her title, but she spoke of the work as being not like a ewer but a fountain: "It's overflowing. It's spread out. I wove the lower part and simply took the threads and spread them out 36 inches, as far as the loom went, and wove a little bar in there. The rest of the warp I let fall over in front with a two-inch space because it's the overflowing fountain."[32] So lightly constructed that it drifts slightly with any

movement of air, *Lekythos* is also effectively transparent, and thus highly responsive in visual terms to its surroundings.

Other works were figural in implication—"tall, thin beings, wavering in space," as Tawney put it—and it was Agnes Martin who reportedly named them, suggesting titles like *The Virgin, The Bride, The King,* and *The Queen* (pages 107, 121), a quasi-medieval or Romantic typology.[33] In these works, Tawney picked up the thread of her earlier *Bound Man* (page 63), now rendering the body in abstract terms but to equally emotive effect. *The King,* executed in two versions in 1962, has a particularly emphatic stance, with two leg-like forms, one black and one white, arcing upward and tapering away. Rifts open up in the weave toward the base. The title may be Martin's, but *The King* definitely makes sense as an allegory of temporal power: commanding, even arrogant, but also precarious. It is bracing to remember how Tawney made these works. Because they were woven continuously, rolling back into the loom as she went, she did not know what the cumulative effect would be until she was completely finished. "I could only see a bit of the work as I was doing it, no more than a foot or so," she remembered. "But every time I took a whole finished piece off the loom, the proportions seemed right."[34] Their dramatic gestures, complex progressions, and sensuous curves were held in her mind and bound up in her process, and indeed represent a perfect union of her intentions and the dictates of technique.

Soon after Paul Smith assumed the directorship at the Museum of Contemporary Crafts, he resolved to create an exhibition inspired by Tawney's impressive new body of work. This was *Woven Forms* (1963), arguably the most influential fiber art show of the twentieth century. Initially, Smith intended the show to be monographic, but as he had two floors to fill and was becoming aware of a wider movement in fiber, he decided to include four other artists. All were women:

29. Quoted in press release from the Art Institute of Chicago, 1962, LGTF.

30. Robert Indiana recorded a visit to Tawney's studio, where he saw her working on *The Path.* He interpreted the work as having sexual, or at least bodily, content: "Lenore's and see her latest tapestry, wh[ich] she is understandably wild about—a handsome natural-colored vertical w[ith] heavy tassels of knotted fringe and a vagina flecken [*sic*] with pure gold in the centre. But her gold leaf is too shiny and she is trying to think of ways to dull it." Robert Indiana journal, entry dated April 25, 1962, collection of Robert Indiana.

31. Tawney discussed these influences in Joan McDonald's film *Lenore Tawney—Above the Cloud,* a documentary made for her American Craft Museum retrospective in 1990.

32. Quoted in d'Autilia, *Personal World,* n.p.

33. Quoted in Munro, *Originals,* 330.

34. Munro, *Originals,* 330.

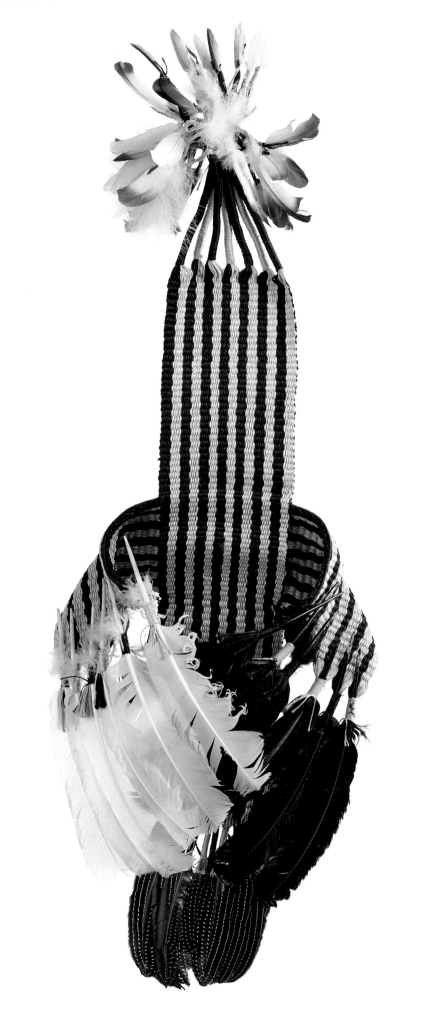

Sheila Hicks, Claire Zeisler, Dorian Zachai, and Alice Adams. Hicks (b. 1934) requires little introduction here, having gone on to worldwide fame since. At the time, though, she was just starting to define her idiom. She had graduated in 1959 from Yale University, where she studied with Anni and Josef Albers. From there she went to Mexico, where by good fortune Smith encountered her on a trip to Taxco el Viejo.[35] Hicks recalls being initially resistant to inclusion in the exhibition, feeling herself quite different from Tawney and the other participants: "I was living in a different world, in Mexico. I had been through the whole Albers program, and they didn't have the fine arts preparation as intensively as I had done."[36] She did not visit the show in person until the end of its run, and when she did she had "mixed emotions. I didn't want to be part of it but when I did see it I was pleasantly surprised. I was interested."[37]

Tawney herself suggested the inclusion of the Chicago-based Zeisler (1903–1991).[38] The two women were roughly contemporaries, and had both studied at the Institute of Design, Zeisler a few years earlier (when she still used her maiden name, Florsheim).[39] Like Hicks, she was still in the formative period of her career at this point and had not yet arrived at the heavy braiding and wrapping that would define her later production. One untitled work she showed in *Woven Forms* could pass for a late 1950s Tawney, with open-warp areas juxtaposed with a solid-weave panel, and long, delicately worked hanging threads.

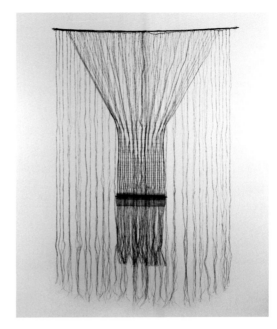

35. Paul J. Smith, interview by the author, December 11, 2017.

36. Hicks recalled saying, "Thank you, but no thank you. I don't want to be in the crafts museum in a group show," but decided "It was in my interest to cooperate and give them biographical information, photos, and to just swallow hard." She continued to have mixed feelings about her inclusion, regretting that she was placed "in lockstep" with the older Zeisler and Tawney in particular, though she did find their work "youthful in attitude." Oral history interview with Sheila Hicks, 2004 February 3

and March 11, Archives of American Art, Smithsonian Institution, Washington, DC.

37. Sheila Hicks, interview by the author, October 29, 2018.

38. Oral history interview with Claire Zeisler, 1981 June, Archives of American Art, Smithsonian Institution, Washington, DC.

39. The two artists did meet at Tawney's studio in March 1962, and responded to each other enthusiastically. Tawney proclaimed Zeisler's "the only original work I've seen in a long time." Tawney to Johnson, March 17, 1962, LGTF.

TOP *Lekythos*, 1962; linen, brass, and acrylic; 50 × 26⅞ in. Tate Modern, London. Presented by the Lenore G. Tawney Foundation (Tate Americas Foundation), 2016. On long-term loan.

BOTTOM *The King I*, 1962; linen and bamboo; 148 × 37½ in. Tate Modern, London. Presented by the Lenore G. Tawney Foundation (Tate Americas Foundation), 2016. On long-term loan.

FACING PAGE Untitled, c. 1965; linen and feathers; 50 × 16 in. Lenore G. Tawney Foundation, New York.

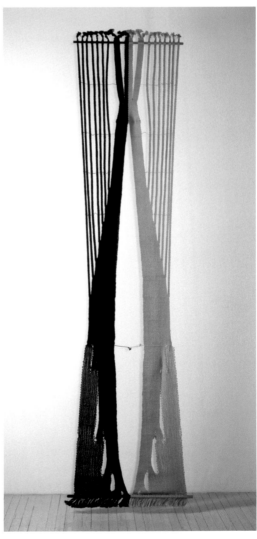

Zachai (b. 1932) had studied at both the School for American Craftsmen (founded by Aileen Webb in 1944 as part of her nationwide craft strategy, it was initially at Dartmouth College and later moved to Alfred University in Alfred, New York) and the California College of Arts and Crafts, Oakland, where she studied with Ed Rossbach. Less technical in orientation than the other artists in the show, her work had a shaggy, rough-and-tumble immediacy. It was a style that Tawney had essayed only occasionally, as in *Primal Garment,* but which would gradually become a dominant idiom in the field toward the end of the 1960s, and a contributor to the "hippie" aesthetic more broadly.

Adams (b. 1930), finally, was a New York–based artist whose sophistication rivaled Tawney's own. She had begun her career studying painting at Columbia University, and spent time in France (1953–54), learning tapestry techniques at Aubusson. While she was never on close terms with Tawney, she had been sent on assignment by *Craft Horizons* to review the Staten Island show, and she praised the "consistently free and courageous" effects ranging from the delicately transparent to the "delightfully disreputable."[40] By this time Adams herself had broken with the traditionally rectilinear format of tapestry; like Martta Taipale and Tawney, she used directionality in the weave to painterly effect. In one striking instance, she even wove a dust mop into the warp, a satirical comment on the stereotypical association of fiber art with feminine domesticity.[41] The two works that were included in *Woven Forms* were impressive, executed mainly in plain tapestry weave but with a clear relationship to abstract painting; their titles, *Major General* and *Yankee Doodle,* were chosen in the wake of the Cuban Missile Crisis. Shortly after her inclusion in *Woven Forms,* Adams abandoned tapestry—her last work in the medium, entitled *The Andes,* was made in 1965. She helped to form an artist-run gallery in SoHo at 55 Mercer Street

and found success as a sculptor, showing in notable exhibitions such as Lucy Lippard's 1968 show *Eccentric Abstraction.* In retrospect, Adams says that while she did find the craft world increasingly "insular," she regrets distancing herself from textiles so forcefully: "But the art world was a brutal place, and it was a decision made in that context."[42]

All in all, Smith's selections for the *Woven Forms* exhibition seem remarkably prescient, as all five participants would go on to be major figures in the fiber art movement. Tawney had clear preeminence, however. Her works, twenty-two in number (about as many as the other four artists put together), occupied a full floor. The presentation was as focused as the Staten Island show had been eclectic, the limited palette helping to point up the consistency of approach. Tawney's monochromatic weavings caromed through the gallery in a rhythmic layout conceived by Smith that echoed the crisscross diagonals of the weavings. The silhouettes were variations on a theme, with constrictions and widenings cascading upward, "expanding, contracting, aspiring," as Tawney put it.[43] Every work hung free in space, away from the wall, though the most lightly built (including *Lekythos*) were placed in front of scrims to increase their legibility. Once lit, they cast shadow drawings on their accompanying white planes, adding ethereal touches to the otherwise materially assertive installation. *Untaught Equation* occupied pride of place in a well at the back of the museum where a stair led up to the mezzanine. This meant that viewers could climb up alongside it, appreciating its great height and dense detail.

The title of the show was Tawney's, too. She had been referring to her new works as "woven forms," as a way of distinguishing them from conventional flat tapestry.[44] The phrase evoked formalism, the dominant school of art theory then prevalent in New York City, as exemplified by the influential writings of

40. Alice Adams, "Exhibitions: Lenore Tawney," *Craft Horizons* 22, no. 1 (January/February 1962): 39. Adams and Tawney had also appeared together in a 1962 show at the Victoria and Albert Museum, London. This exhibition also included Mary Buskirk, Ted Hallman, Trude Guermonprez, and Kay Sekimachi, among others. Ann Sutton, "Modern American Wall Hangings," *Quarterly Journal of the Guilds of Weavers, Spinners and Dyers,* no. 42 (June 1962): 382–84.

41. Susan Hoetzel, introduction to *Alice Adams: Public Projects* (Bronx, NY: Lehman College Art Gallery, 2000), 3.

42. Alice Adams, interview by the author, August 25, 2018.

43. Quoted in Ann Wilson, "Lenore Tawney," in *Woven Forms,* ed. Paul J. Smith (New York: Museum of Contemporary Crafts, 1963), n.p.

44. Johnson wrote to Tawney, "Interesting that they use your term 'Woven Forms' for the exhibition. You, the innovator." Johnson to Tawney, March 11, 1963, LGTF.

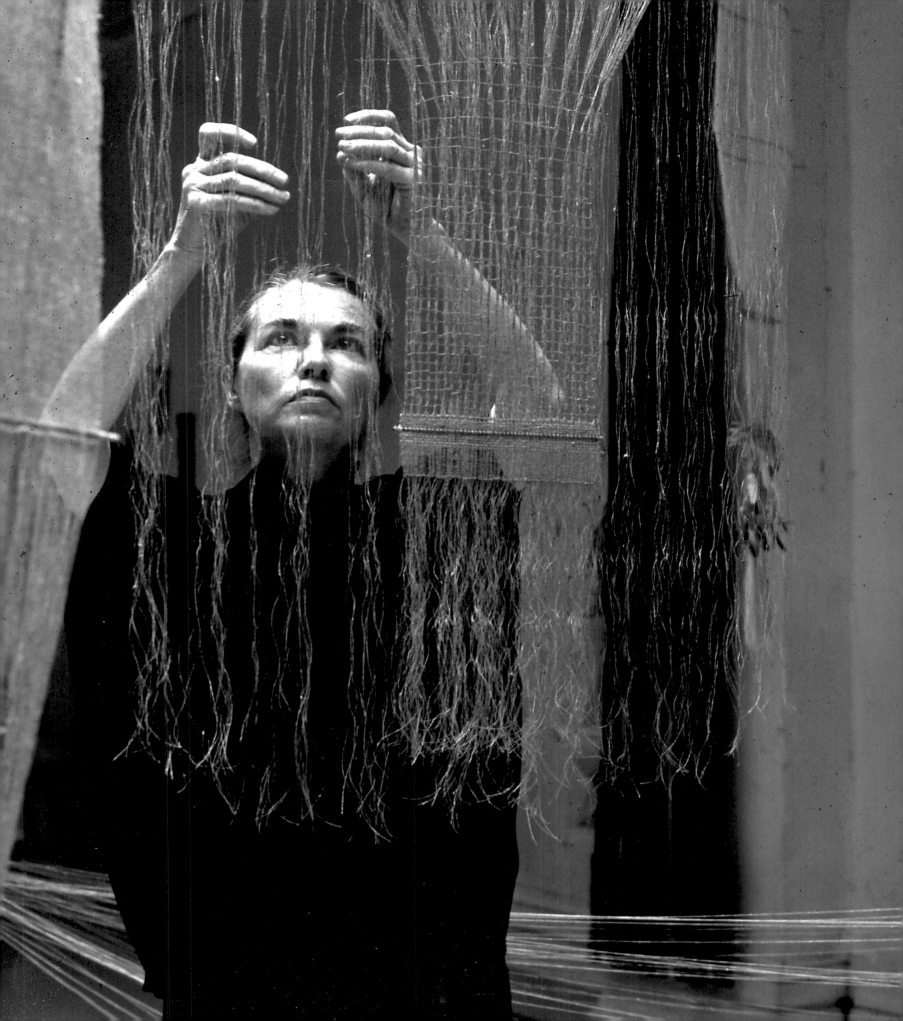

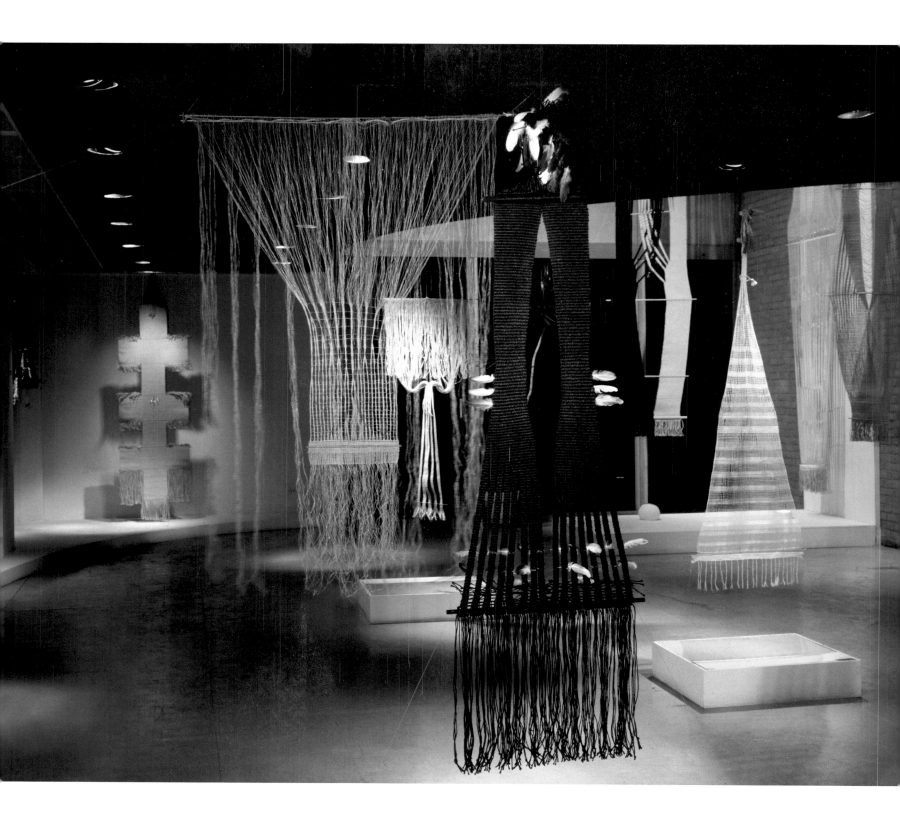

Clement Greenberg, but that association was likely not that important to Tawney, as her formidably wide reading does not seem to have included much contemporary criticism. Nor were members of the Coenties Slip group actively engaged in formalist debates as painters elsewhere in Manhattan were. All the same, there is an intriguing echo here of other chapters in modern craft, in which a functional medium was elevated to sculptural status through emphasis on its purely visual and constructive character.[45] As *Craft Horizons* editor Rose Slivka put it, these were "objects of dimension—possessing form and space with surface and mass interchangeable."[46]

Another implication of the term "woven forms," which certainly was central to Tawney's thinking, was the idea that these were self-standing works, detached from any ornamental purpose. "Form" was a word useful for its neutrality—not a tapestry or a hanging or a garment or a tablecloth, just a form.[47] The contrast with earlier presentations of her work, in which her colorful tapestries were used as room accents, could not have been more complete. The autonomy implied by this language was compatible with the floating quality of the installation. As the artist Robert Kushner (later an acquaintance of Tawney's) points out, this was a moment in sculptural history when there was much discussion of "the base"—the traditional plinth that supported the work and defined it as art. Many artists in the early 1960s, including those associated with Minimalism, were abandoning this convention, and so, too, did Tawney, but she seemed to simply float away from it effortlessly, without associated argumen-

tation or pretension, "because that is just what fiber does."[48] This freed her "woven forms" to become non-relational and internally integrated.

The exhibition opened in March 1963, Tawney attending in a dress of dupioni silk, a "square black Arab coat, and a big knot of black linen yarn in my hair."[49] Afterward Martin hosted a celebration at the Coenties Slip apartment of Robert Indiana. The show was received very positively, attracting such luminaries as the gallerist Betty Parsons (who came three times over the course of the two-month run); the Italian editor and designer Gio Ponti, who saw it in person and then covered it in the pages of *Domus*; and the Austrian émigré architect Frederick Kiesler, who described the show as "an interaction of ritual and art, a shimmering, beautifully articulated sculpture, a mysterious votive."[50] In April the *New York Times* ran a profile of Tawney that underlined her avant-garde credibility—her work "so new and personal that it does not have a name or classification."[51]

The impact of the show was amplified by its subsequent travel to two international locations. In June and July 1963, it was shown at the Museo de Bellas Artes Caracas in exchange for a show on Venezuelan ceramics (which had been on view at the Museum of Contemporary Crafts at the same time as *Woven Forms*).[52] A version then traveled to the Kunstgewerbemuseum Zürich, though only Tawney, Hicks, and Zeisler (page 128) were included. This was a crucial moment of exposure for Tawney's work, and the burgeoning American fiber art scene in general. Margo Hoff wrote Tawney an encouraging note while on

45. On formalist theory applied to the field of ceramics, for example, see Glenn Adamson, "Implications: The Modern Pot," in *Shifting Paradigms in Contemporary Ceramics,* ed. Cindi Strauss (Houston: Museum of Fine Arts, 2012), 36–46.

46. Slivka, "New Tapestry," 10. Smith, in the exhibition catalogue, made a similar observation: "In extending the bounds of the woven piece beyond two dimensions, it was necessary not only to bend or twist the material into

volumetric shapes, but to conceive of the hanging itself as enclosed in space rather than defining a planar limit." See also Ruth Kaufmann, *The New American Tapestry* (New York: Reinhold, 1968), 35ff.

47. For a discussion about similar recent usage of the words "work," "practice," and "site," see Glenn Adamson, *Thinking through Craft* (Oxford: Berg Publishers, 2007), 166.

48. Robert Kushner, interview by the author, December 7, 2017.

49. "I danced (twisted) and drank Scotch.... Next day

nothing hurt but my head." Tawney to Johnson, April 12, 1963, LGTF.

50. Gio Ponti, "Sculture Tessute," *Domus,* November 11, 1963, 26–29; Lillian Kiesler to Tawney, January 10, 1978, LGTF. The Kieslers were friendly with Tawney and Maryette Charlton; this quote is Lillian's recollection of Frederick's comment to her while seeing *Woven Forms* at the museum.

51. George O'Brien, "Weaver Departs from Tradition to Create an Art Form," *New York Times,* April 29, 1963.

52. The exchange, unusual in the early history of the American craft movement, was arranged with the help of Hans Neuman, a Venezuelan industrialist who was a supporter of the Museum of Contemporary Crafts. Neuman paid for the travel costs of both exhibitions. Smith, interview by the author, December 1, 2017. A copy of the Caracas exhibition catalogue, which includes translated texts from the New York publication, is preserved in the LGTF: *Formas Tejidas* (Caracas: Museo de Bellas Artes, 1963).

Installation view of Tawney's work in *Woven Forms*, Museum of Contemporary Crafts (now Museum of Arts and Design), New York, 1963. Lenore G. Tawney Foundation, New York.

Declaration, 1962; linen and gold foil; 212 × 30 in. Lenore G. Tawney Foundation, New York.

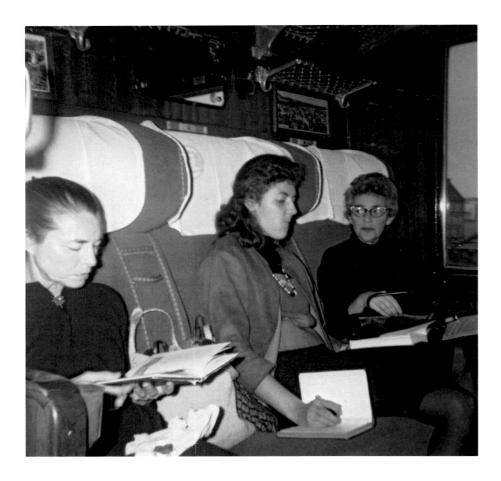

Tawney, Sheila Hicks, and Claire Zeisler traveling during the time of the *Woven Forms* [*Gewebte Formen*] exhibition in Zurich, 1964. Lenore G. Tawney Foundation, New York.

The presentation in Zurich was organized by pioneering textile curator Erika Billeter, who wrote a very perceptive essay for the German-language catalogue, positioning "woven forms" in the European context. "This is no longer the structure of a Gobelin tapestry, a ribbed weaving with an invisible warp, but rather an open statement in which the logic of weaving is revealed, as the artists of the Bauhaus have already demonstrated," she wrote. "Furthermore, surface-oriented composition is overcome by pushing into space.... The result is a 'woven object' in which it is no longer possible to distinguish a 'carrier'—comparable to the painter's canvas—for a decorative image or an abstract composition. A preliminary drawing can be dispensed with, so that these weavers, since they go to their work without any prior conception, approximate the methods of action painting." Billeter rightly ascribed credit to Tawney for her key role in developing the new idiom, and also noted the double meaning in works like *Dark River* and *Lekythos,* which could be seen either as abstract conceptions or as referential depictions, like a Picasso sculpture.[55] The Zürich catalogue also contains a further text on Tawney's work by the artist Ann Wilson, one of the set in Coenties Slip. It, too, is highly observant, though more grounded in technical matters. In the essay's most finely turned phrase, Wilson describes Tawney's yarns as possessed of an animist energy: "One can see the thread twisting, intertwining and spreading; it comes alive and runs like a fiery ribbon on a scroll."[56]

In 1964, the same year that *Woven Forms* was presented in Zurich, Tawney had another international showcase for her work, at the Milan Triennale. This opportunity came thanks to Jack Lenor Larsen, the most accomplished designer of industrially produced textiles of his generation, and a friend and supporter of Tawney's since the two met in the late 1940s in Urbana. Prior to the Milan Triennale, he had already included her work in a small exhibition at the

a trip to Rome: "Of course European shows for you. They must see you here. It will make them stand tall and perhaps smile or weep—but see."[53] Françoise Grossen, for one, saw the exhibition in Zurich and was so moved that she decided to relocate to New York in order to pursue the new sculptural idiom being developed in the United States. Other European artists who would soon become vitally important to the medium were also influenced by Tawney's work, including Magdalena Abakanowicz, Jagoda Buic, and Peter Collingwood—the latter so much so that Tawney would later sharply (and somewhat unfairly) criticize him for copying her too closely.[54]

53. Margo Hoff to Tawney, postcard, May 10, 1963, LGTF.

54. Smith, interview by the author, December 1, 2017; Kay Sekimachi, interview by the author, January 21, 2018.

55. Erika Billeter, "Zur Austellung," in Kunstgewerbemuseum Zürich, *Gewebte Formen: Lenore Tawney, Claire Zeisler, Sheila Hicks* (Zurich: Kunstgewerbemuseum Zürich, 1964), 3-4. Author's translation. Billeter's essay reflected a shift

in her original thinking, which had been more focused on the contemporary interpretation of pre-Columbian techniques; Sheila Hicks had communicated this latter emphasis to Marna Johnson when visiting Chicago for her Art Institute show in

1963. Johnson to Tawney, November 20, 1963, LGTF.

56. Ann Wilson, "Lenore Tawney," in Kunstgewerbemuseum Zürich, *Gewebte Formen,* 6. Author's translation.

Philadelphia Museum College of Art, where he was teaching at the time.[57] More consequentially, he had written a full profile of Tawney for *House Beautiful,* which memorably captured her personality and affect:

> Tawney herself is tough and feminine, and a beautiful refutation of the idea that to be feminine is to be helpless. Physically she is diminutive, with high cheekbones and firm skin—a kind of ageless handsomeness. She moves like a dancer—nimble and relaxed. Her almond-shaped eyes are her most important feature. They take in everything. She can observe without speaking, and be a part of a situation without conversing. When she speaks, her voice is soft and gently modulated—she "throws away" her lines like an assured actress.…The idea, she says, is to be awake. Most of us are asleep.[58]

Larsen was invited to act as the US commissioner for the Milan Triennale in 1964 partly because he had visited the previous iteration of this major design event "as a cub reporter" for *Interiors* magazine.[59] Working with a team that also included Edgar J. Kaufmann Jr. and MoMA curator Mildred Constantine (his later curatorial partner on the important show *Wall Hangings*) as well as architect Charles Forsberg, Larsen delivered an exhibition pavilion on the theme of "leisure," a much-discussed issue at this time of postwar abundance. It was among the last and best of the "designer-craftsman" exhibitions of the era, in which independent studio makers were presented as compa-

rable (and compatible) with industry.[60] Of course, he included Tawney, who was represented by three monumental works: *The King, The Queen,* and *Dark River.*[61]

A fascinating review of the pavilion, written by Judith Miller for *Design Quarterly,* interpreted the selection in relation to American identity: "Free time is here presented as a national and cultural resource which permits the enjoyment of effort, the assessment of quality, the pursuit of ideas, the use of creativity—each for its own sake." She went on to cite Tawney as an example of this principle, noting the thorough inefficiency of her working method. Miller saw in such artistic endeavors "a disdain for our life and times reflected [in] a healthy preoccupation with things un-economic." The independent maker looked on the problems of consumption-obsessed society "with serenity and thoughtfulness. It is as though they have survived a costly communicable disease and now, being immune, can consider how to avoid catching it again."[62]

Miller could not have imagined just how accurate this assessment was, at least in Tawney's case. As we have seen, she had committed herself to a "barer life, closer to reality, without all the *things* that clutter & fill our lives," and her tendency toward solitude was at its most extreme.[63] So much is evident from photographs taken at the time, which show her in splendid isolation, surrounded only by the materials of her craft, and occasionally her cat, Pansy.[64] In this respect, she conformed very much to the romantic image of the artist in her atelier, focused exclusively on creation. Operating without assistants until the very end of her life,

57. *Director's Choice* (Philadelphia: Museum College of Art, 1961), 12. Larsen also included the work of Ed Rossbach in this show, which was chosen by the eleven department directors of the college.

58. Jack Lenor Larsen, "Lenore Tawney—Inspiration to Those Who Want to Develop Their Artistic Potential," *House Beautiful,* March 1962, 158–61, 175–77.

59. Larsen, interview by the author, November 29, 2017. Larsen's review was "Furniture,

Italian and International," *Interiors,* November 1957, 112–16.

60. Among the important predecessors were *Designer-Craftsmen USA* (1953) at the Brooklyn Museum, MoMA's *Good Design* shows, the *California Design* series, and the Walker Art Center's Everyday Art Gallery. See Glenn Adamson, "Gatherings: Creating the Studio Craft Movement," in *Crafting Modernism: Midcentury American Art and Design,* ed. Jeannine Falino (New York: Museum of Arts and Design, 2011).

61. *United States of America Section at the Thirteenth Triennale of Milan* (1964), flyer, LGTF. Among the other prominent makers in the show were Anni Albers, Wendell Castle, Sheila Hicks, Karen Karnes, Dorothy Liebes, and Ed Rossbach as well as Larsen himself.

62. Judith Miller, "The 13th Triennale," *Design Quarterly,* no. 61 (1964): 22–23.

63. Journal (30.10), entry dated December 4, 1967, LGTF.

64. Pansy merits a footnote. Tawney's beloved pet was

featured twice in the *Chicago Tribune,* first in a lament of the departure to New York of "this enchanting, silken-haired cat with the yellow, pansy shaped imprint on her nose," and in 1968 to mark her sad passing: "All along the street people put down coffee cups thoughtfully, glanced out at the shimmer of green in their back yards, and remembered Pansy." Mary Merryfield, "This Gay Creature Makes Us Purr," *Chicago Tribune,* September 25, 1960; Merryfield, "We'll Never Forget Her," *Chicago Tribune,* June 9, 1968.

she also managed to create her work within a fairly restricted material palette, further reducing external dependencies. Tawney bought her materials rather than spinning and dyeing them by hand—she was particularly exacting in her selection of linen, having it cable-plied and polished to increase its luster—and she remained firmly grounded within the repertoire of hand weaving, using a standard four-harness loom.[65]

The year after *Woven Forms,* Tawney did have a transformative encounter with factory technology, but her response was typically idiosyncratic. In the summer of 1964, the First World Congress of Craftsmen was held in New York, at Columbia University. It was another Aileen Webb initiative, and her most ambitious: a global gathering of makers and craft advocates, which aimed for nothing less than an improvement in artisanal welfare worldwide. As part of the program, Tawney hosted a meeting of international weavers at her loft studio.[66] (This was now at a new location downtown, on Beekman Street, as she had been again obliged to leave her quasi-legal dwelling, this time the sail loft on South Street.) As part of the scheduled activities, the weavers traveled out to New Jersey to visit a label factory with a Jacquard loom. For Tawney it was a revelation: "It did twenty labels at a time, each one with little spools and all these threads that went up, up, and they were all going like this; it was terrific like music going."[67] She was sufficiently captivated that she went to study loom technology at Cooper Union and then at the Philadelphia Textile Institute (now Philadelphia University), eventually making a scale model of a Jacquard harness by hand; it hung in her studio as an emblematic object for years after. What interested her, as the above quote indicates, was not the efficiency and complexity that a mechanized

Jacquard loom was capable of, but rather the intricate configuration and frenetic motion of the threads *above* the machine. Interestingly, this displacement of focus, from unaesthetic product to aesthetic process, was exactly paralleled by Eva Hesse's response to the time she spent in an abandoned German textile factory at this time.[68]

The Jacquard encounter did not influence Tawney's weaving in any obvious way, but it did inspire her to create a series of rather wonderful ink drawings, beginning in summer 1964. These are finely made, bearing close comparison with contemporaneous works by the Indian artist Nasreen Mohamedi, which were also partly inspired by looms.[69] For Tawney, the drawings were meaningful primarily for the meditative and repetitive aspect of their execution, a process of ongoing discovery that gave her much joy—Robert Indiana described her at the time as "looking younger than ever, and the great weight that bore her down on the Slip gone."[70] The drawings are typically executed on graph paper, which was both practical (providing Tawney with a preexisting matrix of coordinates) and visual, adding a complex underlayer to her intricate webs. Making the drawings was an experience akin to her weaving; once again, she could only see the complete image when it was finished, as the converging ink lines gradually accumulated into a specific density: "You never know exactly how that will come out."[71] These drawings were as close as Tawney ever came to making work like Agnes Martin's painted abstractions, and like Martin's work they could be read in entirely formal terms, or as screens for spiritual projection. Tawney encouraged this latter response by giving the Jacquard drawings allusive titles like *Gush of Fire* and *The Union of Water and Fire II* and (facing page, page 258), drawn

65. Constantine and Larsen, *Beyond Craft,* 270. Tawney mentions two of her sources—Contessa Yarns in Ridgefield, Connecticut, and the long-established George Butterworth & Son in Philadelphia—in a note to Johnson, August 15, 1959, LGTF. She also ordered custom-made yarns from Scotland.

66. See World Crafts Council, *The First World Congress of Craftsmen,* proceedings (New York: World Crafts Council, 1964). Though Tawney never recorded this, it seems likely that at this event she would have met figures like Kamaladevi Chattopadhyay and Pupul Jayakar from the Indian craft revival movement, which was focused on weaving as a means toward self-sufficiency.

67. Tawney interview, AAA.

68. Sid Sachs makes this insightful comparison in "Lenore

Tawney: Wholly Unlooked For," in Kathleen Nugent Mangan, Sid Sachs, Warren Seelig, and T'ai Smith, *Lenore Tawney: Wholly Unlooked For* (Baltimore: Maryland Institute College of Art, 2013), 8–9.

69. See John Yau, "The Art of Nasreen Mohamedi," in *The Grid, Unplugged: Nasreen Mohamedi* (New York and New Delhi: Talwar Gallery, 2008).

70. Robert Indiana to Rolf Nelson, August 18, 1964, Robert Indiana Catalogue Raisonné Project. Tawney later said of her drawings of the early 1960s, "They were like a meditation, each drawing, each line." D'Autilia, *Personal World,* n.p. See also T'ai Smith, "Lenore Tawney: Asymmetries," in Mangan et al., *Wholly Unlooked For.*

71. Quoted in d'Autilia, *Personal World,* n.p.

PERFECT CROSS SECTION PAPER
10 X 10 TO ONE INCH
No. X25

March of fire

LT

8/27/64

Maquette of Cubed Cube, 1969. Lenore G. Tawney Foundation, New York.

FACING PAGE *Peruvian*, 1962; linen; 86 × 18 in. Lenore G. Tawney Foundation, New York.

from Jakob Böhme (1575–1624), a German mystic who would remain a favorite throughout her life.[72]

A more speculative connection may be drawn between Tawney's interest in weaving technology and a major project that she attempted in the late 1960s. This was *Cubed Cube* (also known as *Ark*), a sculpture that she intended to be her main contribution to the landmark exhibition *Objects: USA,* masterminded by the Manhattan gallery owner Lee Nordness and sponsored by the Johnson Wax Company. Paul Smith took on the role of curating the show with Nordness, traveling across America to find emerging and established talent over a period of two years. Ultimately *Objects: USA* opened in 1969, and then traveled to an astonishing twenty venues in America and a further ten in Europe. In many respects the show was the high-water mark for studio craft; its associated publication immediately became a bible of the movement, and remains a useful reference work to this day.[73]

Given Smith's involvement and Tawney's stature as an artist, there was never any question that she would be included in *Objects: USA*. The question was what she would show. The early tapestry *Jupiter* (page 108), memorably described by art critic Holland Cotter as a "shimmery lavender sphere like a mandala under moving water," was acquired for the Johnson Wax collection prior to the show for the sum of $700 and duly included in the exhibition, though it was inadvertently hung upside down.[74] But Tawney also had an extraordinarily ambitious idea for a woven cube fully twelve feet on each side, which would hang from the gallery ceiling on wires. It was to be woven in black and white linen double cloth (a technique that results in a fabric of double thickness, with a solid block of color on each side). The maquette for the work (at left), illustrated in the *Objects: USA* catalogue, shows it was to have been patterned with checkerboards of various scale.[75] It was an idea with little precedent in her previous work. Tawney had made at least one hanging with a prominent black-and-white grid, a straight-sided piece called *Peruvian* (facing page), whose title suggests a source in the ancient textiles that she and many other weavers were studying at the time.[76] But *Cubed Cube* was something altogether different. Its enormity and geometric design inevitably prompt thoughts of Minimalist art: the orthogonal constructions of Tony Smith and Donald Judd, the metal floor sculptures of Carl Andre. The stipulated size was of industrial scale, another connection to the Minimalists, who pioneered the use of factory processes to make the work. Tawney's project also compares closely to the sculptural work of Sol Lewitt, with its emotionally uninflected mathematical progressions.

Had *Cubed Cube* been successfully realized, it would have been a dominant presence in *Objects: USA* and would likely be remembered as one of the most

72. Tawney took notes on Böhme in an early journal, placing emphasis on his dialectical idea that "a thing can be revealed only through another thing that resists it. Light cannot reveal itself without darkness." Journal (30.1), undated entry [c. 1962], LGTF. Ferne Jacobs recalls reading Böhme aloud to Tawney, after Tawney's

eyesight had failed late in life. Jacobs, interview by the author, December 29, 2017. Tawney's edition was W. Scott Palmer, ed., *The Confessions of Jacob Boehme* (London: Methuen, 1954).

73. Lee Nordness, *Objects: USA* (New York: Viking Press, 1970).

74. Holland Cotter, "Lenore Tawney: Postcard to the World,"

in *Lenore Tawney: Signs on the Wind; Postcard Collages* (San Francisco: Pomegranate, 2002), 8; Lee Nordness to Johnson, March 12, 1969, Lee Nordness Papers, Archives of American Art (hereafter LN/AAA). Johnson alerted Tawney to the mistaken hanging of *Jupiter* after seeing *Objects: USA* in Milwaukee, also noting that some works in the show "were

looking quite bedraggled, we thought, after all those months of travelling." Johnson to Tawney, July 17, 1971, LGTF.

75. A sketch for the work can be found in an undated journal (30.11), LGTF.

76. My thanks to Kathleen Nugent Mangan for pointing out this connection.

surprising and significant textile works of the late twentieth century. It could also be seen, in retrospect, as an important precedent for Tawney's later Cloud series sculptures, which similarly defined a cubic space. But *Cubed Cube* was not realized. Unlike the aforementioned Minimalist artists, Tawney did not manage to secure an industrial manufacturer to execute all its parts. She did find a metal fabricator who could make an aluminum frame to mount the woven panels, at the considerable expense of $2,600.[77] But the weaving was more difficult to achieve. Tawney reached out to industrial mills both in the United States and Europe, but without success; high costs (and probably, required minimums at the mills) frustrated that course of action.[78] Instead she engaged the weaving studio at Cranbrook Academy of Art, headed by Robert L. Kidd, to make her vision a reality.

Kidd was a knowledgeable technician, and fortuitously had just invested in an extra-wide handloom. For whatever reason, though, there were significant delays in beginning the project. Tawney had proposed the cube to Smith and Nordness sometime in the early summer of 1968.[79] But the weaving did not occur until the autumn of the following year, right before the opening of *Objects: USA* in Washington, DC. (Plaintive unanswered letters from Nordness attest to his chagrin: "I'm certain it will be glorious—it's got to be glorious soon in order to be in this exhibition."[80]) When work finally did commence at Cranbrook, disaster ensued. According to Lee Clawson, one of the students who was deputized to work on the project, Tawney did visit campus but kept largely to herself, going to the studio only after dark (and breaking the light bulbs there because she found them too bright).[81] She departed while the weaving was still under way. Then unwelcome news came

77. Undated quote from Designorigins, Inc., Royal Oak, Michigan, LN/AAA. The frame was to be made from extruded aluminum tube with fabricated steel sleeves at the corners, to fix the textile; Velcro was specified to fasten the lengths of the cloth to the frame. This quoted cost included shipping and photography. The expected cost of the whole work, inclusive of weaving, was $6,000. Johnson Wax advanced half this amount to Tawney, an investment that went for naught. Nordness to Tawney, November 2, 1968, LN/AAA.

78. Nordness to Tawney, November 2, 1968, LN/AAA.

79. Nordness to Tawney, July 9, 1968, LN/AAA.

80. Nordness to Tawney, July 8, 1969, LN/AAA.

81. Lee Clawson, email message to the author, January 12, 2018.

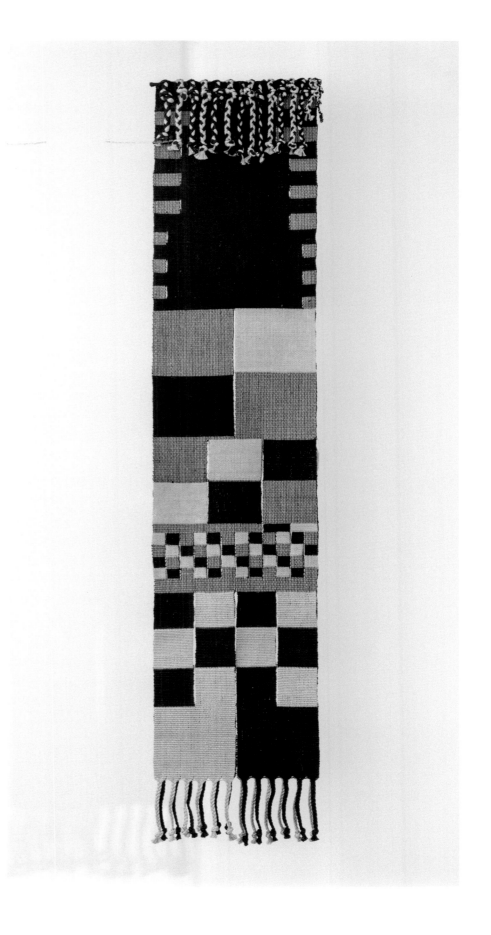

in a letter from Kidd. Due to the heavy weight of the double-weave linen construction, the tension involved was tremendous. Finally, the inevitable occurred: the loom's back beam splintered, and the ratchet wheel cracked in two. To make repairs, the warp would have to be removed, undoing what progress had been made. "It is now certain that this loom will not weave the piece," Kidd informed Tawney, "and the commission will have to be terminated.... It is definitely not a project for the hand-loom, as I rather doubt there is a loom in existence more solidly constructed than mine."[82]

Tawney was furious. She felt that Kidd was prioritizing his own private commissions. "It is all worse than you can imagine," she wrote to her friend Toshiko Takaezu while still at Cranbrook. "Kidd expects me to work every minute and I do, but I don't think they will *ever* finish because he just doesn't push."[83] But Clawson's account attests to the commitment that the studio brought to the project. In an effort to overcome the tension, the weavers attached weights to the batten on the loom so that they could press the long wefts down. They also added reinforcement to the batten to stiffen it, resisting distortion. They contended with other results of the huge force involved: the loom "walked" forward as they worked. The foot treadles cracked under the stress. The heddles that raised and lowered the yarns would not lift them uniformly. Clawson summarizes the experience as follows: "We watched one new idea after another unexpectedly fall short of achieving what we wanted. Lenore felt the same. It was disheartening to see the scale of the project be such a stumbling block. More because large-scale work, sculptural textile art, was a direction many were working towards."[84]

The story of *Cubed Cube* is all the more surprising in light of Tawney's other production in the late 1960s, for this was the period in her career when she was least involved with large scale, or with the textile medium. Instead, she was increasingly devoted to collages and assemblage work, which she saw as a natural outgrowth of her drawings. The pathway to assemblage had begun with what we would today call "mail art," embellished postcards and envelope-clad letters that Tawney sent to friends across the United States, often from overseas. These were thickly encoded, often containing private references that are hard to ferret out many years later—though we might take solace from the artist's comment, "I'm communicating something, but I'm not sure what it is and neither is the recipient."[85] Even when she began making three-dimensional assemblages for exhibition, the scale remained small, the mood intensely private. A portrait of Tawney published at this time shows her folded up inside a cupboard-like structure, a few of the assemblages set out in front of her on the floor; it is captioned, "A noted weaver reaches for confinement."[86]

Tawney's collages and constructions owe something to Surrealism, particularly the gamesmanship of Marcel Duchamp and the inscrutable but deeply felt constructions of Joseph Cornell (images of both artists make appearances in Tawney's mail art oeuvre). Some have the immediacy and wit of contemporaneous Pop art. Others are recondite palimpsests.[87] The intuitive manner of their making also recalls the "flatbed aesthetic" of Robert Rauschenberg; like him, Tawney embedded stray pieces of private life in her compositions.[88] Yet, as valid as these comparisons to other artists may be, her collages are ultimately sui generis, a sensitive register of her artistic sensibility.

They "began in a tentative way," she later said. "One morning I cut a poem apart and reassembled it randomly as the lines came to my fingers as some poets in the twenties did. The lines attached on a central

82. Robert L. Kidd to Tawney, September 24, 1969, LN/AAA.

83. Tawney to Toshiko Takaezu, September 5, 1969, Toshiko Takaezu Family Trust (hereafter "TTFT").

84. Clawson, email message to the author, January 11, 2018. In addition to Kidd and Clawson, the team involved in attempting the cube included Roy Fleming (a friend of Kidd's), Cranbrook students Urban Jupena, Gretchen Bellinger, and Arturo Sandoval, and possibly personal studio assistants of Kidd's.

85. Lenore Tawney interview, AAA. Tawney also spoke of the postcards as coming from her wish "to communicate with friends but not knowing what to say ... messages that looked like writing but they were just signs." D'Autilia, *Personal World*, n.p.

86. "What's New for Living," *House & Garden*, September 1967, 40.

87. In her journal Tawney copied out a passage about palimpsests—"ancient parchments or manuscripts from which an earlier writing is erased in order that the surface can receive another text"—from Theodor Reik, *Fragments of a Great Confession* (New York: Citadel, 1965). Journal (30.10), undated entry [c. 1967], LGTF.

88. Tawney probably saw Rauschenberg's exhibition at the Jewish Museum in 1963—which included his major early combines *Bed, Monogram,* and *Canyon*—because she recommended it in a letter to Johnson. Tawney to Johnson, February 20, 1963, LGTF.

axis assumed a new form, threadlike, quivering, on a background of other lines."[89] These reordered texts demonstrate her love of language as a material in its own right. Most are not even in English. She bought old manuscripts and printed books in French, Italian, Greek, Japanese, and Latin and cut them apart to use in the collages. Sometimes she would overlay closely scribed lines, imposing a drawn screen over the found language. One example (untitled except for the date, May 4, 1964, and completed at two in the morning, as Tawney carefully noted in one corner) is rendered over upside-down text from Edward Gibbon's *Decline and Fall of the Roman Empire*; through extraordinary economy of means, Tawney communicates an Ozymandian message, the vanity of imperial regimes fading into irrelevance behind the warm glow of the cosmic.

More frequently, though, she let her collaged texts float free of such specific response. The words are treated as purely visual traces, graphemes only. In her mail collages, Tawney underlined this quality of abstraction through contrast, adding skittering handwritten messages that *did* mean something. Often her lettering is infinitesimal, "so small as to be a species of micrography, with words and phrases spun out as little more than threads of black ink," in the words of Holland Cotter.[90] This comparison between lines and threads and letters rings true; there is a clear continuity from Tawney's weavings to her drawings to her collages. In each case, she sought a degree of intimacy, yet also an epic quality: the vastness of the ineffable momentarily alighting in material form. (As the poet Richard Howard nicely put it in a 1975 discussion of Tawney's work, "What is the tiny but the last refuge [of] the tremendous in a trifling society?"[91]) One particularly noteworthy series of collages, from 1968, was built around a specific phrase that had caught Tawney's eye—"from his footprints flowed a river"—which she elaborated using images from a Persian acupuncture guide (above).[92] She cut out the figures from this

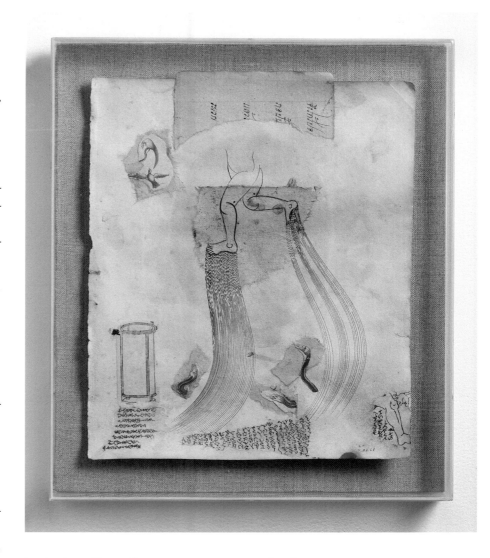

And From His Footprints Flowed a River, 1968; mixed media; 12¾ × 10¾ × 1¾ in. (framed). Lenore G. Tawney Foundation, New York.

book, drew lines of watery current emanating from them, and added other bits of found text and imagery.

Most of Tawney's postcard collages were made for friends: carefully wrought thoughts, sent by post.[93] She valued ongoing exchange, and many of her mail artworks went to a small circle of recipients: Maryette Charlton, Lillian Kiesler, Katharine Kuh, Ferne Jacobs, and Diana Epstein and Millicent Safro, proprietors of a haberdashery shop called Tender Buttons—a Gertrude Stein reference—that was located on East

89. Lenore Tawney, *Autobiography of a Cloud,* unpublished manuscript, comp. Tristine Rainer and Valerie Constantino (New York: Lenore G. Tawney Foundation, 2002), 12.

90. Cotter, "Postcard to the World," 12.

91. Richard Howard, "Tawney," *Craft Horizons* 35, no. 1 (February 1975): 47.

92. The ultimate source of the line is Henry Wadsworth Longfellow's "The Song of Hiawatha," in a passage describing an American Indian myth about the origin of the Mississippi. Tawney saw it as

quoted by Carl Jung. Sachs, "Wholly Unlooked For," 11.

93. See Elissa Auther, "Commentary: Lenore Tawney's Postcard Collages," *Journal of Modern Craft* 8, no. 2 (July 2015): 235–44.

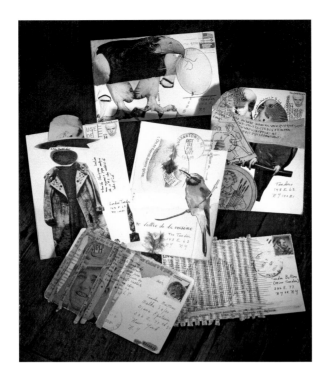

Six mail art postcards to Tender Buttons, 1966–86, mixed media; dimensions variable. Collection of Diana Epstein and Millicent Safro. Lenore G. Tawney Foundation, New York.

such as a rosy-edged feather, "for being tickled pink."[96] She described her own experiences in marvelously sensitive language, as when she set up shop on New Year's Eve, 1963: "Glee must be the word for it, but at the moment eek is more fitting. Silas Marnerishly, I entered the button shop tonight, letting myself in with a smooth gold key the locksmith said must be 30 years old; it would have been nice to dance, but having no room, I fingered buttons."[97] It is no coincidence that Tawney's mail art practice flourished partly through her exchange with Epstein (at left). Together they were establishing artistic ideas, as well as a strong personal connection.

Tawney was interested in the way that an official postmark would land somewhat arbitrarily on her compositions, and thus complete them. On one occasion, when living with Toshiko Takaezu in the late 1970s, she went so far as to walk to the post office on February 14 to mail a valentine to her housemate, ensuring it would bear the imprint of the day.[98] This embrace of the postmark as a "chance operation" within the composition—and an introduction of officialdom into an otherwise personal and hermetic genre—was of interest to others at the time, among them Ray Johnson, who is today remembered as one of the leading pioneers of mail art. Though Tawney eventually fell out with him (apparently over the destruction of a Ruth Asawa sculpture) and decided his work was too "of the moment," the two artists were initially close, and it seems probable that there was mutual influence in their collage works.[99]

In the late 1960s, Tawney and Johnson were both showing at the Willard Gallery on East Seventy-Second Street in Manhattan. This was one of several galleries that mounted exhibitions for Tawney in the late 1960s, the others being Benson Gallery in Bridgehampton (1967), Adele Bednarz in Los Angeles (1968), and Fairweather Hardin in Chicago

Sixty-Second Street in Manhattan. The tiny shop was and is effortlessly artistic, memorably described by artist Jim Dine as "like the bottom of my mother's sewing basket or Joseph Cornell's workshop."[94] Her correspondence with Epstein and Safro teems with imaginative variation, even in the means of address: *Tenders, Tender Birds, Tender Tigers, Tendericus Buttonicus, London Tender, Tender Pears, Tender Peach, Terebrinith Tender, Tender Buttons (Miss Tender), Tender Boos, Too Tender, Malka Safro, Malka Sappho.*

Epstein gave as good as she got; a kindred spirit, she shared Tawney's love of small wonders and delight in wordplay. Her very first letter to Tawney survives; it begins, "What but wow can I say after receiving what I might have thought a ransom note except I knew it was something beautiful."[95] Their correspondence over the years was voluminous, with Epstein sometimes sending letters with objects attached to them,

94. Jim Dine, foreword to Diana Epstein and Millicent Safro, *Buttons* (New York: Harry N. Abrams, 1991), 9. The shop opened in 1964 and remains in business today.

95. Diana Epstein to Tawney, n.d. [1962?], LGTF.

96. Epstein to Tawney, September 4, 1962, LGTF.

97. Epstein to Tawney, December 31, 1962, LGTF.

98. Tawney to Toshiko Takaezu, valentine, February 14, 1979, TTFT. My thanks to Don Fletcher for this observation.

99. Tawney told oral historian Paul Cummings that Johnson "got some work from someone who does knitted sculptures of wire. She's in California; she does forms within forms," likely a reference to Asawa's work. She continued, "They're beautiful and he gave it to May Wilson, who sat on it, destroying it, and then pasted it to something and simply destroyed this person's work. When he told me that, I got very angry with him and I thought he didn't have the right to do that without telling the artist what was going on. So I didn't see him for a long time." Lenore Tawney interview, AAA.

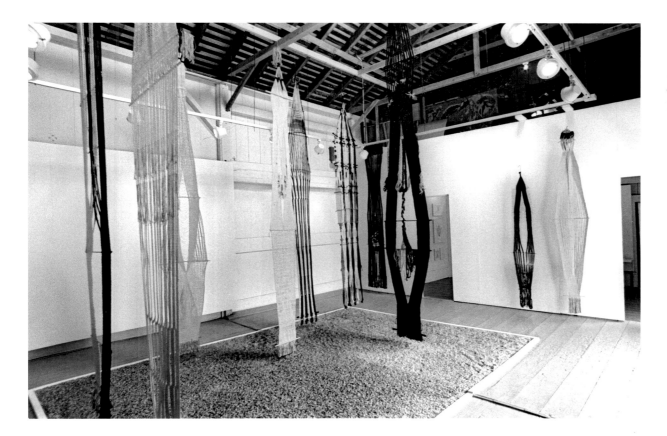

Installation view of solo
exhibition at Benson
Gallery, Bridgehampton,
New York, 1967. Lenore G.
Tawney Foundation,
New York.

(1969). This was her first moment of real art world representation—Marna Johnson having been a private dealer, oriented to the interior decoration trade—and was crucial to the reception of her work at the time. A summer show at Benson (above), installed with help from Takaezu (who also presented some ceramics in the galleries), drew such art world notables as Dorothy Liebes, the sculptors Richard Lippold and Marisol, and the dealer Grace Borgenicht.[100] It was on this occasion that *Untaught Equation*, Tawney's great work of 1962, was hung from an elm tree outdoors—"It looks heroic," she thought.[101] Shortly afterward, in September, she had her show at Willard, which included nearly a hundred works, mostly col-

lages and found-object constructions.[102] The mood of the show was esoteric, foreboding, perhaps a reflection of the intensive psychoanalysis that Tawney was undergoing at the time.[103] This was a good match to Marian Willard's sensibilities, which were informed by Jungian theory and oriented to individualistic practices "probing into the unconscious."[104] Among the highlights were *Médecins Anciens* (or *Quantité Réelle*), a box full of vials suggestive of alchemical experimentation, and *The Cat Kind, The Dog Kind*, a paper collage that transforms the banal idea that people take after their pets into an incantatory concrete poem (pages 138, 139). It was a great success, pronounced by *ARTnews* to be "primitive, beautiful and

100. Tawney to Maryette Charlton, postcard, August 8, 1967, MC/AAA. Liebes purchased a fourteen-foot black-and-white woven work entitled *Cage*; Tawney "knocked it down from $2000 to $1500 for her," and reported that Liebes would put it in her Park Avenue apartment alongside an Alexander Calder sculpture,

and was also planning to bring fashion designer Bonnie Cashin to see the Benson Gallery show. Tawney to Johnson, August 11, 1967, LGTF.

101. Tawney to Johnson, August 11, 1967, LGTF.

102. Price list, 1967, Willard Gallery records, 1917–1973, Archives of American Art,

Smithsonian Institution, Washington, DC. Prices for the works ranged from $50 up to $475 for collages and assemblages, and as much as $900 for weavings.

103. As Tawney was working on the assemblages, she was seeing her analyst thrice weekly: "One reaches deeper

levels, harder, older resistances, stronger self-negations." Tawney to Johnson, April 4, 1967, LGTF.

104. Marian Willard Johnson, quoted in "Marian Willard Johnson, 81, Dealer in Contemporary Art" (obituary), *New York Times,* November 7, 1985, D27.

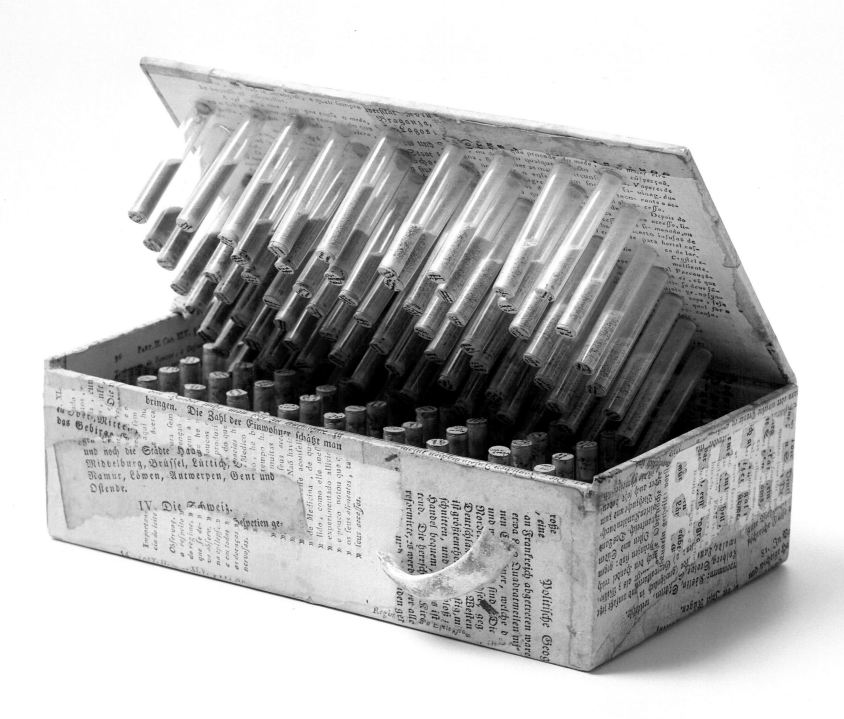

intriguing."[105] Sales were strong, and the collector and patron Dominique de Menil even considered commissioning Tawney for "a church in Texas," perhaps something analogous to Mark Rothko's famous chapel.[106] The painter Paul Jenkins stopped in and left a note for Tawney congratulating her on the show: "As long as we have this kind of magic and energy 'man' so to speak, will go on and will throughout the darkness. Your attitude shines through the simplest statement with force."[107]

All the materials that Tawney used in her collages and constructions were organic: bones, seedpods, shells, eggs, wood, string, an archive's worth of torn paper. Of particular importance were feathers. Tawney had previously used these frequently in her work, beginning with her tapestries of the 1950s; some of the breakthrough woven forms also bore birdlike crests (an example is *Morning Dove*, 1962). A standout work in the Willard Gallery show was *Feather Music* (page 94), described in the *Craft Horizons* review as containing "feathers of some unflashy bird—wing feathers of a city pigeon, probably—put in on edge, as though filed."[108] Feathers were also present in the handful of woven works that were included in the Willard presentation, including two Shields, a format that Tawney had recently introduced—usually asymmetrical and featuring large and small feathers in profusion, with each quill either tied or glued to the weave. As Katharine Kuh noted, these "minute new weavings often require more effort than the large ones, if only because of their greater density and their dependence on the integration of myriad natural objects.... Divorced from their usual habitats, these familiar little forms become curiously obsessive when seen in profuse, yet organized repetition."[109] This intensity of workmanship lends the Shields a ritualistic, even apotropaic quality. "It seems shields are for protection," Tawney mused later. "I didn't know what I was protecting myself from."[110]

The Shields refer explicitly to Native American material culture, which was undergoing a reappraisal

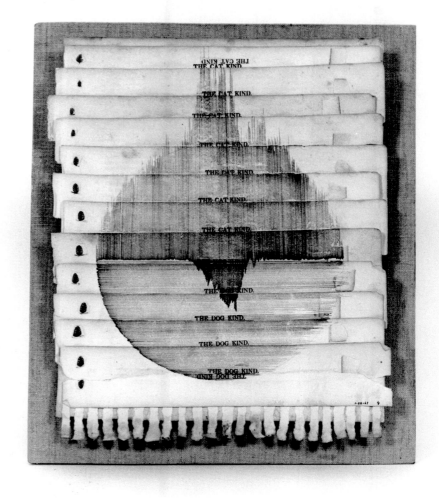

at the time, both from an art historical perspective and on a popular level. Tawney was by no means the only weaver who drew from this well. Her friend Ted Hallman was deeply involved in the study of Native American material culture, as were other fiber artists such as Walter Nottingham and Dominic DiMare. In 1966 the weaver and designer Bernard Kester proposed that the discipline was undergoing "a kind of revolt against the abundance of materials, and fancy ones, too, that the weaver has available."[111] To the extent that Native American crafts were a part of this impulse, one could argue that fiber artists were indulging in a degree of

The Cat Kind, The Dog Kind, 1967; ink on paper; 12¾ × 10¾ in. Lenore G. Tawney Foundation, New York.

FACING PAGE *Médecins Anciens* (or *Quantité Réelle*), 1966; mixed media; 2½ × 8½ × 5¼ in. Lenore G. Tawney Foundation, New York.

105. L. C., "Lenore Tawney," *ARTnews,* November 1967.

106. "Mrs. De Menile [*sic*] for a church in Texas." Note taken by Charlton in conversation with Tawney, August 13, 1967, MC/AAA.

107. Paul Jenkins to Tawney, note, October 21, 1967, Willard Gallery File, LGTF.

108. James Schuyler, "Lenore Tawney," *Craft Horizons* 27, no. 6 (November/December 1967): 23.

109. Katharine Kuh, "Sculpture: Woven and Knotted," *Saturday Review,* July 27, 1968, 37.

110. Quoted in d'Autilia, *Personal World,* n.p.

111. Quoted in "Textiles," *Craft Horizons* 26, no. 3 (June/July 1966): 33. A work by Tawney is illustrated on the same page.

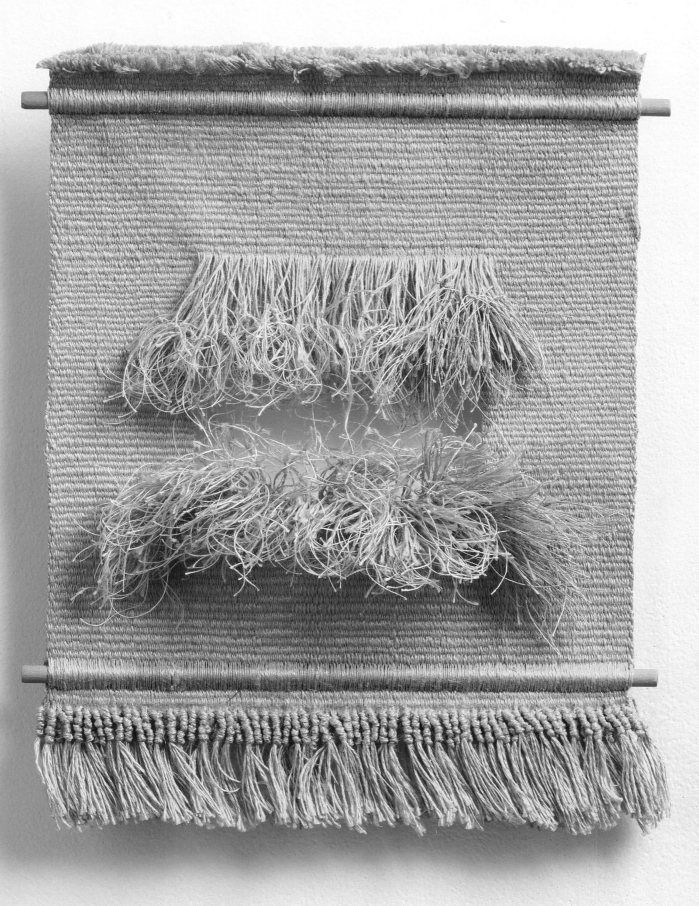

primitivism—an aesthetic choice that paralleled the "back to the land" lifestyle of the counterculture. But in Tawney's case, at least, the work seems free of appropriative stereotyping. She was a syncretic thinker, and though she may have seen a kind of essentialist power in pre-Columbian and Native American artifacts, that was no more or less true of her involvement with medieval mysticism or contemporary abstraction.

Despite the emphasis on her new collage and assemblage work, Tawney's 1967 exhibitions at Benson and Willard further established her as a dominant figure in American fiber art, all the more so because of her convincing achievements in other disciplines. The textile artist Warren Seelig recalls that when he was studying at Cranbrook just a few years later, he was primarily interested in fine artists like Jackie Winsor, Robert Rauschenberg, and Sol Lewitt; in his own chosen field, "it was primarily Lenore Tawney who felt in sync with these contemporary artists."[112] Seelig first discovered Tawney's work not in person but through the gloriously illustrated publication *Beyond Craft,* edited by the curator Mildred Constantine and Jack Lenor Larsen. Though not published until 1972, the book was a further development of the 1969 MoMA exhibition (and publication) *Wall Hangings,* which built on Smith's earlier *Woven Forms* by including international artists, among them Magdalena Abakanowicz, Olga de Amaral, and Françoise Grossen. Because Tawney's *Dark River* was too tall to fit in the galleries, she made a smaller version in natural linen, entitled *Little River* (1969), and gifted it to the museum; also exhibited was a work entitled *Little Egypt* (1964).[113] In *Beyond Craft,* Tawney was once again accorded primacy, described as "the presence around whom American weavers' have rallied."[114]

Wall Hangings and *Beyond Craft* occupy an ambiguous historical position. At the time, they seemed to represent an ironclad imprimatur for fiber; the mighty MoMA had finally recognized textiles as a legitimate art form. Other events around this time reinforced the impression, among them the exhibition *Deliberate Entanglements* at the UCLA Art Galleries in 1971 and a solo presentation by Magdalena Abakanowicz at the Pasadena Art Museum, and the Lausanne biennials of 1967 and 1969 (which marked the series' first official support for "fiber art").[115] Not the least of the exhibitions of the moment was an untitled one-off presentation that Tawney held in her own building on East Fourth Street, a fire-damaged property she had bought in 1970 and refurbished with the help of a painter named Po Kim, who also shared residency with her.[116] The exhibition, which opened in April 1972, was like MoMA's *Wall Hangings* reprised. Tawney included her own work alongside that of Hicks, as well as international figures like Grossen, Ritzi Jacobi, and Olga de Amaral. A major *Abakan* by Magdalena Abakanowicz was accorded pride of place. Ceramics by Takaezu were also included. Photos show that the setting contributed greatly to the exhibition: arched niches created a sepulchral, quasi-religious atmosphere (page 143). Though little known today, this was surely one of the most sculpturally powerful exhibitions mounted in New York in the period, in any medium.[117]

Yet it is easy to overstate the degree to which a barrier had been broken. For one thing, textiles had been shown at MoMA for years, in the Architecture and Design department. Larsen and Constantine brought new ambition to *Wall Hangings,* but as the show's rather bland title suggests, from an institutional perspective it was a natural continuation of

Untitled (Shield), 1967; linen; 10¾ × 9 in. Lenore G. Tawney Foundation, New York.

112. Warren Seelig, "Thinking Lenore Tawney," in Mangan et al., *Wholly Unlooked For,* 17.

113. Mildred Constantine and Jack Lenor Larsen, *Wall Hangings* (New York: Museum of Modern Art, 1969). *Little Egypt* had also been shown at the Museum of Contemporary Crafts in 1964, in the exhibition *The American Craftsman.* Museum of Contemporary Crafts, *The American Craftsman* (New York: Museum of Contemporary Crafts, 1964), n.p.

114. Constantine and Larsen, *Beyond Craft,* 271.

115. See Pasadena Art Museum, *The Fabric Forms of Magdalena Abakanowicz* (Pasadena: Pasadena Art Museum, 1971); and Jenelle Porter, "About Ten Years: From the New Tapestry to Fiber Art," in *Fiber Sculpture: 1960–Present* (Boston: Institute of Contemporary Art, 2015), 168. See also Porter, "The Fiber Art Pioneers," in *From Tapestry to Fiber Art: The Lausanne Biennials, 1962–1995,* ed. Giselle Eberhard Cotton and Magali Junet (Milan: Skira, 2017).

116. Jack Lenor Larsen recalls that the building "was for sale for virtually no money. It required all kinds of fix-up; it wasn't habitable. But she found a Korean painter who was willing to fix it up, at her expense, if he could live at the top. She had the two bottom floors—plus an English basement, which is where the kitchen was. So she could have programs there in addition to the studio." Larsen, interview by the author, November 29, 2017. Po Kim had also helped Tawney move into her Beekman Street loft, together with Toshiko Takaezu. Tawney to Johnson, postcard, January 15, 1963, LGTF. Like Tawney, he would later show at Benson Gallery in Bridgehampton.

117. Information on this show is taken from photographs and a printed invitation in the LGTF.

industry-oriented exhibition series such as *Design Trends, Useful Objects,* and *Good Design,* as well as the medium-specific *Textiles USA* (1956). Art historian Virginia Gardner Troy has noted that these displays did chart a progressive trajectory that "emphasized at first [textiles'] adaptability, then their technical properties, and finally their singular aesthetic qualities."[118] But to say that MoMA ever committed fully to a recognition of fiber artists as equal players in contemporary sculpture would be a misinterpretation; and as far as national reception is concerned, it is indicative that the touring version of *Wall Hangings* went not to major institutions but rather smaller venues like the Ringling Museum of Art in Sarasota, Florida.

In any case, the flurry of interest that fiber art attracted in the late 1960s and early 1970s was soon on the wane.[119] Given that Tawney was regularly and rightly positioned as the first innovator in the medium, it is unsurprising that her personal profile adhered to this same pattern. She showed again at Willard in 1970 and 1974, but, amazingly, these would be her last important solo gallery shows until Helen Drutt presented her work in her gallery in New York in 1988.[120] Tawney's work was included in group exhibitions at American museums during this period: the Cleveland Museum of Art yet again positioned her alongside Takaezu (a former Clevelander) in 1979; the Art Institute of Chicago, where curator Christa C. Mayer Thurman (previously of the Cooper Union in New York) led an unusually ambitious textile art program, acquired Tawney's work assiduously and has by far the most significant institutional collection of her work today; and in 1981 the San Francisco Museum of Modern Art hosted the traveling exhibition *The Art Fabric: Mainstream,* curated by Jack Lenor Larsen and Mildred Constantine, the grand finale of their collaboration.[121] But most of the institutions that showed Tawney's

work in the 1970s and 1980s were smaller: the gallery at California State University, Fullerton (1975), the New Jersey State Museum in Trenton (1979), the Tacoma Art Museum (1981). Given Tawney's stature, one might well have expected more attention to be directed her way.

There were several reasons for this comparative neglect. It is hard to believe that sexism was not a factor—very few women of her generation enjoyed much institutional support, no matter what their medium. This itself was probably part of why fiber art's fortunes declined so precipitously, as so many of the field's leaders were female. But there were also considerations specific to Tawney. Her increasing focus on spiritual pursuits in the 1970s reduced the volume and intensity of her artistic production, and she stopped engaging so directly with currents in contemporary art. Finally, like other leading artists working in materials like fiber and ceramics, the very enthusiasm with which the studio craft movement claimed her as a paragon may have overwhelmed other potential contexts in which her work could have been understood. For all these reasons, she remained a fascinating and generative artist, but one increasingly detached from the New York avant-garde.

In 1970 the artist Virginia Hoffman published an article in *Craft Horizons* entitled "When Will Weaving Be an Art Form?" She forwarded a new paradigm in which the first generation of fiber artists could only be understood as rear-guard figures. Hoffman criticized weavers who still operated in a formalist manner, exploring "colors, textures, shapes, and intriguing illusionary effects" but without explicit conceptualization. She did not name Tawney specifically, but seemed to be describing her precisely when critiquing weavers who "work within a two-dimensional frame of reference and break away only by contriving to

118. Virginia Gardner Troy, "Textiles on Display, 1945–69," in *Exhibiting Craft and Design: Transgressing the White Cube Paradigm, 1930–Present,* ed. Alla Myzelev (London: Routledge, 2017), 23.

119. For further discussion on this point, see Elissa Auther, *String Felt Thread: The Hierarchy of Art and Craft in American Art*

(Minneapolis: University of Minnesota Press, 2010).

120. A quasi-exception was *Lenore Tawney: A Personal World* (1978), a small retrospective organized by Brookfield Craft Center that traveled to Hadler Gallery in New York; Tawney did have occasional shows at Fairweather Hardin in Chicago (1980) and Mokotoff Gallery in

the East Village in Manhattan (1985, 1986), but these were modest affairs.

121. Thurman (then Christine Mayer) arrived at the Art Institute in 1967 and remained in the post for forty-two years. She first acquired a work of Tawney's, *Two Forces Meeting and Opposing* (1959), through Marna Johnson in 1969.

Johnson to Tawney, May 3, 1969, LGTF. The Art Institute would later receive works by Tawney from Katharine Kuh's personal collection, and from the artist herself. See also Mildred Constantine and Jack Lenor Larsen, *The Art Fabric: Mainstream* (New York: Van Nostrand Reinhold, 1981).

Installation views of exhibition organized by Tawney at her residence on East Fourth Street, New York, 1972. Lenore G. Tawney Foundation, New York.

Detail of *The Bride*, 1962.

PAGE 146 Untitled (Bird),
c. 1965; linen, feathers, and
wood; 65 × 30 in. Lenore G.
Tawney Foundation,
New York.

PAGES 147–49 Untitled
(Lekythos), 1962; linen, silk,
gold, and feathers; 46½ ×
29¼ in. Lenore G. Tawney
Foundation, New York.

PAGE 150 *Pia Avis,* 1969;
mixed media; 6¼ × 6⅝ ×
4¾ in. Lenore G. Tawney
Foundation, New York.

PAGE 151 *Peach Hüm
with Threads,* 1979; mixed
media; 8¾ × 8 × 1½ in.
(framed). Lenore G. Tawney
Foundation, New York.

PAGES 152 AND 153 *Orinoco,*
c. 1967; linen; 129 × 22½ ×
4 in. Lenore G. Tawney
Foundation, New York.

appear to be three-dimensional. They expand multi-layer fabrics naively, believing they have entered into outer space; they weave slits…but they do not actually involve space."[122] Hoffman did have positive things to say about a few established weavers who worked in a fully sculptural manner, like Kay Sekimachi and Alice Adams, but her preferred models were the Post-minimalist artists who had recently been presented in the exhibition *Anti-lllusion: Procedures/Materials* at the Whitney Museum of American Art, New York. She also illustrated work by a range of younger fiber artists—none of whom went on to make much of an impact, as it happens—who employed non-loom techniques and rough materials like rope and wire.[123]

Hoffman's article was unusual, coming as it did from an artist who was sympathetic to the cause of fiber art, but was nonetheless critical of its trajectory. As Elissa Auther has written, more powerful voices in the art world (notably including the sculptor Louise Bourgeois, in a review of *Wall Hangings* published in *Craft Horizons*) were simply dismissive of the new turn in textiles and its relevance to the broader sculptural field.[124] At this point in history, it was still easy for people to miss the obvious—for example, the similarities between Tawney and Eva Hesse, who was also interested in material experimentation, repetitive handwork, and humanized geometries. In retrospect, it is possible to see continuity across boundaries that were then strictly (if implicitly) enforced. But Tawney herself was unconcerned about these matters of status. "I think the biggest problem is thinking about an audience," she said in 1971. "That's the one thing you have to lose."[125] In the following years, her art and her life would take an increasingly spiritual turn. She had spent the 1940s and most of the 1950s as a student, learning her craft. In the 1960s, she established herself as a major sculptor, independent and self-defined. In the 1970s, she would again put herself in the position of an initiate, ready to learn from those with wisdom to impart. She would remain an artist of great power and achievement; but first and foremost, she would be a seeker.

122. Virginia Hoffman, "When Will Weaving Be an Art Form?," *Craft Horizons* 30, no. 4 (August 1970): 18. Hoffman was a professor of art at California State University at Los Angeles.

Her contributor's note in *Craft Horizons* described her as "weaving on the loom using metal exclusively, then off the loom using processes of the metalsmith to create tubular weavings of rigidity and strength as well as plasticity" (5). See also Auther, *String Felt Thread,* 44.

123. In addition to her own work, Hoffman included the work of Bill Koons, Judith Millis, and Susan Streuter.

124. Auther, *String Felt Thread,* 33.

125. Tawney interview, AAA.

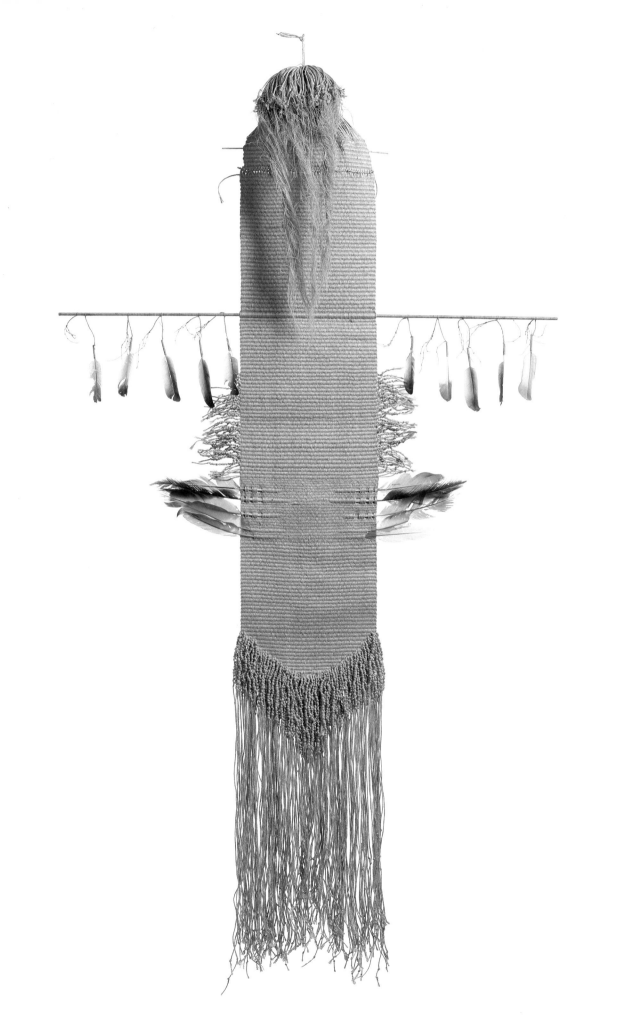

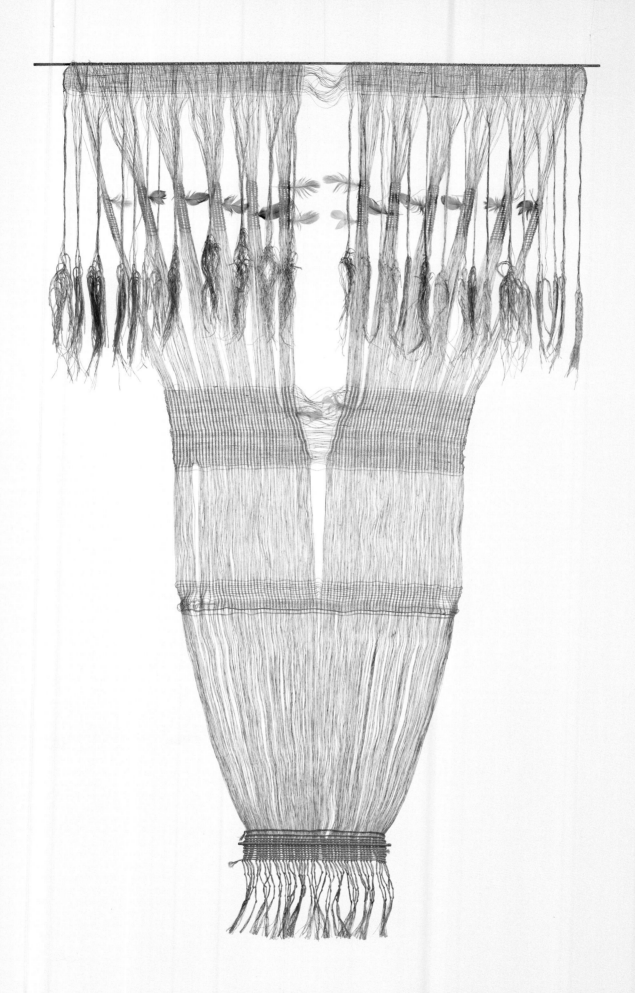

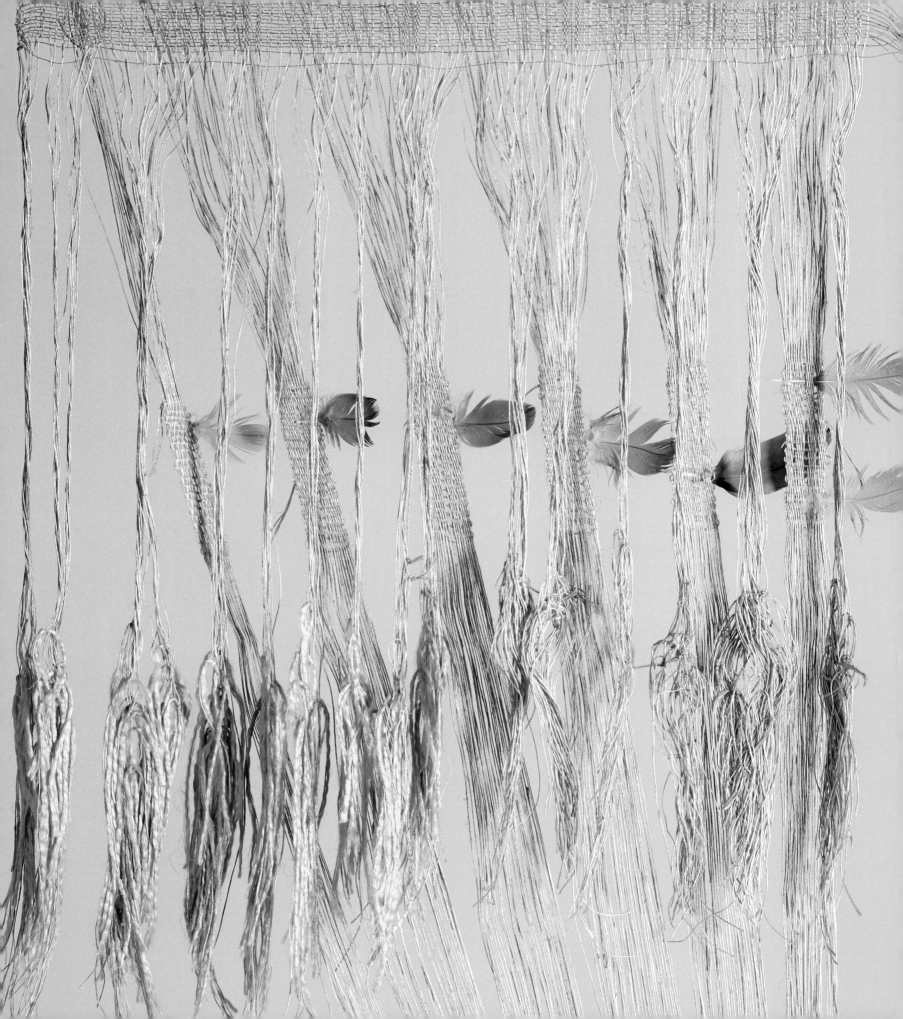

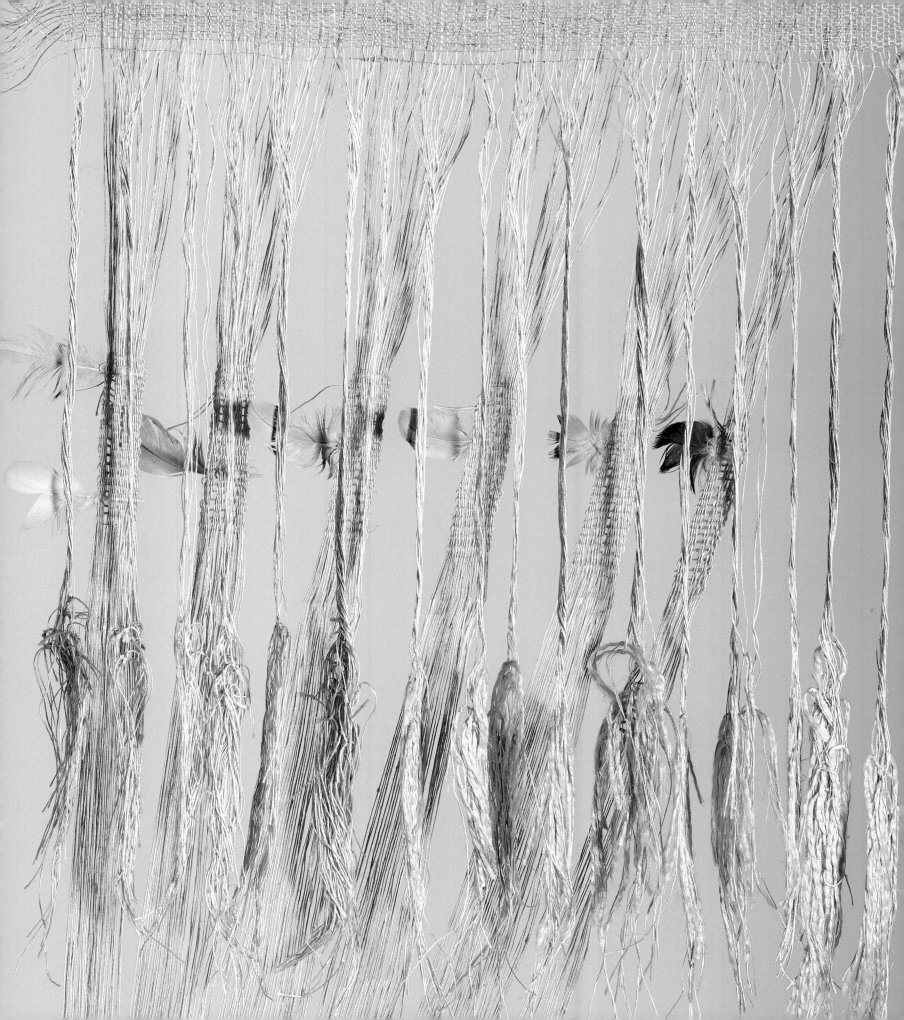

hüm hüm hüm hüm hüm hüm hüm hüm hüm hüm hüm hüm hüm

LT 7.11.79

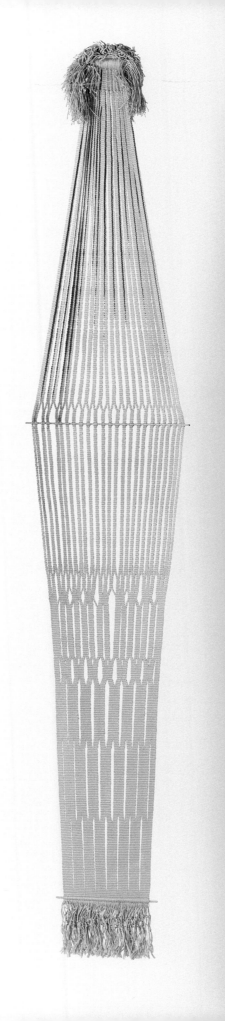

The Archive
The Waters below the Firmament

MARY SAVIG

In 1977 Lenore Tawney mailed a postcard to a friend, artist Lillian Kiesler, that featured a reproduction of John Sloan's gloomy 1907 seascape *The Wake of the Ferry II*. Sloan's expressive swirls of paint form churning waters and melancholic sky, which prompted a critic to describe the work as "one of the few really first-rate mood paintings in early twentieth-century American Art."[1] On the verso (facing page), in lieu of a conventional message, Tawney generously applied horizontal strokes of white acrylic paint. Along the lower right edge, she wrote "the waters below the firmament." Like much of Tawney's mail art, this postcard is an assemblage of sources that are witty, self-referential, and utterly puzzling. The phrase originates from the Book of Genesis and later appears in the work of seventeenth-century German mystic Jakob Böhme (esteemed by Tawney), who defined the firmament as the liminal space between "the outermost of this world from the outermost of the upper heaven."[2]

The inscription is also a sly nod to Tawney's 1976 wall hanging *Waters above the Firmament* (page 195). The ethereal tapestry features a circle set within a square, a visual depiction of Böhme's distinction between this world and the eternal afterlife. The top half of the circle features warps embellished with strips of vintage books and coated in a luminous blue paint, evoking stars hung from heaven's dome.[3] The bottom half lays bare the unadorned linen warps,

implying the humble terra firma. In this light, Tawney's postcard to Kiesler, with its reaching painted lines and decontextualized quote, privileges a toiling humanity beneath the boundless beauty of the cosmos. Like much of her collage work, it poses more questions than it answers.

Tawney's all-encompassing studio practice, especially her deep engagement with mail art, builds on genealogies of amateur women's work and vanguard art movements. With feminine hobbies such as poetry, shellwork, paper collage, floral illustrations, and needlework, a woman could articulate a sense of refinement as well as control over an environment (and herself). Avant-garde artists, comparatively, provoked art world categories by incorporating found materials into radical assemblages, as well as privileging ideas and language over finished artworks. Tawney drew freely from these eclectic wells to express intimate affection, even sensuality, through coded subject matter and materials.[4]

Tawney's process began with the cultivation of her studio landscape. The accumulation and arrangement of books, artworks (both made by Tawney and acquired by Tawney), and natural ephemera was an ongoing process. The abundance can be discerned in photographs as well as in Tawney's oral history interview in 1971 for the Archives of American Art. As she and oral historian Paul Cummings walk through her studio on East Fourth Street toward the end of

Mail art postcard to Lillian Kiesler (verso), postmarked September 21, 1977; postcard, acrylic, and ink; 4 × 6 in. Lillian and Frederick Kiesler papers, circa 1910–2003, bulk 1958–2000. Archives of American Art, Smithsonian Institution, Washington, DC.

QUAKERTOWN, N.J.
SEP
21
PM
1977
08868

RIGHT OF PEOPLE PEACEABLY TO ASSEMBLE
USA 9c

Lillian Kiesler
56 Seventh Ave
N.Y. N.Y.

the waters below the firmament

the interview, Cummings expresses fascination with her troves of global commodities, to which Tawney responds, "It's too much going on." She gestures to a sieve from Colombia, some unidentified objects from Egypt, something else from Peru sitting atop an artwork by American ceramicist Peter Voulkos, and two alabaster fountains (one from Damascus) before concluding, "I think that's all. We were going all right downstairs, but I think we started to lose track of this."[5] The interview abruptly ends there, likely because the highly visual tour was not well suited for an audio recording.

The effects of her studio were a favorite subject of photographers. Mary Alice Roche, founder of the Sensory Awareness Foundation, provided a lengthy, exceptionally textured description of Tawney's West Twentieth Street studio in 1990:

> The gleaming, highly polished wooden floor stretched the whole length of the building, front to back, broken only by a few supporting columns. Columns, walls, and ceiling were painted white. What a sense of lightness and space! Thousands of objects inhabited this loft, but only seemed to enhance the feeling of spaciousness....
>
> There were a few pictures on the wall, and many long tables with an unimaginable collection of materials for "collages in progress." Lenore, at 83, and after a serious illness, was, as usual, hard at work. I could have spent weeks and never seen all of the bits and pieces, large and small, that Lenore had gathered and lay all about—from the natural world, and the lives of human beings. There were pages from ancient books; parts of little dolls, baskets of egg shells; shelves of antique wooden hat forms, some already being surprisingly transformed into people/heads; cupboards with dozens of small drawers, each one with its own special occupants. A line of stone "eggs" divided the space: starting with a very small one in the middle of the floor and marching on in increasing, graduated sizes to a very large one by a central column....
>
> But somehow, the whole place was a "work in progress." What might have been clutter

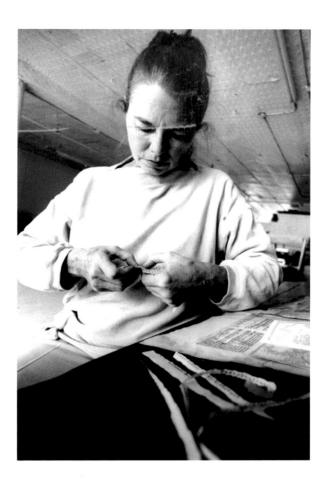

Tawney in her studio on Spring Street, New York, 1966. Photo by Clayton J. Price. Lenore G. Tawney Foundation, New York.

FACING PAGE Contact sheet with images of Tawney's studio on Wooster Street, New York, 1974. Photos by Clayton J. Price. Lenore G. Tawney Foundation, New York.

> disappeared into a kind of order—of various sizes and shapes and colors and areas with an encompassing sense of space.[6]

Tawney's studio was evidence of how the irrepressible artist generated a visual and tactile world around her, intersecting sight and touch. Tawney committed herself fully to her process with intellectual and creative rigor.

Mail art was an ideal vehicle for disseminating her accumulated treasures. Tawney's endeavors were part of a broader international mail art movement, evolved from Dadaist and Fluxus interventions in the art world. In the 1960s mail art helped a growing contingency of conceptual artists circumvent traditional modes of acquisition and display in galleries and museums. In other words, Tawney could insert an artwork into a private collection simply by mailing a collage, without having to work with a dealer. "People have framed them, and they collect them. They're fun to do, you know because you don't have any critics on that. I think the biggest problem is thinking about an audience,

Mail art to Kirk Winslow (son of Maryette Charlton), c. 1965; mixed media; 8¼ × 5½ in. Maryette Charlton papers, circa 1890–2013. Archives of American Art, Smithsonian Institution, Washington, DC.

RIGHT Mail art to G. Espenscheid, postmarked February 11, 1978; mixed media; 6 × 4 in. Lenore G. Tawney Foundation, New York.

BELOW Ceramic postcard (with Toshiko Takaezu) addressed to Katharine Kuh, November 7, 1977; glaze on clay; 4 × 5½ × ½ in. Lenore G. Tawney Foundation, New York.

that's the one thing you have to lose," she reflected in an interview.[7] Tawney was aware of the broader mail art movement through her friend Ray Johnson. Both artists delighted in visual and textual wordplays, with a goal to bring the everyday to their art. Tawney, however, eschewed participating in more anonymous correspondences. Whereas Johnson's New York Correspondence School, among other global collaborations, encouraged practitioners to share their mail with strangers, Tawney preferred to make art for a known recipient. With this in mind, Tawney's mail art demonstrates the affection she held for her network of confidants.

A friendly intensity orients all of Tawney's mail art. Language is intertwined with found images, feathers, flowers, and stones into exquisite assemblages that passed through the postal system and into the mailboxes of her cherished friends, including Lillian Kiesler, Maryette Charlton, Toshiko Takaezu, Samantha Sneed, Ferne Jacobs, Katharine Kuh, Jack Lenor Larsen, Charles and Charlotte Selver, and Diana Epstein and Millicent Safro, proprietors of Manhattan button shop Tender Buttons (pages 136, 243). The postal system offered structure for circulating mail art, and also tempted makers to tests its limits. Tawney, for example, once teamed up with Takaezu, a ceramicist, to make postcards out of thin slabs of etched and glazed clay (at left, bottom). (If any of the delicate pieces were actually mailed, they likely did not survive the journey.) The rest of her mail art features more typical materials (at least for Tawney): bird feathers, pebbles, clippings from magazines and books, photographs, and thread.

These outgoing gifts articulated her unique visual vocabulary. For a postcard collage for Charlton, a filmmaker, a page of German gothic type serves as a striking backdrop for a sweet clipping of a yellow duckling nestled in a bed of actual feathers (facing page, top). In the right corner is a large black fingerprint, signifying the material presence of the artist. We might picture Tawney feathering this nest from her own stash of feathers in her nest-like studio. Along similar lines, Tawney cleverly compacted the soaring space of her South Street studio into a mailbox-friendly collage for Charlton (facing page, bottom). Again, the message brims with the inimitable presence of Tawney.

Her spiritual renderings and decontextualized quotes often lend inchoate gravitas to her mail art collages. There are hieratic texts, medical diagrams, and

kowaikae, hi. 2/96

hippomit pilosus) HOOF SHELL

to dear lenore - with much love. kay + bob 2/9/96

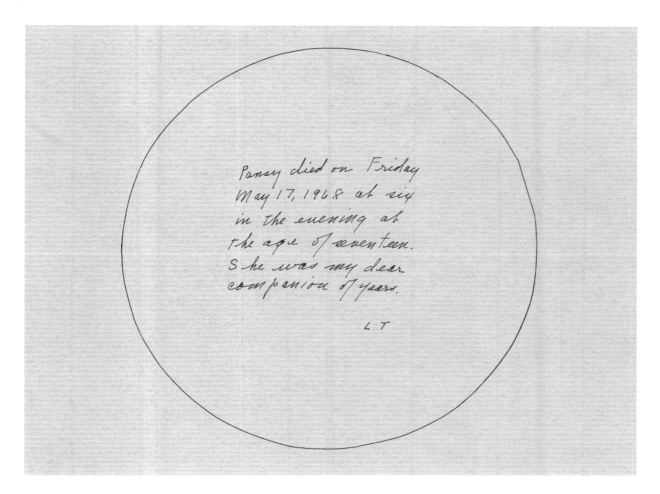

Pansy died on Friday
May 17, 1968 at six
in the evening at
the age of seventeen.
She was my dear
companion of years.

L T

Letter to Maryette Charlton, c. May 17, 1968; ink on paper; 7½ × 7¼ in. Maryette Charlton papers, circa 1890–2013. Archives of American Art, Smithsonian Institution, Washington, DC.

FACING PAGE Kay Sekimachi and Bob Stocksdale, greeting card with hoof shells to Lenore Tawney, February 8, 1996; mixed media; 6¼ × 4½ in. Lenore G. Tawney Foundation, New York.

abstract paintings. They emphasize the vitality of life, with delicate eggs, sensuous peaches, and adorable baby animals. They also point toward the inevitability of death, with dried flowers, images of skeletal body parts, and a poignant announcement of the death of Tawney's beloved cat Pansy (above). Individual components have been placed into dynamic conversations in an otherworldly language. "The postcards came from wishing to communicate with friends, but not knowing what to say—you don't want to say anything but you want to be a friend. So I began making these postcards with messages that looked like writing but they were just signs. There *was* a message, but it was invisible," she clarified.[8]

The content of the messages often registered her mood, and sometimes she was simply hilarious. A card for Lillian Kiesler features a watercolor illustration of a banana (page 162, left). Addressing it to "my slippery friend," Tawney provides some facts about banana trees and signs off with unsolicited, silly advice: "If you see a banana skin, eat it don't slip on it." A 1977 holiday card to curator Lee Nordness suggests Tawney's more subtle sense of humor (page 162, right). The postcard features an image of a checkered cube, layered with a checkered visage of a man in a checkered top hat. The collage surely refers to *Cubed Cube,* Tawney's unrealized woven sculpture for Nordness's 1969 exhibition *Objects: USA,* and more wryly nods to her checkered past with Nordness, as the failure of the piece sparked substantial tension between the two.

Tawney took delight in disrupting the expected narrative of correspondence with her illogical arrangements of inside jokes and symbols. Like her studio space, this mode of making meaning from ambiguous sources became legendary. Her own aesthetic interests were a magnet to others—she often received small watercolors, collages, and ephemera from friends that spoke to her influence. Jeweler Kazuko Oshima glued feathers and wisps of handmade paper to cards for Tawney, and Berkeley-based artists Kay Sekimachi and Bob Stocksdale organized small seashells in a grid on their correspondence (facing page), demonstrating

ABOVE LEFT Illustrated letter to Lillian Kiesler, May 26, 1982; paper, watercolor, graphite, and ink; 4¾ × 5½ in. Lillian and Frederick Kiesler papers, circa 1910–2003, bulk 1958–2000. Archives of American Art, Smithsonian Institution, Washington, DC.

ABOVE RIGHT Mail art postcard to Lee Nordness, postmarked December 20, 1977; postcard, printed material, and ink; 5½ × 4¾ in. Lee Nordness business records and papers, circa 1931–1992, bulk 1954–1984. Archives of American Art, Smithsonian Institution, Washington, DC.

FACING PAGE Mail art postcard to Michael Callaghan, September 29, 1977, postmarked October 1, 1977; mixed media; 6½ × 4¼ in. Lenore G. Tawney Foundation, New York.

that Tawney remained the nexus of her self-fashioned mail art network.

Tawney's mail art practice can be seen as a collaborative extension of her unique studio environment. With her multifaceted sources at hand, she bridged the distance among friends. While these works prompt more nuanced stories about Tawney's relationships, they also harbor many secrets—the inside jokes that only ever existed between two people and floating signifiers that never held meaning. But the point is not to gaze upon each star, but to appreciate the constellation.

1. John Canaday, "A Bright Beginning, a Long, Sad Ending," New York Times, September 26, 1971.

2. Jakob Böhme, The Confessions of Jacob Boehme, ed. W. Scott Palmer (London: Methuen, 1920), 24.

3. In a statement for the Brookfield Craft Center, Tawney wrote about Waters above the Firmament: "The circle is divided…this is from the Bible, when the waters were divided…the waters above the firmament were separated from the waters below. The waters above are blue collage. This was the first time I had used collage in weaving. It made my collage and weaving come together. I was happy about that because I had this thought in my mind for quite a long time without articulating it. This idea of collage and weaving. I do the collage while I'm weaving it." Lenore Tawney papers, archives of the Lenore G. Tawney Foundation, New York (hereafter "LGTF").

4. See Lisa L. Moore, Sister Arts: The Erotics of Lesbian Landscapes (Minneapolis: University of Minnesota Press, 2011), 3.

5. Oral history interview with Lenore Tawney, 1971 June 23, Archives of American Art, Smithsonian Institution, Washington, DC.

6. "Interview with Lenore Tawney by Mary Alice Roche in the Tawney Studio in NYC, July 17, 1990," LGTF. Roche interviewed Tawney about the sensory teachings of Charlotte Selver.

7. Oral history interview with Lenore Tawney, 1971 June 23, Archives of American Art, Smithsonian Institution, Washington, DC.

8. Quoted in Jean d'Autilia, Lenore Tawney: A Personal World (Brookfield, CT: Brookfield Craft Center, 1978), n.p. Emphasis is Tawney's.

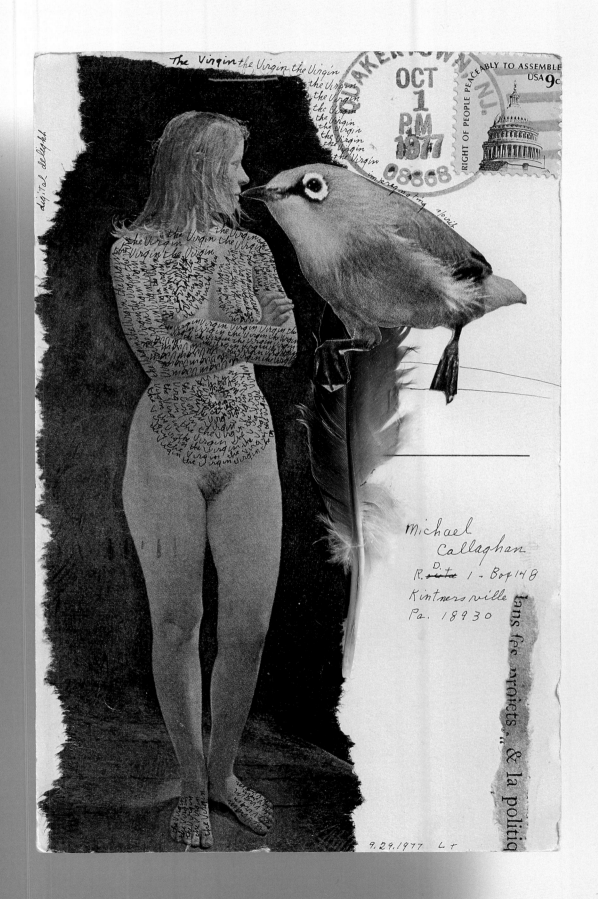

The Virgin the Virgin the Virgin
the Virgin
the Virgin
the Virgin
the Virgin
the Virgin
the Virgin
the Virgin

digital delight

QUAKERTOWN N.J.
OCT
1
PM
1977
08868

RIGHT OF PEOPLE PEACEABLY TO ASSEMBLE

USA 9c

Michael
Callaghan
R. D. 1 - Box 148
Kintnersville
Pa. 18930

lans fes projets … & la politiq

9.29.1977 Lt

*When the Two Shall Be
One*, 1966; mixed media;
10½ × 13 × 1½ in. (framed).
Lenore G. Tawney
Foundation, New York.

FACING PAGE *Crown of
Thorns*, 1966; mixed media;
7½ × 7¼ in. (framed).
Lenore G. Tawney
Foundation, New York.

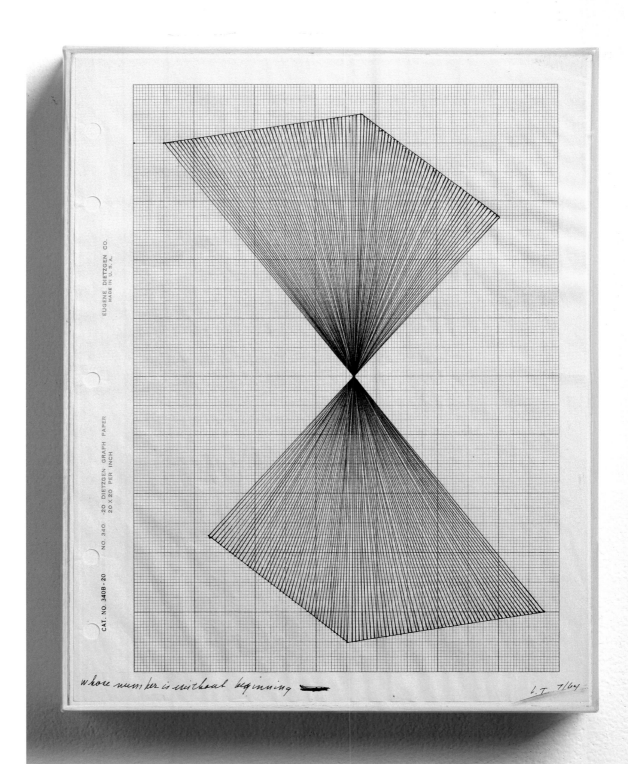

And Whom Is My Dearest One, 1988; mixed media; 7¼ × 9¼ × 4½ in. Lenore G. Tawney Foundation, New York.

FACING PAGE *In Silence*, 1990; mixed media; 7½ × 3 × 4½ in. Lenore G. Tawney Foundation, New York.

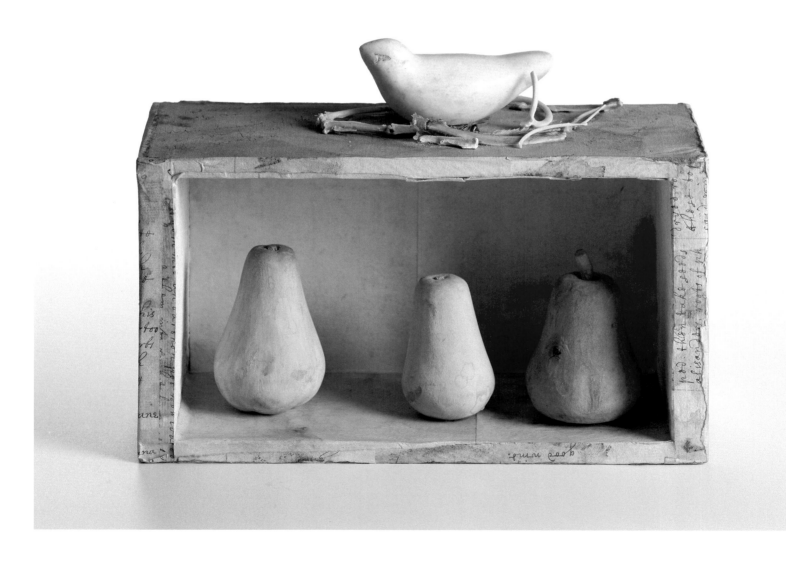

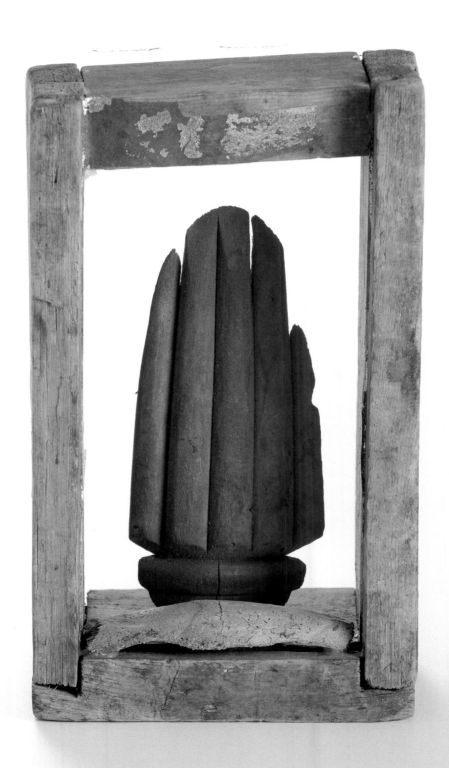

Technical Analysis
The Bride

DR. FLORICA
ZAHARIA

The Bride, one of Lenore Tawney's iconic "woven forms," is made of various weaving components assembled in a long, narrow, unconventionally sculptural shape. Dense areas of warp-faced weave contrast with vertical slits in the upper portion and the aerated surface of the gauze weave in the lower section, while the width varies throughout the entire length. The combination of multiple weaving structures in one piece was not a new technique, but correlating this with the width variation throughout the weaving is Tawney's invention.

A warp that maintains even tension for the entire duration of the weaving process is perhaps the most important element that assures a technically successful woven surface. The consistency of the warp's density is established during the preweaving setup by passing the warp through the reed, and the warp threads remain in this position; the horizontal insertion of the weft creates a perpendicular relationship with the warp. Tawney knew these important facts, yet, unsatisfied with the limitations of this process, she reinvented the rules by experimenting with the positioning of the warp at various densities without varying the number of threads to create different widths. She achieved this by using an "open reed," made to her specifications, with a removable top (a conventional reed is made of wooden or metal dents secured in place at their top and bottom by two fixed ribs). This allowed her to move each warp one by one, after untensioning it, from its initial position to one to the left or right of the weaving's center line. Skillfully, she controlled the expansion and contraction of the width as the weaving evolved from her inner creative life force. The bottom of the weaving and the widest areas are held in place with metal rods. There is a focal point in the upper middle area created by feathers inserted in the weft direction. The warp's ends were knotted and braided to complete the composition at the top and bottom. Black-dyed linen tying the gathered warp threads at the top marks the presence of the bride's delicate head.

The Bride, 1962; linen and feathers; 138 × 13 in. Lenore G. Tawney Foundation, New York.

Techniques: warp-faced plain weave, warp-faced plain weave with discontinuous weft, gauze, and braided and knotted fringes.

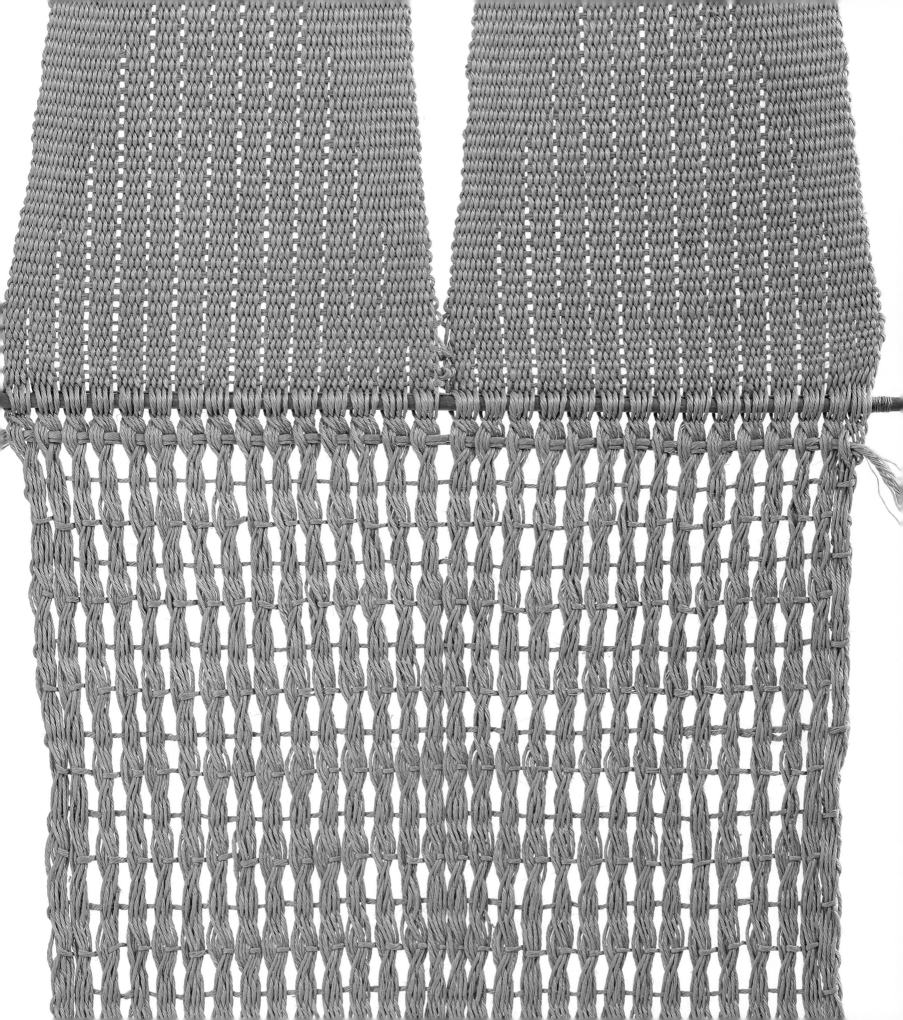

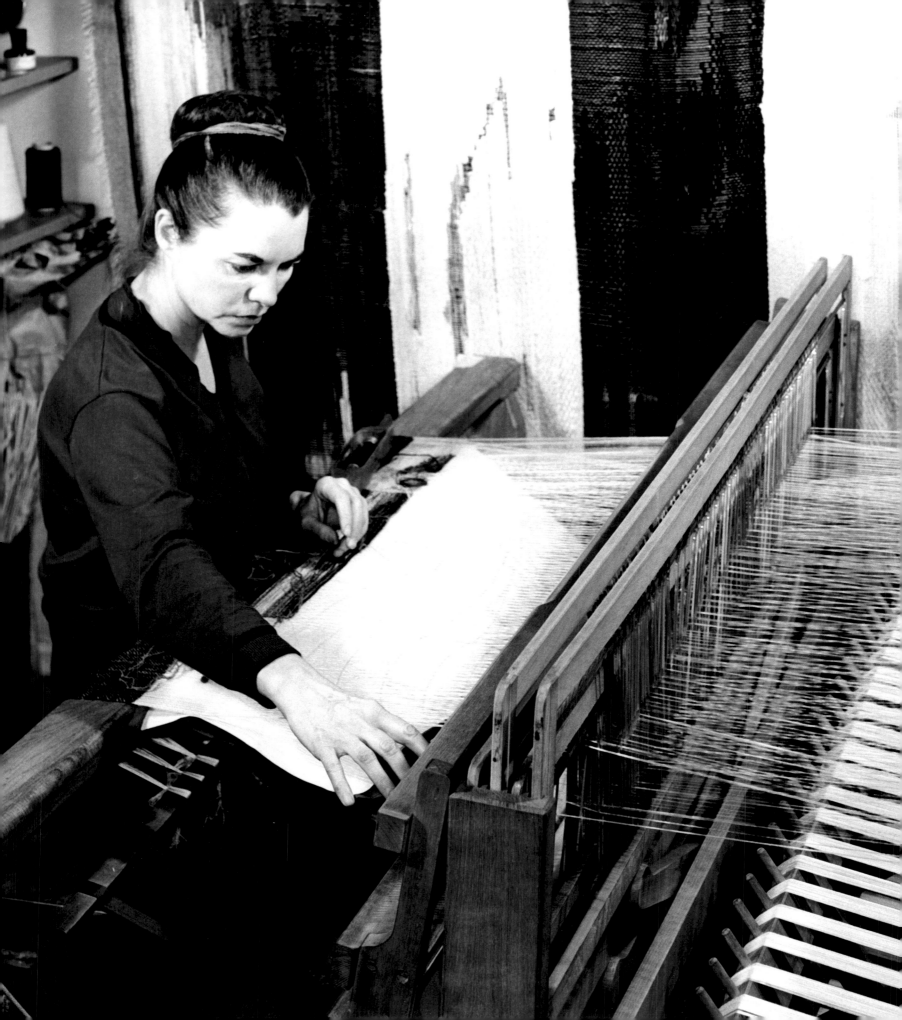

Tawney at the loom, 1950s.

"What desires did Lenore keep coiled in the fiber of her bun? This ritual work, this discreet corporality was as much a sculpture as her sculptures were corporalities reaching out from the center of the room. And this is what has always excited me about Lenore: I can feel her works reaching back to meet her hands—and there I am, suddenly, threaded by the intimacies performed by the object for the artist herself."

—INDIRA ALLEGRA

Artist included in *Even Thread [Has] a Speech* (page 265)

Weaving Infinity

Seeker *1970 to 1980* GLENN ADAMSON 176

The Archive *That Point Is the Point* MARY SAVIG 206

Technical Analysis *Dove* DR. FLORICA ZAHARIA 216

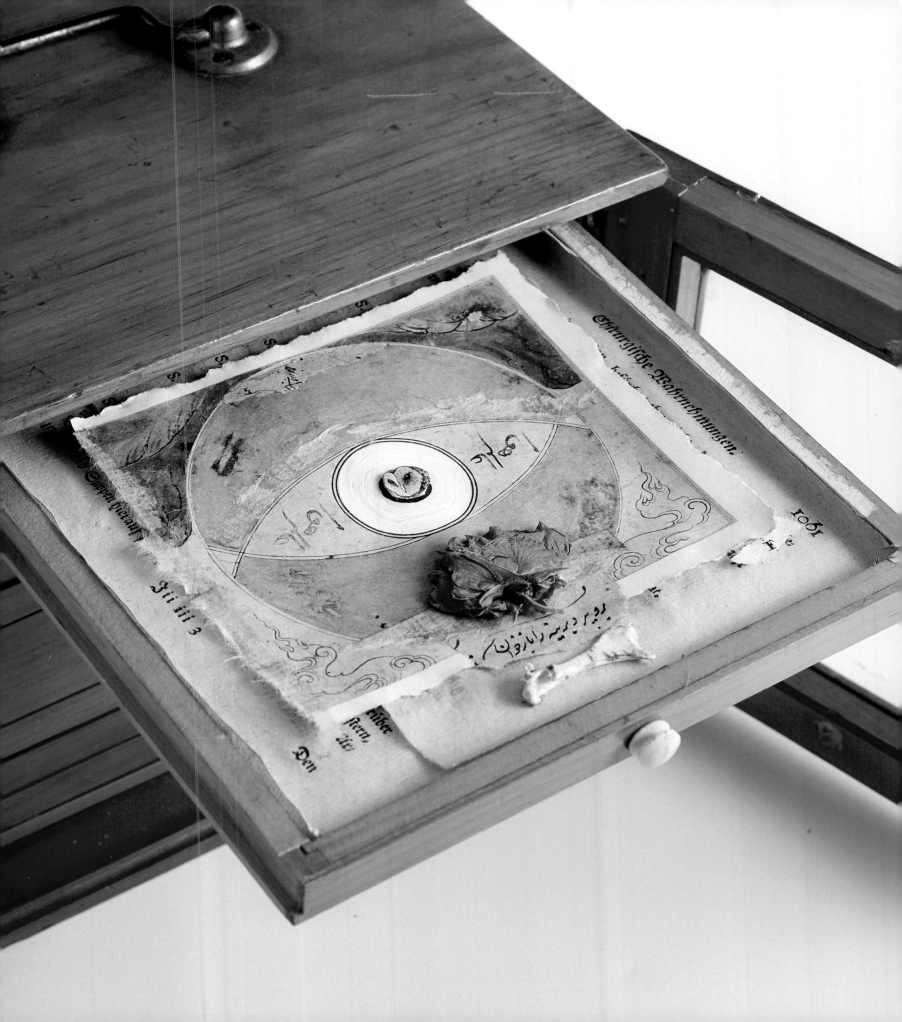

Seeker
1970 to 1980

GLENN ADAMSON

Of all Lenore Tawney's creations, perhaps the most impressive was her own evolving environment. Following her ejection from 27 South Street near Coenties Slip, she lived in a succession of locations in Lower Manhattan: 70 Thomas Street, in a space recently vacated by Empire Yarn & Twine Co. (1962); then to 59 Beekman Street (1962–66), 115 Spring Street (1966–70), 37 East Fourth Street (1970–73), 64 Wooster Street (1973–76), and finally 32 West Twentieth Street (1981–2007).[1] Though these spaces had their differences, all were postindustrial lofts, with an open plan, high ceilings, and plenty of light. She furnished sparely, sometimes sleeping in the same enormous room where she worked, demarcating the bed area only with a few hung cloths. While these living quarters were ascetic by any normative American standard, they were meticulously composed and highly original, manifestations of the same art of arrangement that she brought to her mail art collages. In addition to her own fiber sculptures and the work of artists in her shifting circles of friendship, she displayed a variety of other aesthetic totems: stones and shells, Asian and African craft objects, baskets filled with hollow eggs (which she liked to "mend" after eating them for breakfast). One area was reserved as a so-called iron corner, filled with odds and ends of antique blacksmithing and industrial equipment. She kept cabinets of many small drawers filled with curious objects both artificial and natural, which she would show to visitors in a performative ritual that equally recalls the habits of the Surrealists and of Renaissance collectors. Tawney lofts were nested spaces, microcosms with microcosms within, where there were no fixed boundaries between sculpture and decor. Ovoid pebbles might be carefully laid out on the floor in order of size, or a massive section of a wooden beam from Coenties Slip set standing upright, hung with full pouches.

We are fortunate to have two vivid descriptions of Tawney's lofts from the 1960s. One is a beautiful account of 27 South Street in 1967 written by Evey Riesman, who was married to the well-known sociologist David Riesman. Riesman originally composed the text as part of a work of fiction, and then re-edited it as straight reportage.[2] She captured the total

Dove, 1974; linen; 118 × 108 in. Lenore G. Tawney Foundation, New York.

1. Lenore Tawney to Marna Johnson, September 1, 1962, archives of the Lenore G. Tawney Foundation, New York (hereafter "LGTF"). The Marna Johnson papers are housed at the LGTF. Tawney also maintained a summer residence in Truro, Massachusetts, on Cape Cod, in the 1960s and 1970s.

2. E. T. [Evelyn Thompson] Riesman to Maryette Charlton, October 5, 1967, Maryette Charlton papers, circa 1890–2013, Archives of American Art, Smithsonian Institution, Washington, DC (hereafter "MC/AAA"). Riesman seems to have edited it specifically for Charlton's use in the development of a film on Tawney: "Here is the little sketch which I have to tried to adapt from the original bit of fiction I mentioned. I am afraid it is not descriptive enough of Lenore's work to be of much use. But it might suggest things to you."

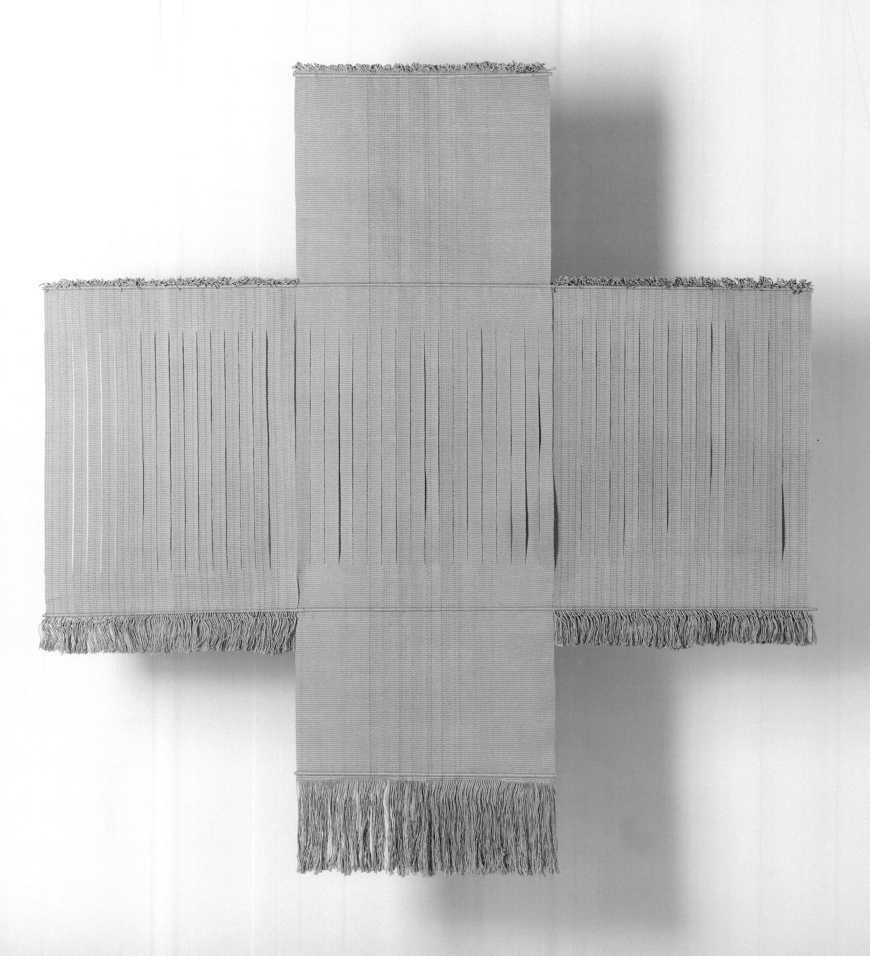

transformation of Tawney's lifestyle from her Chicago days, when she lived an "interesting, gay life" and had a "rich apartment with antiques, plants, paintings and rugs," to her New York situation, "almost empty." The picture Riesman paints is that of a recluse who has "stripped herself bare" in a relentless pursuit of higher meaning: "I have the feeling that she has become strong not only spiritually: what enormous physical labor—to a thing almost superhuman—to do this, and she so tiny and frail. And this room which is a place to work, but hardly a place to live in, perhaps explains—her work has taken over and become her life."[3]

A second text, more fragmentary but also revealing, dates to November 1967, just after Tawney's first show at Willard Gallery in New York. A class from New York University had visited that exhibition and then came to speak with Tawney in her studio; the instructor was Chandler Montgomery, a specialist in art education and an associate of Tawney's friend Lillian Kiesler.[4] A student named Rosilyn W. Lieberman kept detailed notes of the visit, giving us her impressions of what she evidently considered an extraordinary experience, as well as some of Tawney's own words.[5] "All the urgency and frenzy of the street vanishes," Lieberman began, describing the class as they ascended in the elevator. Then they were able to see Tawney working:

> Time stops in her hands as she caresses a composition of glued feathers and meticulously drawn lines, or ties the rough yarn on the loom into knots…quiet—calm—patience—and remoteness….We sat on rugs, couch, bench. She sat on the floor, knees under. The cat stood at attention before her.

As it happens, this description corresponds precisely to a photograph by Nina Leen, published the previous year in *Life* magazine (page 266). Tawney, described as "a weaver of shimmering fabrics," had been chosen for the opening spread of a remarkable article profiling America's leading craft mak-

ers, including Alice Kagawa Parrott; Dorian Zachai and her potter husband, Bill Sax; Peter Voulkos; furniture designers Paul Evans and Wendell Castle; and the glassblower Harvey Littleton.[6] Tawney's preeminence in this impressive company attests to the high regard in which she was held at this point in her career. Given the beauty of Leen's portraits and the publication's mass distribution, the article was among the most high-profile coverage the studio craft movement ever received. The reasons are not far to seek: at a time of seismic cultural upheaval, individualistic creativity of the kind Tawney embodied had unprecedented cachet. In the preceding pages of the magazine, readers would have encountered very different images of the American woman: a busy mother in a General Motors ad, checking off her to-do list—"pick up cleaning, Debbie's music lesson, hair dresser, party snacks"—and a Brigitte Bardot look-alike in a Clairol ad emblazoned "Blonding Simplified." In this context, the bohemian, black-clad Tawney in her spare surroundings must have come as quite a shock, and also as wildly divergent from popular conceptions of American craft.

Certainly, Rosilyn W. Lieberman was left amazed by her encounter with Tawney. She dutifully recorded the artist's pronouncements and words of wisdom: "You do not do the same thing over, not to copy, not to go backwards." "One of the hardest things is to get away from preconceptions, from what you're supposed to do or see." "Imagine that you don't have to show it to someone…then find your own way of seeing and saying." "It's a fight to find what you like: *to allow* it." Lieberman captured a moment in which Tawney brought forth several antique books and said:

> These papers give me something textural. When I see a page like this, it's so beautiful I have to use it for something. But one needs the ability to look at it. With torn paper, I feel as though I'd gone into the earth and it's the beginning of life all over again.

3. Evelyn Thompson Riesman, "Lenore Tawney," unpublished typescript, 1967, LGTF, 16.1.

4. See Chandler Montgomery, *Art for Teachers of Children: Foundations of Aesthetic*

Experience (Columbus, OH: Charles E. Merrill, 1968).

5. Rosilyn W. Lieberman, typescript notes, November 1, 1967, MC/AAA.

6. "The Old Crafts Find New Hands," *Life,* July 29, 1966, 34–43. Other makers included in the article were the bell maker and architect Paolo Soleri, batik artists Otto and Peggy

Holbein, rug maker Francesca Tyrnauer, and bronze caster William Underhill.

When the students quietly left the loft, there was "no confusion, yet for each there had been 'an experience,'" reported Lieberman. "Her soft voice lingers in our ears: as she said, as she tied knots at the loom: One has to forget time."

Lieberman's choice of the words "an experience," which she set off in quotes, is a quintessential late sixties touch. It is a reminder that this was the period not only of *Life* magazine, of GM and Clairol, but also of Jimi Hendrix and Timothy Leary, Esalen and the Summer of Love, tuning in and dropping out. And unsurprisingly, just as the class was visiting Tawney, she (at the age of sixty) was starting her own personal exploration of the country's burgeoning counterculture. She had been a relatively early participant in the American fad for Zen Buddhism, studying it at least as early as 1962 and regularly attending sessions at a New York Zendo (meditation hall). In 1969 she traveled to Japan, visiting the Zen monk and tea master Kobori Roshi at the Ryōkōin, a temple within the historic Daitoku-ji complex in Kyoto.[7] Like many Americans at this time, craft artists especially, she was captivated by the simplicity and profundity of Zen, and the way that certain objects, like tea ceremony implements, could be understood as anchors of a heightened awareness. While in Japan she made note of an exchange with Kobori in which he had spoken of a plum blossom in a vase. "Inside it," he said, "it does not know that it is a flower. It simply *is*." Tawney accepted this as an insight about her own practice: "The same with us. When we are drawing a line, it is a part of our being. Only after it is done, can someone look at it and say, It is a line."[8]

Anyone who has practiced meditation knows that it is one thing to intellectually grasp an abstract premise— that the self is part of a continuum with all things, for example—and quite another to actually experience it. Many find that the observance of silence can be an effective way to reach this feeling. This was certainly of great importance to Tawney. She often attended meditation events that involved prolonged stillness; a particularly intense episode was a weeklong retreat in Connecticut in March 1971, in which forty-eight participants spent sixteen hours a day in complete silence. "It is hard, but wonderful," she wrote to Maryette Charlton, "especially at the end, when you are just ready to begin."[9] Even at home in New York, not a place noted for its quiet, Tawney created a sustained, non-interruptive soundscape, listening to records of birdsong, chant, and Japanese shakuhachi music; as she noted in her journal, "the desire to silence the mind is but the pursuit of sensation."[10] When asked to give lectures on her work, she would sometimes simply show images without narration, standing wordlessly. The artist Anne Wilson remembers the mesmerizing, John Cage–like effect of one such performance in the late 1970s: "I remember the sound of the slide projector, clicking the carousel through."[11]

Tawney's exposure to meditation involved a complex mixture of sources and affiliations. In addition to Zen masters like Kobori and Eido Shimano—the abbot of the New York Zendo—she learned from Charlotte Selver and Charles Brooks, leaders of the "sensory awareness" movement, who were associated with the well-known spiritual retreat Esalen, in Big Sur, California. Together with Ted Hallman, a fiber artist with whom she was friendly in the 1960s and 1970s, Tawney attended workshops with Selver on Monhegan Island in Maine at least as early as 1964. Hallman describes their sessions as involving "very esoteric work," with simple physical acts and bodily interactions.[12] It was a

7. Kobori (1918–1992) was a student of the great popularizer of Zen, D. T. Suzuki. See Milton Moon, *A Potter's Pilgrimage* (Adelaide: Wakefield Press, 2010), 153; Frederick Franck, *The Buddha Eye: An Anthology of the Kyoto School* (Bloomington, IN: World Wisdom, 2004). Tawney recorded visiting an old bookstore and a "shop with ancient ceramics" together with Kobori. Tawney to Charlton, postcard, January 27, 1970, MC/AAA.

8. Lenore Tawney journal, entry dated February 1969, Kyoto; quoted in Lenore Tawney, *Autobiography of a Cloud*, unpublished manuscript, comp. Tristine Rainer and Valerie Constantino (New York: Lenore G. Tawney Foundation, 2002), 24–25.

9. Tawney to Charlton, March 24, 1971, MC/AAA.

10. "Sounds/Records Tawney listens to while working," note, October 10, 1977, MC/AAA;

journal (30.11), undated entry, LGTF. The quotation is from Jiddu Krishnamurthi, *Commentaries on Living* (New York: Harper, 1956).

11. Anne Wilson, email message to the author, January 3, 2018. This event was held at Fiberworks in Berkeley, California; Wilson is not to be confused with the Coenties Slip artist Ann Wilson.

12. "We would lift these pebbles from the beach. We were out

looking at pebbles and lifting pebbles and then we would lift somebody's foot. And we were relating body to all the environment and it was very interesting." Oral history interview with Ted Hallman, 2006 May 23–2008 June 3, Archives of American Art, Smithsonian Institution, Washington, DC.

Manuscript Writing, 1980;
mixed media; 8⅜ × 9⅝ ×
1¼ in. (framed). Lenore G.
Tawney Foundation,
New York.

transformative experience in a spiritual sense. Tawney later said that through Selver's teaching, "I learned to feel the ground below my feet, and to pay attention to each breath, and to every sensation."[13] But the time she spent in Maine was important to her artistically, as well; Tawney brought nothing to work with but a fine-point Rapidograph pen and some handmade paper, and it was there that she began her drawings of converging lines.

Tawney also visited the Lama Foundation in July 1970, three years after this legendary countercultural site was founded in San Cristobal, New Mexico. She came at the invitation of painter Stephen Durkee and his wife, Barbara, friends since the Coenties Slip days.[14] Set up with the express purpose to "serve as an instrument for the awakening of consciousness," Lama was a spiritual community in which various currents were intertwined into a syncretic fabric. Temporary attendees and permanent residents practiced Buddhist-inspired chants, Indian yoga, and Chinese tai chi. They also engaged in the self-improving arts of farming and building construction, on the theory that "the essence of 'spirituality' is an intense practicality applied at all levels." The Lama Foundation was also a grassroots publisher, and was the first to circulate Buckminster Fuller's *4D Time Lock* (comprising texts written in 1928), *The Dome Cookbook* by Steve Baer (1969), and *From Bindu to Ojas* by Baba Ram Dass, "a cookbook for psychic space" that soon became a runaway bestseller under the title *Be Here Now* (1971).[15]

Another of Tawney's intriguing countercultural connections, which also came about through the Durkees, was with USCO—short for Us Company, or Company of Us—a New York artist collaborative that created psychedelic "intermedia" events incorporating light, sound,

painting, sculpture, and various elements of viewer participation.[16] In 1966 she was pictured in a *Life* magazine photo essay on psychedelia, meditating in a USCO exhibition at the Riverside Museum in Manhattan.[17] It is a remarkable photograph. Tawney could pass for half her age, surrounded by twentysomething hippies. A blast of light swirls around her, but her eyes are closed. Her legs are folded in lotus position. The article claimed psychedelia as an exclusively youth-oriented phenomenon, noting that "older people who prefer what is called a rational sequential experience, i.e., just one movie or a single radio station at a time, tend to freak out."[18] But Tawney seems utterly "immersed in a Be-In," just as the photo caption says.

Tawney had become, in sixties parlance, a "seeker." This was not exactly a new pathway for her; she had been avidly pursuing spiritual enlightenment since her discovery of Vivekananda during World War II and had shared those interests with Agnes Martin while in Coenties Slip.[19] All along, her attitude had been remarkably inclusive and nonjudgmental—or indiscriminate and even gullible, depending on your perspective. The potter Jeff Schlanger, a friend of Tawney's who shared her spiritual interests (and also showed at Benson Gallery in Bridgehampton, New York), recalls that in this period "it became a struggle to sort out the true religious path from what's in the magazine."[20] *Life,* in its coverage of the psychedelic craze, put it more bluntly: "The voyager who wants to blast off into inner space has the choice of many routes."[21] Tawney took it all in and even made a point of adopting a universalist position. She espoused the belief—originally taken from Vivekananda—that "all religions are going to the

13. Tawney, *Autobiography of a Cloud,* 16.

14. Tawney had known the Durkees at least since 1962, when they bought a church building in Stony Point, Long Island, and renovated it as their home. She described it as "like going to heaven." Tawney to Johnson, August 1, 1962, LGTF.

15. Quotes concerning the Lama Foundation are taken from a foldout flyer sent by Tawney to Charlton on August 1, 1970, MC/AAA. For more information see Elissa Auther, *West of Center: The Counterculture Experiment in*

America, 1965–1977 (Minneapolis: University of Minnesota Press, 2011); Felicity Scott, *Architecture or Techno-utopia: Politics After Modernism* (Boston: MIT Press, 2007). Ram Dass, born Richard Alpert, was an associate of Timothy Leary prior to becoming a "seeker" and traveler in India.

16. Founded in 1963 by Durkee, poet Gerd Stern, and sound engineer Michael Callaghan, USCO would go on to be featured in the 1970 exhibition *Contemplation Environments* at the Museum of Contemporary Crafts, with two enclosed

fiberglass chairs incorporating sound. See Tina Rivers Ryan, "Toward a Stroboscopic History: An Interview with Gerd Stern of USCO," in *Hippie Modernism: The Struggle for Utopia,* ed. Greg Castillo and Esther Choi (Minneapolis: Walker Art Center, 2015).

17. "Psychedelic Art," with photographs by Yael Joel, *Life,* September 9, 1966, 65. The exhibition was entitled *Down by the Riverside.*

18. "Psychedelic Art," 65.

19. The two artists continued to reference these interests in their

correspondence. On one occasion, Martin advised Tawney not to use the title *The Tablet of the Laws* for one of her works, "because I don't believe in any laws. I guess I just go along with Mind, like the Zen Buddhists [*sic*]. I really can't see any contradiction in any of them. But the Old Testament + Judiacism [*sic*] and Pauls Christianity are hard to take." Agnes Martin to Tawney, October 5, 1976, LGTF.

20. Jeff Schlanger, interview by the author, December 14, 2017.

21. "Psychedelic Art," 61.

same place, they're simply on a different path."[22] Tawney retained this open-mindedness throughout her life, engaging variously with Buddhism, Christian mysticism, the I Ching, and astrology; consulting psychics when she needed to make an important decision; and delving into "the archaeology of the past" with her psychoanalyst.[23]

There was, however, one spiritual leader she came to value above all others: Baba Muktananda Paramahansa.[24] A fascinating and controversial figure, Muktananda was a major protagonist in the transmission of Indian spiritual philosophy and practice to the United States. He had originally trained under the holy man Bhagawan Nityananda in India, who practiced a strand of Tantric Hindu religious practice called Siddha Yoga. This was an ancient tradition broadly falling within a strand of Saivism—the worship of the god Shiva—that originated in Kashmir in the early medieval period, roughly in the seventh to tenth centuries CE. The term "Siddha" refers to a "self-realized being," and this guru's teaching is held to be a fundamental requirement to devotees' spiritual progress, their authority accepted as absolute. Other key features of the path include the repetitive chanting of mantras, the contemplation of cosmic maps of mandalas, and the principle of nondualism—that is, that all existence is one. The purpose of a mantra is to continually reinforce this idea of unity, the inward and outward passage of breath both symbolizing and providing physical realization of the principle. Ultimately, devotees of Siddha Yoga come to understand their own divinity, their lack of separation from God.[25]

Muktananda accepted Bhagawan Nityananda as his guru in 1947, and when Nityananda died in 1961, Muktananda assumed the leadership of Siddha Yoga.[26] For nearly a decade, his work was conducted entirely in India, at an ashram complex in Ganeshpuri, near Bombay (now Mumbai). In 1970, though, he followed in the wake of other Indian spiritual leaders and traveled to the United States seeking new followers. Financial support came from Werner Erhard, the founder of the New Age movement Est. Two additional trips followed, in 1974 and 1976. By the time of the third visit, his following in America was so huge that he projected the aura of a rock star. He and his followers took ownership of a faded hotel in the Catskills called the DeVille, converted it into an ashram, and thus established a permanent base in upstate New York; in the 1970s, there were also hundreds of small centers for meditation practice following Muktananda's teachings—one of them being Tawney's own loft.

In a poignant essay entitled "Hanging Out with the Guru," the journalist Sally Kempton described her own gradual absorption into Muktananda's "court." She first heard of him in 1972, in a café on Manhattan's Bleecker Street. "He's a saint," a friend told her. "His presence transmits energy. People get it and their lives change." When Kempton pressed for more detail, her friend—and then others who were following the guru, perhaps eventually "disappearing" into an ashram in India—could not help her understand what it was like to be with him. "What I heard," she wrote, "made him sound almost abstract, more like a phenomenon than a person." Finally, in 1974, her curiosity having gotten the better of her, Kempton did travel to a retreat with Muktananda in Pasadena, California. He was in his usual garb: orange robe, dark sunglasses, an incongruous ski cap: "At first glance, he looked like a jazz musician. At second glance, he looked like a king." She describes falling under his spell, the irresistible attraction of the man and "the subtle feelings of all-rightness" that she felt in his presence. Finally, her article concluded with a remarkable confession: the skeptical journalist was entirely gone. Now, Kempton wrote, "I want to be like Muktananda. Someday, if I hang out with him long enough, I figure I can get to be a saint."[27]

22. Oral history interview with Lenore Tawney, 1971 June 23, Archives of American Art, Washington, DC (hereafter "Tawney interview, AAA").

23. Tawney to Johnson, February 5, 1966, LGTF. Tawney met her analyst through Charlotte Selver. She also saw a psychic regularly. Charlton recorded the results of an astrological reading Tawney received in 1968, which yielded the "most complicated chart" the astrologer had ever seen. Note, March 5, 1968, MC/AAA.

24. *Baba* is an informal term meaning father; *Paramahansa* is an honorific meaning "fully realized."

25. My thanks to my brother Peter Adamson for his help in understanding the origins of Siddha Yoga. For more information see episode 57, "Learn by Doing: Tantra" (January 7, 2018), in his podcast series *The History of Indian Philosophy*, episode 57, https://historyofphilosophy.net/tantra.

26. For more on Muktananda's life prior to his arrival in the United States, see his autobiography *The Play of Consciousness* (Oakland, CA: Shree Gurudev Siddha Yoga Ashram, 1974), republished as *Guru* by Harper & Row. Tawney's copy, acquired in August 1975, is in the LGTF.

27. Sally Kempton, "Hanging Out with the Guru," *New York*, April 1976, 36, 38, 46.

Kempton did indeed "disappear" into Muktananda's orbit, remaining with the guru for years afterward; so it was reported in a very different article, published in the *New Yorker* in 1994. This piece of investigative reporting by Lis Harris disclosed disturbing revelations about Muktananda, which emerged after the guru's death in 1982. The most serious accusations involved his sexual exploitation and abuse of female followers, some of them young teenagers. Moreover, the ashram at South Fallsburg, New York, had fallen into a bitter feud between two gurus, both of whom he had recognized as successors at different moments; far from being models of perfect enlightenment, the leaders of Siddha Yoga were engaged in petty disputes and even physical violence.[28] It is an ugly story, and one that appears all the more ironic given Muktananda's own rhetoric during his tours. Well aware that he was operating in a competitive marketplace, he disarmingly acknowledged the abuse of Indian spiritual traditions: "The guru is a commodity which sells at a fantastic price in the American market. You have crowds and crowds and crowds of gurus, and they have been watering down their disciplines to the point at which they just disappear," he said during one talk in San Francisco. "It's very difficult to survive as a guru in India. It is quite easy to be a guru here…you can pass anything off on credulous folks."[29] As with most things about Muktananda, one can read this alternatively as remarkable directness or skillful manipulation. Documentation of his visits to the West—including a film made of his time in the United Kingdom in 1976—show mostly young, all-white crowds immersed in meditation, sometimes transported in rapturous response. Muktananda walks among them, occasionally placing his hand firmly on a devotee's forehead, or swatting them with a wand of peacock feathers.[30]

It is easy to find in all this the signs of a personality cult, an impression that is not necessarily dispelled by Siddha Yoga literature, which encourages total identification with the guru and gives advice like "keep one set of clothes for meditation and don't wash the *shakti* out by washing them too frequently."[31] Yet the personal testimony of many Siddha Yoga devotees—among them several people who were close to Tawney and shared her experiences directly—paints a much more positive picture. Ahza Moore, for example, was one of a small group of spiritually inclined weavers who had known Tawney since the mid-1960s, and also became involved in Siddha Yoga. Others included Jean d'Autilia, who became director of the Brookfield Craft Center in Connecticut and organized the exhibition *Lenore Tawney: A Personal World* there in 1978; and Susan Weitzman, a proficient fiber artist who considered Tawney a mentor and showed alongside her numerous times, including in the 1969 exhibitions *Objects: USA* and *Wall Hangings,* and the untitled 1972 exhibition that Tawney presented at her own building on East Fourth Street.[32] Muktananda was particularly important to Weitzman, who adopted the spiritual name Nandini, traveled to the ashram in India, hosted meditation sessions in her New York apartment, and eventually gave up art to focus on her spiritual practice and holistic medicine.[33]

The satisfaction that this group of weavers found through meditation was profound. Doubtless, like Tawney, they found it to be compatible with their creative practices—the experience of repetition, of boredom that blossoms into joy given time. But there was more to it than that. Ahza Moore matter-of-factly acknowledges the unsettling stories about Muktananda's behavior, but says, "It's not about guilt and sin.…I did experience the removal of the whole idea of guilt when I got involved in Siddha Yoga." She also

28. Lis Harris, "O Guru, Guru, Guru," *New Yorker,* November 14, 1994, 94–109.

29. Baba Muktananda, "The Guru," transcribed lecture, in *Muktananda: Guru Om,* newspaper-format brochure, 1976, MC/AAA.

30. Malcom Stewart (producer), *The Guru's Touch* (1976), film. The ritual described is known as darshan, a presentation to

the guru, and was typically experienced at the end of a day of group meditation outside of Muktananda's presence.

31. "Muktananda World Tour," undated flyer, MC/AAA. "Shakti" is short for the *shaktipat,* or enlightening energy emanating from the guru.

32. *Wall Hangings* included a piece by Weitzman titled *Homage to Lenore Tawney,* which

was also included, along with three works by Tawney, in *Fibre Art* at Halls Exhibition Gallery, Kansas City, Missouri, in 1973, organized by the textile specialist and sometime dealer Ruth Kaufmann. Both Moore and Weitzman had studied weaving with artist Alice Adams at her New York apartment. Through this connection, Adams and

Weitzman both offered instruction in the craft in the Museum of Modern Art's educational department, then headed by Victor D'Amico. Alice Adams, interview by the author, August 25, 2018.

33. Chaya Spencer, daughter of Susan Nandini Weitzman, interview by the author, December 11, 2017.

eloquently expresses what it was like to be in Muktananda's presence and receive his instruction:

> He was a person who really embodied the truth—it sounds not very explanatory, but there was something extremely profound, not only a physical presence, but someone who *knew* and could transmit that awareness. What he gave people was an experience that you are divine and you have a reason to exist....The first time I saw him I saw him as a being made of light and love. That's how he appeared. And he never seemed to falter from that example.[34]

The artist Robert Kushner, well known for his role in the Pattern and Decoration movement and his more recent paintings, is another former devotee of Siddha Yoga who looks back on the experience with great warmth and respect: "I felt Muktananda's power—for sure." When he first encountered the guru in 1974, he says, "I was an uncooked pot—I hadn't been fired. I couldn't take what he was transmitting. But it was the beginning of the unfolding."[35]

Kushner's account is particularly valuable because he was part of a small coterie who met weekly to meditate at Tawney's Wooster Street loft. This was in the wake of Muktananda's second visit to the United States, in late 1974. Tawney had first seen him speak onstage in 1970 but did not immediately gravitate to him: "I threw the brochure about him in the wastebasket." The second encounter, however, was up close and all-consuming:

> I knew what *shaktipat* was, the arousal of the *kundalini* energy in one, and I wanted it, so when Baba started giving *shaktipat* every night in a small room in uptown Manhattan, I began to go receive it every night. He had to squeeze his way through the crowd of people wall to wall in this little room. We were all shaking and screaming with laughter, with the energy in those days....It was customary to kneel before Baba before you left. When I did we

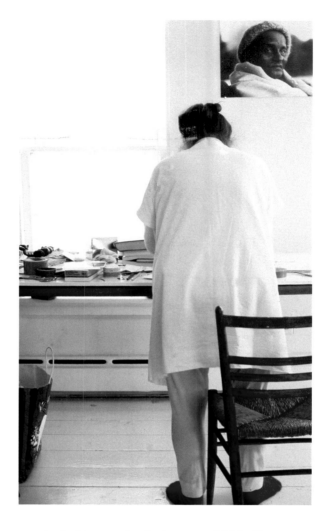

Tawney in her studio in Quakertown, New Jersey, 1977. Photo by Christine Martens. Lenore G. Tawney Foundation, New York.

PAGE 186 *O Sing,* 1966; mixed media; 7 × 7⅜ in. Lenore G. Tawney Foundation, New York.

PAGE 187 *In Fields of Light,* 1975; linen; 108 × 100½ in. Lenore G. Tawney Foundation, New York.

looked into each other's eyes and I felt, I have come home. It was like jumping off a cliff.[36]

Tawney was not entirely unacquainted with Indian spiritualism prior to this revelation. There was of course the early encounter with Vivekananda, and she had taken a keen interest in the philosopher Jiddu Krishnamurti's visit to New York in 1966.[37] The same year, she included text from the Diamond Sutra in a letter to Maryette Charlton:

> All composite things are like a dream
> A phantasm, a bubble, and a shadow
> Are like a dewdrop and a flash of lightning
> They are thus to be regarded[38]

34. Ahza Moore, interview by the author, December 15, 2017.

35. Robert Kushner, interview by the author, December 7, 2017.

36. Tawney, *Autobiography of a Cloud,* 32–33.

37. Tawney to Charlton, note, November 1966, MC/AAA.

38. Tawney to Charlton, November 3, 1966, MC/AAA.

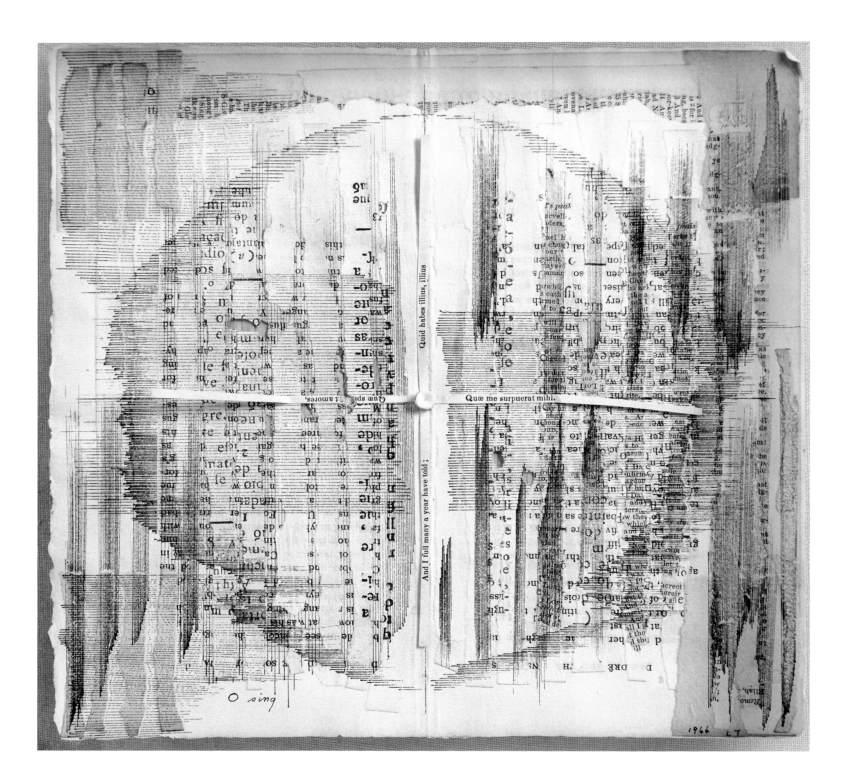

Quid habes illius, illius

Quæ me surpuerat mihi.

Quæ spirat tamores,

And I full many a year have told;

O sing

1966 LT

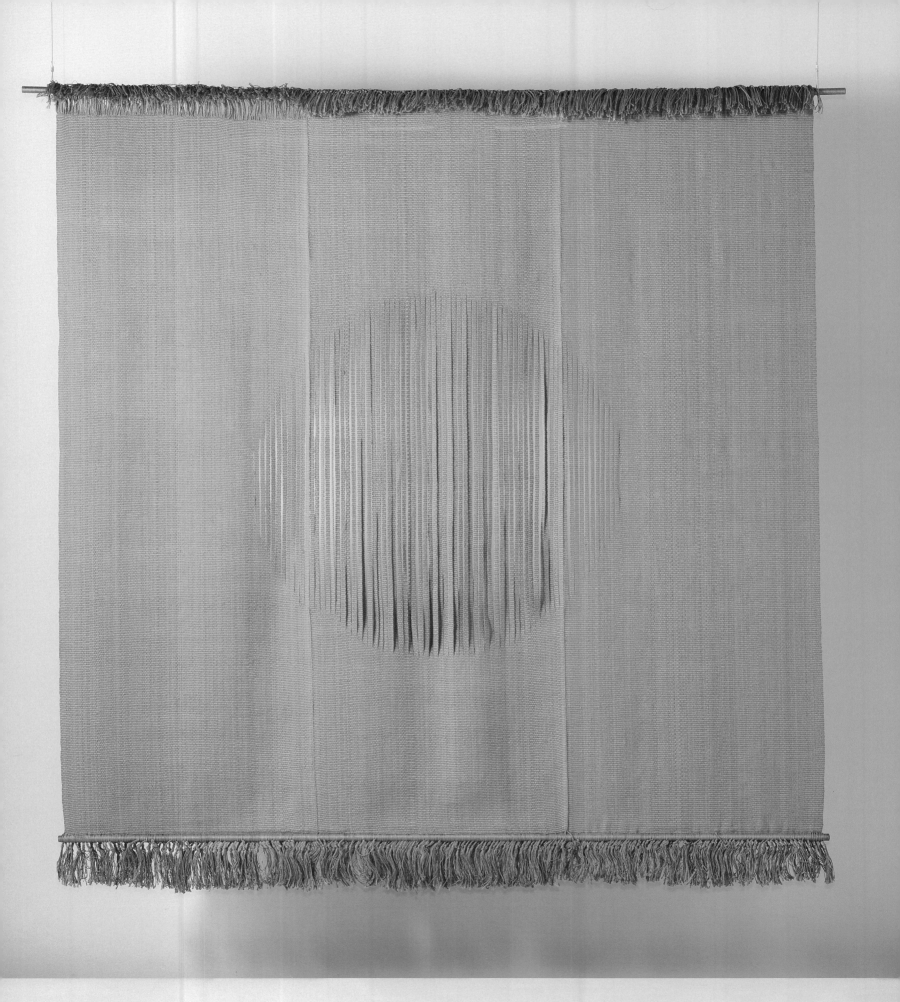

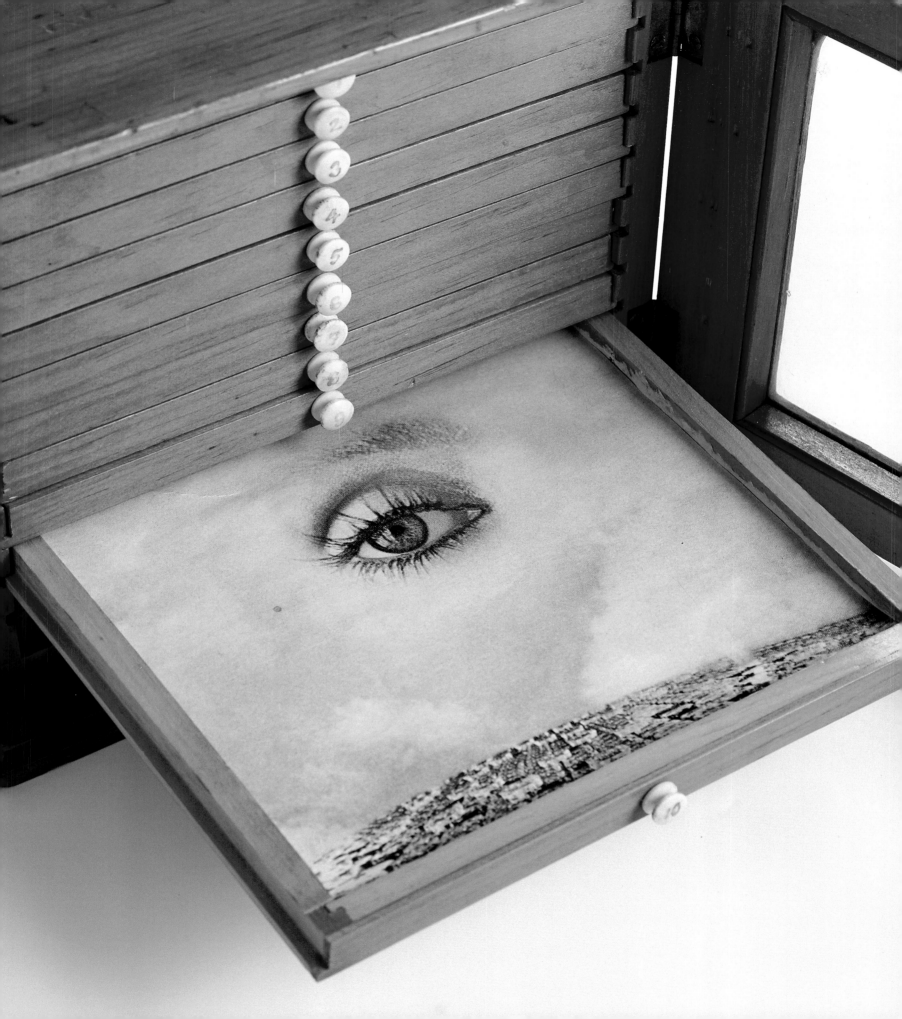

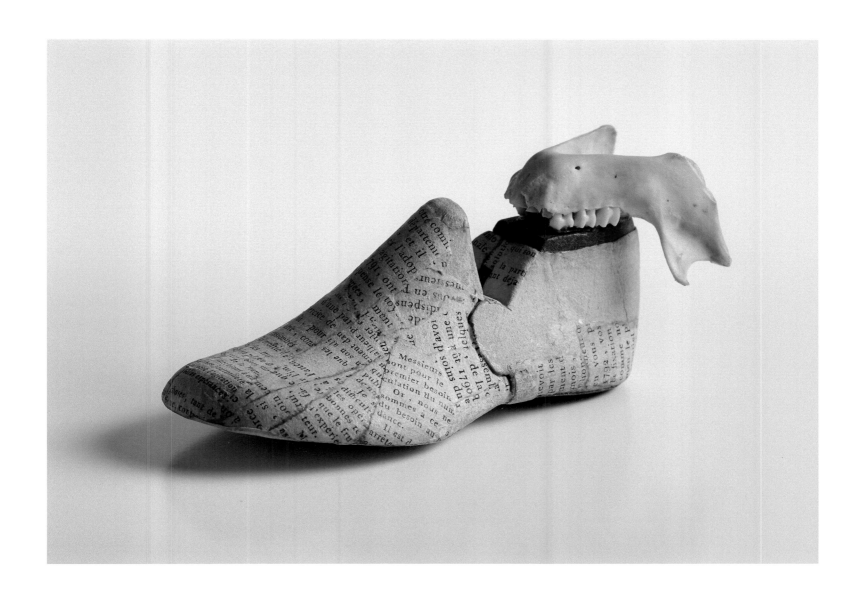

According to Kushner, Tawney also had an interest in the teachings of Sri Chinmoy, an Indian spiritual leader who had been based in Queens since 1964.[39] And in early 1969, en route to Kyoto, she had traveled to Kathmandu and Darjeeling, reading Vivekananda as she went, "overcome by emotion when he spoke of giving up materiality and becoming desireless, knowing only Spirit."[40] As deep as her previous spiritual interests had been, however, it was nothing like the all-consuming reaction she had to Muktananda. The guru, when departing the United States, asked various devotees to set up centers to continue the work during his absence. Susan Weitzman's was one of these, and Tawney's was another. Kushner remembers that she "took a corner of her loft and turned it into an art piece. She hung up sheer fabric, put down Moroccan rugs, a large photo of Muktananda, and artifacts from her collection. Six or eight of us would go to her house one night a week and we would chant and meditate." He adds, perceptively, that Tawney "was very strong with her devotion, and I think that is because she had other spiritual practices, but this one put it all together."[41]

Tawney's commitment to Muktananda was such that she spent the months from November 1976 to May 1977—the month she turned seventy—at the Sri Gurudev Ashram in Ganeshpuri. She wrote several letters to her friend Toshiko Takaezu about her experiences there. Tawney slept in a two-room suite shared with four other women; other time was spent in the meditation hall, one of the simple cafés, or a courtyard. The schedule was demanding: she would wake at 2:30 in the morning, meditate for two hours, have morning tea, chant until 7:30 when there was a pause for breakfast (including the milk and meat of a coconut—"Baba recommends it for its minerals"), then return to further meditation, and so on throughout the day.[42] Tawney's textile skills were put to good use; she embroidered a "cushion for Baba's slippers" and attempted to weave a portrait tapestry of the guru (but it failed because the upright loom that had been custom-built out of teak for the purpose was too difficult for her to operate).[43] Doubtless it was not helpful that in December she had broken her arm while trying to disembark from a train just as it began to move out of a station. She was brought to a hospital in Bombay, where her arm was set in a cast, an experience that occasioned a lovely bit of descriptive writing:

> At the hospital little babies were born every night. The women took care of the deliveries, the nurses or midwives. There was hardly a sound. The babies were quite small, wrapped like little mummies, and stayed with the mother all the time. There was no crying. Everyone was contented.[44]

Following this incident, Tawney struggled with her meditation. "I've sat so many hours at a time my right sitting bone seems to be cracking up," she wrote in March 1977. "Four or five hours at a time chanting. I enjoy it, and my love and devotion overflow but now I must stop that."[45]

Tawney was gratified that the Indian media was interested in her story, and her work; she showed her slides to a gathering in Bombay, was interviewed for a TV program, and received coverage in the *Times of India,* which celebrated her not only as a famous artist but also as a "radiant and realised soul."[46] She was

39. Kushner, interview by the author, December 7, 2017.

40. Journal, entry dated February 4, 1969, Darjeeling, quoted in Tawney, *Autobiography of a Cloud,* 23.

41. Kushner, interview by the author, December 7, 2017. Other participants in these sessions were the artists Brad Davis, Jackie Winsor, Nancy Holt, and Jared Bark, and the videographer Carlotta Schoolman, who was associated with the avant-garde performance space The Kitchen, in New York.

42. Tawney to Toshiko Takaezu, November 26, 1976, Toshiko Takaezu Family Trust (hereafter "TTFT").

43. "They made the loom. It is beautiful. But I can't work on it. It is the kind I hate. It's not a backstrap but it's that type, up right, like Navajo looms, with string heddles attached to two bars like the Guatemala loom. The warp is 27" wide, 12 to inch but the thread is too heavy + shows. I am very disappointed and the two who got it made for me are still counting on my working 8 hours a day for 6 wks! An inch a day! . . . It is truly impossible to do it, especially since I can't cover the warp—it's too thick and close together. It's as hard as ditch digging." Tawney to Takaezu, April 10, 1977, TTFT.

44. Tawney to Takaezu, February 9, 1977, TTFT. Tawney later recalled that she had the only private room in the hospital, the mothers all together in one large room. "These women were very poor. They had only one sari. One night we became aware of a delivery in the small birthing room. We watched as the mother put her newborn baby into a tin basin on the floor. It was a very quiet affair." Tawney, *Autobiography of a Cloud,* 38.

45. Tawney to Takaezu, March 3, 1977, TTFT.

46. Vivek Karekatte, "Creativity in Weaving by US Indophile," *Times of India,* April 7, 1977.

fascinated by the celebrations for Muktananda's birthday: "Thousands come. They set up tents and they sleep neck to neck, if that's the way to say it."[47] Finally, though, it was time to return home. She did so via Paris, where she saw the exhibition *Gods and Demons of the Himalayas* ("fantastique," she thought), and then alighted briefly at Takaezu's house in Quakertown, New Jersey.[48] At this point, it seems likely that Tawney envisioned herself a permanent pilgrim; she had written to Takaezu just prior to her departure from Ganeshpuri that "instead of setting up another place I want to be free. I'll probably get rid of most of what I have left except linen thread.... I may live at the Oakland Ashram and work in a room nearby. What could be simpler?"[49] And her first move in the United States was indeed to conduct a further one-month residency at the Siddha Yoga ashram in Oakland. She also visited with the great ceramicist Beatrice Wood in Ojai.[50] It was an important trip in career terms, too; while in India, Tawney had been informed that she was to be awarded a major commission at a federal building in Santa Rosa, and she visited the site while she was in California. Then she returned to Takaezu's, which for all intents and purposes was home.

Here seems a good place to comment on Tawney's relationship with Takaezu, whom she had met back in 1957 at the Asilomar craft conference in California, and remained close to since. The two were natural counterparts: both independent women artists at a time when such a life was difficult; one was physically small and introverted, the other robust and bursting with generosity. Their work was often shown in juxtaposition, with Tawney's ethereal open weavings floating above and around Takaezu's closed ceramic forms.[51] They often traveled together, and from 1977 to 1981 cohabited in Quakertown while Tawney sorted out her living arrangements back in Manhattan. It was also a difficult relationship in some respects. Given the total control that Tawney had previously exerted over her surround-

ings, it is not surprising that she was a demanding permanent house guest, driven to distraction by noise and cooking smells. Takaezu patiently weathered the occasional storms and went to extraordinary lengths to be accommodating, reserving the entire second floor of the house for Tawney's use, allowing a loom to be installed, and even painting the ceiling, walls, and floors white prior to her arrival. Jeff Schlanger remembers visiting the two and thinking that Takaezu was motivated by deep respect for her elder, perhaps reflecting the traditional Japanese regard for a sensei figure; in any case, "Toshiko was intensely practical and she knew a lot about not talking." Schlanger also remembers visiting Tawney's upstairs studio, which "faced across the road to the stubble of a farmer's field." It struck him that "what she was doing on the loom was exactly the same thing—these two horizontal fields."[52]

Another congenial aspect of Quakertown, for Tawney, was the proximity of other New Jersey friends whom she knew through Takaezu, among them the pioneering craft collectors Sandy and Lou Grotta and a couple named Vince and Pearl Cioffi, whom they would often visit. The Cioffis have a nice memory of the normally quiet Tawney in unusually high spirits one evening, dancing on the table, down to the floor, out the door, and under the moon. It is telling that both the Grottas and the Cioffis amassed a large collection of pots by Takaezu and a few mail artworks by Tawney. Neither couple, however, ever bought a weaving from her.[53] She did little to establish a market, partly because of the constantly shifting nature of her practice, as she herself recognized in a 1990 interview: "What happens is I do something and by the time I'm ready to move on, people are accustomed to it and they like that and I'm not doing it. So they can't buy my work then because I'm not doing what they want, and they don't like what I'm doing until another ten years pass."[54] In any case, by the 1970s she was making relatively little salable work. Willard Gallery continued to represent her, but

47. Tawney to Takaezu, April 10, 1977, TTFT.

48. Tawney to Takaezu, postcard, June 1, 1977, TTFT.

49. Tawney to Takaezu, April 28, 1977, TTFT.

50. Tawney was accompanied on this visit by her friend

Tristine Rainer. Tawney, *Autobiography of a Cloud,* 40.

51. The two first showed together at Asilomar conference exhibition, and Takaezu's work was included in Tawney's untitled 1972 exhibition at her home on East Fourth Street. Subsequent shows that paired them

included *Form & Fiber* at the Cleveland Institute of Art (1979) and joint presentations at the New Jersey State Museum, Trenton (1979), and the University Wisconsin, Eau Claire (1981).

52. Schlanger, interview by the author, December 14, 2017.

53. This passage is based on interviews by the author with Sandy and Lou Grotta, December 4, 2017, and Vincent and Pearl Cioffi, December 8, 2017.

54. Tawney, interview by Karen Michelle McPherson, National Public Radio, May 15, 1990.

Kissinger's proposal

Kissin-

Kis-

China's gifts to Japan—

journey of a thousand miles with a single step,

a wife has a cow a
Love Story — *G. Stein*

Tokyo Zoological Society

Tokyo's pandas: A long march begins with a kiss

amorous advances last week —
Tokyo's Ueno Zoo had keepers *(not a single step)*

cooing about the possibility of a blessed panda event in the near future. Not that anything was taken for granted. "Lan Lan, at 5, is probably old enough to seek a mate," one zoo official noted, "but Kang Kang is only 3 years old—he's just a child." Still, the kiss—and the "love bites" that keepers believe Lan Lan has been bestowing on Kang Kang in recent weeks—had everyone's hopes up. And zoo officials acknowledged that the wire barrier that separates the two pandas could be removed at any time.

*M. Charlton
Schooley's Mtn.
New Jersey
07870*

own long march with a kiss.

Mail art postcard to Maryette Charlton, postmarked September 26, 1977; mixed media; 6½ × 4¼ in. Maryette Charlton Papers, circa 1890–2013. Archives of American Art, Smithsonian Institution, Washington, DC.

FACING PAGE Untitled (flag), 1974; linen, cotton, metal, and wood; 78¹³⁄₁₆ × 26⅛ in. The Cleveland Museum of Art, Cleveland, Ohio, Gift of the Textile Arts Club (1975.39). © The Cleveland Museum of Art.

not often in an exhibition context; immersed in meditation pursuits, she was far less productive than she had been in the previous decade.[55] She focused principally on collage and assemblage works, often keeping them as private artworks, mailing them away, or giving them to friends as gifts. Not until the development of the Cloud series at the end of the decade would she establish anything resembling a "late style" that rivaled the significance of her earlier woven forms.

There were exceptions, however, ranging from the surprising to the sublime. Perhaps the most uncharacteristic works of her career were a small group of woven flags, made in the summer of 1974 from red- and blue-dyed linens left over from an unusually colorful woven form from 1962 called *Declaration* (page 127).[56] Tawney was mainly apolitical; her idea of social commentary—rather wonderful, actually—was to send a collage postcard with a news clipping about a pair of kissing pandas and snippets of Henry Kissinger's name, cleverly playing off the word "kiss" (at left). In the wake of the Watergate affair, however, she said that she felt the flag was "being shamed." Riffing on the imagery of youth protest culture in the age of Vietnam, she substituted blue jean fabric and buttons for the field of stars on the flag (facing page)—Tawney may have been inspired by the exhibition *Denim Art,* held at the Museum of Contemporary Crafts that spring. The ends of the flags have warp fringe hanging loose at top and bottom, possibly legible as a reference to a fraying national fabric. But ultimately, these are patriotic works, looking ahead to the spirit of the bicentennial and back to the founding of the nation. "The true sentiments of that early time are still there," she said. "The 'true blue,' the good and strong linen."[57]

More typical of Tawney's woven production in the 1970s is a series of large-scale geometric works, often monochromatic. The first of these was *Four Petaled*

55. Tawney sold only three works through Willard from 1977 through 1979: a Shield for $900 and two collages for $400 each (one in a fund-raiser for the Pascack Valley Hadassah Chapter, a women's Zionist organization in New Jersey). Miani Johnson to Tawney, November 14, 1980, LGTF.

56. Tawney wrote that she had the linen yarns dyed to make *Declaration,* "The first not of the black or bone color linen. It's almost shocking to see the red and natural warp." Tawney to Johnson, August 21, 1962, LGTF.

57. Quoted on a Cleveland Museum of Art Textile Arts Club program, 1975, LGTF.

Flower (1973), commissioned by her longtime friend and critical champion Katharine Kuh, who had taken on the role of curator for the First National Bank of Chicago art collection.[58] Tawney had not been working at the loom for the previous few years, and said that if Kuh had not asked her to make the work, "I might never have begun to weave again." But she was entranced by a title that came to her, *Four Petaled Flower,* and the simple geometry it suggested—two woven rectangles intersecting in a cross, with thin apertures in the center allowing light through. Tawney saw it as a form in which "all opposites are resolved, the integration of the personality, but deeper than the personality for it includes the unconscious (God within the heart) as well."[59] In addition to this spiritual connotation, the work is clearly responsive to developments in abstract painting—the Hard Edge and Minimalist styles that had come to dominate New York's gallery scene in recent years—and a masterful exposition of textile's specific materiality. Most of Tawney's early "woven forms" had been attenuated, and had extensive passages of gauze weave and other open structures, creating a diaphanous effect. In the new body of work, she reversed this priority, filling most of the form with tight rep weave, and leaving only slim slit openings. When illuminated in display, the weavings seem to glow from within, "thinly lanced with brightness," as Kuh put it.[60] Often, as with *In Fields of Light* and *Four Petaled Flower II* (pages 187, 194), she used the figure of a circle within a square or cross form, recalling the cosmic geometry of a mandala or the humanism of Leonardo's Vitruvian Man. In her early works of comparable design, such as *Jupiter* and *Triune* (pages 108, 113), Tawney sought to locate transcendence within materiality itself, and the experience of its patient manipulation. In her works of

58. Kuh commented that her priority in forming the collection was to "accumulate objects of high quality before their prices became unduly inflated...fine works that were not necessarily in fashion." Wall hangings were one of the main categories within her acquisition strategy. Katharine Kuh, *The Art Collection of the First National Bank of Chicago* (Chicago: First National Bank, 1974), 6, 217ff. The first version of *Four Petaled*

Flower is in now in the corporate art collection of JPMorgan Chase. Tawney made a second version of the work in 1974, to keep; it was gifted to the Whitney Museum of American Art, New York, by the LGTF in 2014.

59. Tawney to Ferne Jacobs, December 20, 1978, Collection Ferne Jacobs.

60. Kuh, *Art Collection of the First National Bank of Chicago,* 227.

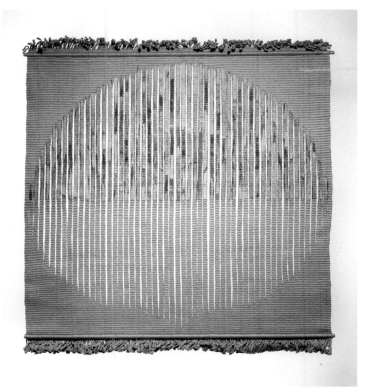

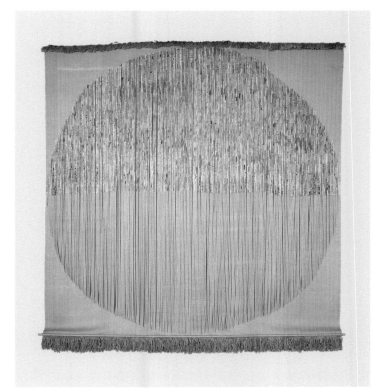

the mid-1970s, she added the further element of luminosity, envisioning the weave as a perceptual filter shot through with celestial light.

Closely related to these geometric weavings are a group of works including collaged paper, which Tawney simply glued directly onto the surface of the fabric. A good example is *Aurora, or Morning Redness* (above left). The bits of paper, ripped out of a book published in Paris in 1771, bear fragments of Latin text that Tawney obviously did not intend to be readable.[61] Rather, the composition presents a bisected world in which language rises like the dawn. Slits at half-inch intervals create a sense of vertical movement, anchored at top and bottom by metal rods around which the warps are tightly wrapped. The image, and the work's two variant titles, prompt thoughts of the cycle in which we all live—the daily arrival of new light. A similar conception appears in a related, larger work entitled *Waters above the Firmament* (above right), now in the Art Institute

of Chicago; Tawney said that the title was inspired by her favorite mystic author, Jakob Böhme, for whom the earthly firmament was "the connecting link between time and eternity."[62] It seems profitable to view these late masterpieces as Tawney herself might have, in oblique relation to a poem by George Ripley, which she inscribed in a postcard to Takaezu the same year that she made *Waters above the Firmament*:

> My Bodies-Masse is of a Lasting-Stuffe
> Exceeding delicate, yet hard enough
> And when the Fire Assays to try my Sprite
> I am not found to weigh a Graine too light.
>
> My Mother in a Sphaere gave birth to mee
> That I might contemplate Rotunditie
> And be more Pure of kind than other things
> By right of Dignity the Peer of Kings.[63]

ABOVE LEFT *Aurora, or Morning Redness*, 1974; linen, paper, and acrylic; 36 × 36 in. Collection of Sandra and Louis Grotta.

ABOVE RIGHT *Waters above the Firmament*, 1976; linen, paper, acrylic, and steel; 156½ × 145¼ in. Art Institute of Chicago.

FACING PAGE *Four Petaled Flower II*, 1974; linen and steel; 87½ × 85¼ × 1¼ in. Whitney Museum of American Art, New York; Gift of the Lenore G. Tawney Foundation. Whitney Museum of American Art/Licensed by SCALA/Art Resources, NY.

61. The Grottas acquired it in 2001 via their son Tom Grotta, a prominent fiber gallerist. The title, drawn from Jakob Böhme's *Aurora* (1612), was noted by Tawney in an undated journal (30.14) entry, LGTF. Tawney related the published source in a note to the Grottas, dictated to Kathleen Nugent Mangan, October 20, 2001, Sandy and Lou Grotta Collection.

62. Quoted in Eleanor Munro, *Originals: American Women Artists* (New York: Simon & Schuster, 1979), 331. Tawney also commented, "I cannot say I always understand Boehme, but I always *feel* what he says."

Tawney to Jacobs, December 20, 1978, Collection Ferne Jacobs.

63. Tawney to Takaezu, collage postcard, February 17, 1976, TTFT.

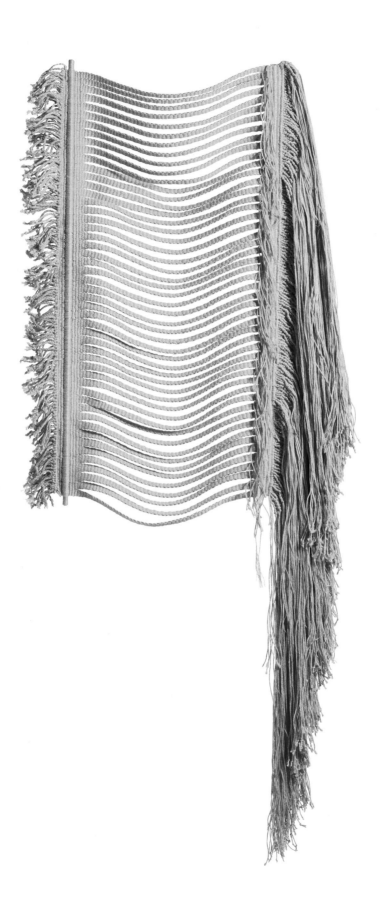

Waterfall, 1974; linen; 60 × 24 in. Lenore G. Tawney Foundation, New York.

PAGE 198 *Tau*, 1974; linen; 80 × 108 in. Lenore G. Tawney Foundation, New York.

PAGE 199 *Inquisition*, 1961; linen; 138 × 28 in. Lenore G. Tawney Foundation, New York.

PAGE 200 *Personnages*, 1976; mixed media; 14¼ × 8½ × 4½ in. Lenore G. Tawney Foundation, New York.

PAGE 201 Group of Tawney's studio objects. John Michael Kohler Arts Center Collection, gift of the Lenore G. Tawney Foundation and Kohler Foundation Inc.

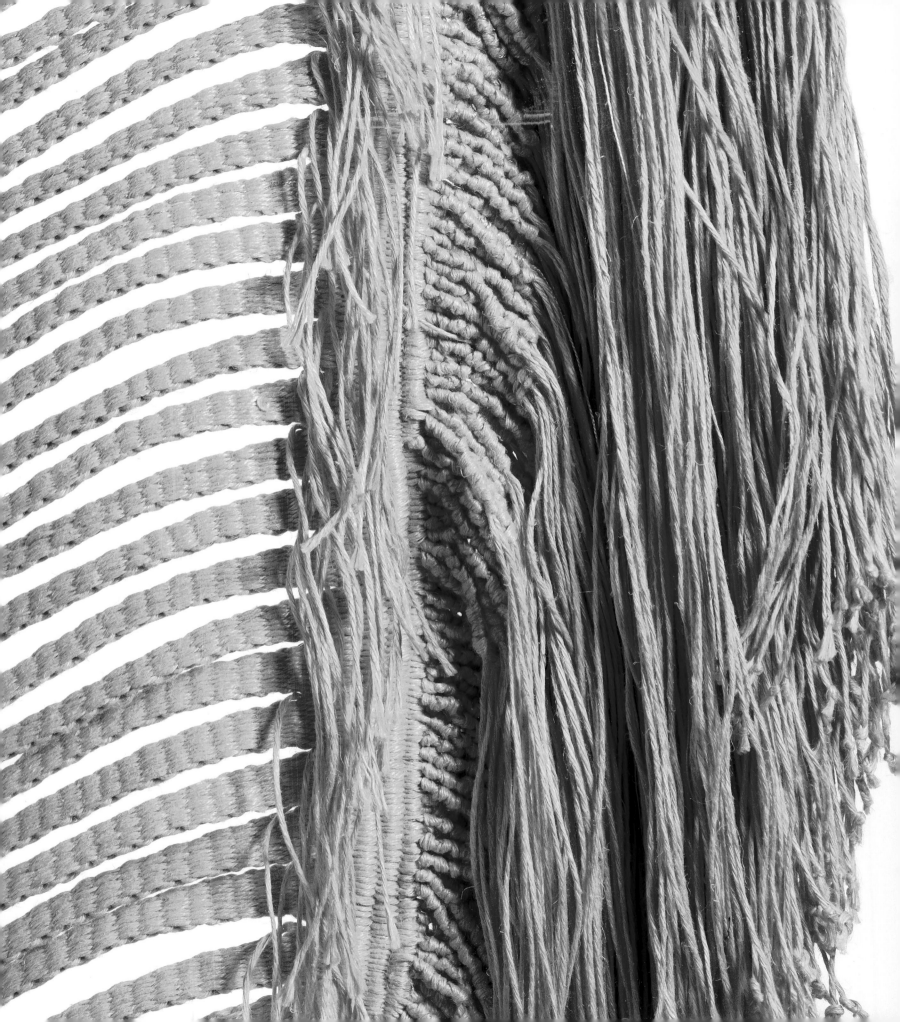

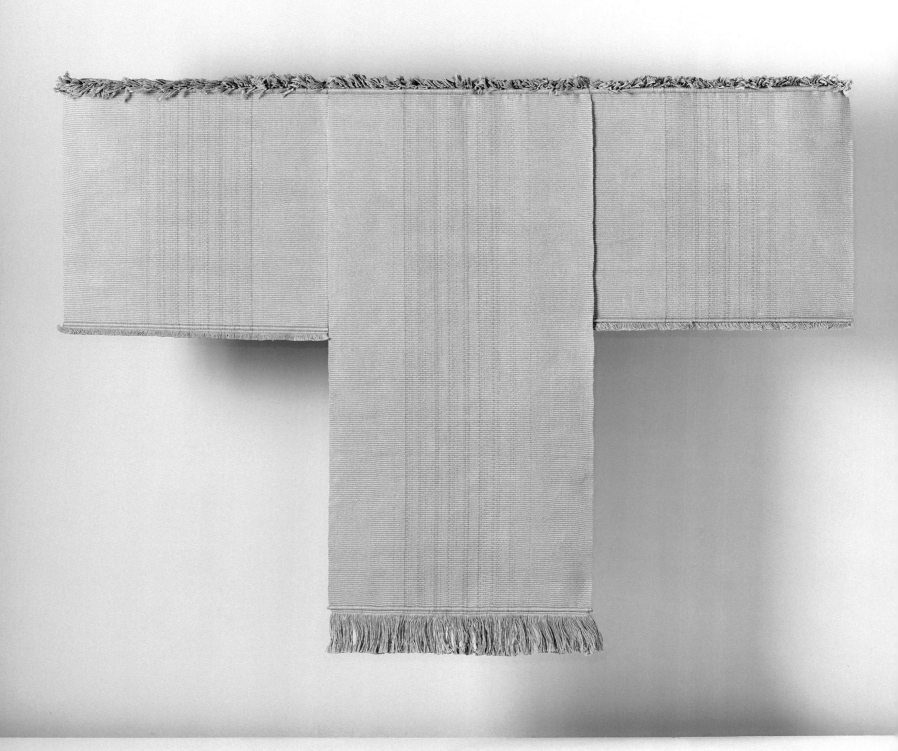

Hüm, 1986; mixed media;
74⅜ × 75⅜ in. Lenore G.
Tawney Foundation,
New York.

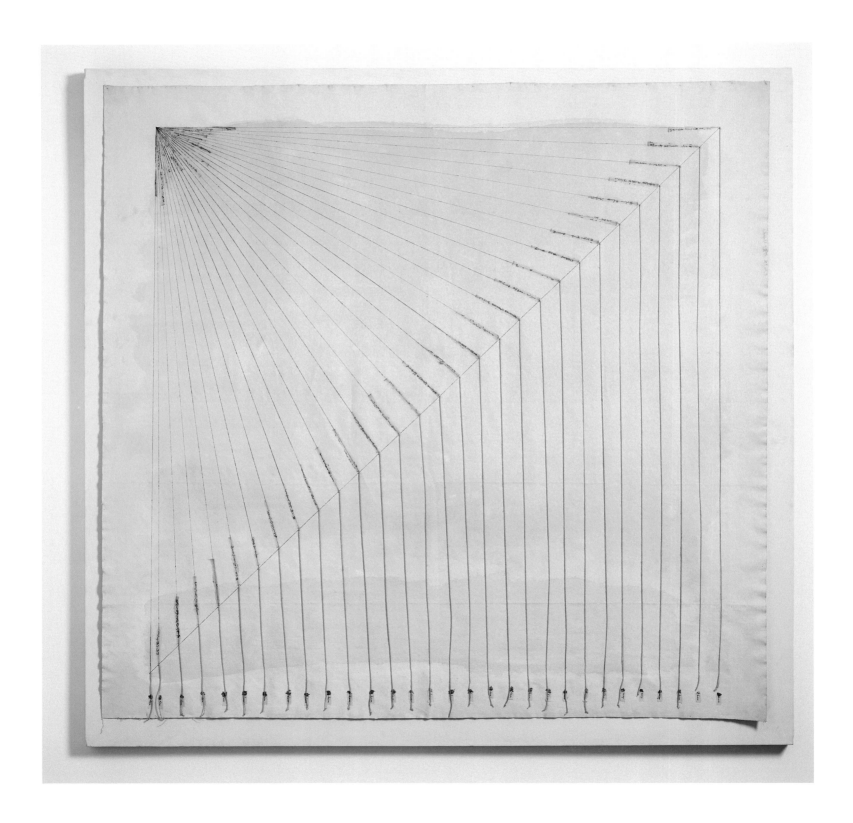

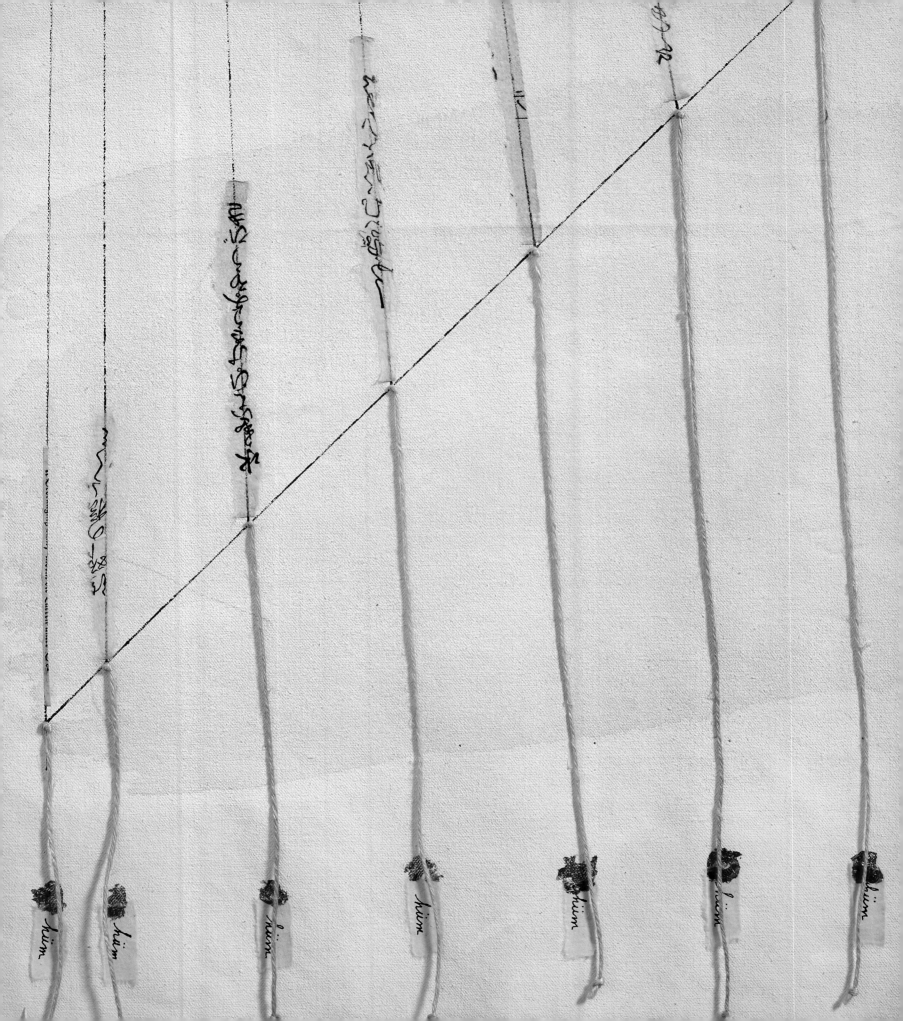

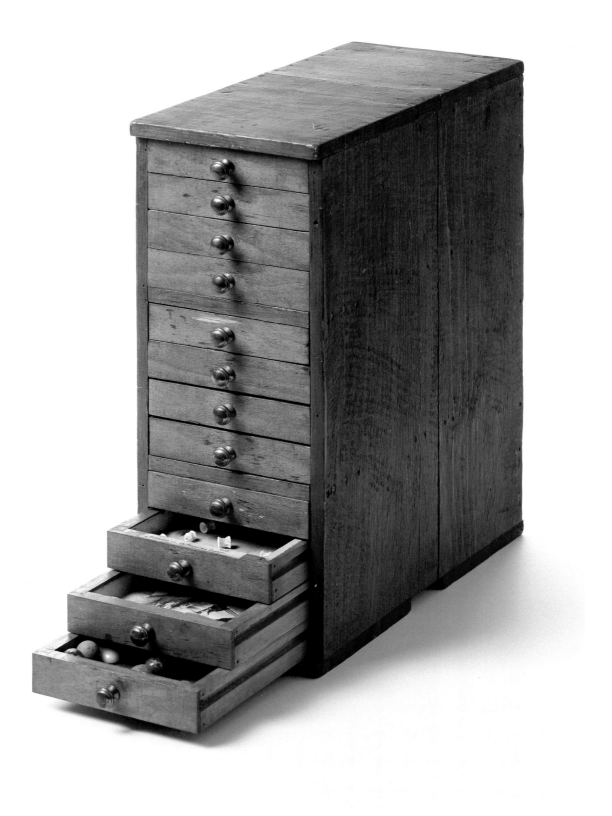

Collage Chest II, 1974;
mixed media; 13⅛ × 5⅜ ×
11¼ in. Lenore G. Tawney
Foundation, New York.

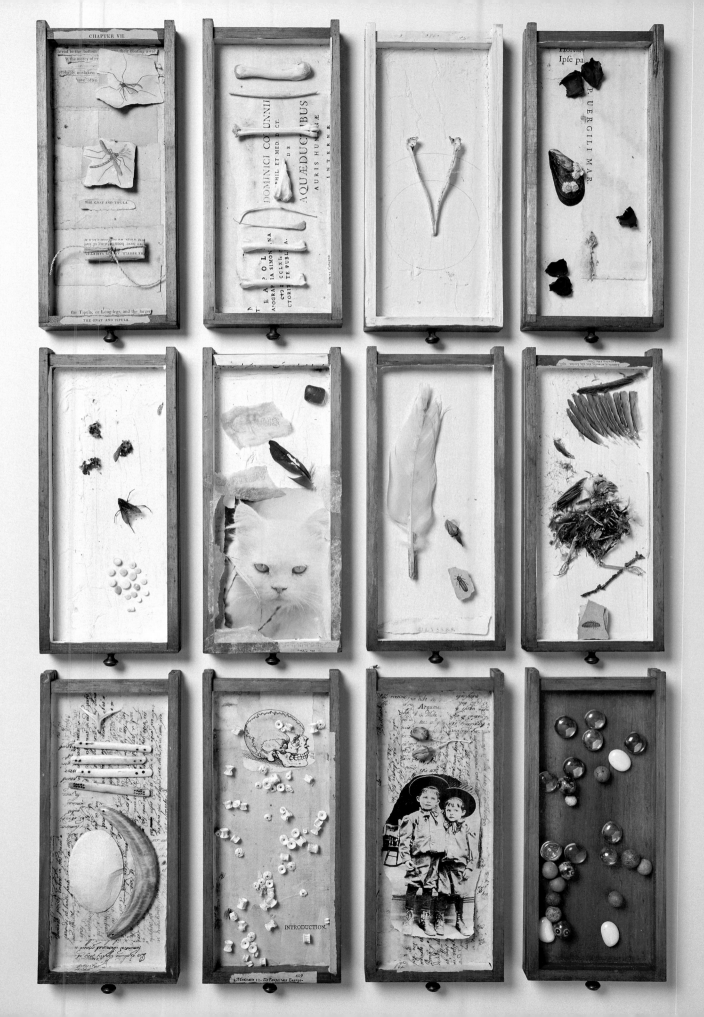

The Archive
That Point Is the Point

MARY SAVIG

"When we are drawing a line, it is a part of our being. Only after it is done, can someone look at it & say, It is a line." Thus concluded Lenore Tawney in a 1970 letter to her close friend Maryette Charlton, a filmmaker (at right).[1] Tawney was quoting one of her journal entries from her time in Kyoto, Japan, in 1969. Writing was integral to her daily life. Indeed, writing was another way of following a line, seamlessly drawing a parallel with her fiber work and works on paper.

Artists' journals typically provide a valuable record of working methods and major art-world events. A dedicated and deliberate journalist, Tawney gets at the very essence of her conceptual development in her writings. The journals are a guide to where her mind traveled as she read, meditated, and sketched. Embedded with personal ruminations, they show how Tawney negotiated the world around her. They track various sources of inspiration and recurring motifs in her artworks, notably her ongoing explorations of non-Western language and religion, prominent literature, spiritual and scientific symbols, and flora and fauna.

The following selections from Tawney's journals and correspondence shed light on the compelling range of sources from which she drew inspiration. "The source is a point without any dimensions. It expands as the cosmos on the one hand & as Infinite Bliss on the other. That point is the point," she wrote in one passage that uniquely characterizes her search for sources as she, in turn, generated her own source

Lenore Tawney, letter to Maryette Charlton, January 27, 1970; ink on paper; 8 × 7½ in. Maryette Charlton papers, circa 1890–2013. Archives of American Art, Smithsonian Institution, Washington, DC.

FACING PAGE Sketchbook, July 1972; ink and collage on paper; 6⅜ × 3½ × ½ in. (closed). Lenore G. Tawney Foundation, New York.

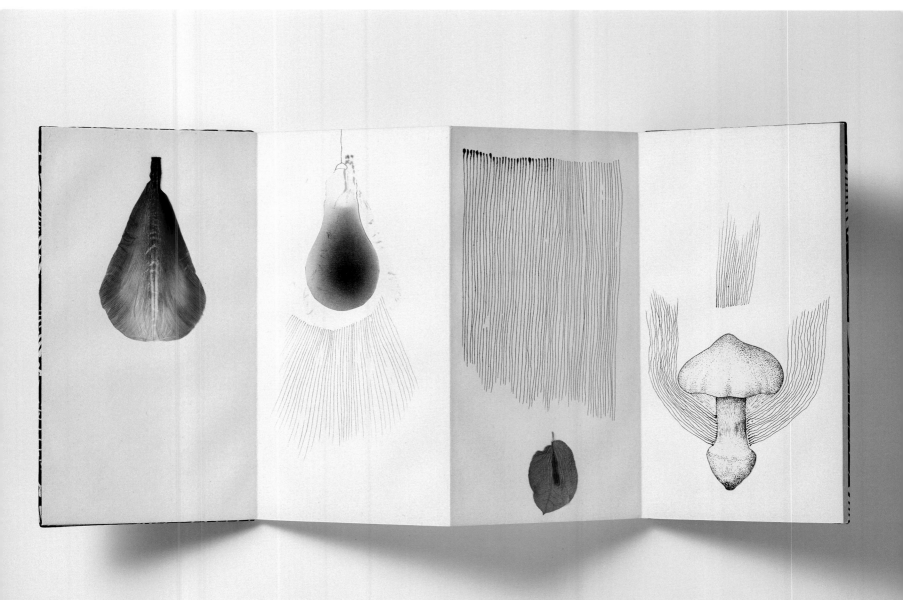

TOP Sketchbook, c. 1985–89.
Lenore G. Tawney
Foundation, New York.

BOTTOM Sketchbook,
c. 1984. Lenore G. Tawney
Foundation, New York.

FACING PAGE Sketchbook,
n.d. Lenore G. Tawney
Foundation, New York.

materials.[2] The selections are loosely gathered from biographical sketches, stream-of-consciousness musings, and direct quotes of people she admired from books and poems. The thread running through these journal entries is her attention to various types of knowledge that guided her artworks and her formation of self.

Journal (30.1), undated entry:

> The creative man knows himself to be a "mouth" through which passes what has arisen in his innermost earthen night. Only the source point, in which the stream emerges from darkness and enters the light, and is both at once darkness and light, is the turning point of transition and transformation. It cannot be looked for and cannot be held; in every moment it is creation from nothingness, independent of its history, and as pure present it is independent of its past as well as its future.

Sketchbook, n.d. (facing page):

> Water still is like a mirror…mind being in repose becomes the mirror of the universe the speculum of all creation.…

Journal (30.12), entry dated August 11, 1967:

> A symbol is an indefinite expression, with many meanings, pointing to something not easily defined & therefore not fully known.

Journal (30.6), undated entry [c. 1975]:

> He on whom the sky, the earth, & the atmosphere are woven, & the wind, together, with all life-breaths, Him alone known as the one Soul.
> —Brahman, the unifying thread in the cosmic web.

Journal (30.10), entry dated December 4, 1967:

> I left [Chicago] to seek a barer life, closer to reality, without all the *things* that clutter & fill

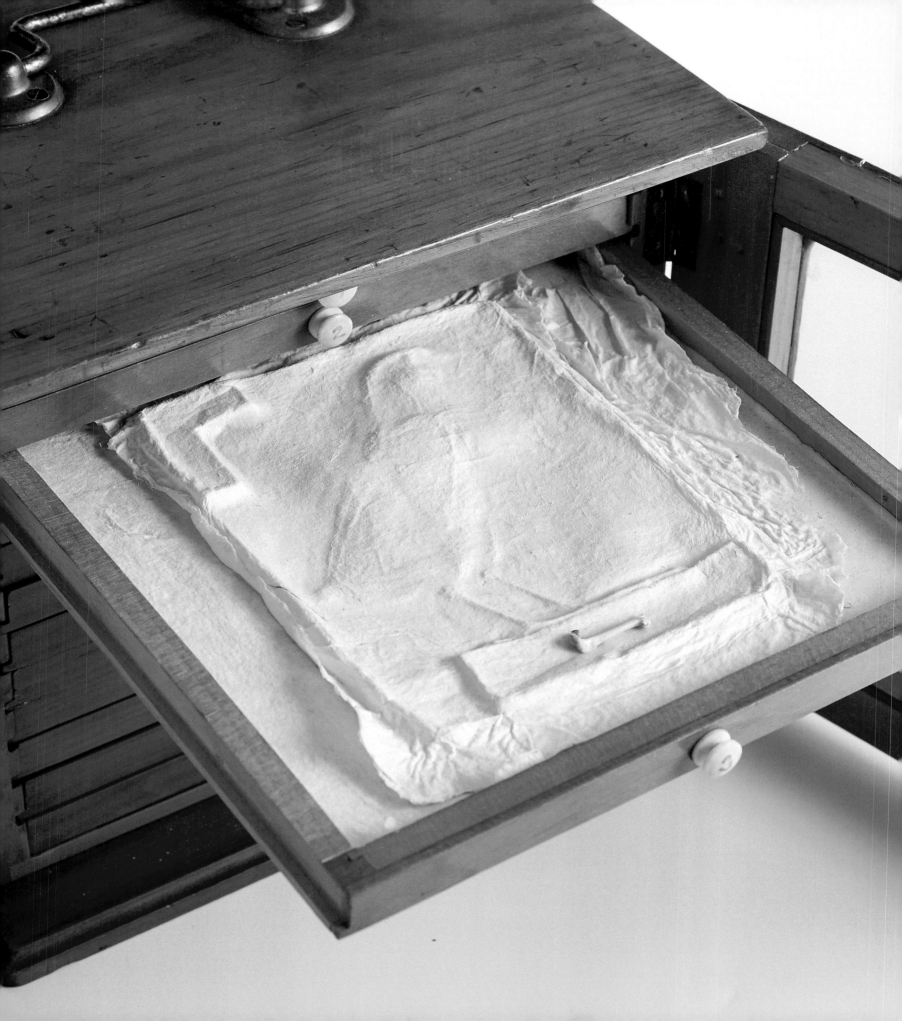

our lives. I left friends whose preconceptions of me held me to their image of me. In N.Y. I came closer to the gutter.…The truest thing in my life was my work. I wanted my life to be as true. Almost gave up my life for my work, seeking a life of the spirit. Gradually (it took years) I came to see one had to live one's life in this world and that out of this flowed the work. I am still coming back to living life.

Unsent card to Erika Billeter, n.d.:

In Fall of 1964 I became extremely introspective. I went deep into myself. I became a seed, buried in the earth. This process went on for a long time. Then it seemed tendrils began to come softly out of the seed. And the tendrils became new work, collages, boxes, drawings, and postcards to friends. It was a real inner sensation. And it was a most wonderful place to be. —of being nothing at all. "I am the dust on the road."

Journal (30.10), undated entry [c. 1969]:

The primordial mystery of weaving and spinning has been experienced in projection upon the Great Mother who weaves the web of life and spins the thread of fate, regardless of whether she appears as one great Spinstress or, as so frequently, in a lunar triad.

Journal (30.10), undated entry [c. 1969]:

Thus the Great Goddesses are weavers in Egypt & also in Greece, among the Germanic peoples & the Mayans. And because "reality" is wrought by the Great Weavers, all such activities as plaiting, weaving & knotting belong to the large-governing activity of the woman who, as Bachofen discovered, is a spinner & weaver in her natural aspect.

Journal (30.5), entry dated July 31, 1979:

The worm turns
The earth turns

On the right toe I whirl
Whirling whirling whirling
The world stops

Journal (30.12), undated entry [c. 1967]:

Threads leading from the past, interwoven with others formed by the present. Strewn between these—still invisible to us—lie those of the future.

Journal (30.16), entry dated May 23, 1981:

It is as if I am walking thru dark caverns, looking, looking. I am trying to get back to the source—from where did I come, from what. What is it that moves us, that makes meaning. I am walking thru water. There is water all around, waterfalls, lakes, streams, brooks, water trickling.

Birds school forth in noiseless flight, darting in all directions. Their wings make patterns against the waterfall, against the splashing fountains.

The drops at the top of fountains, continually changing, rivet my eyes for hours. As from the bow of the ferry, leaning over, the water splashes up, the drop in endless formations, fascinating. It is like gazing into dazzling crystals. Here time is endless. It in fact disappears in the drops. This is the source.

1. Special thanks to Kathleen Mangan for surfacing this letter in the Charlton papers.

2. Lenore Tawney journal (30.5), entry dated 1979, archives of the Lenore G. Tawney Foundation, New York.

Detail of *Collage Chest I*, 1974; mixed media; 8¾ × 7¼ × 8½ in. Lenore G. Tawney Foundation, New York.

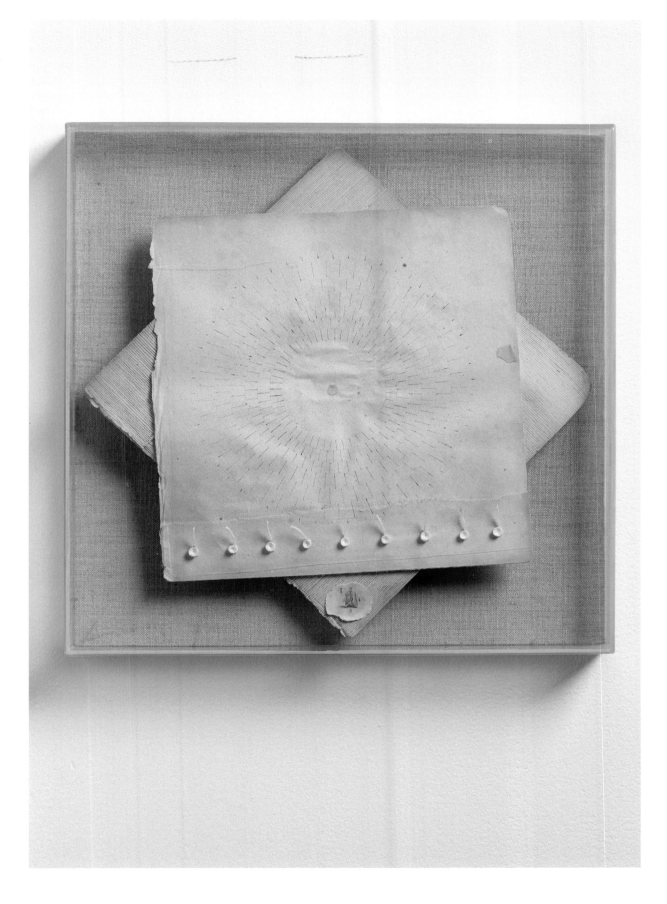

Plate I, 1966; mixed media; 12¼ × 12½ × 2 in. (framed). Lenore G. Tawney Foundation, New York.

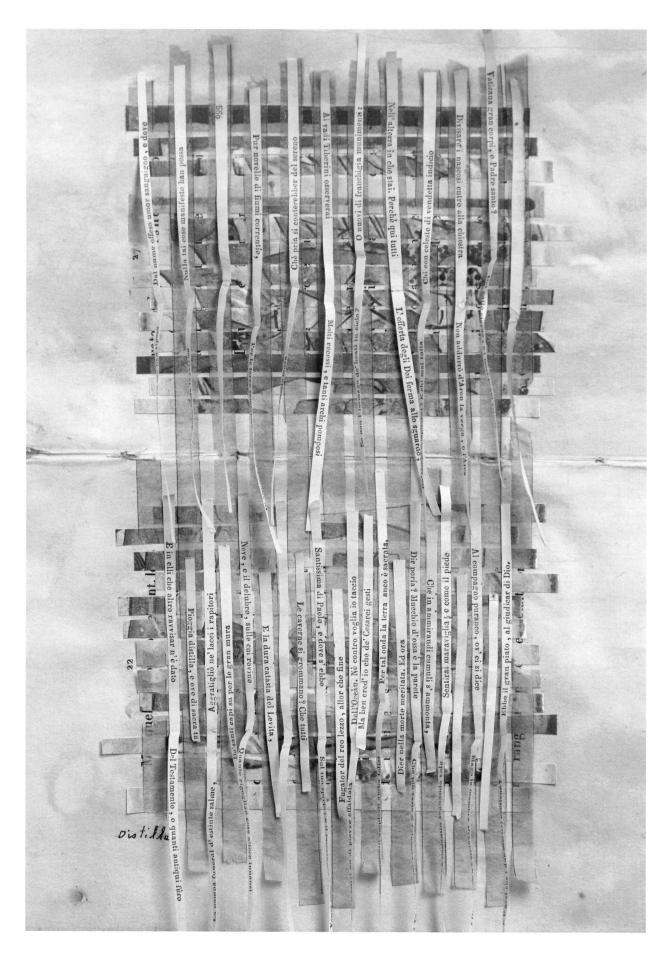

CAL

Cachectical, *kă-kĕt'-tĭ-kăl.*
Cachectick, *kă-kĕk'-tĭk.* } a. Having an ill habit of body.

Cachexy, *kă-kĕk-sў.* f. Such a distemperture of the humours, as hinders nutrition, and weakens the vital and animal functions.

Cachinnation, *kă-kĭn-nă'-ſhŭn.* f. A loud laughter.

Cackerel, *kăk'-ĕ-rĭl.* f. A fiſh.

Cackle, *kăk'l.* v. n. To make a noiſe as a gooſe, or as a hen.

Cackle, *kăk'l.* f. The voice of a gooſe or fowl.

Cackler, *kăk'-lŭr.* f. A fowl that cackles.

Cacochymical, *kă-kŏ-kĭm'-ў-kăl.*
Cacochymick, *kă-kŏ-kĭm'-ĭk.* } a. Having the humours corrupted.

Cacochymy, *kă-kŏk'-ў-mў.* f. A depravation of the humours from a found ſtate.

Cacophony, *kă-kŏf'-fŏ-nў.* f. A bad ſound of words. [dal.

Cacuminate, *kă-kŭ'-mĭ-nàte.* v. a. To make ſharp or pyrami-

Cadaverous, *kă-dăv'-ĕ-rŭs.* a. Having the appearance of a dead carcaſs.

Caddis, *kăd'-dĭs.* f. A kind of tape or ribbon.

Cade, *kă'de.* a. Tame; ſoft, as a cade lamb.

Cade, *kă'de.* f. A barrel.

Cadence, *kă'-dĕns.*
Cadency, *kă-dĕn-sў.* } f. { Fall; the fall of the voice; the flow of verſes or periods.

Cadent, *kă-dĕnt.* a. Falling down.

Cadet, *kă-dĕt'.* f. A volunteer, in the army, who ſerves in expectation of a commiſſion.

Cadger, *kăd'-jŭr.* f. A huckſter.

Cadi, *kă-dĭ.* f. A magiſtrate

Cadillack, *kă-dĭl-lăk.* f. A

Cæſura, *ſĕ-ſŭ'-ră.* f. A f fyllable is made long

Caftan, *kăf'-tăn.* f.

Cag, *kăg.* f. A wood

Cage, *kă'je.* f. An incloſ

Cage, *kă'je.* v. a. To inclu

Caiman, *kă'-măn.* f. The A

Cajole, *kă-jŏ'le.* v. a. To flatter

Cajoler, *kă-jŏ-lŭr.* f. A flatterer;

Cajolery, *kă-jŏ'-lŏ-rў.* f. Flattery.

Caitiff, *kă-tĭf.* f. A mean villain; a de

Technical Analysis
Dove

DR. FLORICA
ZAHARIA

Dove belongs to a group of works that evidence the quality of Lenore Tawney's weaving, as seen in the uniformity of the weave, the regularity of the very long slits, and the meticulous selvages. It is made of three widths of warp-faced weave woven on a Macomber horizontal loom.[1] The overall effect of rep weave is attained by the high density of the warp, which entirely covers the thick weft. During the weaving process, two weft threads were inserted in a shed carried in the opposite direction by two shuttles. Tawney knew that by weaving with this method, the desired thickness of weft could be obtained without affecting the smooth quality of the selvages.

The artist allowed for light to pierce this compact weave by using the discontinuous weft technique for a significant portion of each of the forty-nine narrow, vertical strips distributed throughout the central horizontal panel; the selvages of each strip create long slits.[2] While in the warp-faced weave, the weft travels from one selvage to another transported by the shuttle, for the weaving of these slits the discontinuous weft is inserted in the shed by hand.

Four metal rods secure the cross shape of the piece along each horizontal edge. The heavy rods are held in place with braided and knotted warp threads, in clusters of three, giving a vibrant effect to the piece. On the top edges, the warp ends are trimmed short. Along the bottom edges of the left and right arms of the cross,

Dove, 1974; linen; 118 × 108 in. Lenore G. Tawney Foundation, New York.

Techniques: warp-faced plain weave, warp-faced plain weave with discontinuous weft, and braided and knotted fringes.

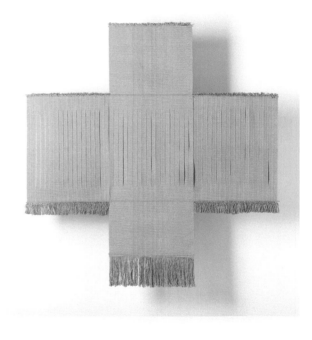

the braided and knotted warp ends are left longer and are more clearly exposed. Those at the bottom of the vertical axis hang longer and more freely, the braiding intermittent and the threads left unknotted.

1. Warp-faced weave woven with a thick weft, which creates a fabric with a ribbing effect oriented in the weft direction, is often called "rep fabric."

2. The length of the slits is approximately a quarter of the entire height of the piece.

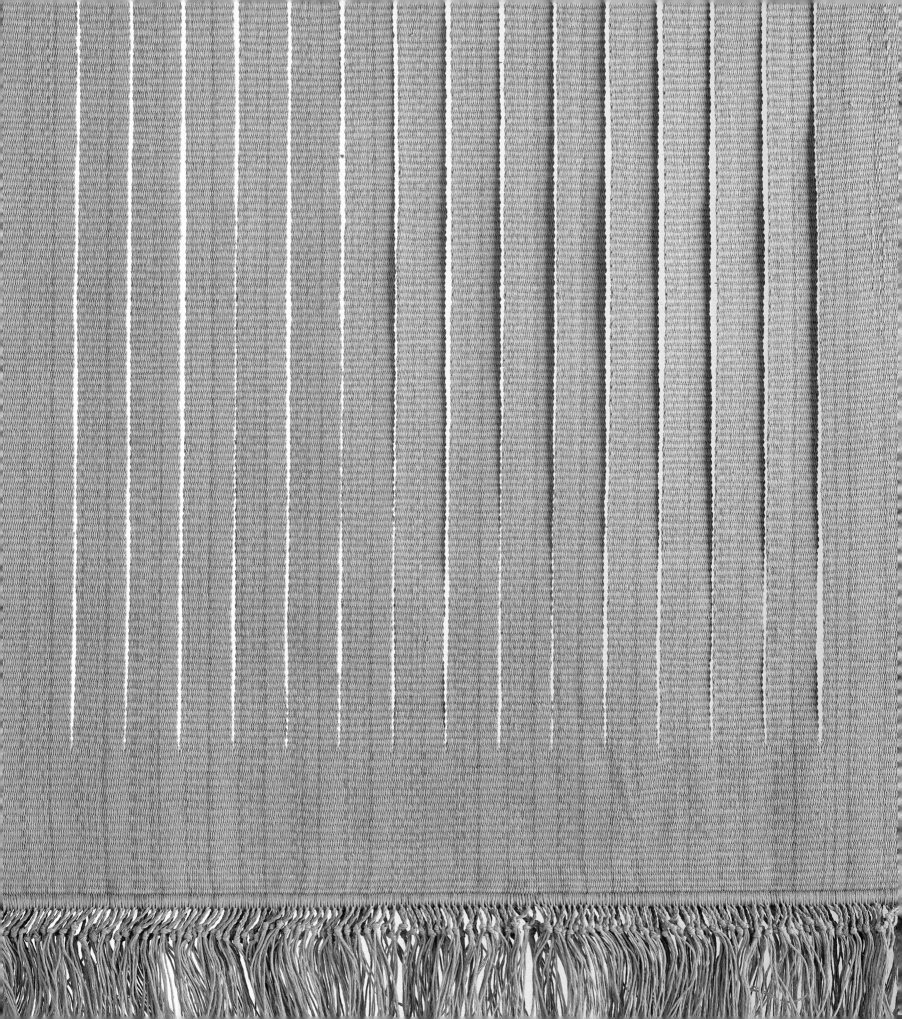

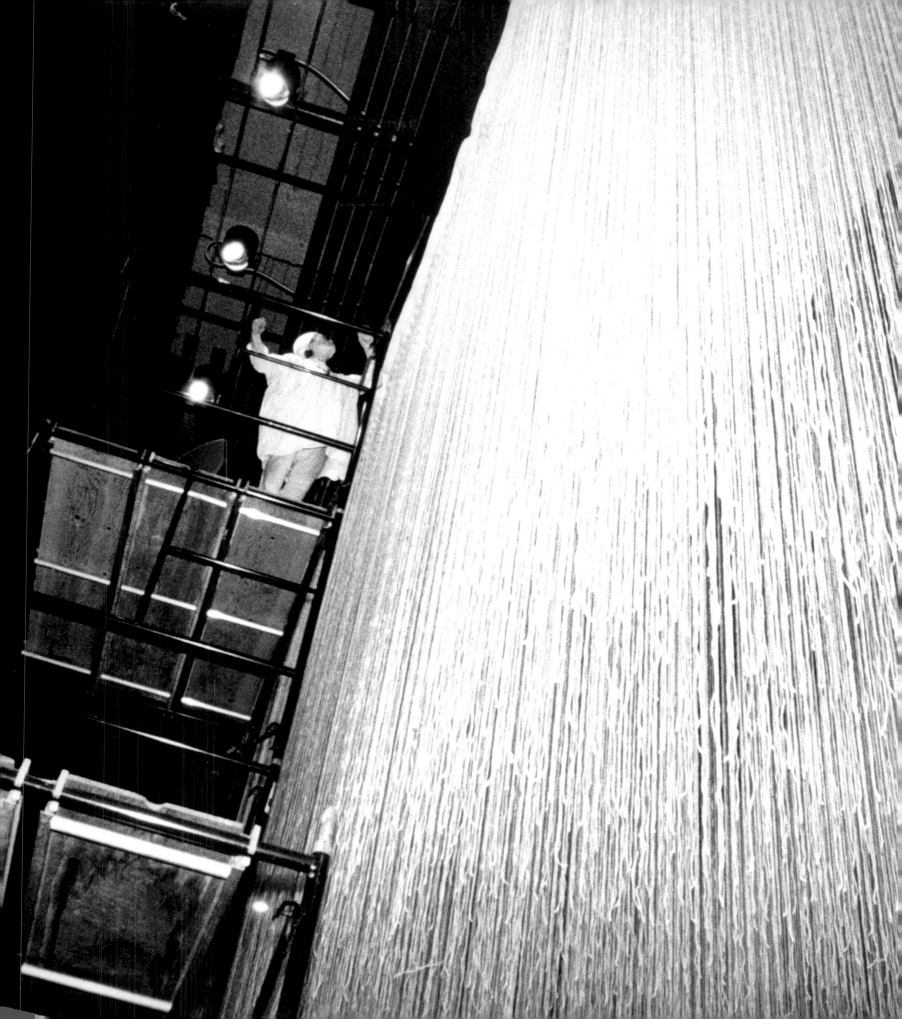

"Being introduced as a young artist to images of Lenore Tawney's work, in particular the Cloud series, opened for me both curiosity and courage to pause at any moment in a known process and to open it, to intensify it, either through material dwelling-on, or through attentional staying-with. In her work I saw material become event, a preparatory gesture within weaving become in fact the main draw. I trace a direct connection from this to my own practice of reading aloud, where the reading that should properly be folded forward into writing or something productive is arrayed as reading itself, reading alone, vocal thread, tenderly refusing to complete a form."

—JUDITH LEEMANN

Artist included in *Even Thread [Has] a Speech*
(page 256)

Tawney installing *Cloud Series VI*, 1981.

That Other Sea

Sage *1980 to 2007* GLENN ADAMSON 222

The Archive *This Cage of Bones, & Blood, & Flesh* MARY SAVIG 240

Even Thread [Has] a Speech SHANNON R. STRATTON 254

Technical Analysis *Written in Water* DR. FLORICA ZAHARIA 272

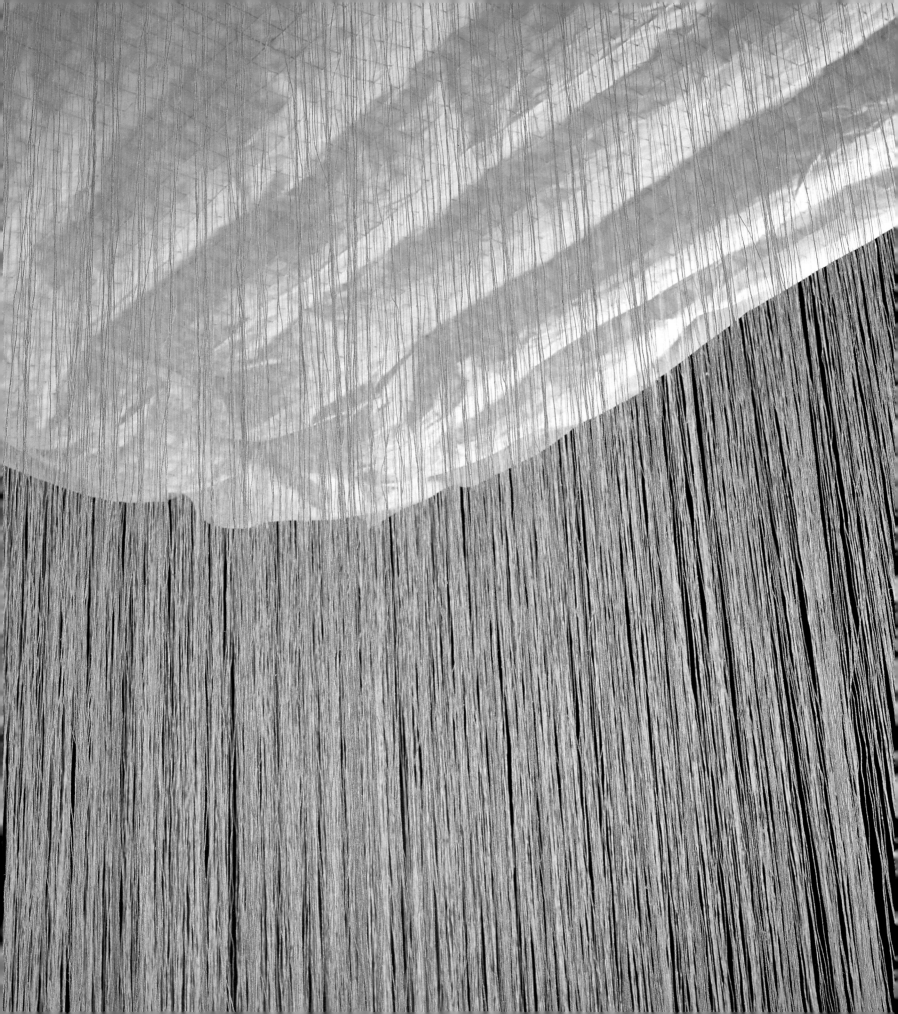

Sage
1980 to 2007

GLENN ADAMSON

The concept of "late style" has attracted a certain amount of attention over the years. Artists working deep into old age, the thinking goes, find themselves in a very particular creative situation. Possessed of accumulated skill and wisdom, unconstrained by worry about self-advancement, and facing approaching death, they often create work of uncommon power and freedom. This is of course a cliché. We should not overgeneralize to the point that every elderly artist's work is treated as a reflection on our common mortality.[1] Yet the concept of "late style" does seem to apply to certain paradigmatic figures. Titian, Monet, and Matisse are among them; and so, too, is Lenore Tawney.

The late works in question are the Clouds, sculptures of great simplicity and ingenuity that Tawney first envisioned in 1977. The series would ultimately encompass a variety of scales and contexts: monumental public commissions and temporary installations as well as smaller gallery-sized works. All were based on the same straightforward construction technique. Tawney first prepared a canvas to serve as the upper support or ceiling of the piece. To this horizontal field, she then attached innumerable thread elements at regular intervals, in a grid. Typically, these were of linen, the material she had preferred since the time of her "woven forms." Each thread was pulled through the canvas and then knotted to secure it, and sometimes further articulated with knotting along its length—an extraordinary amount of repetitive labor.[2] Tawney would tightly coil the threads against the top cloth, tie them off, roll up the whole construction, and then bring it to the installation site. Then the cloth was hung, draping slightly under its own weight, and she would release the threads one by one, letting them tumble down into space. The result is a sculptural conception at once geometric—the accumulated mass of threads defining a parallelogram of space—and ethereal. Not just light but air passes through the open structure, making the threads sway in concert. "I sometimes think of my work as breath," Tawney wrote of these works, returning to a metaphor she had used for her woven forms of the early 1960s. "Breath is life. Breath moves. It is inspiration and aspiration. In and out."[3]

The Clouds were not only a majestic consummation of Tawney's career but also a realization of particular strands of her artistic thinking. One could say that they

Written in Water, 1979; canvas, linen, and acrylic; 10 × 10 × 10 ft. Lenore G. Tawney Foundation, New York.

1. See Gordon McMullan and Sam Smiles, *Late Style and Its Discontents* (Oxford: Oxford University Press, 2016).

2. Tawney kept a log of her progress on one of the works in this series, *Four Armed Cloud* (1978–79); on one day she spent twelve hours making seven lines of threads. Lenore Tawney journal (30.6), entry dated February 20, 1979, archives of the Lenore G. Tawney Foundation, New York (hereafter "LGTF").

3. This text appears as a short poem in an undated brochure (c. 1978) for *Cloud Series IV* at the Santa Rosa Federal Building, LGTF.

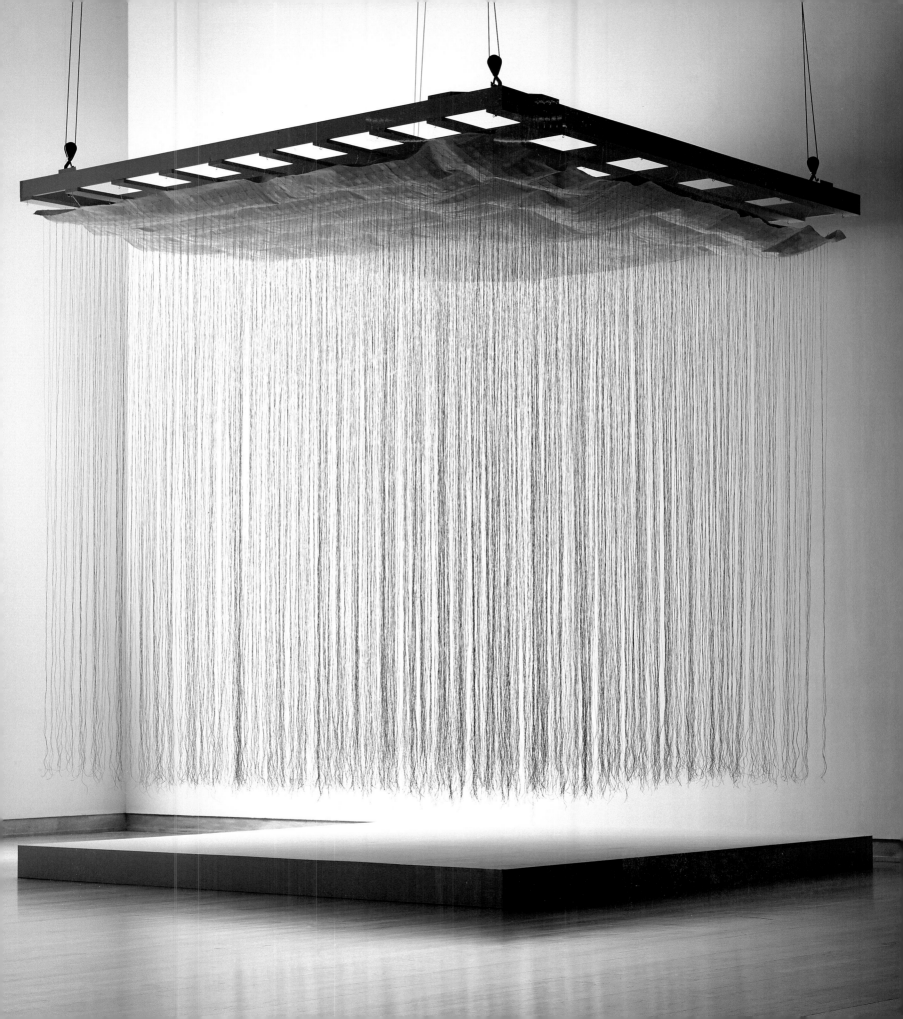

completed a trajectory that began all the way back in the mid-1950s, with her introduction of open-warp tapestry. Those early works were distinguished by the variable integration of loose wefts, so that vertical threads often traversed lengths of open space unsupported. The Clouds are the ultimate rendering of the same idea—no wefts at all, only warps. In a sense this is no longer weaving at all, but the framework of reference remains firmly connected to the loom, given the selection of materials, Tawney's own past as a weaver, and the use of a grid structure to produce textural and visual complexity. The threads do not actually touch, but they nonetheless interact visually, creating ever-changing patterns as one changes vantage point on the work. Another important precedent for the Clouds is *Cubed Cube* (page 132), the failed project that Tawney had hoped to present in the 1969 exhibition *Objects: USA*. It is as if, faced with the impossibility of realizing this form through conventional loom technology, she had sublimated the project and finally reimagined it through a wholly different process. Had it been successfully made, *Cubed Cube* would have been massive and obdurate, a feat of machinery; the Clouds are equally monumental (indeed, in most cases they are far larger), but evanescent, and made with hardly any tools but Tawney's own deft fingers.

The earliest work of the group, strangely, bears the title *Cloud Series IV* (1978), and was made as a public commission for the Santa Rosa Federal Building in California, as part of the "art in architecture" program run by the General Services Administration (GSA), operating in federal buildings nationwide since the Kennedy administration.[4] Tawney had her eureka moment about the work in June 1977 when conducting a site visit, immediately following her six-month stay at the Ganeshpuri ashram in India. Standing in

the Federal Building lobby, she had what she described as a "marvelous feeling of openness," and then the darkly amusing thought that a cloud with threads falling like rain might be appropriate, given the "drought that Northern California and I were suffering at the time."[5] Tawney returned to New Jersey, where she had been living at Toshiko Takaezu's house in Quakertown, to make the work, using the open spaces around her friends Vince and Pearl Cioffi's home to paint and dry the cloth. Polaroids show the septuagenarian artist nimbly climbing over the blue textile, its edges weighted down by pumpkins; it is a reminder of how much she was achieving with how little, a stark contrast to the industrial production facilities that Minimalist and Postminimalist sculptors were using at the time.

Tawney's progress on this first Cloud was not helped by the fact that she injured her arm (the other one this time), having slipped on ice and fallen at a Thanksgiving event hosted by her friends Jean and Frank d'Autilia.[6] Wrist in a splint, she completed the work nonetheless, two thousand threads, each twenty-five feet long, transforming a building of no real architectural distinction into a vault of transcendence. Tawney, deeply satisfied by the achievement, credited the GSA for "the complete esthetic freedom accorded the artist. I have never accepted a commission which did not give absolute freedom."[7] This statement was not strictly true—in her early days with Marna Johnson, she had accepted many commissions with narrow parameters—but it was certainly true to form. By this time, Tawney's sense of independence, always fierce, had become bound to her spiritual commitments. This is another, deeper sense in which the Clouds mark a triumphant realization. She had long sought to express mystical ideas in her work, but had mostly done so in

4. The architect of the building was Craig Roland; the jurors who selected Tawney were the Bay Area artist Cecile McCann, San Francisco Museum of Modern Art Director Henry T. Hopkins, and Janet Kardon of the Philadelphia College of Art, who was later director of the American Craft Museum.

5. Quoted in Eleanor Munro, *Originals: American Women Artists* (New York: Simon & Schuster, 1979), 332.

6. Ahza Moore, interview by the author, December 15, 2017. Moore recalls that the accident happened at Star Camp in New Jersey, and that Tawney understood it as a sign: "It was a lesson about her attachment to her work." Tawney seems to have misremembered this later, saying that the injury she struggled through to make this first Cloud was from her fall from the train in India, but that incident had been well over a year earlier. Lenore Tawney, *Autobiography of a Cloud,* unpublished manuscript, comp. Tristine Rainer and Valerie Constantino (New York: Lenore G. Tawney Foundation, 2002), 41.

7. Undated brochure for *Cloud Series IV.* Tawney continued, "But GSA requires knowing what you are going to do. This is for criticism from the point of view of the needs of the building. So with some trepidation I took my model to Washington to face the GSA Design Review Panel. One smiling face was familiar and gave me courage. The architects spoke of sprinklers, heat, fire, water, and hazards from the public, but the piece itself was not in question."

her small collage and assemblage objects—works in a minor key, riddling and esoteric. The Clouds, by contrast, were sublime. They communicated the sheer power of Tawney's spirituality, which was not just an intellectual matter but also something she felt through her whole body and soul. She later said of the Santa Rosa installation, "It was thrilling. It was my vision. But it wasn't mine. It came from God."[8]

In his recent book *No Idols,* Thomas Crow has written of the secular biases of art history. Much world art has been motivated by faith, but historians have tended to bracket out that content in favor of formal, iconographic, and stylistic concerns: "Religious behavior and belief, along with theological meaning, appear as cultural artefacts to be dissected and decoded with clinical detachment, next to nothing presumably at stake for the interpreter beyond demonstration of scholarly acumen."[9] With the notable exception of visionary practices among self-taught artists, this has also been the overwhelmingly dominant critical paradigm for modern and contemporary art. Tawney's Clouds do have a place within secular accounts, as a nearly dematerialized Minimalism, perhaps, or as responsive site-specific installation art. They also offer rich visual pleasure, particularly later versions in the series in which color, variations of density, or knotting patterns create elusive internal fields or spheres. But to really understand these sculptures, it is necessary to *believe* in them. This is best done by exploring them bodily, standing underneath, then walking up and alongside them (Tawney often positioned them in relation to stairways and balconies, extending an invitation to do just that). The Clouds are ideally experienced over prolonged time, quietly meditating on the ripple of the threads as one might sit quietly by the sea.

The last film that Maryette Charlton made of Tawney was taken in 1979, at a joint exhibition with Toshiko Takaezu held at the New Jersey State Museum in Trenton. For the show, Tawney installed *Four Armed Cloud* (1978–79), which consisted of four square Cloud elements arranged in a larger square. This left a cruciform open space between them, which

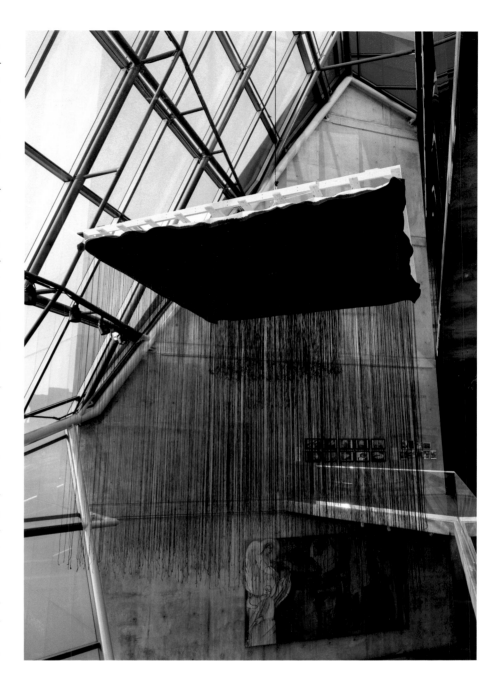

Scripture in Stone, 1990; canvas, linen, acrylic, and gold leaf; 14 × 14 × 14 ft. Lenore G. Tawney Foundation, New York. Installation view, Maryland Institute College of Art, Baltimore, 2012.

8. Tawney, *Autobiography of a Cloud,* 42.

9. Thomas Crow, *No Idols: The Missing Theology of Art* (Sydney: Power Publications, 2017), 6.

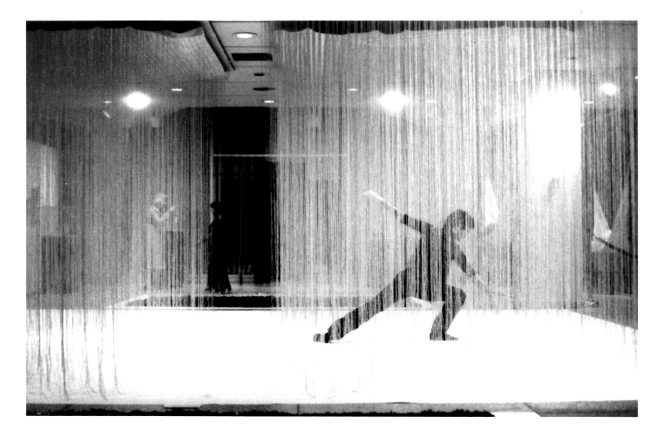

Andy de Groat performance inside *Four Armed Cloud*, 1978–79; canvas, linen, and acrylic; dimensions variable, each of the four Clouds approximately 10 × 10 × 10 ft. Lenore G. Tawney Foundation, New York. The performance took place during Tawney's solo exhibition at the New Jersey State Museum, 1979.

visitors were invited to walk into and explore. As Katharine Kuh wrote, it was a "transparent maze of magical power."[10] A view through one of the installation's interior alleys ended in *Dove* (page 177), a cross-shaped piece in natural linen, adding a further opportunity for meditative absorption. Charlton shot an extraordinary sequence of Tawney doing just this, seated in the lotus position at the very center of the installation. She seems to perfectly embody Siddha Yoga practice, which sought to put devotees "in touch with the place where they are perfect in themselves and, at the same time, perfectly connected to everything around them."[11] Tawney had arrived at just such a place, employing her own art as a literal and figurative pathway. Takaezu's presence in the exhibition made it all the more significant: her closed pot forms, distributed on fields of pebbles, anchored the space.

Earlier works of Tawney's were also included, among them *Dark River* (page 114), on loan from the Museum of Modern Art.

The Trenton show was also the setting for an important collaboration between Tawney and the choreographer Andy de Groat (also spelled "de Groot"), a major presence in the New Wave dance scene in New York at the time. Tawney may have first seen him perform in 1977 in a collaboration with the artist Ann Wilson—an associate of hers since the Coenties Slip days—that was based on Alban Butler's *Lives of the Saints,* an eighteenth-century compendium of Christian hagiography that Tawney and Agnes Martin had also read with interest.[12] De Groat also often collaborated with the well-known stage auteur Robert Wilson, with whom he was romantically linked, providing the original choreography for *Einstein on the Beach* (1976).

10. Katharine Kuh, preface to *Lenore Tawney* (Trenton: New Jersey State Museum, 1979), n.p.

11. "Who Is Swami Muktananda?," in *Muktananda: Guru*

Om, newspaper-format brochure, 1976, 2, Maryette Charlton papers, circa 1890–2013, Archives of American Art, Smithsonian Institution, Washington, DC (hereafter "MC/AAA").

12. Wilson's project, supported by the then-new public art organization Creative Time, was staged in Philadelphia and was one of a series of innovative multimedia performances. These "painted plays" (as she

called them) included large-scale projections as well as spoken text and dance. *Butler's Lives of the Saints,* brochure, 1977, MC/AAA.

Whether or not she had previously been aware of him, Tawney did see De Groat perform in January 1979, and praised his "graceful, light, most beautiful movements" in a letter to Takaezu, who was wintering in Honolulu (Tawney had also recently seen a beautiful show of Islamic calligraphy: "my cup overfloateth").[13]

It was an inspired idea to invite De Groat to dance inside *Four Armed Cloud* (facing page). For some years, he had developed a dance repertoire incorporating spinning movements, sustained over long periods. This demanding practice required extensive training (both to overcome dizziness and to retain rigor in the movement) and compares closely to Tawney's own investment in somatic repetition. De Groat commented that his rotational choreography was "like taking a walk, without going anywhere," an idea that parallels Tawney's statement about her Cloud sculpture: "It should give you the suggestion of motion, though stationary."[14]

Later, in 1979, Tawney had a chance to realize a third Cloud sculpture, this time in Zurich. Though most major American museums were no longer paying her work much attention, the curator Erika Billeter—who had restaged *Woven Forms* in 1964 at the Kunstgewerbemuseum and also included Tawney's work in an exhibition about collage in 1968—remained an unswerving supporter. She invited Tawney to take part in the exhibition *Weich und Plastisch: Soft-Art,* at the city's Kunsthaus.[15] The shift in venue from *Woven Forms* was significant, marking a transition from a craft gallery to a fine art exhibition space. Tawney traveled to Zurich to install the work, and wrote to Takaezu of the high times she had there, working "every day, all day, except Sunday" on the installation, getting drunk on pisco sours, and dancing all night with Bil-

leter and other friends. As in Santa Rosa, she was pleased with the effect of her work—"I have a big corner all to my self. It does look beautiful—it vibrates a little"—but also struck by the disparity between her classical aesthetic and the more rough-and-tumble works elsewhere in the exhibition: "This is a *very* big, and important show. Most things have that dirty look of things picked off the street. I should have dirtied my canvas and used old rope, greasy."[16]

It was a grudging recognition on her part of the divergence between her interests and those prevalent in contemporary sculpture, which Virginia Hoffman had presciently noted a decade earlier.[17] *Soft-Art,* the English-language title that Billeter appropriated for her show, had been coined in the late 1960s as a nonjudgmental term that encompassed sculptures made with conventional fiber techniques and more experimental methods. One project in this vein, curated by Ralph Pomeroy, had been staged in 1969, also at the New Jersey State Museum and also entitled *Soft Art*. It included two of Tawney's earlier woven forms (*The King* and *The Queen,* both 1962), alongside Postminimalists like Richard Tuttle, Robert Morris, and Eva Hesse as well as Claes Oldenburg; Tawney saw it as emphasizing "the chance approach" in art.[18] Pomeroy's and Billeter's exhibitions, one decade apart, offer a tantalizing glimpse of a rubric that never caught on—one way that Tawney's work could have been successfully woven into a broader sculptural narrative. As Elissa Auther has noted, the category of "soft art" failed to win critical support at a time when medium-based hierarchies were still in force; it is only in recent years that the continuities acknowledged in these exhibitions have come to seem more important than the distinctions they bridged.[19]

13. Lenore Tawney to Toshiko Takaezu, January 22, 1979, Toshiko Takaezu Family Trust (hereafter "TTFT"). The calligraphy show, *It Is Written: Calligraphy in the Arts of the Muslim World*, was at Asia House, the gallery of the Asia Society, New York.

14. Quoted in Catherine Galasso, "Notes on De Groat," lecture/performance, Brooklyn Art Exchange, January 11, 2018;

Tawney journal (30.16), undated entry [c. 1981–82], LGTF.

15. Erika Billeter, ed., *Weich und Plastisch: Soft-Art* (Zurich: Kunsthaus Zürich, 1979). In addition to bringing *Woven Forms* to Zurich in 1964, Billeter had also included Tawney in her exhibition *Collagen: Die Technik der Collage in der angewandten Kunst* at the Kunstgewerbemuseum in 1968.

16. Tawney to Takaezu, postcard, November 13, 1979,

TTFT. Tawney sent this postcard, depicting a Kuan Yin sculpture from the Rietberg Museum, Zurich, on the day that she completed her installation.

17. Virginia Hoffman, "When Will Weaving Be an Art Form?," *Craft Horizons* 30, no. 4 (August 1970): 18.

18. Ralph Pomeroy, *Soft Art* (Trenton: New Jersey State Museum, 1969); Tawney to Marna Johnson, November 22,

1968, LGTF. The Marna Johnson papers are housed at the LGTF.

19. Elissa Auther, *String Felt Thread: The Hierarchy of Art and Craft in American Art* (Minneapolis: University of Minnesota Press, 2010), 43–44. See also Jenelle Porter, "About Ten Years: From the New Tapestry to Fiber Art," in *Fiber: Sculpture 1960–Present* (New York: Prestel in association with Institute of Contemporary Art Boston, 2015).

Another missed connection for Tawney at this time was with feminism. As Julia Bryan-Wilson has shown in her important recent book *Fray: Art and Textile Politics,* the medium of fiber was central to feminist and queer critical practice in the 1970s. The artists Faith Wilding, Harmony Hammond, Miriam Schapiro, and Judy Chicago as well as the critic Lucy Lippard—to name a few of the most influential American figures—were all interested in the way that popular and amateur craft practices could be redeployed in a fine art context. This ambition was fraught with difficulties, for, as Bryan-Wilson puts it, "The pervasive idea that craft might be utilized for strategic or polemical purposes has always been shadowed by an even more prevalent story within the twentieth century regarding textile techniques such as sewing, knitting, or quilting, which is that they are fundamentally *trivial.*"[20] For her part, Tawney had no desire whatsoever to engage in hobbyism or historical "women's work." Nor did she mount the barricades with her sister artists. She was acquainted with women who did, like Nancy Azara, a founder of the New York Feminist Institute, as well as figures affiliated with the Pattern and Decoration movement, but she did not engage explicitly with feminism artistically.[21]

Tawney did embrace narratives about gender that we might today regard as "essentialist"—that is, based on an understanding of a female principle in fixed opposition to the male—which were widely circulated among feminists in the 1970s. A key source for her was *The Great Mother* (1955), a treatise by the Jungian theorist Erich Neumann that advanced a theory of "the eternal feminine" as a mythological and psychological archetype. She transcribed lengthy passages from Neumann's book in her journals, focusing particularly on his use of textile imagery:

> The Great Goddesses are weavers, in Egypt as
> in Greece, among the Germanic peoples and

the Mayans. And because "reality" is wrought by the Great Weavers, all such activities as plaiting, weaving and knotting belong to the fate-governing activity of the woman, who…is a spinner and weaver in her natural aspect.[22]

For Tawney this conception of the feminine principle was compatible with ideas that she found in Siddha Yoga, which similarly taught that one could find within oneself a nurturing "Universal Mother" through the words of the guru.[23]

Thus, for the most part, her position with regard to feminism was one of an admired exemplar rather than active participant. Her professional achievement in a previously marginalized craft—one with deep historical associations to female creativity—was a paradigmatic tale for feminists who believed that the personal was the political. As Gloria Orenstein put it in a *Feminist Art Journal* article on Tawney, "The artist wove the very destiny of the craft itself, as she spun the story of her interior evolution into the fabric of her own life."[24]

Gradually, this emphasis on Tawney's lifelong creative journey—arduous but ultimately successful—became the dominant trope in commentary about her. A 1979 profile by the journalist Anne Woolfolk, entitled "Tawney Creates with Bliss," leads with a charming picture of the artist blowing soap bubbles. Throughout the interview, she speaks of a new sense of freedom and composure, which she attributes to Muktananda's influence, and also to her own work. She saw the humorous side of this; "I cut my hair," she told the journalist, and that "is supposed to mean you want to change your thoughts. My thoughts are so happy, so peaceful, I must have gotten bored with them."[25] On another occasion, Woolfolk recorded her saying, wistfully, "When you reach a certain age in Japan, you can become a 'national treasure.' After this age, nothing you do is considered wrong."[26]

20. Julia Bryan-Wilson, *Fray: Art and Textile Politics* (Chicago: University of Chicago Press, 2017), 20.

21. In 1986 Tawney attended a session of the Women's Caucus for Art at Azara's invitation, where she heard talks by Sylvia Sleigh and Faith Ringgold. She wrote to Ferne Jacobs that Sleigh's vulnerable portraits made male viewers uncomfortable—"Men want to be portrayed as macho, in control of the whole situation"—but primarily she was interested in the personal pathway of each artist, stating (with a hint of self-portraiture), "Unless you follow someone's work closely you can't understand just where they are at." Tawney to Jacobs, February 12, 1986, Collection Ferne Jacobs.

22. Journal (30.10), undated entry [c. 1967–69], LGTF. The quoted line is from Erich Neumann, *The Great Mother: An Analysis of the Archetype* (1955; repr. New York: Pantheon, 1963), 227.

23. Journal (30.5), undated entry [1979?], LGTF.

24. Gloria Orenstein, "Lenore Tawney: The Craft of the Spirit," *Feminist Art Journal* 2, no. 4 (Winter 1973–74): 11.

25. Anne Woolfolk, "Tawney Creates with Bliss," *Princeton Packet: Time Off,* November 14–20, 1979, 7.

26. Anne Woolfolk, "Dream Weaver," *New Jersey Monthly,* April 1980, 112.

There is a detectable current of pride in such mild jokes; certainly, to the extent that the spiritual path involves overcoming the ego, Tawney had a great deal to overcome. Her journals attest to that constant effort. Most of them consist of lengthy quotations, transcribed in Tawney's mesmerizingly fine script: Jakob Böhme, Carl Jung, Leo Tolstoy, James Joyce, Rainer Maria Rilke, and a huge range of Christian, Buddhist, and Hindu spiritual leaders. She gravitated particularly to writers who counseled nonattachment: "The sea is not aware of its wave. Similarly the Self is not aware of its ego" (Ramana Maharshi).[27] "Life is but a procession of shadows, and God knows why we embrace them so eagerly, and see them depart with such anguish, being shadows" (Virginia Woolf).[28] Sometimes, she simply wrote numbers, over and over again, filling a page: "eight eight eight eight eight." Or quotes a single line of poetry, which seems to condense all that she is looking for: "I'm taught as water teaches stone" (Theodore Roethke).[29]

Tawney's formidable erudition was never for its own sake; rather, her breadth of reference was motivated by a need to find a balance between ambition and tranquility. By the 1980s, she had found that harmony, and it was a productive time for her. At a residency at the Fabric Workshop in Philadelphia, she created a *Cloud Garment*—an enormous pillow that one could wear over the shoulders during meditation—and a series of *Ear Pillows* printed with sheet music, suggesting the delightful conceit of a music transmitted only in sleep.[30] In 1988, for the pioneering gallerist Helen Drutt, also a Philadelphian but then running a space in New York, Tawney conceived a kinetic sculpture entitled *Collage Chest*, which would simulate the experience that visitors had in her loft by slowly opening and closing drawers filled with her collected curiosities. The machinery of the work was never completed to her satisfaction, despite the efforts of her friend the architect Frank Weise, but the work still succeeded as a static object. It is now in the collection of the Whitney Museum of American Art.

Tawney executed several more Cloud series works, including public commissions in Cleveland and at a university in Connecticut as well as temporary installations in several museum exhibitions, including Jack Lenor Larsen and Mildred Constantine's big touring exhibition *The Art Fabric: Mainstream* (1981). She traveled to Switzerland for the 1983 Lausanne Biennial, which had the theme "Fiber Space: Fiberart creates its own environment." Larsen and Billeter, Tawney's longtime supporters, were among the key architects of this show, which positioned Tawney's contribution, a complex iteration of the series, titled *Cloud Labyrinth* (page 230), in the context of works by younger artists who were similarly concerned with "the transparency of materials, the active role of air and light, [and] the weightlessness of installations."[31] The artist Gerhardt Knodel, who also traveled to Lausanne to install a large-scale work, remembers Tawney as impressive, demanding, and fun-loving by turns. She had no hesitation climbing up onto a tall scaffold and manipulating the many threads of her *Cloud* by hand.[32]

Unfortunately, though she met them with equanimity, challenges did lie ahead for her. In the first months of 1982, she seemed to have an acute sense of foreboding: "I shall reach 75 this year. The years bounce. They tumble over one another. To get to the end the beginning. The cause of death is birth."[33] She traveled back to the ashram in India, only to find that Baba Muktananda was ill; in October he died. He had been not just her spiritual anchor, but in many ways the center of her life for nearly a decade. Yet she accepted his passing and embraced his successor Gurumayi Chidvilasananda with equal devotion. Tawney had met Gurumayi back in 1974, when the future guru was only seventeen. Now, she held an event at her loft for a group of followers to meet the new leader. Robert Kushner, who helped host the event, remembers Tawney giving the new guru the usual tour of the loft, opening up cabinet drawers to show curious objects; then the two retired to her curtained bedroom area and sat talking alone. The other devotees looked on

27. Journal (30.16), undated entry [c. 1981–82], LGTF.

28. Journal (30.16), undated entry [c. 1981–82], LGTF.

29. Journal (30.12), undated entry, LGTF.

30. These works were displayed in the Fabric Workshop exhibition *Process and Practice: Forty Years of Experimentation* (2017–18).

31. Jenelle Porter, "The Fiber Art Pioneers," in Giselle Eberhard Cotton and Magali Junet, eds., *From Tapestry to Fiber Art: The Lausanne Biennials, 1962–1995* (Milan: Skira, 2017), 101.

32. Gerhardt Knodel, interview by the author, January 3, 2018.

33. Journal (30.16), undated entry [c. 1981–82], LGTF.

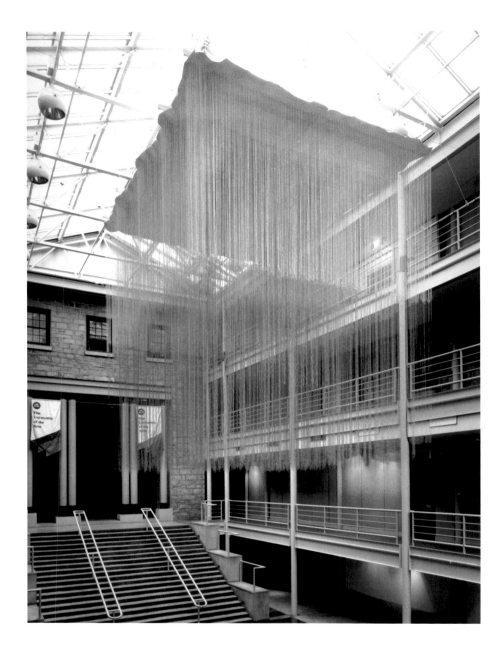

Cloud Labyrinth, 1983;
canvas and linen; 16 × 24 ×
18 ft. Lenore G. Tawney
Foundation, New York.
Installation view,
University of the Arts,
Philadelphia, 1992.

at the two women, aged exactly fifty years apart, both worthy of great respect.[34] At the ashram at South Fallsburg, too, Tawney was regarded with something bordering on reverence, sometimes being asked to model proper meditation technique for other followers. Her faith in Siddha Yoga remained unswerving; in 1989, she wrote, "I am a tiny flying spirit that is always flying around Gurumayi, wherever she is."[35]

The first indications of a more tragic dimension of her later years also emerged in 1982. In August, she confided to her journal: "upon arising, when I sit down to read, my eyes water and print seems veiled…looking into other eyes in conversation is extremely uncomfortable, is an effort."[36] It was the beginning of a degenerative process that would eventually leave her almost completely blind. For any artist, this would be devastating; for Tawney, accustomed to prolonged periods of finely detailed work, it was all but career ending. In the early 1990s, her failing eyesight obliged her to work for the first time with studio assistants, Richard McKay and Barbara Tiso, to repair and complete pieces discovered in Takaezu's attic. In the case of small weavings, she might execute just a few knots or braids to show how she wanted them done, and then hand the work over for completion. One late series called Drawings in Air (pages 232, 233), created in the late 1990s, was made entirely by Tiso to Tawney's specifications. These consist of acrylic boxes with taut linen yarns inside, describing intersecting curved and planar shapes. While they lack the finesse that only Tawney herself could bring to her work, they are nonetheless fascinating as continuations of certain long-standing interests, recalling the configurations of her 1964 Jacquard-inspired drawings, certain constructions (like *Thread Box,* 1968, now in the collection of the Art Institute of Chicago), and even the Cloud series, which also filled a volume with unwoven threads. In this latter connection, it is appealing to think of the Drawings in Air as maquettes for monumental sculptures, and this was a possibility Tawney herself considered. According to Kathleen Nugent Mangan, she once spoke of realizing them with bronze

34. Robert Kushner, interview by the author, December 7, 2017.

35. Journal (30.6), entry dated September 27, 1989, LGTF.

36. Journal (30.8), entry dated August 22, 1982, LGTF.

rods, and wondered how the wind would sound passing through.

This was the moment when Mangan herself entered the story. A curator at the American Craft Museum, she had been working there since 1981. Director Paul J. Smith was determined to mount a full retrospective of Tawney and asked Mangan to begin work on the project. Though Smith retired in 1987, the planned exhibition stayed on the books through a turbulent change of leadership (eventually Janet Kardon, who had been on the jury that selected Tawney to create the first Cloud series in Santa Rosa, assumed the post). Mangan remembers her first beguiling encounter with Tawney, who began the conversation by blowing soap bubbles in the studio. Gradually they became extremely close, with Mangan serving in multiple roles: curator, researcher, assistant, caregiver, archivist, and, finally, the steward of Tawney's legacy. The retrospective exhibition that she curated for the American Craft Museum opened in April 1990, then toured to the Art Institute of Chicago with the support of Christa Thurman, and finally to the Renwick Gallery in Washington, DC. At each stop a Cloud was installed; in New York, it was positioned in the museum's spiral stair, echoing the floor-spanning verticality that *Untaught Equation* (page 115) had brought to *Woven Forms* almost three decades earlier.

The retrospective was crucial in documenting Tawney's work, and retrieving her work for a new generation. It would be inaccurate to say that she had been entirely forgotten in the preceding years, but there is little doubt that the 1980s had been the low ebb of her career. When Moke Mokotoff, proprietor of a small gallery on East Ninth Street east of Avenue C (not exactly art world central), gave her a show in 1986, *Art in America* covered it as if she were a figure from a distant age. After her last Willard Gallery show in

1974, the magazine reported, Tawney "came to dislike the gallery system in general. So she stopped showing…her reputation went pretty much underground." Now, however, "Word was out on the Lower East Side grapevine that the work of this sweet, rotund pixie with funny red-dyed hair was something that had to be seen."[37]

This was the sort of casual disregard that Mangan set out to dispel, and she was largely successful. Coverage of the retrospective was voluminous and for the most part positive, establishing Tawney decisively as the grande dame of American textile art. This did leave room for disagreement about her collage and assemblage works: Were they minor works, derivative of artists like Kurt Schwitters and Joseph Cornell? An interesting sideline, if not the equal of her weavings? Or did they, in fact, "best illuminate her poetic vision"?[38] Then there was the question of Tawney's larger art historical contribution, beyond the realm of the studio craft movement. The most accomplished critic to write on the show, Roberta Smith of the *New York Times,* was disappointingly unsupportive on this score. While she praised the powerful figurative presence of the woven forms, Smith characterized Tawney's textile works of the 1970s as "inert," and said that the collages and constructions bespoke "an inspired amateur whose mystical slant often tapers off into sentimentality." In all, she concluded:

> It would be wonderful to be able to say that Mrs. Tawney's achievement transcends the craft-art distinction, adding an important chapter to the history of late 20th-century art. But on the contrary, Mrs. Tawney's work exists in a limbo that is endemic to much contemporary craft: it has departed from craft and function without quite arriving at art.[39]

37. Gerrit Henry, "Cloudworks and Collage," *Art in America,* June 1986, 118.

38. The *Washington Post* was particularly dismissive of the assemblage works: "Fiddling obsessively…the more time she spends making elaborate and off-putting arrangements of bird eggs and torn-up manuscripts the less original

and engaging her weavings become." Hank Burchard, "Fiber Art's Revolutionary," *Washington Post Weekend,* April 19, 1991, 59. Tawney's peers and co-exhibitors in the important 1963 *Woven Forms* exhibition, Claire Zeisler and Sheila Hicks, also found her turn to collage disappointing, with Zeisler describing them as "not very

interesting," and Hicks seeing in them a return to her early work: "She migrated back into the woods in the end, into mysticism…. There was a foray in between, with the geometry and the slits and the abstraction, and she rode that vehicle for a certain distance and then lapsed back into being Nature Lady." Oral history interview

with Claire Zeisler, 1981 June, Archives of American Art, Smithsonian Institution, Washington, DC; Sheila Hicks, interview by the author, October 29, 2018.

39. Roberta Smith, "Lenore Tawney's Work in Fiber and Beyond," *New York Times,* May 18, 1990.

In one sense, such harsh judgments did not particularly matter. Immediately upon the heels of the retrospective, Tawney was given an exhibition at the Stedelijk Museum in Amsterdam, which opened in conjunction with a show on the Abstract Expressionist sculptor John Chamberlain. The Stedelijk selection featured some important works that had been temporarily "lost" in Toshiko Takaezu's attic (temporarily in this case meaning about fifteen years), stored behind some of her paintings.[40] Other museums began acquiring her work again, a process that has accelerated ever since. And Mangan's foundational research on the artist—carried out without the benefit of an organized archive, one should remember—became the basis for further projects, notably a beautiful small book on Tawney's postcards with an insightful essay by Holland Cotter (Smith's colleague at the *Times*), praising her collages' "accessibility, their fleet wit, their conceptual ingenuity, their stimulating metaphoric play."[41]

Yet there is another sense in which reactions like Roberta Smith's were premised on a persistent categorical rigidity, which had already held back the recognition of Tawney's work for decades. Those ideas have survived the twenty-first century far less well than Tawney's own. Rather than seeing her restless explorations as drifting into "limbo," we can now understand her as productively evading classification. She may at times have been amateurish, mystical, and sentimental, but these were strengths, not liabilities—indications of her curiosity, conviction, and humanity. Rather than parsing her oeuvre in a conventional manner, with some periods and works held up for esteem, others swept aside as less consequential, we might at least try to take Tawney on her own terms. And that means taking her whole. She was a person who sought to transcend critical judgments about herself and her work, instead thinking in terms of unmediated experience. Are we so cynical, or unimaginative, not to rise to this challenge?

The art historian Alexander Nemerov has recently stressed the importance of the primary encounter with works of art, and of a form of criticism that would respect that primacy, "an arrival back at what the painting was *before* anyone said anything about it."[42] Tawney, too, wrote a sort of review of her own retrospective, and she did it precisely in this spirit. It takes the form of a journal entry, written just after she had seen the show in Chicago: "I see that I have worked from the deepest sources of my being, that I have been serious and yet playful, full of joy and love, and at the same time full of pain and despair. The tension between these opposites has been the wire upon which I have walked."[43] It is as accurate an assessment as anyone could wish for.

In one of her later journals, Tawney noted down a thought from her reading: "The sage bears the body, awaiting the right and destined time to discard it."[44] On September 24, 2007, just a few months after her hundredth birthday, that time arrived. She died as, for the most part, she had lived, alone in her spacious white loft. Her cremated remains were returned to Urbana and laid to rest near her husband, George, in Woodlawn Cemetery.

Prior to her passing, Tawney had made certain preparations. In 1989 she set up a foundation for the preservation of her own work and papers, perhaps imagining a book like the one you are reading right now. She also stipulated that her foundation would support the work of young artists, a mission that it continues today through a modest grant program. Tawney did not die a wealthy woman, but she did leave behind two key assets: the loft on West Twentieth Street and a painting by Agnes Martin entitled *Homage to Greece*. The painting was sold at Christie's in 2011, along with other works from Tawney's collection. The loft was also sold; until recently it was owned by the decorator Cheryl Mowinckel and her husband, John, who preserved the spacious, all-white

40. Rita Reif, "Artistry and Invention Seamlessly Joined," *New York Times,* November 26, 1995. It was these "attic collection" works, some of them unfinished and others requiring restoration, that the studio assistant Richard McKay principally worked on.

41. Holland Cotter, "Lenore Tawney: Postcard to the World," in *Lenore Tawney: Signs on the Wind; Postcard Collages* (San Francisco: Pomegranate, 2002).

42. Alexander Nemerov, introduction to *Experience: Terra Foundation Essays,* vol. 4 (Chicago: Terra Foundation for American Art, 2017), 18.

43. Journal entry dated July 25, 1990, quoted in Tawney, *Autobiography of a Cloud,* 65.

44. Journal (30.8), entry dated August 7, 1964, LGTF. The line is quoted from Sri Ramana Maharshi, "About the Loss of the Beloved by Death," in *Talks with Sri Ramana Maharshi* (Tiruvannamalai: Sri Ramanasramam, 1955).

character of the space, as well as one of Tawney's artistic interventions, a central support pillar ornamented with gold and silver leaf.[45] The foundation offices are across the street.

Meanwhile, Tawney's legacy continues to unfold. This was something she did think about in advance, for all that she tried to live in the moment. Ferne Jacobs tells a revealing anecdote about a plane trip she took together with Tawney. As they were approaching New York City, the aircraft was caught in terrible turbulence. The passengers, distressed, were variously crying or panicking; Jacobs herself was white-knuckled with fear. Tawney simply closed her eyes and sat, perfectly placid. When the plane finally landed without serious incident, Jacobs asked her how she had managed to remain so calm. Tawney smiled and said, "I was thinking of my *New York Times* obituary."[46]

It is a wonderful story, capturing as it does Tawney's ever-present duality. She was extraordinarily ambitious yet utterly serene; both self-absorbed and self-possessed; deeply spiritual yet profoundly connected to the material plane. These contradictions were the fault lines of her creative life, the deep sources of her originality. From them she constructed, stitch by stitch and bit by bit, a life that she herself could respect. Tawney witnessed the beginning of our current century, and the changes that it has brought. The studio craft movement, which embraced her so enthusiastically, has fragmented and transformed into other currents. Makers of a cross-disciplinary turn of mind will find much to value in Tawney's explorations. But her central medium of fiber has also undergone a reevaluation; new scholarship, exhibitions, and, most important, artistic energy have been brought to this discipline in the past two decades. The role of spiritualism in the arts, whether in the context of individual visionary practices or more organized forms of worship, has been taken more seriously as a historical topic. Tawney's own work is finding new contexts for display and study, from Tate Modern in London to the Menil Collection in Houston. The John Michael Kohler Arts Center's acquisition of Tawney's working environment, which occasioned this research project, is a significant marker not just of the increasing regard in which she is held, but also of the broader shifts that have made that reassessment inevitable.

It's not clear what Tawney would have thought about these developments. Her concerns were primarily of an interior and transcendent nature. Though she did want her legacy to be honored, she also did very little to promote herself during her lifetime, and considered her own judgment (and that of a few intimate friends) to be the only really meaningful one when it came to her art. Looking back at her extraordinary life, however, we can see how much she did—by her own example—to win respect for women in the arts, for textiles as a medium, for the interweaving of sacred and secular belief. These shifts in opinion were never her priority. She was too wayward for that. But all the same, she was the one who started us down this road: the pathway to now.

45. See Eric Boman, "A (Mostly) Untouched Artist's Loft," *New York Magazine*, January 22, 2018. The silver leaf tarnished to black during Tawney's lifetime, "which she of course loved, as it evidenced impermanence and the passage of time," according to Kathleen Nugent Mangan.

46. Ferne Jacobs, interview by the author, December 29, 2017.

Group of Tawney's studio objects. John Michael Kohler Arts Center Collection, gift of the Lenore G. Tawney Foundation and Kohler Foundation Inc.

FACING PAGE *Ode to a Sparrow*, 1987; mixed media; 8 × 11⅞ × 3¼ in. Lenore G. Tawney Foundation, New York.

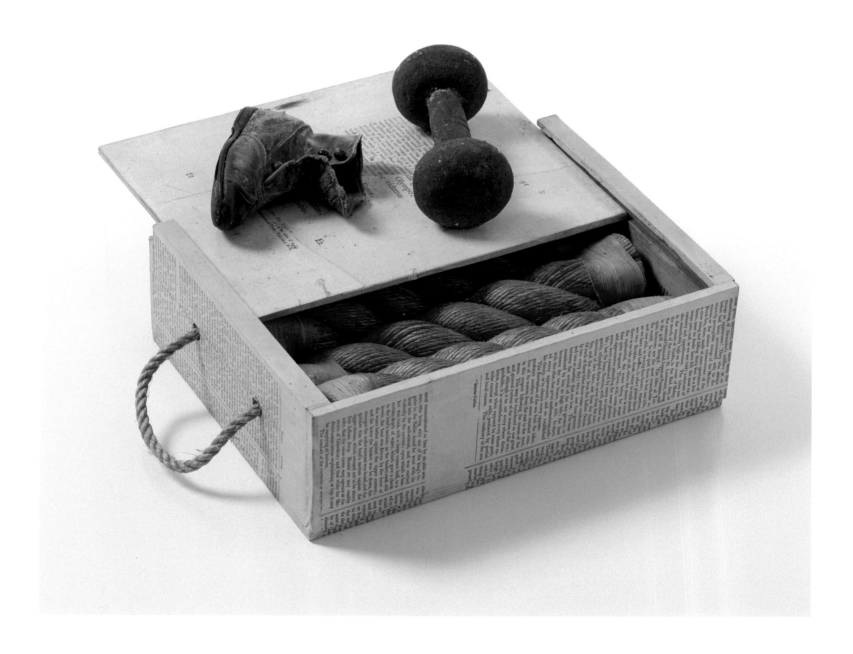

THAT OTHER SEA

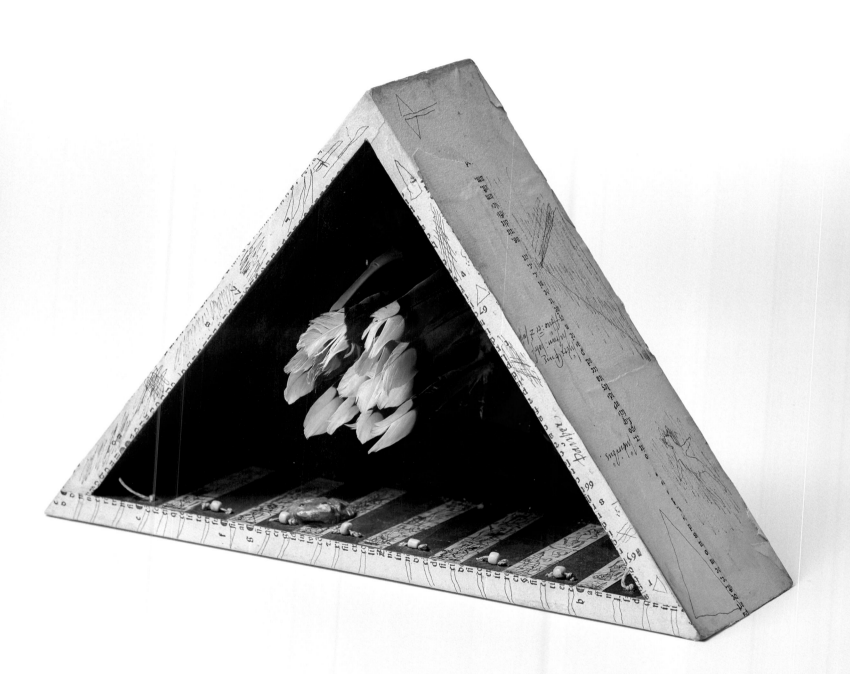

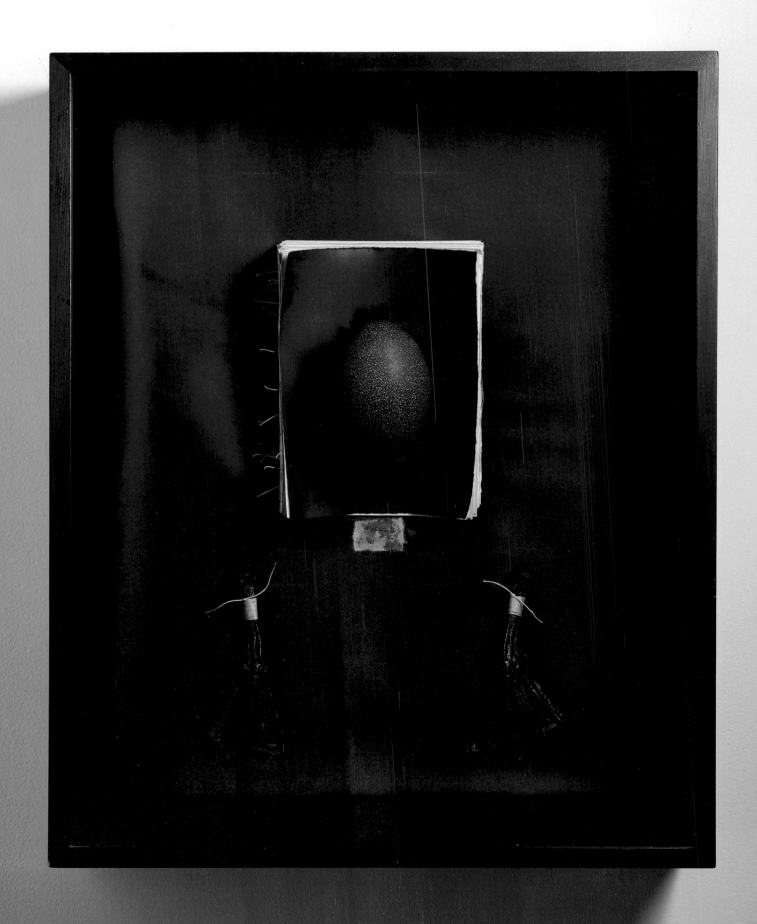

Or to an Illegible Stone, 1989; mixed media; 3 × 3⅜ × 7¼ in. Lenore G. Tawney Foundation, New York.

FACING PAGE *The Flower Lies Hidden*, 1986; mixed media; 24½ × 19 × 5 in. Lenore G. Tawney Foundation, New York.

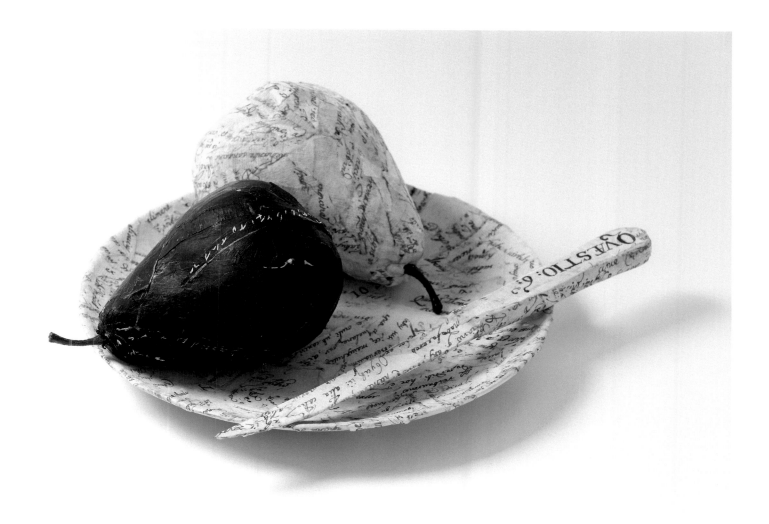

The Archive
This Cage of Bones, & Blood, & Flesh

MARY SAVIG

"This cage of bones, & blood, & flesh will turn to ashes at last one day," wrote Lenore Tawney in one of her lined notebooks.[1] The statement is part of a list of dozens of spiritual teachings, likely transcribed from the Guru Gita. A visual counterpart to this quote can be seen in a mail art postcard Tawney sent to herself featuring a vintage illustration of a blackbird inside the rib cage of a human skeleton (facing page). Perched on the skull is an eagle drawn by Tawney in black ink. Perhaps aware of her own cosmic fate, Tawney honored the immediacy of all matter around her by embellishing her manuscripts—writings, letters, and photographs—with the detritus of the natural world. In this way, she expanded the very definition of an archive by highlighting the most primary of sources.

Tawney's engagement with her various collections is captured in this poetic description by Gandhian painter and anthropologist Haku Shah (page 242):

> Lenore celebrates the moment which
> > becomes immortal through her work.
> She picks up anything,
> a feather,
> broken egg shells,
> a piece of paper with any script
> a thread
> a bead
> a mirror
> a bone and everything.

Mail art to herself, postmarked November 29, 1978; ink on paper; 6 × 4 in. Lenore G. Tawney Foundation, New York.

> She gives them a new life by her
> > creative urge.
> She talks to a piece—a pebble for days
> > together;
> she feels,
> she percieves [*sic*]
> she smells,
> she hears and make him (it), her own family
> > member; in him she sees herself. She
> > [embraces] the piece and becomes one
> > with it.

As Haku Shah poignantly observes, Tawney imbued trivial objects—even discards—with a personal vibrancy.

Performance historian Diana Taylor has challenged assumptions that archives are static, neutral repositories of historical evidence. Rather, she characterizes them as ever-changing sites of knowledge production. A document, she argues, is not inherently archival: "What makes an object archival is the process whereby it is selected, classified, and presented for analysis."[2] The meaning contained in archival objects such as bones, texts, and correspondence is a porous reflection of the interpreter. Tawney intuited this understanding of archival inquiry and made visible the many ways in which her own archives produced knowledge.

As she continually mediated her studio surroundings, Tawney shifted scales of power. Let us consider, for example, the ways in which she elevated the

the eagle

Tawney
Q'town
nj 08868

G. Pasteur

LT 11.27.78

H a k u S h a h

Lenore celebrates the moment which
becomes immortal through her work.

She picks up anything,
a feather,
broken egg shells,
a piece of paper with any script
a thread
a bead
a mirror
a bone and everything.
She gives them a new life by her
creative urge.

She talks to a piece – a pebble for
days together;
She feels,
she percieves,
she smells,
she hears and make him (it), her
own family member; in him she sees
herself, she embrasses the piece and
becomes one with it.

Her world is thousands of such pieces
to which the world says,
Scrap,
filth,
garbage, inanimate useless things.
The educated may say to her child
Darling do not touch it you will spoil
yourself, you will be dirty.
Lenore kisses it.

16, Nemnath Society, Narayan Nagar Road, Paldi, Ahmedabad-380 007, India. Phone : (0272) 413473

humble button. In the 1960s Tawney lent her support to her close friends Diana Epstein and Millicent Safro as they opened a button shop in Manhattan, aptly named Tender Buttons, where they display (and sell) their beautiful collection of vintage and antique buttons, which run the gamut from run-of-the-mill plastic blouse buttons to exotic, ancient buttons and everything in between. Soon after the shop opened in 1964, Epstein wrote to Tawney (her "Lucky Mushroom") that people "never stopped coming in until I shuttered the shop Saturday evening…eventually, the point is, people may learn to see small things and appreciate a sweet new rhythm" (below left). In another charming piece of correspondence, Epstein sewed three fanciful brass buttons to a card, writing, "These were GLOVE buttons. Now they're LOVE buttons." In return, Tawney made elaborate collages, mail art, and keepsakes for Epstein and Safro. When I visited Tender Buttons in May 2018, Safro kindly showed me two simple gifts from Tawney: a cylindrical vessel, decorated with a graphic number six, containing small white buttons; and a box, decorated with collaged texts, containing small black buttons. Tender buttons between tender friends.

On December 27, 1983, Epstein and Safro sent Tawney a virtual bouquet of roses and tender buttons in the form of a postcard (below right). The recto features a Henri Fantin-Latour still life of roses in full bloom. The verso reads, "Dear T, Hope you are O.K. Sending hugs & kisses." Three of the letters are graphics punctuated by buttons. At the time, Tawney was starting to experience a loss of vision. This cage of bones, and blood, and flesh will turn to ashes at last one day. After years of friendship, Epstein and Safro surely understood when Tawney was not in the mood for visitors, and so this postcard is a sweet reminder of their support for her.

Tawney sewed and sketched buttons into the fabric of her everyday life. She lined the front of her handmade studio smock (pages 245, 246) with twenty-nine

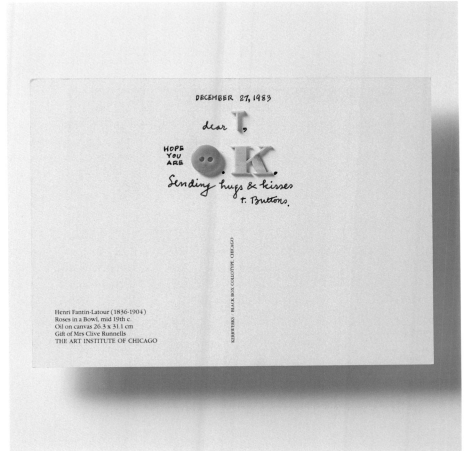

ABOVE LEFT Tender
Buttons card of vegetable
ivory buttons, n.d.; mixed
media; 7¼ × 3½ in. Lenore G.
Tawney Foundation,
New York.

ABOVE RIGHT Tawney
in the Southwest, 1984.
Photograph by Kalika
Stern. Lenore G. Tawney
Foundation, New York.

FACING PAGE AND PAGE
246 Tawney's studio smock,
n.d.; cotton and vegetable
ivory buttons; 31¾ × 38 in.
Lenore G. Tawney
Foundation, New York.

vegetable ivory (tagua nut) buttons—the same kind author Tom Wolfe had sewn onto his white suits. One sheet of these buttons remains in her Tender Buttons correspondence file (above left). The chic column of buttons adds interest to a simple smock. Over time the vestment became a record of Tawney's physical labor, with its smattering of holes, smudges, chipped buttons, and a patched pocket. The smock is comparable to similar Marimekko dresses worn by urbanist/activist Jane Jacobs and painter Georgia O'Keeffe. According to architectural historian Alexandra Lange, their roomy clothes, featuring clean lines and useful pockets, and paired with flat shoes, confirmed the confidence of an intellectual American woman.[3]

For formal studio portraits and significant events, Tawney favored vivid shirts and capes, which she also handmade. She sincerely and beautifully performed a public version of herself that was an extension of her studio life. Her brilliant fabrics and extraordinarily innovative designs often preceded avant-garde fashion trends. Private and unstaged photographs also convey Tawney's personality. While on a trip through the Southwest in 1984, Tawney's friend Kalika Stern captured the whimsical scene of the petite artist, cocooned

in a beige top and hat, standing at a bank of pay phones in stark contrast to a tall man in a dark cowboy hat, shirt, and vest (above right). In another series of photographs taken outside of the studio, in 1961, Tawney unfurled herself on a Long Island boardwalk (page 247), opening her body to the sun's rays.

Across all her archival records—journals, correspondence, photographs, and sketches—are glimpses of Tawney's humanity through her daily life. The papers are a prism through which we can read her self-confidence, her sense of humor, her intelligence. During her lifetime, Tawney understood the importance of preserving this archival universe. Her significant body of work will remain relevant to future audiences; and yet, Tawney's spiritual meditations remind us that even the distant future is just a spark in the span of eternity.

1. Lenore Tawney notebook, undated entry, archives of the Lenore G. Tawney Foundation, New York.

2. Diana Taylor, *The Archive and the Repertoire: Performing Cultural Memory in the Americas*

(Durham, NC: Duke University Press, 2003), 19.

3. Alexandra Lange, "Jane Jacobs, Georgia O'Keeffe, and the Power of the Marimekko Dress," *New Yorker*, June 23, 2017.

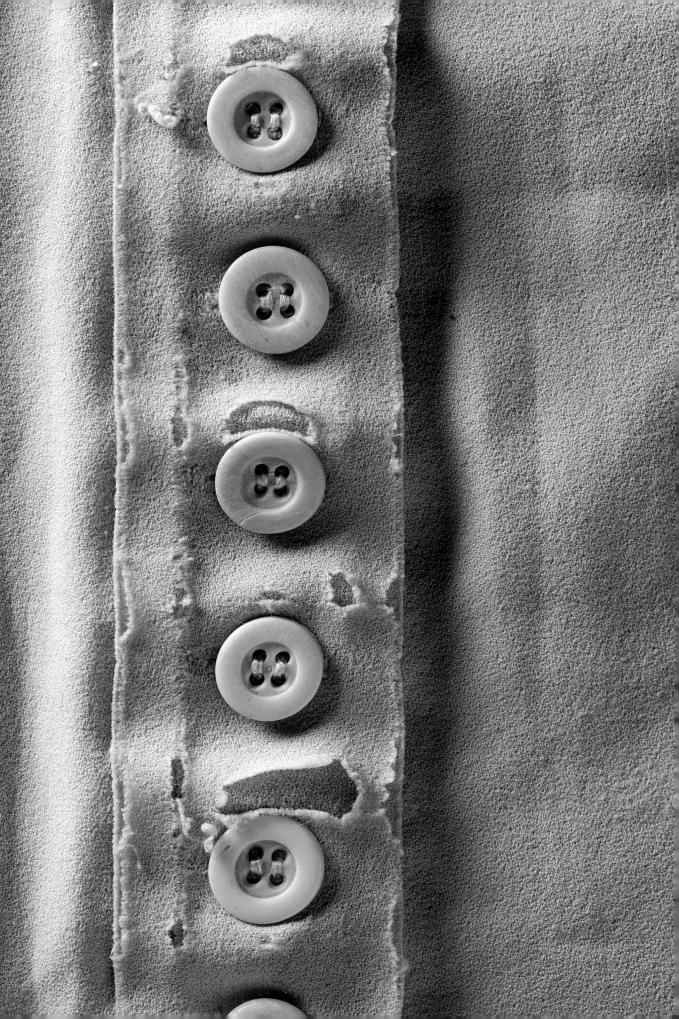

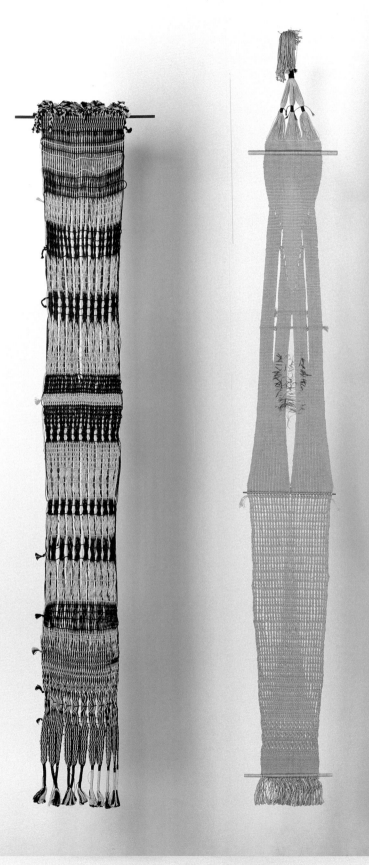

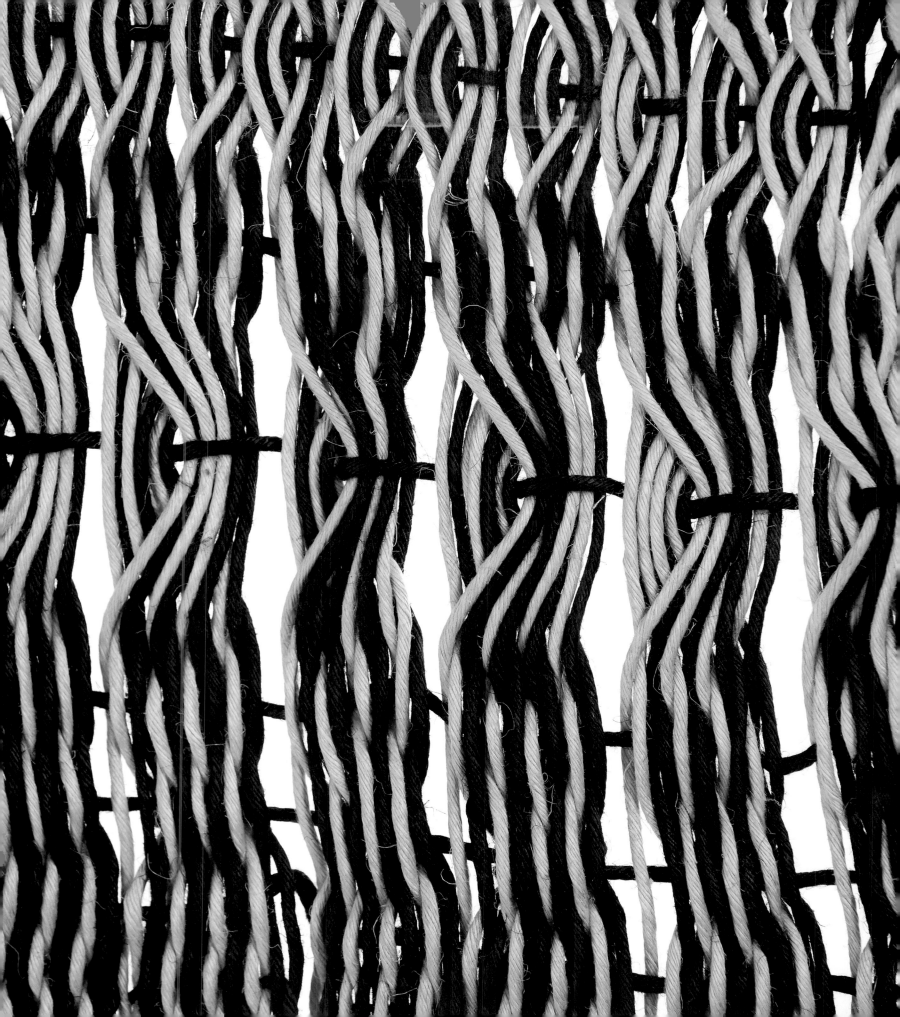

Feather Music, 1987; mixed media; 5¾ × 2¼ × 4 in. Lenore G. Tawney Foundation, New York.

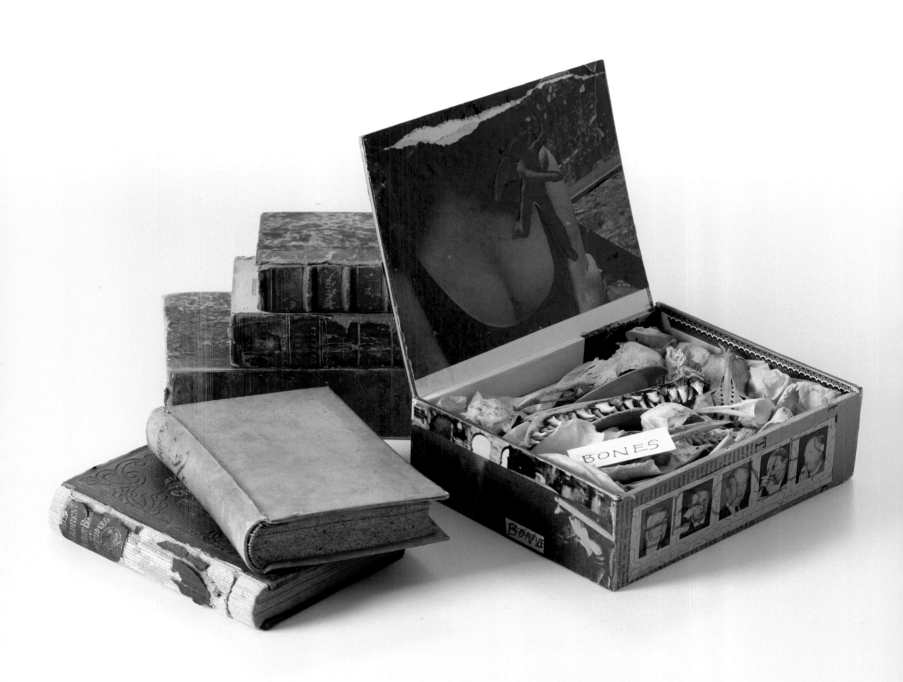

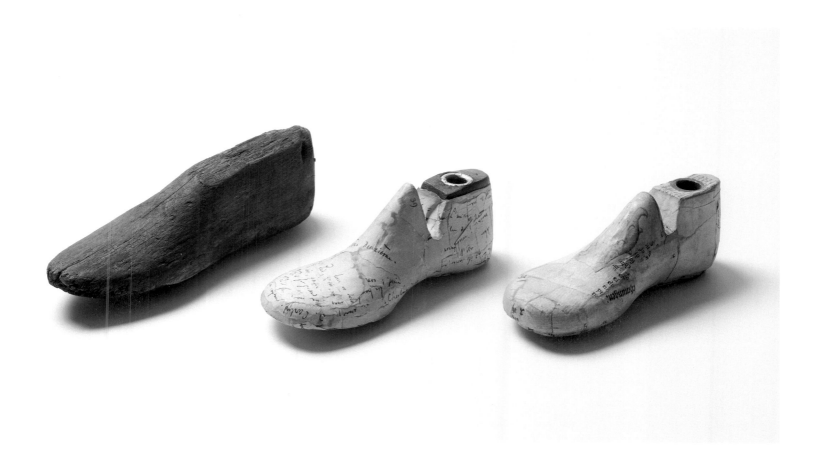

Even Thread [Has] a Speech

SHANNON R.
STRATTON

I met a collector of string, a shepherd of
 slow forms.
My mission became the salvation of minnows
I stretched like a board, almost a tree.
Even thread had a speech.
 —Theodore Roethke, "Unfold! Unfold!," 1951

A square box, open on one side: 5 by 5¼ by 2¼ inches. At the center meet tightly spun threads, linen? That yellow-gold-brown that is the color of dried leaves or stalks of plants shrinking toward winter. They radiate from their twisted point of engagement, traveling out to the edges of the box, a few bursting through the walls at the corners, almost wiry as they commingle. Visible through the threads, like a lenticular postcard that cuts the image in quick tight lines, is a collage of words and drawings—a found page from a book— mapping a destination that winks between the gaps in the threads (facing page). A little like the way memory peeks in and out of our running mental narratives, weaving its way into the present, occasionally tugging the mind back into the past.

Even Thread Had a Speech, says Lenore Tawney, naming that way objects communicate without language, a canny premonition of object-oriented ontology before those three words were ever strung together. Yes, too, the old adage about text and textile, the beginning of logos and mythos, taking shape on

Even Thread Had a Speech,
1966; wood, paper, and
linen thread; 9 × 7½ ×
2¾ in. Whitney Museum of
American Art, New York;
Gift of the Lenore G.
Tawney Foundation,
New York.

the grid, becoming material as the weave gives flexible form, the foundation for stories about to be told.

This meditation of Lenore's is the foundation for commingling the work of eight contemporary artists whose work in some way intersects with, extends from, or dances with hers: Judith Leemann, Michael Milano, Julia Bland, Anne Lindberg, Jesse Harrod, Sheila Pepe, Indira Allegra, and kg. Each selection is an echo of Lenore, perhaps because her work is a memory peeking in and out of their own, whether explicitly stated or not. My inclination was to look for those echoes in artists who had studied or worked in close proximity to an education in fiber, my instinct coming from my own years studying and practicing as a fiber artist before I moved into curating and writing.

What seeps into our minds, our perspectives, and thus our fingers and our work is the endowment an artist's oeuvre leaves behind. Their presence is perhaps not always as apparent as a direct influence, but the subtle or seismic shifts their work made on art objects, thinking, writing, and education is always running in the background, contaminating the new until, at last, art looks over its shoulder and sees the tributaries that were always feeding it.

Judith Leemann and I took on the term "brown art" after it was disparagingly applied to her work in a critique while we were graduate students at the School of the Art Institute of Chicago in the Fiber and

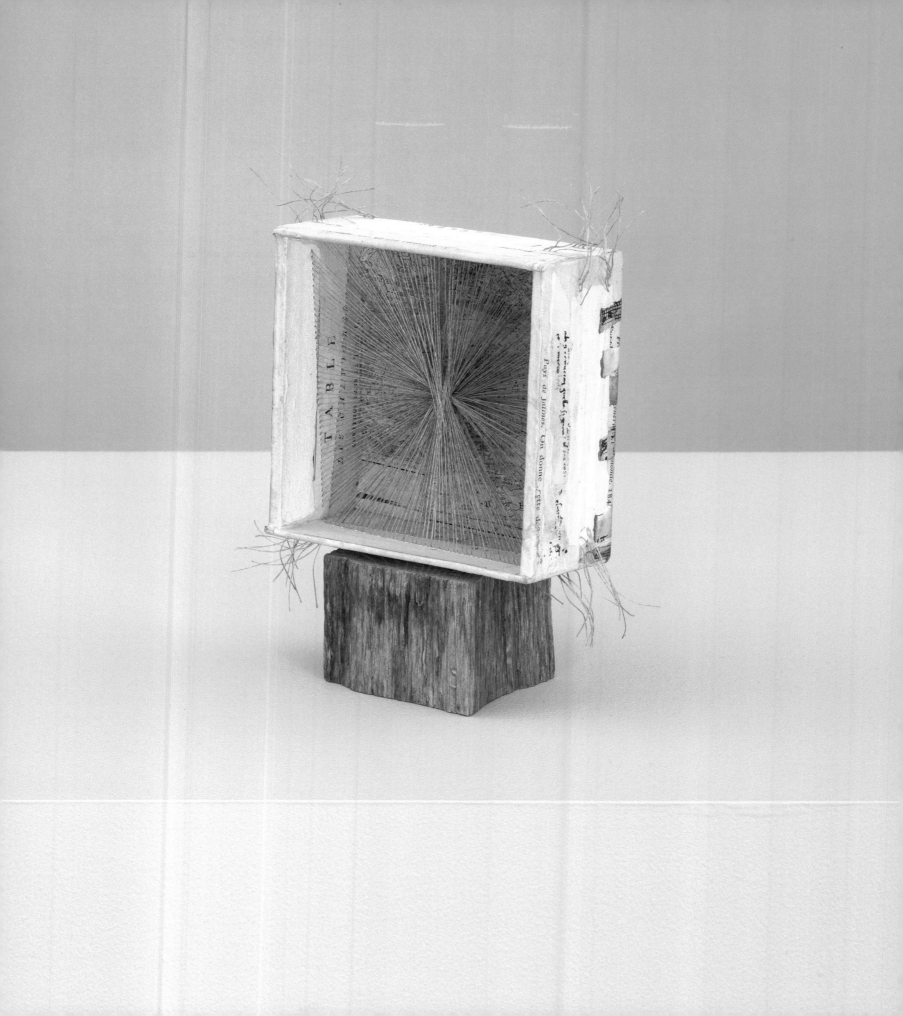

Judith Leemann, *reading aloud: stories about a coyote* (detail), 2013; digitally printed cotton; 102 ft. × 44 in. Courtesy of the artist.

of course she is here *now,* because *now* we are finally ready to receive ways of knowing that marry the spiritual and the physical, the mystical with the material, to deviate from the linear and travel in a circle, and to listen to what life murmurs from things outside ourselves. Lenore studied Carl Jung, theosophists, mystics, and Eastern philosophy, and it surfaces in her work. While I can't presume a wide, consistent, and popular embrace of this same subject matter today, the signal boost that social media and other digital forms of connection and distribution has given to a broad range of thinking has destabilized the idea and severity of a fixed perspective—in other words: the Western, male, white, and heteronormative frame that has strangled much of Western culture for far too long.

I have a residual shame in my prior rejection of this other knowing, my own artwork atrophying in an attempt at a kind of artificial "conceptual" born out of the hammering of that forced and fixed point of view in nearly every art exhibition, art review, or art history class I ever encountered. Despite finding my place in fiber departments not once, or twice, but over and over as student and teacher, I still hid from gut-thinking, missing the call over and over from that "inner thing that permits the creation of original work."[1]

I can't speak to every artist's level of gut-think in this exhibition, but I tried to draw on the ways they maneuver through the grid, understanding it as a fluid plane rather than a trap. Where some tug at the edges of the lines, unraveling, others cut it up and reweave it; still others pull it inside their body and move with it, through it, and on top of it.

Material Studies department—the "brown" here was in reference to, and in easy dismissal of, the creamy beige color of undyed fiber and experiments in natural dying as well as surface treatments with tea, rust, wax, and other materials—the bodily seepage evoked by the work. Our *uneasy* continued use of the term might have been referencing *Even Thread Had a Speech,* unwittingly, but also intentionally. We were at the cusp of some kind of transition in fiber where the larger apparatus of the art world and art education had cast a kind of shame around assemblage, text collage, watercolor, natural fibers, and dyes. Those things that seemed to communicate something inherently female—although not necessarily feminine—and probably intuitive were banished to a two-word joke.

In truth, brown art was work that wasn't easily formulated as dryly conceptual, and thus "rigorous" by the standards of a 1990s art world still grappling with a major hangover from the decadence of the 1980s. It didn't feel like it made you look smart, since it felt like it was mining places a little deeper than our minds. It was drawing on some kind of gut-knowing, maybe even epigenetic rivulets, that ran underneath and in between the rhetorical, which always locks art down with tight constraints in an arrogant striving for legitimacy.

It is an "of course" that comes readily to my lips when I say: Lenore has now, finally, assumed her rightful place as a profoundly pivotal voice in art, because

Judith, or Judy, as I call her, is my friend and sometime collaborator. I feel like we walk beside each other in life, sometimes racing past each other, other times losing each other altogether, catching up at some point when those tributaries magically feed back into one another. We studied together, curated together, and, for the most part, continue to cross each other with ideas and words that sometimes fit and other times find no cohesion. Our friendship feels like one that is about the pleasure of cutting up gut-knowing and language and pasting it back together in odd configurations only to remake it again and again. An assemblage of texts that both of us read differently.

When I think of Judy, I think of words that either blanket and hold me or suffocate me. Language is her material; she lugs it with her eternally, performing it anew in every context (facing page). Sometimes I'm alert to it, pleased by it—other times I realize I can't track on it; it starts to feel like an undertow I have to resist. But it is so, so very material. And occasionally her words land on a piece of cloth, or inside a thing whose speech she releases, or in a composition constructed from the fragments of other people's speech—a kind of language net that sticks a bit to your brain, as those words and ideas had found stickiness for her.

In the beginning, there was the word—between 1927 and 42 in Chicago, Lenore Tawney supported herself as a proofreader for a publisher of court opinions....Perhaps perversely for a former proofreader, she reveled in not consciously knowing what was signified, often choosing texts written in tongues she could not speak.[2]

Lenore "harvested" words from antique books, much like Judy harvests words from her library of cultural and political theory, philosophy, poetry, sociology, and ecology. Where Lenore found pleasure in the personality of the fonts and scripts, Judy finds pleasure in braiding together secondhand words, allowing them to contaminate one another. So, to Judy, I assign Lenore's *I am word woman,* a narrow black box from which the ends of unraveling spun fibers protrude (at right). The sides are marked up with a fine, illegible white script.

Michael Milano's work, like Judy's, is "weaving adjacent"—engaging in a dialogue with the weaving draft or grid, as opposed to the action of assembling the text or textile itself. In early drawings he uses drafting/graph paper to make truth tables–turned–weaving drafts in pen (red and blue felt ink and ballpoint) and then later as color studies that examine every possible combination of a set of hues (page 258). In recent work, Michael uses woven and printed mass-market fabrics as a grid on which to produce a second "woven," using stitch resist to draw out an image of woven cloth between print motifs. The final works are cyanotypes

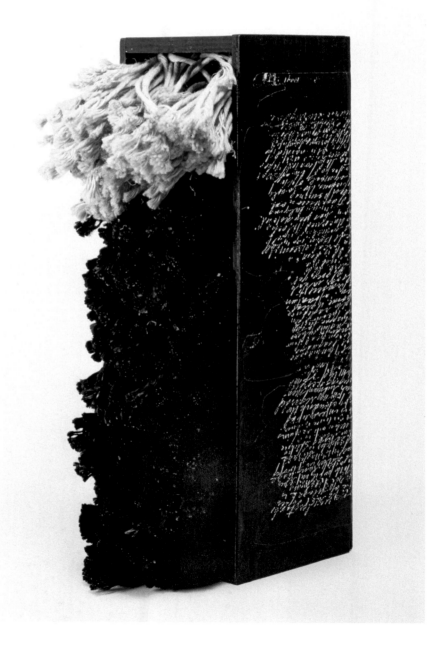

I am word woman, 1967–97; mixed media; 12 × 4 × 6½ in. Lenore G. Tawney Foundation, New York.

on cloth, "exposing" patterns on the surface of the fabric that bring to light a kind of embedded code in the cloth, a pattern that is coaxed to the surface through the opposites of negative and positive.

In his unpublished lecture "Propositions on Cloth," he works out a theory of cloth as a thing unto itself, whose construction of over-and-under threads prompts him to determine whether cloth is a tautology:

> A piece of woven cloth can be described as a tautology. Concerning the intersection of every vertical and horizontal thread, one can map a binary logic of mutually exclusive conditions onto it: a given thread is either up or down, over or under, present or absent.[3]

Michael's truth table weaving drafts explore logic, systems, and binaries—analyzing cloth as a site ripe for philosophical argument. His notes end with a paragraph on woven cloth as dialectical: "The vertical and horizontal threads can be mapped into the structure of thesis and antithesis, where at their intersection there is a necessary overcoming of one by the other."

Perhaps Michael is looking for the true nature or being of cloth, an important exercise at a time when object-oriented ontology, a study of existence in respect to things, has gained some traction outside of philosophical circles. His positing of woven textiles as in-and-of-themselves dialectical is a delicious opportunity to consider the inherent tension of a woven cloth's being, and thus how logic and argument make up the very structure of an ancient object that is also part of computing's genetic makeup.

So to Michael I allocate Lenore's *The Union of Water and Fire II,* an India ink drawing on graph paper (above right). A blue triangle overlays a red one at the center of the paper, their mass constructed from perfectly drawn lines radiating from a single, central point to evenly spaced intersections of graph lines. This era of Lenore's practice is an anticipation of the grid-based minimalism that would emerge around her in the 1960s and 1970s.

The union of opposites, or elements in tension, speaks to both the binary of the weaving—the over and under in tension that Michael marks out in his drawings—and the alchemical tension between elements: light and dark, fire and water—that Lenore was drawn to in her reading of mystics like Jakob Böhme.

> All things originated from the fire-root as a twofold birth "in light (Wohl = good) and

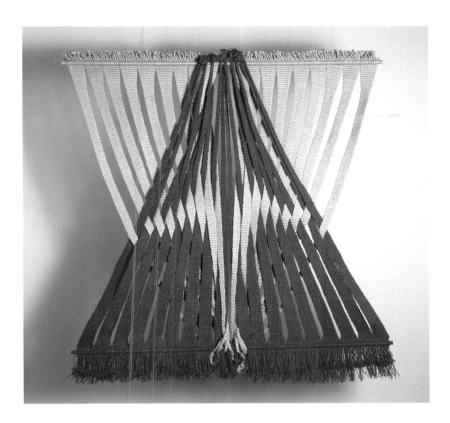

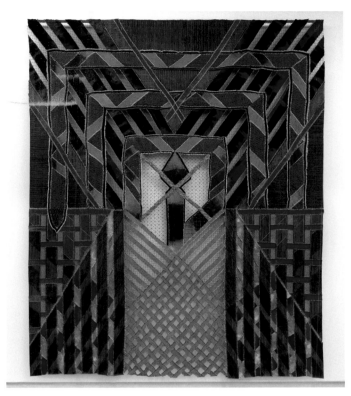

darkness (Wehe = ill)" // "In this world, love and anger are inside one another, in all creatures, and man has both centres within himself" /// "Each man is free and is like his own God, in this life he may turn himself into anger or into light.
—Jakob Böhme, *Theosophische Wercke*, 1682[4]

To Julia Bland, I assign Lenore's woven work of the same name: *The Union of Water and Fire,* a linen construction of red and beige with woven strips converging at a point on the top and bottom rods (above left). Julia's fiber drawings combine weaving, piecework, and other collage techniques, with the triangle as a grounding symbol in her work. But the triangle is liberally in contact with the grid and the circle, creating work that feels archetypal in ways Lenore made familiar (above right). Despite taking a predominantly abstract approach, Julia inserts the snake form in occasional works—the living creature becoming line within the weaving, perhaps bringing the textile to life, or at least animating the warp and weft and imagining that space not as a mere mathematical plane but a dimension that quivers alive.

Lenore was fascinated with the possibility of ancient, archetypal symbols and forms, as revealed in journals riddled with quotes by Böhme, Goethe, and Jung. "A word or an image," Jung wrote, "is symbolic when it implies something more than its obvious and immediate meaning. It has a wider 'unconscious' aspect that is never precisely defined or fully explained.... As the mind explores the symbol, it is led to ideas that lie beyond the grasp of reason."[5]

While more complex in their incorporation of color, Julia's work resonates as a kind of amalgamation of Lenore's—some part weavings like *Dove* (page 177) or *Red Sea* (page 260) and some part assemblage and collage like *Emblem of Infinity* or *Round and Square* (page 261). A quick dive into the history of alchemical and mystical illustration locates the cosmic egg, the serpent, the ladder, and other hermetic emblems, symbols that are clarified and heightened in both artists' work.

These alchemical cues suggest a kind of magic at the roots of textile. How might weaving as an act of creation order the chaotic, the materia prima, through its marriage of opposites in the warp versus the weft? Lenore's *Union of Water and Fire* is an intersection of light and dark, the rays of each extending from a shared core.

ABOVE LEFT *The Union of Water and Fire,* 1974; linen; 38 × 36 in. Lenore G. Tawney Foundation, New York.

ABOVE RIGHT Julia Bland, *Drink This,* 2016; canvas, denim, silk, wool, dye, oil paint, wax, and linen; 98 × 76 in. Courtesy of the artist and Helena Anrather.

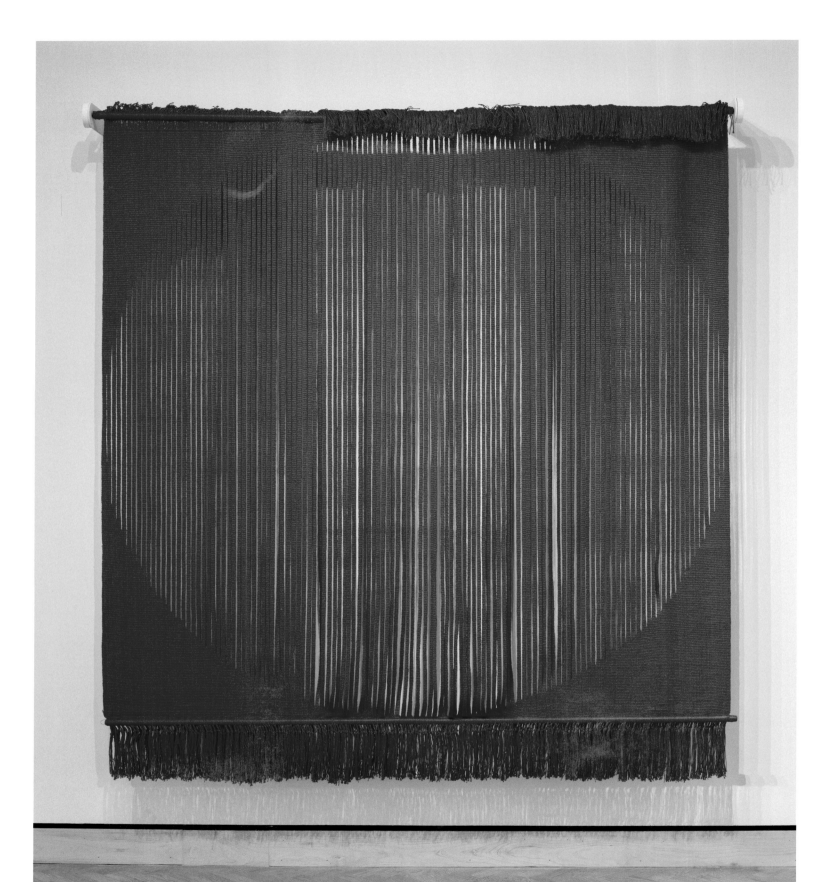

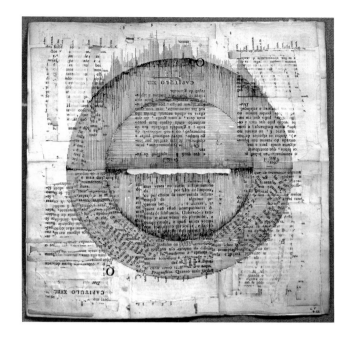

Visible world. To construct it from light and darkness. Or break it down into light and darkness. That is the task, for the visible world, which we take to be a unity, is most agreeably constructed from those two beginnings.
—Goethe, *Lectures on Physics*, 1806[6]

Anne Lindberg's thread installations experiment with the construction of light *from* dark—the concentration of threads that she builds up, stretched across space, building the phenomenon of light from material that is fundamentally absorbent rather than reflective. Her large-scale, architectural "drawings in air" enlarge on Lenore's own series by that name, treating the built environment much as Lenore had utilized the acrylic box—as the loom on which the warp is dressed (page 262). But in both cases, the weft is no longer required. The weaving is unwoven, or perhaps never commences, and thread becomes a trace of the body drawn across space and time—a trail of energy suspended in air.

Like Lenore, Anne has a complimentary drawing practice, but unlike Lenore, that practice is simultaneous. Whereas some thirty years passed between Lenore's ink on paper drawings and the multimedia assemblages that were her Drawings in Air series (pages 232, 233), Anne moves back and forth concurrently between the meditative drawing on board

and the meditative drawing in air. Lenore's words, however, could be Anne's: "I did some of these drawings that look so much like threads that people think they are threads.…But I didn't do them with that in mind.…It's like meditation—you have to be with the line all the time—you can't be thinking of anything."[7]

Anne's installations make it so that the body is with the line all the time—the trace of her body, yes, but now the viewer's is implicated as necks strain to look up at the thread hovering overhead or face the lines with their hearts, receiving them like bursts of light. At this scale, things that seem delicate—thread, light, line—become monumental; reverie is enlarged. While that gesture is shared across color-field and minimalist histories in twentieth-century art, in Anne's installations that gesture manages to be simultaneously substantial and subtle. A state of perfect harmony between opposites.

Jesse Harrod also explores the relationship in scale between the architectural and the body and both the tension and release in that connection. Their earlier work animated the sexual and sensual qualities of the material they worked with—using rope as a pliable, linear element and, like Anne and Lenore, a drawing. Concepts of play and support, specific to queer communities, are translated in Jesse's sculptural drawings,

ABOVE LEFT *Emblem of Infinity*, 1969; mixed media; 4 × 5½ in. (unframed). Lenore G. Tawney Foundation, New York.

ABOVE RIGHT *Round and Square*, 1966; paper and ink; 10¾ × 10¾ in. The Menil Collection, Houston, purchased with funds provided by Leslie and Shannon Sasser in honor of Janie C. Lee; and gift of the Lenore G. Tawney Foundation.

FACING PAGE *Red Sea*, 1974; linen; 98 × 84¼ in. Minneapolis Institute of Art, Gift of Funds from Alfred and Ingrid Lenz Harrison, Sara and David Lieberman, the Textile Council, Ruth Kaufmann, and Richard Simmons.

Anne Lindberg, *the eye's
level*, 2018; thread and
staples; 60 × 672 × 288 in.
Installation view, Museum
of Arts and Design, New
York, October 16, 2018–
March 3, 2019.

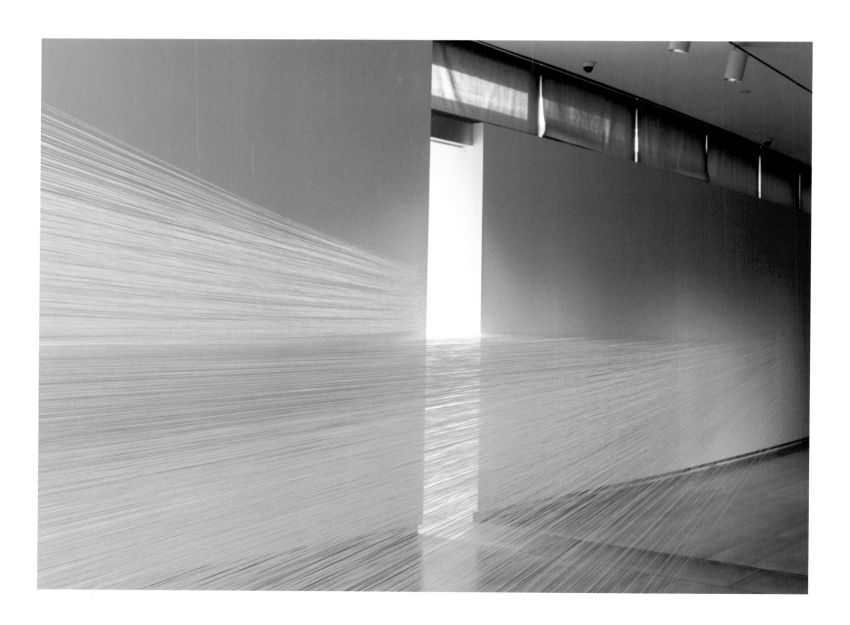

THAT OTHER SEA

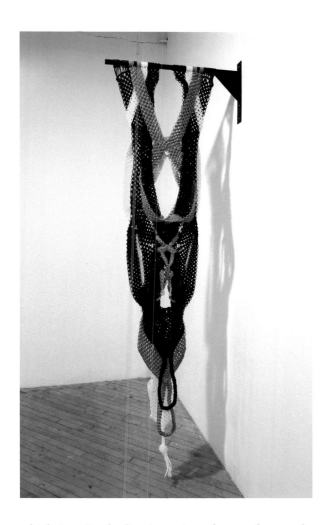

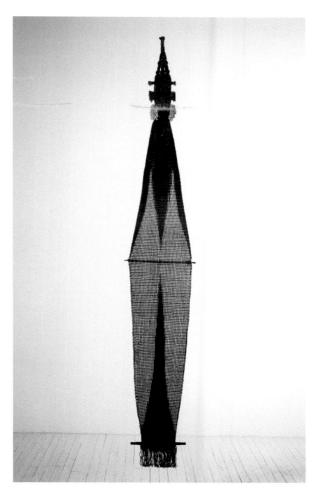

LEFT Jesse Harrod, *Mascot 1*, 2016; paracord and metal; 72 × 27 in. Courtesy of the artist.

RIGHT *Inside the Earth, a Mountain*, c. 1965; linen; 103 × 16½ in. Lenore G. Tawney Foundation, New York.

which imagine bodies in various forms of entanglement and embrace, the work's shape suggestive but never didactic (above left). Their macramé work simultaneously speaks to restraint and support—a concept that Jesse has now translated into large-scale outdoor sculpture that utilizes paracord.

With architecture that embraces community in mind, Jesse's large-scale public entanglements bring the body up in scale, making immense and majestic their concepts of community and how it is both embodied and envelops the body. With sites for alternative community and spirituality in mind, this work relates the power of those spaces and their architecture to the sites on the body that hold power and tension. A conversation about the engineering and tectonics of "building"—architecture, communities, and self. Jesse's sculptures move between flag and shield as they stand guard in public space—an abstract, sculptural insignia that gestures to those who can read it: belong here, we will hold you.

Many of Jesse's shapes recall Lenore's woven forms—with them, I pair *Inside the Earth, a Mountain,* a black linen weaving with a small burst of natural yarn at its top (above right). An almond shape, like Jesse's almond shapes—which suggest the eye, the mouth, and female genitalia but also the mountain, the shield, and the Sephiroth, the mystical symbol within the Kabbalah of esoteric Judaism, used to describe the path to God. Inside this body a formidable force resides, which could be said of both the body of community Jesse conjures or the singular body whose strength is concealed but palpably in position.

Lenore's work is redolent of spirituality, with specificity just out of reach. Her long sculptural practice of assemblage sculpture, which sat alongside her drawing and weaving for over thirty years, is for the most part the most indicative of this. Here, shapes are no longer suggestive, but evident—with feathers, eggs, and shells (among other found objects and texts) recombined in small- and medium-size totems.

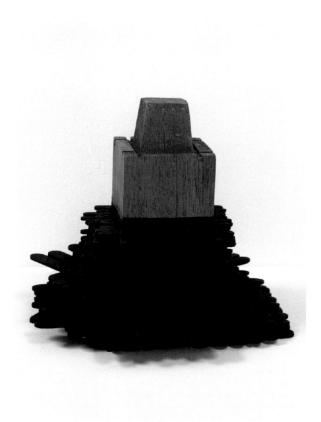

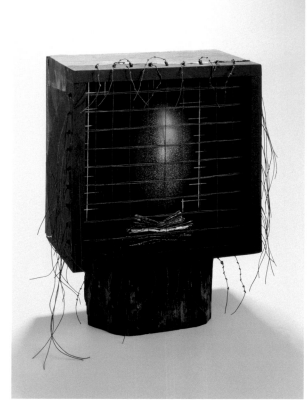

Sheila Pepe, like Lenore, has long been known for her fiber work, taking thread far away from the loom and using it as a line that travels across enormous amounts of space—linking and entangling immensity through fluid and visceral demarcations. But as with Lenore, alongside this work has existed a consistent practice of small sculptural assemblage (above left). Dating back over twenty years, Sheila's Votive Moderns are made from a range of found media, including sewn cloth and crocheted bits, but also clay, plaster, wood, and scraps of wire, plastic, and other flotsam.

To Sheila I allot the *Woven Field with Deity,* a relatively late assemblage of Lenore's that, standing sturdily on its base, reminds me of the strange way Sheila is able to make something quite rugged yet unsettled (above right). Lenore's assemblages seem to seek a kind of symmetry, whereas Sheila's embrace a kind of stubborn irregularity. Both adopt the concept of the totem, a personal object of spiritual significance, with Sheila's—titled *votive*—proposing an offering.

While I have avoided the specifics of the exhibition at the John Michael Kohler Arts Center, *Even Thread [Has] a Speech,* for Sheila I will make the exception.

Her installation in the Glass Gallery at the Arts Center takes a site—filled with plants thriving in the cool Wisconsin sunlight—that visitors already use as a place for repose and enhances it as place for reflection, offering, or acts of observance through an object-intervention. It's the kind of exhibition that I think Lenore deserved for her assemblages—to have them experienced by a public as the communicative offering they were, tender messages to the universe.

One of Lenore's assemblages, the *Collage Chest,* seems almost like a tool chest of symbols, tucked away for future deployment; it is this piece that I offer to Indira Allegra—as a partner to her *Toys and Tools* (facing page). Indira is both an active weaver and a performance artist, inhabiting both spheres equally, but it is her performative work, the photography that captures that, and the tools that she arranges in relationship to those gestures that interest me in relation to Lenore.

Indira told me in a Skype call that if Lenore was alive today, she'd probably be making performance art,

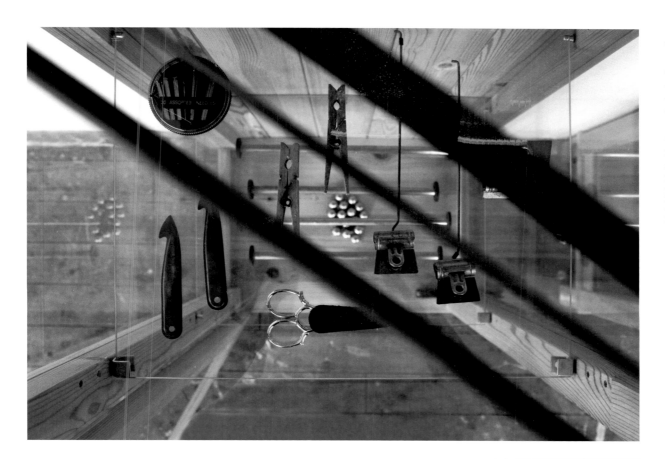

and I had to agree with this musing. It seems in reflection that all the materials Lenore gathered around her, and the way she set her studio like a stage for a modern dance and dressed herself as if ready to perform, were an indication of a great act about to commence.

There are many photos of Lenore at her work, and in her studio—her relationship to the art and the tools perhaps less dynamic than what Indira might picture—but while they were not meant to be "artworks," per se, they still speak to the relationship between maker and made, making and made with. They conjure up a sense of the deep way that the artist abides by the studio, by the practice, often in reverence. While clearly staged, the 1966 photo of Lenore with her cat, Pansy, in her Beekman Street studio seems to capture something outlined in the relationships and dances I propose here (page 266). Sitting with her back to the camera, Lenore works some knots at the bottom of a woven form while her cat watches intently, as if they are in conversation. The photo is lit dramatically, as though she is inside a set for a performance, preparing the last details—or, perhaps, inside a kind of chapel, in meditation and at peace.

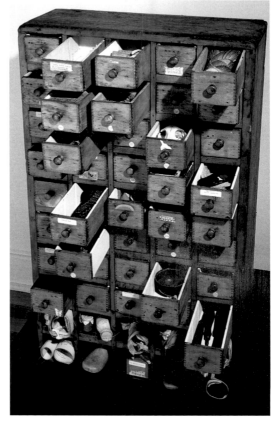

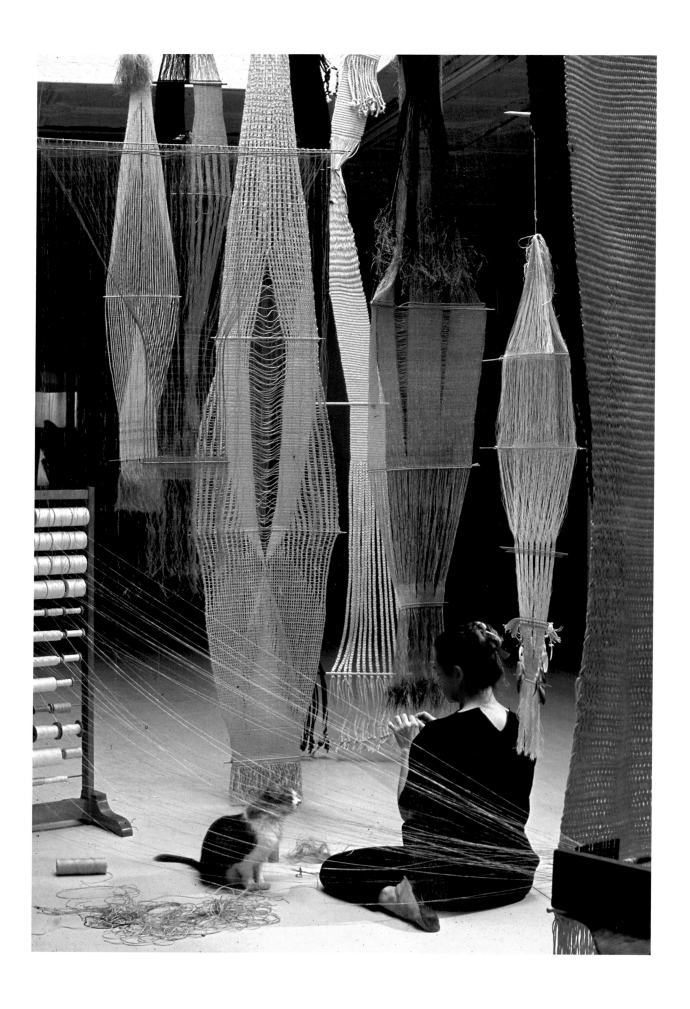

If Anne removes the loom from the thread, then Indira removes the thread from the loom, her body taking the warp and weft's place entirely, as opposed to one or the other being represented as trace. Throughout Indira's work, her site-specific interventions, performances, and acts of decommissioning use her body, movement, the memory of the weaver's labor, and cloth's capacity as text (both document and cache) as surrogates for navigating and narrating both the presence and history of political and emotional tension.

In her Body Warp series, Indira becomes the foundation, very much present and standing in for the fiber warp, held under tension not only by the loom, but by the specters that haunt spaces, labors, and relationships. In a series of photos, performances, and videos, she wrestles with her loom, entangles herself in it, allowing it to compress her before she in turn dominates it—an alluring dance with a thing that conjures up the range of ways that the body and spirit are subjected to both the command of the studio and labor more broadly. The verb "to loom"—as in to both materialize and to dominate—takes on a canny double meaning in Indira's work, as this implement shape-shifts back and forth in the guise of lover, dance partner, and taskmaster—and also ghost. Out of the loom, as it takes shape and makes shape, emerges the histories of women's labors: voluntary and forced, honored and neglected, in meditation and care and under duress—thousands of years of hands writing and rewriting history in the cloth that unfurled from their fingers. In a sense, Indira's dance is like a transitional moment for weaving, the moment that metabolizes the act itself and all its epigenetic inheritance, pulls it inside the body, and moves with it.

The tiny weavings from a series titled Shield are my final partners, and I give them to kg. In *Shield IV* (at right), Lenore selected small shells as the finials for a heavy linen yarn that appears to emerge from the warp, extending like some sort of antennae from the golden cloth. One can speculate on the purpose of such small "shields" that seem just about the right size to protect the breast—perhaps defending the heart from intrusion or sending material messages from its depths.

kg is a weaver's weaver, I think—their work truly embracing the textile as document. While some of their large-scale weavings taunt the resiliency of the

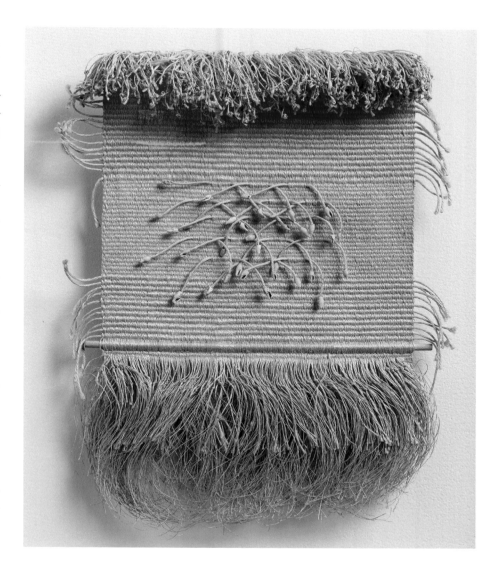

Shield IV, 1966; linen, beads, and shells; 13½ × 10½ in. Lenore G. Tawney Foundation, New York.

FACING PAGE Tawney with her cat, Pansy, in her studio on Beekman Street, New York, 1966. Photo by Nina Leen. The LIFE Picture Collection/Getty Images.

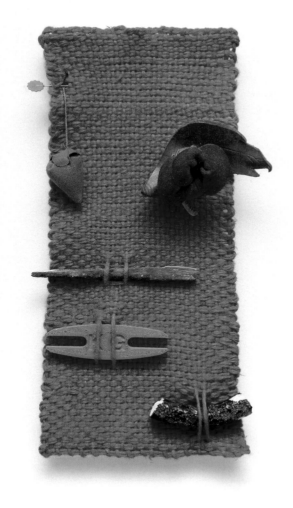

All the red things
holding the sharpener
from a tomato pin cushion
with the leather scraps brooch from Poland
atop the splinter from the floor of
my past studio
above the shuttle some kid printed for me
and a shard of broken ceramic ring Mike
Kaysen
handed over
dressed and woven
in Lenore Tawney's give away linen.

kg's weavings are a sample of a life; like a scraping from the inside of a cheek, their work provides a wealth of information if you learn how to decode it. But the specificity, the autobiography, as seen in *The Red Parts* (at left) is also its own form: these samples fill up the empty warp like our lives gather onto our "self," exaggerating cloth's absorbency or stickiness, to make a point about our own: the little stuff sticks with us and to us. It makes our "empty" full.

1. Kathleen Nugent Mangan, *Lenore Tawney: Drawings in Air* (Wilton, CT: browngrotta arts, 2007), 9.

2. Judith E. Stein, *Lenore Tawney—Meditations: Assemblages, Collages, and Weavings* (New York: Michael Rosenfeld Gallery, 1997), 4.

3. Michael Milano, "Propositions on Cloth," unpublished lecture.

4. Alexander Roob, *Alchemy & Mysticism: The Hermetic Museum* (Cologne: Taschen, 2014), 216.

5. Carl Jung, *Man and His Symbols* (New York: Anchor Books, 1964), 4.

6. Roob, *Alchemy & Mysticism*, 231.

7. Mangan, *Drawings in Air*, 7.

kg, *The Red Parts*, 2018; mixed media; 9½ × 4½ in. Courtesy of the artist.

FACING PAGE *Entablature*, 1974–94; linen and mixed media; 10¾ × 8 in. (framed). Lenore G. Tawney Foundation, New York.

woven form through open-weave structures taken to their limits, it is their small weavings that echo Lenore so magically. These tiny cloths, some just the scale of a scrap of paper, incorporate bits and pieces of life, like notes jotted on the back of a hand. The results are woven poems I can imagine folding up and sliding into my back pocket—a talisman or a shield when needed, to carry the heart onward.

The weavings have been made in pairs, meant to be in conversation with an "other," given a mate, so to speak, a fraternal twin that echoes and mirrors. Spooky action at a distance. Their titles or names unfold in the small pencil portraits and poems that accompany them—a list that weaves together remnants of kg's life that feel comfortably familiar. Our own pockets full of the same:

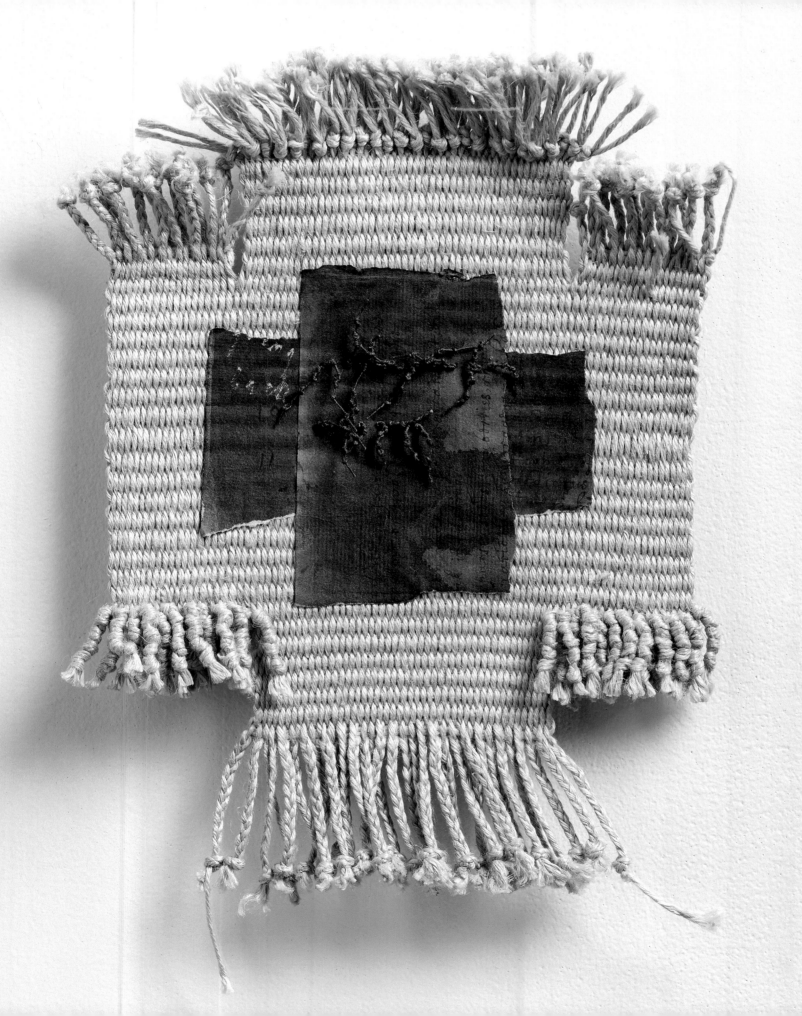

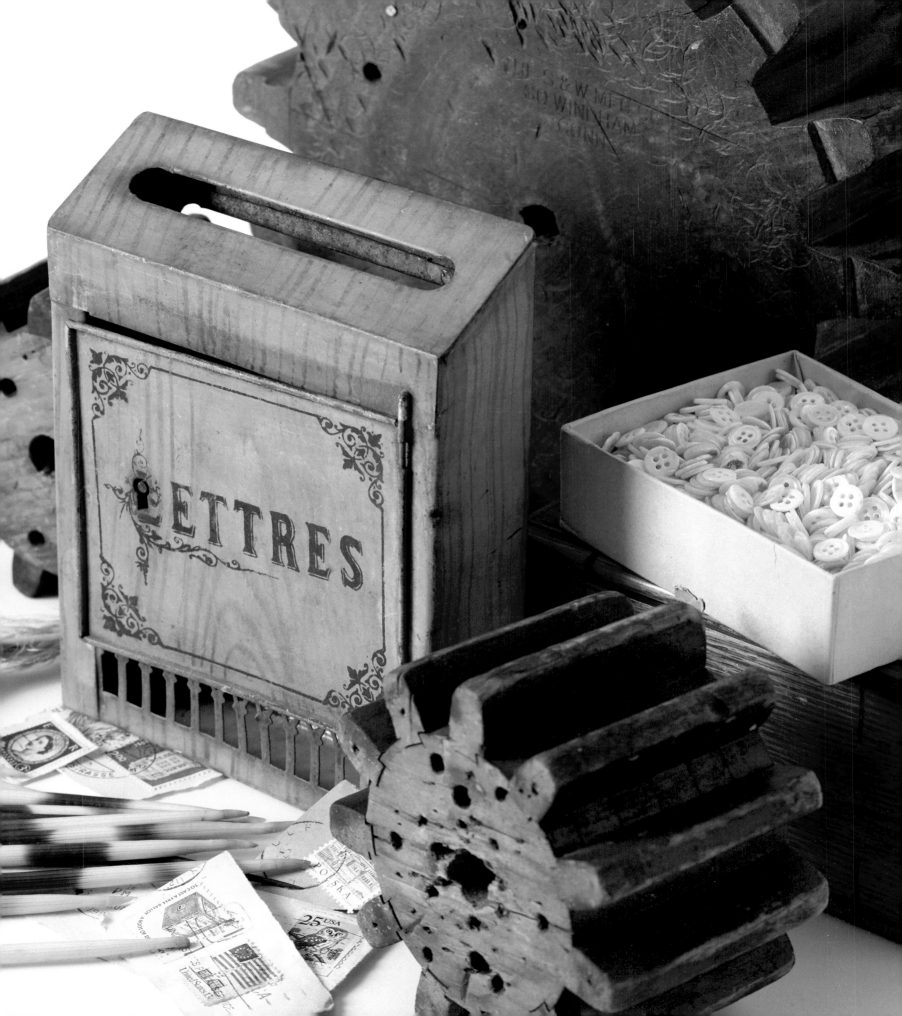

Group of Tawney's studio objects. John Michael Kohler Arts Center Collection, gift of the Lenore G. Tawney Foundation and Kohler Foundation Inc.

271

Technical Analysis
Written in Water

DR. FLORICA
ZAHARIA

Lenore Tawney variously sought to transpose the fluid lines of drawings into her weaving, to attain sculptural forms, and to bring light into her work. Perhaps the effect of light is what stayed with her most. Consequently, it is not surprising to see the Cloud series that evolved in the later years of Tawney's practice, as these pieces are the embodiment of all the qualities that had previously characterized the artist's work—they are made of the heavy linen threads that she knew intimately, they are three-dimensional, and they are airy. (Except for the early creations, Tawney's woven pieces are made predominantly of five *Z*-spun, *S*-plied, thick linen threads.)

The Clouds are composed of two main elements, precisely interrelated: a canvas horizontal support at the top, and long, unwoven threads hanging vertically underneath. Thus the threads and canvas, interacting perpendicularly, simulate the warp and weft relationship. However, the binding point is not repeated, as it is with conventional loom weaving. Tawney connected the two elements in a single point: each linen thread hangs from a corner of a square in a uniform grid penciled onto the underside of the canvas. In *Written in Water,* the grid is formed by fifty-seven by fifty-nine squares of about two by two inches each, from which hang approximately 3,500 threads. The threads were secured to the canvas with a knot above the surface and another one below. The light effect is amplified by daubs of white paint in the center of each square

THIS SPREAD AND FOLLOWING SPREAD *Written in Water,* 1979; canvas, linen, and acrylic; 10 × 10 × 10 ft. Lenore G. Tawney Foundation, New York.

Techniques: drawing, painting, and hooked and knotted threads on canvas.

sketched on the canvas (and on some of the threads as well). The freely hanging multitude of linen threads creates vibrant sculptural objects, which the artist called "vertical weavings in volume" or "weavings without weaving." For Tawney, the concept of a single interaction of the two elements is essential and sufficient for recasting the definition of weaving.

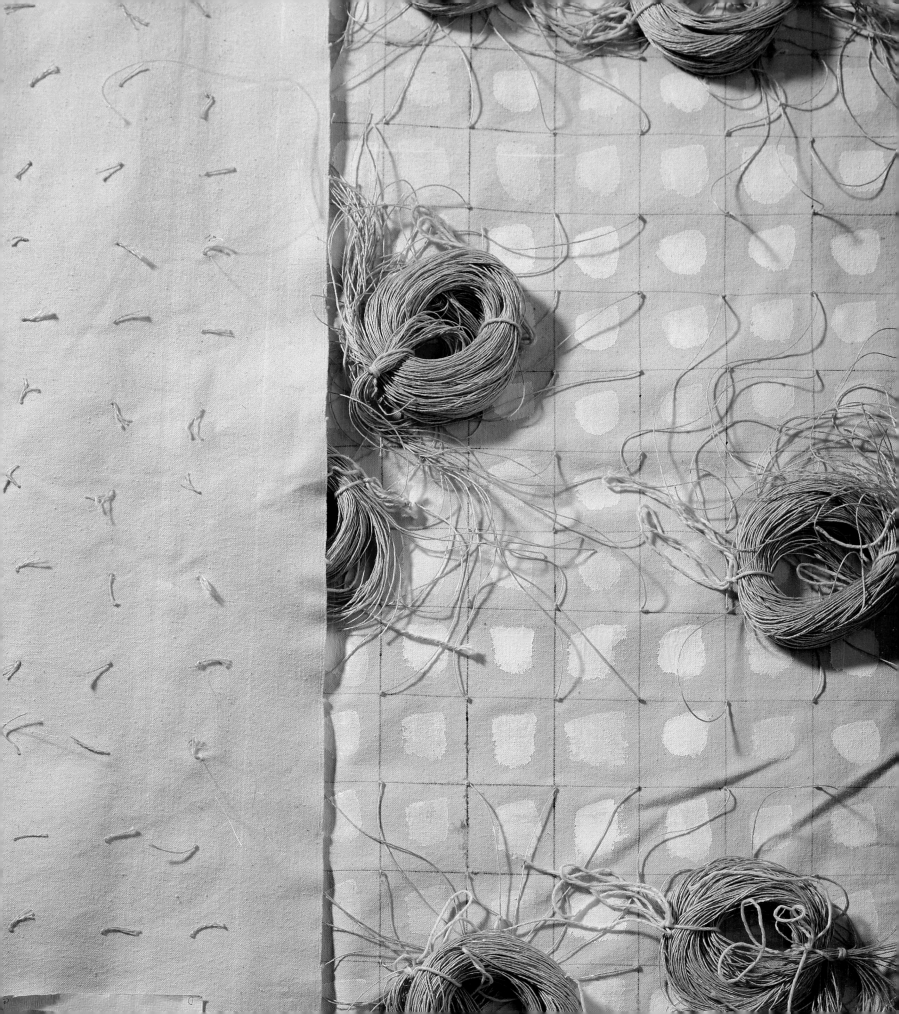

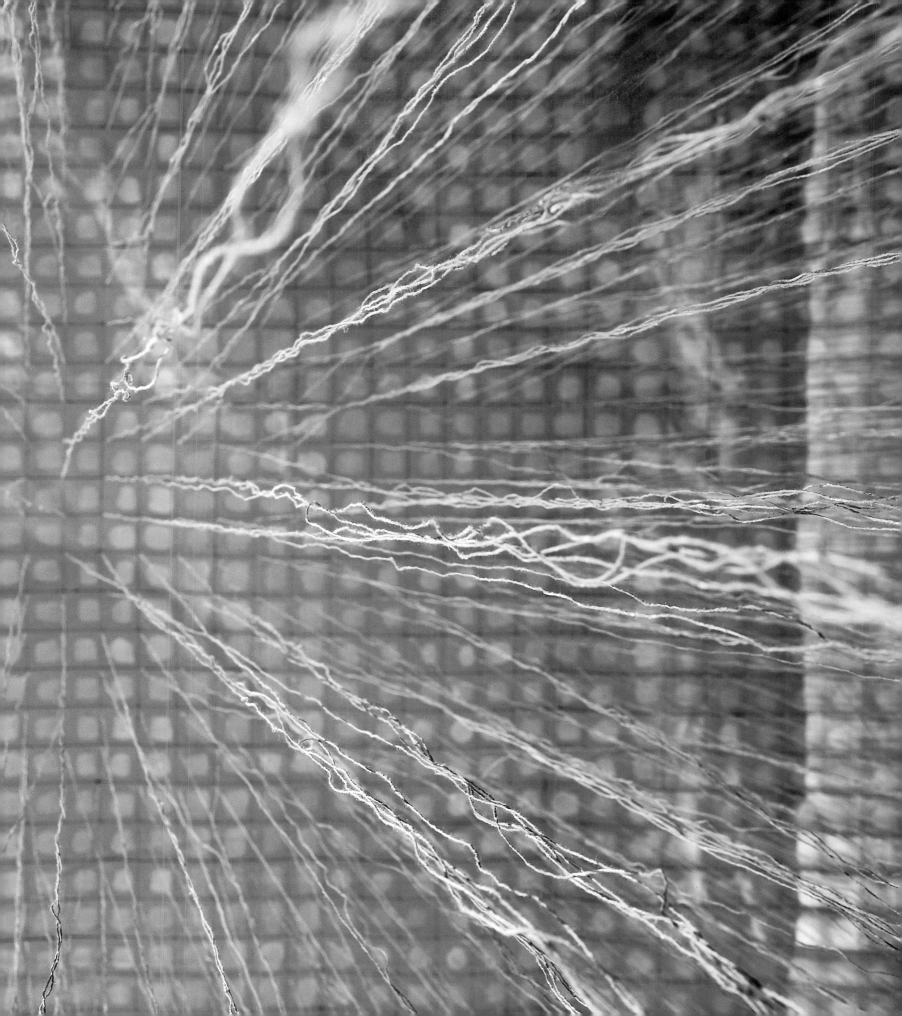

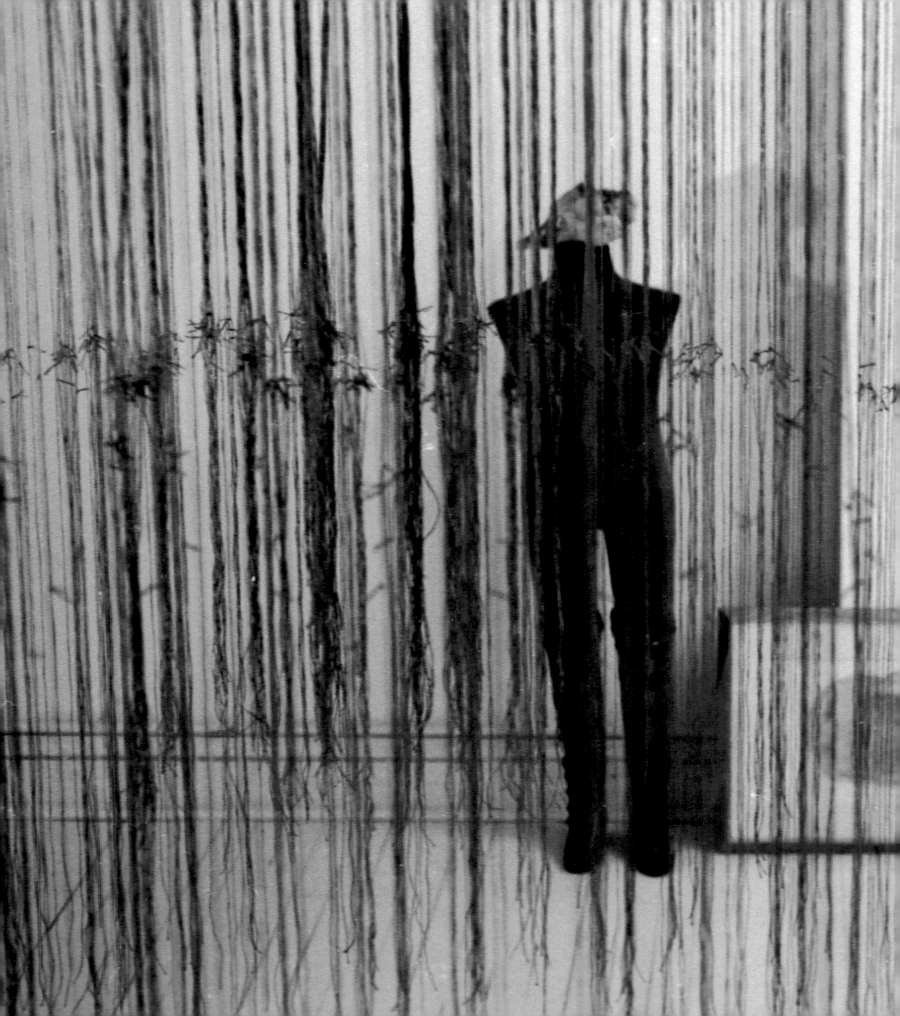

Afterword

KATHLEEN NUGENT
MANGAN

Tawney in her studio on West Twentieth Street, New York, c. 1987. Photo by Elaine Salkaln. Lenore G. Tawney Foundation, New York.

Let's return, for a moment, to my first visit to Lenore Tawney's studio in 1987. I was there at the request of Paul J. Smith, then director of the American Craft Museum, who had asked me to "go down to Lenore Tawney's loft and see if she has enough material" to make organizing a retrospective exhibition feasible. At that point, Smith had known Tawney for thirty years (having also moved to New York the year she did, in 1957) and had presented her work in numerous shows at the museum. But even given their long history together, he did not know how much work Tawney had retained. In recent years she had been relatively quiet, out of the limelight. Although she had not woven in a decade, Tawney had continued to work on Clouds, collage, and assemblage, "following," in her words, "the path of the heart." She professed indifference to the art world: "I didn't plead to be in the art world; I didn't pay attention. I just took what came."[1]

Reality was a bit less laissez-faire. At the age of eighty, with a vast collection of hundreds of artworks (her own and those of others) in addition to the materials that filled her loft, Tawney was thinking about her work, her legacy, and the future. In 1989 she incorporated the LGT Foundation and became part of a small but growing number of artists to establish a foundation for charitable and educational purposes. The foundation's broad aims were to increase public access to and knowledge about the visual arts and to assist learning opportunities for emerging artists. Tawney's choice of anonymity—using only her initials for the name of the foundation—is both revealing and characteristic. She was often generous, but frequently preferred to make gifts without disclosing her identity. With the foundation in place, she could ensure the continuation of her philanthropic interests and the care of her life's work.

During the 1990s, Tawney provided periodic support to the foundation, enabling it to begin a modest grantmaking program. She acted as board president until her death and clearly articulated her goals for the foundation's future. One request was that upon transfer of her estate to the foundation, the art collection and archive were to be made available as resources for exhibitions and scholarly study. She also asked that select examples of her work be placed in museum collections and educational holdings, and she specified her wishes for future grantmaking.

It has been noted that Tawney's 1990 retrospective at the American Craft Museum was a positive moment for a late-career artist, and it was followed by several additional exhibitions, publications, and projects. One of these was an exhibition and honorary doctorate awarded by the Maryland Institute College of Art in Baltimore in 1992 (page 280). On that occasion, Tawney gave a commencement address to the graduating students:

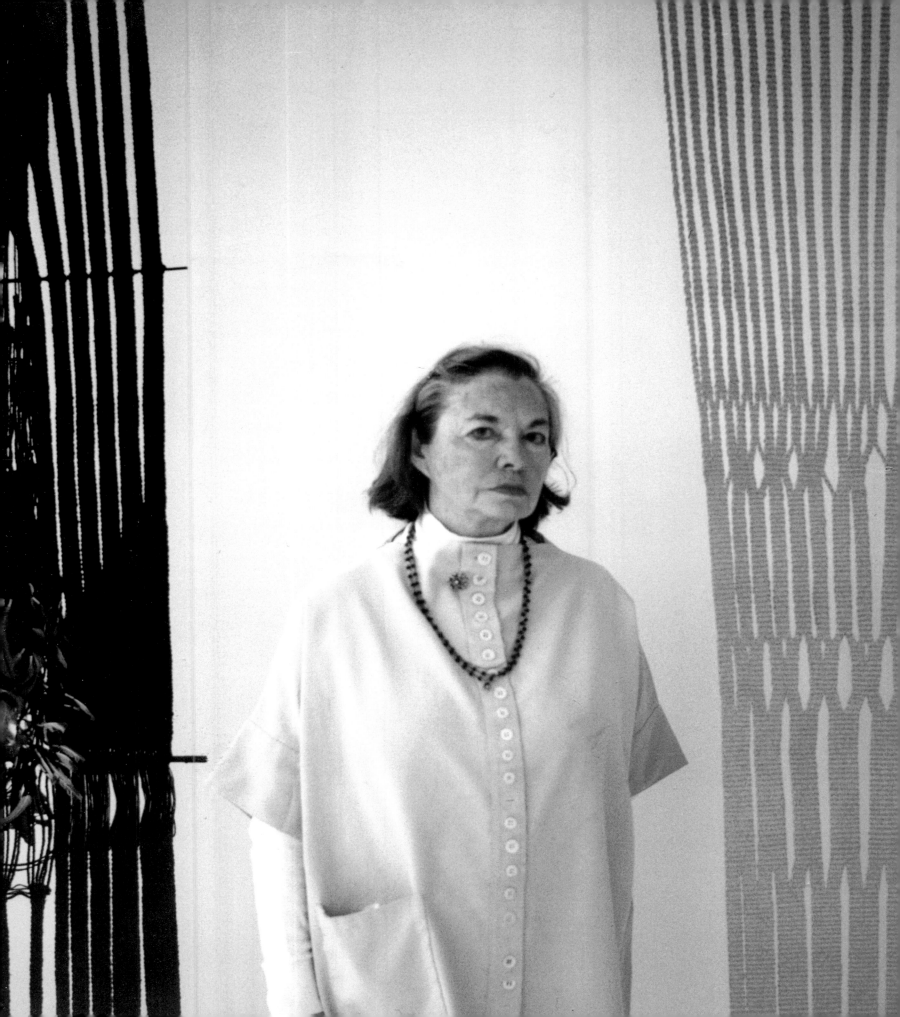

Tawney at the Maryland Institute College of Art, 1992. Lenore G. Tawney Foundation, New York.

To be an artist, you must be brave. You can't let yourself be scared by a blank sheet of drawing paper or a white canvas. But what you put on that paper or canvas must come from your deepest self.... To discover this place is our aim and our goal. Your attitude of openness toward this place in yourself can be like the thick layer of leaves on the forest floor, in that it is always there, no matter what goes on above.... Our instinct drives us downward to the source; there we have visionary experiences made visible. This can be what motivates you to keep on what I call the Path of the Heart. This Path and the seed of your own work are within each one of you....

One thing I must tell you: what we most try to avoid in life is, in fact, our greatest teacher—that is pain, anguish. This pain and this anguish, take us off the surface of life and into the depths where the treasure lies. This is your life dear friends; meet it with bravery and with great love.[2]

So much of the journey to which Tawney had devoted decades was expressed in her brief remarks to the students that day—the search for the deepest self, the desire to reach "to the source," the wish to make the visionary visible, the imperative to follow the "Path of the Heart." And—at both beginning and end—the emphasis on the need for bravery.

Tawney certainly knew both bravery and pain. At the age of fifty, she had left a comfortable life and moved to New York to reinvent herself. As a woman artist and a weaver, she had followed her own path and remained true to it in spite of the challenges she faced. And during the last years of her life, the need for bravery was never greater as she gradually lost her vision and with it her ability to work, read, and write—the activities that had filled her life with deep meaning and sustained her for so long.

Tawney's work is in constant conversation with itself. There is a consistent iconography spanning time and media: the squared circle, the cross, the circle bisected by the cross. There are birds and eggs—references to poets and poetry, to philosophers and Christian mystics.

Undated sketch for a Cloud; ink on paper; 3⅞ × 3⅞ in. Lenore G. Tawney Foundation, New York.

crystal buttons
14,400 - small

But more than anything else, there is water—the element, Tawney wrote, "in and by which all things live."[3] "Water is fertilizing and water is dissolving and water is cleansing and water is life giving," Tawney told art historian Paul Cummings in her oral history interview for the Archives of American Art, and her work abounds with it.[4] There are rivers, seas, springs, fountains, waterfalls, and, ultimately, clouds (above).

"Water is the primordial womb of life from which all life is born," she wrote in a journal.[5] "It is the water 'below,' the water of the depths, ground water & ocean, lake, & pond. The maternal water not only contains, it also nourishes and transforms." Water, for Tawney, represented reaching the "source," just as she

had hoped for the MICA students. And the source, as Mary Savig has noted in this volume, "is a point without any dimensions. It expands as the cosmos on the one hand & as Infinite Bliss on the other. That point is the point."[6]

Physical proximity to a great body of water was as important to Tawney as its symbolic significance in her work and thought. She often noted that she had grown up on Lake Erie and moved to Chicago, on the shores of Lake Michigan. When she came to New York, she recalled, "I wanted to be on the water, that was the first thing that I thought. . . . So there I was right on the river, looking at the river and the boats and the lights of Brooklyn. . . . It was as if New York was at my back."[7]

Wake of the Staten Island Ferry, c. 1970s. Photo by Lenore Tawney. Lenore G. Tawney Foundation, New York.

FACING PAGE Tawney on Long Island, New York, 1961. Lenore G. Tawney Foundation, New York.

Reveling in her immediacy to New York's harbor, she rode the Staten Island Ferry for enjoyment. She photographed its wake, the great bay, the open sky (above). Inspiration was all around her.

In light of these reflections, I now ask myself: How would Lenore Tawney feel about the move of her studio environment, with its precious collections mapping the trajectory of her life, to Sheboygan, Wisconsin? On the shores of Lake Michigan, with its vast expanses of water and sky? I believe she would be delighted.

1. George Melrod, "The Fame Game," *Art & Antiques* (Summer 1997): 72–79, 75.

2. Lenore Tawney, "Commencement Remarks," Maryland Institute College of Art commencement exercises, Baltimore, May 18, 1992, typescript, Lenore G. Tawney Foundation, New York (hereafter "LGTF").

3. Undated note, LGTF.

4. Oral history interview with Lenore Tawney, 1971 June 23, Archives of American Art, Smithsonian Institution, Washington, DC (hereafter "Tawney interview, AAA").

5. Lenore Tawney journal (35.17), undated entry [c. 1990], LGTF.

6. Journal (30.5), undated entry [c. 1979], LGTF.

7. Tawney interview, AAA.

Chronology

1907
Born in Lorain, Ohio, daughter of Sarah Jennings and William Gallagher.

1927
Moves to Chicago.

1927–42
Works as proofreader for publisher of court opinions and attends evening classes at Art Institute of Chicago.

1941
Marries George Busey Tawney.

1943
Death of George Busey Tawney.

1943–45
Resides in Urbana, Illinois, and studies art therapy at University of Illinois.

1945
Travels to Mexico.

1946–47
Returns to Chicago.

Attends Institute of Design. Studies sculpture with Alexander Archipenko, drawing with Laszlo Moholy-Nagy, drawing and watercolor painting with Emerson Woelffer, and weaving with Marli Ehrman.

Moves to 48 East Cedar Street.

1947–48
Furthers studies with Archipenko in Chicago and at his studio in Woodstock, New York.

1949–51
Lives in Paris and travels extensively throughout Europe and North Africa.

1950
Group exhibition *Good Design,* sponsored by the Museum of Modern Art, at Chicago Merchandise Mart.

1952
Returns to Chicago.

1954
Studies tapestry with Martta Taipale at Penland School of Crafts in Penland, North Carolina.

Creates first pictorial weaving, *St. Francis and the Birds* (page 48).

1955

Begins open-warp weavings.

Solo exhibition at Chicago Public Library.

Group exhibitions at Palmer House Galleries, Chicago, and the Midwest Designer-Craftsmen Show at Art Institute of Chicago.

1956

Travels to Greece, Lebanon, Jordan, Syria, and Egypt.

Group exhibition (inaugural) *Craftsmanship in a Changing World* at Museum of Contemporary Crafts (now the Museum of Arts and Design), New York.

Wins Best in Show at the Los Angeles County Fair.

1957

Moves to 27 Coenties Slip in New York.

Member of textile design panel at First National Conference of Craftsmen at Asilomar in Pacific Grove, California, and included in concurrent group exhibition.

Group exhibitions *The Patron Church* and *Wall Hangings and Rugs* at Museum of Contemporary Crafts, New York, and the Midwest Designer-Craftsmen Show at Art Institute of Chicago.

First piece of serious criticism on Tawney's work published in *Craft Horizons*.

1958

Moves to 27 South Street.

Group exhibition *American Artists and Craftsmen* at the American Pavilion, Brussels World's Fair, Belgium.

Bound Man (page 63) acquired by the Museum of Contemporary Crafts, New York.

1959

Included in Trend House showroom operated by Marshall Field & Company, Chicago.

1960

Solo exhibition *Tapestries by Lenore Tawney* at Henry Art Gallery, University of Washington, Seattle.

Group exhibition *Visual Communication in the Crafts* at Museum of Contemporary Crafts, New York.

Completes *Nativity in Nature* (page 76) for Interchurch Center in New York.

1961

Explores gauze weave and studies the technique with Lili Blumenau.

Solo exhibition *Lenore Tawney* at Staten Island Museum in New York.

Group exhibitions *Director's Choice* at Philadelphia Museum College of Art; in Birmingham, Michigan (title and venue unknown); and *Contemporary Handweaving IV* at University of Nebraska Art Galleries, Lincoln.

1962

Designs "open reed" for her loom, allowing the shape of works to change as they are woven. Starts producing works in style referred to as "woven forms."

Moves to 70 Thomas Street and then to 59 Beekman Street, both in Lower Manhattan.

Solo exhibition *Woven Forms by Lenore Tawney* at Art Institute of Chicago.

Group exhibitions *Collaboration: Artist and Architect* at Museum of Contemporary Crafts, New York; *Adventures in Art* in Fine Arts Pavilion at Seattle World's Fair; and *Modern American Wall Hangings* at Victoria and Albert Museum, London.

1963

Group exhibition *Woven Forms* at Museum of Contemporary Crafts, New York. Portions of exhibition tour internationally.

Dark River (page 114) acquired by the Museum of Modern Art, New York.

1964

During First World Congress of Craftsmen, visits New Jersey factory to see an industrial Jacquard loom. Studies Jacquard harness at Textile Institute in Philadelphia and begins series of drawings inspired by Jacquard loom.

Group exhibitions *The American Craftsman* at the Museum of Contemporary Crafts, New York; *Gewebte Formen,* based on *Woven Forms,* at Kunstgewerbemuseum, Zurich; and *La Triennale di Milano* in Milan.

Travels to Switzerland and France.

1964–65

Begins work in collage and assemblage; creates first postcard collages.

1965

Travels to Peru and Bolivia.

1966

Moves to 115 Spring Street.

1967

Group exhibition *Acquisitions* at Museum of Contemporary Crafts, New York.

1967–81

Solo exhibitions at Willard Gallery, New York (1967, 1970, 1974); Benson Gallery, Bridgehampton, New York (1967, 1969, 1975, 1981); and Adele Bednarz Galleries, Los Angeles (1968).

1968

Group exhibition *Collagen: Die Technik der Collage in der angewandten Kunst* at Kunstgewerbemuseum, Zurich.

1969

Travels to Japan, Thailand, and India.

Studies at New York Zendo.

Group exhibitions *Objects: USA* at National Collection of Fine Arts, Washington, DC (national and international tours); *Wall Hangings* at the Museum of Modern Art, New York (national tour); and *Soft Art* at New Jersey State Museum, Trenton.

1969–90

Solo exhibitions at Fairweather Hardin Gallery, Chicago (1969, 1980, 1990).

1970

Meets Swami Muktananda.

Solo exhibitions *Lenore Tawney* at Hunterdon Art Center, Clinton, New Jersey; and *Lenore Tawney: Collages, Constructions, Drawings, Objects, and Weavings* at Peale House Gallery, Pennsylvania Academy of the Fine Arts, Philadelphia.

Group exhibition *Neuerwerbungen aus den letzten Jahren* at Museum Bellerive, Zurich.

Moves to 37 East Fourth Street.

1971

Group exhibition *Furs and Feathers* at Museum of Contemporary Crafts, New York.

1972

Mounts group exhibition *1844 Landmark House* in her home on East Fourth Street. Exhibits her own work alongside that of Sheila Hicks, Françoise Grossen, Ritzi Jacobi, Olga de Amaral, Magdalena Abakanowicz, and Toshiko Takaezu.

1973

Moves to 64 Wooster Street.

Travels to Ireland.

Group exhibition *Fibre Art* at Halls Exhibition Gallery, Kansas City, Missouri.

1974

Integrates weaving and paper collage.

Travels to Guatemala.

Group exhibitions *Nine Artists/Coenties Slip* at Whitney Museum of American Art (Downtown Branch), New York; *In Praise of Hands* at Ontario Science Centre, Toronto; and *Fiber Forms…past and present* at Brookfield Craft Center, Brookfield, Connecticut.

1975

Elected Fellow of American Craftsmen's Council (inaugural group).

Solo exhibition *Lenore Tawney* at California State University, Fullerton.

Group exhibition *7ème Biennale Internationale de la Tapisserie* at Musée Cantonal des Beaux-Arts, Lausanne, Switzerland.

1976

Weaves *Waters above the Firmament* (page 195), her last work on the loom.

1976–77

Travels to India.

1977

Moves to Quakertown, New Jersey.

Solo exhibition *Lenore Tawney and a Fiber Tradition* at Kansas City Art Institute, Kansas City, Missouri.

Group exhibition *Fiberworks* at the Cleveland Museum of Art, Cleveland, Ohio.

1977–78

Cloud Series IV commission installed at the Santa Rosa Federal Building in California.

1978

Artist-in-residence at University of Notre Dame in Notre Dame, Indiana.

Solo exhibition *Lenore Tawney: A Personal World* at Brookfield Craft Center, Brookfield, Connecticut.

Joint exhibition *Tawney/Higa/Sawada* at Hunterdon Art Center, Clinton, New Jersey.

1979

Receives National Endowment for the Arts Craftsman's Fellowship Grant.

Joint exhibitions *Lenore Tawney/Toshiko Takaezu* at New Jersey State Museum, Trenton; and *Form and Fiber, Works by Toshiko Takaezu*

and Lenore Tawney at Cleveland Institute of Art, Cleveland, Ohio.

Group exhibitions *100 Artists, 100 Years: Alumni of the School of the Art Institute of Chicago Centennial Exhibition* at Art Institute of Chicago; *Selections from the Permanent Collection* at American Craft Museum, New York; and *Weich und Plastich: Soft-Art* at Kunsthaus Zürich.

1980

Solo exhibition *Lenore Tawney* at Sawhill Gallery, James Madison University, Harrisonburg, Virginia.

1981

Moves to 32 West Twentieth Street in New York.

Cloud Series VI commission (page 218) installed at the Frank J. Lausche State Office Building in Cleveland, Ohio.

Solo exhibition *Lenore Tawney: Fibers/Collages* at Tacoma Art Museum, Tacoma, Washington.

Joint exhibition *Lenore Tawney/Toshiko Takaezu* at Ruth Foster Gallery, University of Wisconsin–Eau Claire.

Group exhibitions *The Art Fabric Mainstream,* organized by American Federation of Arts, premiering at San Francisco Museum of Modern Art (national tour); and *Tracking the Marvelous* at Grey Art Gallery and Study Center, New York University, New York.

1982

Artist-in-residence at the Fabric Workshop in Philadelphia.

Travels to Taiwan and India.

Group exhibition *Fiber 82* at Hunterdon Art Center, Clinton, New Jersey.

1983

Cloud Series VII commission installed at Western Connecticut State University in Danbury.

Receives Honor Award for Outstanding Achievement in the Visual Arts by Women's Caucus for Art at the Port of History Museum (now Independence Seaport Museum) in Philadelphia.

Group exhibition *11ème Biennale Internationale de la Tapisserie* at Musée Cantonal des Beaux-Arts, Lausanne, Switzerland.

Triune (page 113) acquired by the Metropolitan Museum of Art in New York.

Waters above the Firmament (page 195) acquired by Art Institute of Chicago.

1985–86
Solo exhibitions at Mokotoff Gallery, New York (1985, 1986).

1986
Group exhibitions *Craft Today: Poetry of the Physical* at the American Craft Museum, New York (national tour); and *Fiber R/Evolution* at Milwaukee Art Museum (national tour).

1987
Distinguished Lecturer at the University of Arizona, Tucson.

Receives American Craft Council's Gold Medal Award.

Group exhibition *The Eloquent Object* at Philbrook Museum of Art, Tulsa, Oklahoma (national and international tours).

1988
Solo exhibition at Helen Drutt Gallery, New York.

1989
Travels to Italy.

Group exhibitions *Craft Today USA,* organized by American Craft Museum, New York, premiering at Musée des Arts Decoratifs, Paris (international tour); *Fiber Concepts* at Arizona State University Art Museum, Tempe; and *Frontiers in Fiber: The Americans,* organized by North Dakota Museum of Art, Grand Forks, premiering at Ishi-kawa Design Center, Kanazawa, Japan (international tour).

1990
Solo exhibition *Lenore Tawney: A Retrospective* at American Craft Museum, New York (national tour).

Group exhibition *Revered Earth,* premiering at Contemporary Arts Museum Houston (national tour).

1991
Travels to Greece.

Group exhibition *Intimate and Intense: Small Fiber Structures* at Minneapolis Institute of Art.

1992
Awarded honorary doctorate degree by Maryland Institute College of Art in Baltimore.

Solo exhibition *Lenore Tawney* at Maryland Institute College of Art, Baltimore.

Cloud Labyrinth (page 230) installed in the Great Hall at the University of the Arts in Philadelphia.

1993
Group exhibition *Small Works in Fiber: The Collection of Mildred Constantine* at the Cleveland Museum of Art, Cleveland, Ohio.

1994
Group exhibition *Inspired by Nature* at Neuberger Museum of Art, Purchase College, State University of New York, Purchase.

Begins Shrines and Drawings in Air series.

1994–98
Solo exhibitions at Tenri Gallery, New York (1994, 1998).

1995
Travels to Colombia.

Solo exhibition *Lenore Tawney: Boundless World* at Perimeter Gallery, Chicago.

1996

Travels to Netherlands.

Solo exhibitions *Lenore Tawney: Meditative Images* at the Contemporary Museum of Honolulu; *Lenore Tawney: roots, tendrils, threads* at Schick Art Gallery, Skidmore College, Saratoga Springs, New York; *Lenore Tawney* at Stedelijk Museum, Amsterdam; and *Lenore Tawney: Shrines* at E. M. Donahue Gallery, New York.

Group exhibition *Fiber and Form: The Woman's Legacy* at Michael Rosenfeld Gallery, New York.

1997

Solo exhibitions *Vestures of Water: The Work of Lenore Tawney* at Allentown Art Museum, Allentown, Pennsylvania; and *Lenore Tawney, Meditations: Weavings, Collages and Assemblages* at Michael Rosenfeld Gallery, New York.

Group exhibition *Hanging by a Thread* at Hudson River Museum, Yonkers, New York.

1998

Solo exhibition *Lenore Tawney: Shrines Part II* at Donahue/Sosinski Art, New York.

Group exhibition *North and South Connected: An Abstraction of the Americas* at Cecilia de Torres Gallery, New York.

1999

Receives Master of the Medium award from James Renwick Alliance, Washington, DC.

Group exhibition *Material Perception—Celebrating Art and Architecture: Creating a Place for People* at Bank of America Plaza, Charlotte, North Carolina.

2000

Receives Visionaries Award from American Craft Museum, New York.

Solo exhibition *Lenore Tawney: Celebrating Five Decades of Work* at browngrotta arts, Wilton, Connecticut.

2001

Group exhibition *Abstraction: The Amerindian Paradigm* at Palais des Beaux-Arts (now BOZAR: Centre for Fine Arts), Brussels, and Institut Valencià d'Art Modern, Valencia, Spain.

2003

Solo exhibition *Lenore Tawney: Visions in Time* at Brattleboro Museum and Art Center, Brattleboro, Vermont.

Group exhibition *Generations/Transformations: American Fiber Art* at American Textile History Museum, Lowell, Massachusetts.

2004

Group exhibition *Traditions/Transformations: The Changing World of Fiber Art* at Wadsworth Atheneum Museum of Art, Hartford, Connecticut.

2007

Solo exhibition *Lenore Tawney: Drawings in Air* at browngrotta arts, Wilton, Connecticut.

Dies at her loft on West Twentieth Street in New York.

2008

Group exhibition *Messages and Magic: 100 Years of Collage and Assemblage in American Art* at John Michael Kohler Arts Center, Sheboygan, Wisconsin; and *Circa 1958: Breaking Ground in American Art* at Ackland Art Museum, The University of North Carolina at Chapel Hill.

2010

Group exhibition *Contemporary Fiber Art* at Art Institute of Chicago.

2011

Group exhibition *Crafting Modernism: Midcentury American Art and Design* at Museum of Arts and Design, New York.

2012

Solo exhibition *Lenore Tawney: Wholly Unlooked For* at Maryland Institute College

of Art, Baltimore, and University of the Arts, Philadelphia.

Group exhibitions *Art=Text=Art: Works by Contemporary Artists* at Zimmerli Art Museum, Rutgers University, New Brunswick, New Jersey (national and international tours); *To Be a Lady* at 1285 Avenue of the Americas Art Gallery, New York; and *Retro/Prospective: 25+ Years of Art Textiles and Sculpture* at browngrotta arts, Wilton, Connecticut.

2013
Group exhibitions *Art & Textiles: Fabric as Material and Concept in Modern Art from Klimt to the Present* at Kunstmuseum Wolfsburg, Wolfsburg, Germany; *The Art of Handwriting* at Archives of American Art, Smithsonian Institution, Washington, DC (national tour); and *Textiles: Open Letter* at Museum Abteiberg, Mönchengladbach, Germany.

2014
Group exhibitions *Thread Lines* at the Drawing Center, New York; and *Fiber: Sculpture 1960– Present* at Institute of Contemporary Art/Boston (national tour).

2015
Group exhibitions *Pathmakers: Women in Art, Craft and Design, Midcentury and Today* at the Museum of Arts and Design, New York (national tour); and *Influence and Evolution: Fiber Sculpture…then and now* at browngrotta arts, Wilton, Connecticut.

2016
Group exhibition *3 Women* at The Landing Gallery, Los Angeles.

2017
Group exhibitions *Between Land and Sea: Artists of the Coenties Slip* at the Menil Collection, Houston; *Making Space: Women Artists and Postwar Abstraction* at the Museum of Modern Art, New York; *Process and Practice: 40 Years of Experimentation* at The Fabric Workshop and

Museum, Philadelphia; *Liminal Focus* at Barbara Mathes Gallery, New York; and *Beyond Craft* at Tate Modern, London.

2018
Solo exhibition *Frieze Masters: Lenore Tawney* at Alison Jacques Gallery, London.

Group exhibition *bauhaus imaginista: Learning From* at SESC Pompéia, São Paulo, Brazil. Included in *Anni Albers* at Tate Modern, London.

2019
Solo exhibition *Lenore Tawney: Mirror of the Universe* at John Michael Kohler Arts Center, Sheboygan, Wisconsin (with the first large-scale monograph dedicated to the artist published under the same title).

Group exhibition *bauhaus imaginista: Still Undead* at Haus der Kulturen der Welt, Berlin.

More than four hundred objects from the artist's studio gifted to the John Michael Kohler Arts Center with support from the Lenore G. Tawney Foundation and Kohler Foundation Inc.

Bibliography

Adams, Alice. "Lenore Tawney." Review. *Craft Horizons* 22, no. 1 (January/February 1962): 39.

Albers, Anni. *On Weaving*. Middletown, CT: Wesleyan University Press, 1965.

American Craftsmen's Council. *Asilomar: First Annual Conference of American Craftsmen*. Proceedings. Minneapolis: American Craftsmen's Council, 1957.

Art Institute of Chicago. *Midwest Designer Craftsmen 1957*. Chicago: Art Institute of Chicago in association with Midwest Designer-Craftsmen, 1957.

Auther, Elissa. "Commentary: Lenore Tawney's Postcard Collages." *Journal of Modern Craft* 8, no. 2 (July 2015): 235–44.

"Back-Strap Weaving: An Age-Old Craft Revisited." *Los Angeles Times,* June 23, 1968.

Barnet, Andrea. "Beyond the Loom." Review. *New York Times Book Review,* July 22, 1990.

Barron, Stephanie. "Giving Art History the Slip." *Art in America,* March/April 1974, 80–84.

Billeter, Erika. *Collagen: Die Technik der Collage in der angewandten Kunst*. Zurich: Kunstgewerbemuseum, 1968. Exh. cat.

——, ed. *Weich und Plastich: Soft-Art*. Zurich: Kunsthaus Zürich, 1979. Exh. cat.

Boman, Eric. "A (Mostly) Untouched Artist's Loft." *New York Magazine,* January 22, 2018, 57–61.

Braff, Phyllis. "Pulse on the Trigger." Review. *Cover,* no. 11 (June 1997): 12.

"A Break-Through in Weaving: Open Tapestries." *House Beautiful,* January 1960, 57.

Brite, Jane Fassett, Jean Stamsta, and John Perreault. *Fiber R/Evolution*. Milwaukee: Milwaukee Art Museum/University Art Museum, University of Wisconsin, 1986. Exh. cat.

Brown, Rhonda, ed. *Influence and Evolution: Fiber Sculpture…then and now*. Wilton, CT: browngrotta arts, 2015. Exh. cat.

Brüderlin, Markus, ed. *Art & Textiles: Fabric as Material and Concept in Modern Art from Klimt to the Present*. Wolfsburg, Germany: Kunstmuseum Wolfsurg, 2013. Exh. cat.

Coggin, James. *Lenore Tawney*. Staten Island, NY: Staten Island Museum, 1961. Exh. cat.

Constantine, Mildred, and Jack Lenor Larsen. *The Art Fabric: Mainstream*. New York: Van Nostrand Reinhold, 1981.

——. *Beyond Craft: The Art Fabric*. New York: Van Nostrand Reinhold, 1972.

———. *Wall Hangings.* New York: Museum of Modern Art, 1969. Exh. cat.

Cotter, Holland. "At MoMA, Women at Play in the Fields of Abstraction." Review. *New York Times,* April 13, 2017.

———. "Lenore Tawney, 100, Innovator in Weaving." Obituary. *New York Times,* September 28, 2007.

———. *Lenore Tawney: Signs on the Wind; Postcard Collages.* San Francisco: Pomegranate, 2002.

Cotton, Giselle Eberhard, and Magali Junet. *From Tapestry to Fiber Art: The Lausanne Biennials, 1962–1995.* Milan: Skira, 2017.

Crommelin, Liesbeth, Rudi Fuchs, and Kathleen Nugent Mangan. *Lenore Tawney.* Amsterdam: Stedelijk Museum, 1996. Exh. cat.

d'Autilia, Jean. *Lenore Tawney: A Personal World.* Brookfield, CT: Brookfield Craft Center, 1978. Exh. cat.

Director's Choice. Philadelphia: Museum College of Art, 1961. Exh. cat.

Falino, Jeannine, ed. *Crafting Modernism: Midcentury American Art and Design.* New York: Museum of Arts and Design, 2011. Exh. cat.

Feinstein, Roni, and Emily Kass. *Circa 1958: Breaking Ground in American Art.* Chapel Hill: Ackland Art Museum, The University of North Carolina, 2008. Exh. cat.

Frame, Mary, Lucy Lippard, Cecilia de Torres, César Paternosto, and Ferdinán Valentín. *Abstraction: The Amerindian Paradigm.* Brussels: Palais des Beaux-Arts/Institut Valencià d'Art Modern, Valencia, 2001. Exh. cat.

Frankel, Dextra, Bernard Kester, and Katharine Kuh. *Lenore Tawney.* Fullerton: California State University, 1975. Exh. cat.

Gaylor, Robert B., Diane Armitage, Suzi Gablik, Dominique Mazeaud, and Melinda Wortz. *Revered Earth.* Santa Fe, NM: Center for Contemporary Arts, 1990. Exh. cat.

Gedeon, Lucinda H. *Fiber Concepts.* Tempe: Arizona State University Art Museum, 1989. Exh. cat.

Generations/Transformations: American Fiber Art. Lowell, MA: American Textile History Museum, 2003. Exh. cat.

Glentzer, Molly. "Menil Show Looks at How Abstract-Artist Friendships Shaped Works, Genre." Review. *Houston Chronicle,* May 27, 2017.

Griffin, Jonathan. "Weaving Histories." *Frieze Masters,* no. 5 (2016): 72–77.

Guralnick, Margot. "Collage of a Lifetime." *House & Garden,* June 1991, 118–23, 155.

Halls Exhibition Gallery. *Fibre Art.* Kansas City, MO: Halls Exhibition Gallery, 1973. Exh. cat.

Harren, Natilee. "Critics' Picks: 'Between Land and Sea: Artists of the Coenties Slip.'" Review. *Artforum,* May 18, 2017, https://www.artforum.com/picks/the-menil-collection-the-menil-collection-68448.

Henry, Gerrit. "Cloudworks and Collage." Review. *Art in America,* June 1986, 116–21.

Hoff, Margo. "Lenore Tawney: The Warp Is Her Canvas." *Craft Horizons* 17, no. 6 (November/December 1957): 14–19.

Hoffman, Virginia. "When Will Weaving Be an Art Form?" *Craft Horizons* 30, no. 4 (August 1970): 18–25.

Howard, Richard. "Tawney." Review. *Craft Horizons* 35, no. 1 (February 1975): 46–47, 71–72.

Jewett, Eleanor. "Old Town Shows Art of Resident." Review. *Chicago Tribune,* September 30, 1956.

Kaufmann, Ruth. *The New American Tapestry.* New York: Reinhold, 1968.

Kuenzi, André. *La Nouvelle Tapisserie.* Lausanne: Bibliothèque des Arts, 1981.

Kuh, Katharine. *The Art Collection of the First National Bank of Chicago.* Chicago: First National Bank, 1974.

———. *My Love Affair with Modern Art: Behind the Scenes with a Legendary Curator,* ed. Avis Berman. New York: Arcade, 2006.

———. "Sculpture: Woven and Knotted." *Saturday Review,* July 27, 1968, 36–37.

Kuh, Katharine, and Leah P. Sloshberg. *Lenore Tawney*. Trenton: New Jersey State Museum, 1979. Exh. cat.

Kunstgewerbemuseum Zürich. *Gewebte Formen: Lenore Tawney, Claire Zeisler, Sheila Hicks*. Zurich: Kunstgewerbemuseum Zürich, 1964. Exh. cat.

Kushner, Robert. "Lenore Tawney at Tenri." Review. *Art in America,* December 1994, 103–4.

Larsen, Jack Lenor. "Lenore Tawney—Inspiration to Those Who Want to Develop Their Artistic Potential." *House Beautiful,* March 1962, 160–61, 175–77.

Lawrence, Lee. "Artist of the Eternal Moment." *American Style,* Spring 1998, 54–61.

L. C. "Lenore Tawney." Review. *ARTnews*, November 1967.

"Lenore Tawney: Her Designs Show Imaginative Departure from Traditional Tapestry Techniques." *Handweaver & Craftsman* 13, no. 2 (Spring 1962): 6–9.

"Library Shows Mrs. Tawney's Tapestry Art." Review. *Chicago Tribune,* February 6, 1955.

Livingston, Jack, and Peter Boyce. "Lenore Tawney: Wholly Unlooked For." Review. *Journal of Modern Craft,* no. 6 (July 2013): 229–34.

Malarcher, Patricia. "Lenore Tawney: Wholly Unlooked For." Review. *Surface Design,* no. 37 (Summer 2013): 58–59.

Mangan, Kathleen Nugent, ed. *Lenore Tawney: A Retrospective*. New York: Rizzoli International Publications in association with American Craft Museum, 1990. Exh. cat.

Mangan, Kathleen Nugent. *Lenore Tawney: Drawings in Air*. Wilton, CT: browngrotta arts, 2007. Exh. cat.

——. "Lenore Tawney's Cloud Series VI." *Surface Design,* no. 39 (Winter 2015–16): 48–51.

——. "Remembering Lenore Tawney." *New York Arts,* March/April 2008, 70.

——. *Vestures of Water: The Work of Lenore Tawney*. Allentown, PA: Allentown Art Museum, 1997. Exh. cat.

Mangan, Kathleen Nugent, Sid Sachs, Warren Seelig, and T'ai Smith. *Lenore Tawney: Wholly Unlooked For*. Baltimore: Maryland Institute College of Art; Philadelphia: University of the Arts, 2013. Exh. cat.

Manhart, Marcia, and Tom Manhart, eds. *The Eloquent Object*. Tulsa, OK: Philbrook Museum of Art, 1987. Exh. cat.

McDonald, Joan. *Lenore Tawney: Above the Cloud*. VHS. US: J. McDonald, 1990.

Melrod, George. "The Fame Game." *Art & Antiques,* Summer 1997, 72–79.

Millar, Lesley, and Jo Ann C. Stabb. *Retro/Prospective: 25+ Years of Art Textiles and Sculpture*. Wilton, CT: browngrotta arts, 2012. Exh. cat.

Miller, Judith. "The 13th Triennale." Review. *Design Quarterly,* no. 61 (1964): 22–23.

Moorjani, Angela. *Beyond Fetishism and Other Excursions in Psychopragmatics*. New York: St. Martin's, 2000.

Munro, Eleanor. *Originals: American Women Artists*. New York: Simon & Schuster, 1979.

Museum of Contemporary Crafts. *The American Craftsman*. New York: Museum of Contemporary Crafts, 1964.

——. *Craftsmanship in a Changing World*. New York: Museum of Contemporary Crafts, 1956. Exh. cat.

——. *Wall Hangings and Rugs*. New York: Museum of Contemporary Crafts, 1957. Exh. cat.

Myers, John Bernard. *Tracking the Marvelous*. New York: Grey Art Gallery and Study Center, New York University, 1981. Exh. cat.

Myzelev, Alla, ed. *Exhibiting Craft and Design: Transgressing the White Cube Paradigm, 1930–Present*. London: Routledge, 2017. Exh. cat.

Nordness, Lee. *Objects: USA*. New York: Viking Press, 1970. Exh. cat.

O'Brien, George. "Weaver Departs from Tradition to Create an Art Form." *New York Times,* April 29, 1963.

"The Old Crafts Find New Hands." *Life,* July 29, 1966, 34–43.

Oral history interview with Lenore Tawney, 1971 June 23. Archives of American Art, Smithsonian Institution, Washington, DC. Interview by Paul Cummings. Audio, 1 hr., 21 min. https://www.aaa.si.edu/collections /interviews/oral-history-interview-lenore-tawney -12309#transcript.

Oral history interview with Merry Renk, 2001 January 18–19. Archives of American Art, Smithsonian Institution, Washington, DC. Interview by Arline M. Fisch. Audio, 3 hr., 9 min. https://www.aaa.si.edu /collections/interviews/oral-history-interview -merry-renk-11961.

Orenstein, Gloria. "Lenore Tawney: The Craft of the Spirit." *Feminist Art Journal* 2, no. 4 (Winter 1973–74): 11–13.

Orth, Maureen. "The Cosmic Creations of Lenore Tawney." *New York Woman,* May/June 1987, 66–67.

Park, Betty. "Lenore Tawney." Review. *Craft Horizons* 38, no. 7 (October 1978): 52.

Pomeroy, Ralph. *Soft Art.* Trenton: New Jersey State Museum, 1969. Exh. cat.

Porter, Jenelle, ed. *Fiber: Sculpture 1960–Present.* New York: Prestel in association with Institute of Contemporary Art Boston, 2014. Exh. cat.

"Psychedelic Art." *Life,* September 9, 1966, 65.

Rannells, Elizabeth. "Have You Heard?" *Chicago Tribune,* March 2, 1952.

Raynor, Vivien. "Fabric of Surrealism." Review. *New York Times,* July 2, 1978.

Reid, Michael. *Convergence/Divergence: Exploring Black Mountain College and Chicago's New Bauhaus/ Institute of Design.* Asheville, NC: Black Mountain College Museum and Arts Center, 2015. Exh. cat.

Reif, Rita. "Artistry and Invention Seamlessly Joined." *New York Times,* November 26, 1995.

Romanow, Joanna Kleinberg. *Thread Lines.* New York: Drawing Center, 2014. Exh. cat.

Rubenstein, Charlotte Streifer. *American Women Artists.* Boston: G. K. Hall, 1982.

Schuyler, James. "Lenore Tawney." Review. *Craft Horizons* 27, no. 6 (November/December 1967): 20–25.

——. *Selected Art Writings.* Santa Rosa, CA: Black Sparrow Press, 1998.

Seaman, Donna. *Identity Unknown: Rediscovering Seven American Women Artists.* New York: Bloomsbury, 2017.

Seelig, Warren. "Meditative Image: The Art of Lenore Tawney." Review. *American Craft* 50 (August/ September 1990): 36–43, 66.

Shorr, Mimi. "Fiber Sculpture." *Saturday Review,* May 20, 1972, 57–61.

Simpson, Tommy, and Lisa Hammel. *Hand and Home: The Homes of American Craftsmen.* Boston: Little, Brown, 1994.

Slivka, Rose. "The New Tapestry." Review. *Craft Horizons* 23, no. 2 (March/April 1963): 10–19, 48–49.

Smith, Dido. "Lenore Tawney." Review. *Craft Horizons* 30, no. 4 (August 1970): 54.

Smith, Paul J., ed. *Woven Forms.* New York: Museum of Contemporary Crafts, 1963. Exh. cat.

Smith, Paul J., and Edward Lucie-Smith. *Craft Today: Poetry of the Physical.* New York: American Craft Council, 1986. Exh. cat.

Smith, Roberta. "Lenore Tawney's Work in Fiber and Beyond." Review. *New York Times,* May 18, 1990.

Stein, Judith E. "The Inventive Genius of Lenore Tawney: Reflections on a Lifetime of Art." *Fiberarts,* no. 24 (September/October 1997): 28–34.

——. *Lenore Tawney–Meditations: Assemblages, Collages, and Weavings.* New York: Michael Rosenfeld Gallery, 1997. Exh. cat.

Sutton, Ann. "Modern American Wall Hangings." *Quarterly Journal of the Guilds of Weavers, Spinners and Dyers,* no. 42 (June 1962): 382–84.

"Textiles." *Craft Horizons* 26, no. 3 (June/July 1966): 33.

Thalacker, Donald W. *The Place of Art in the World of Architecture.* New York: Chelsea House, 1980.

Umberger, Leslie. *Messages & Magic: 100 Years of Collage and Assemblage in American Art.* Sheboygan, WI: John Michael Kohler Arts Center, 2008. Exh. cat.

Ward, Evelyn Svec, Sherman E. Lee, and Edward B. Henning. *Fiberworks.* Cleveland, OH: Cleveland Museum of Art, 1977. Exh. cat.

"Weavings by Lenore Tawney." *Staten Island Institute of Arts and Sciences: The New Bulletin* 11, no. 3 (November 1961): 25–26.

Weltge, Sigrid Wortmann. "Lenore Tawney: Spiritual Revolutionary." *American Craft,* no. 68 (February/March 2008): 90–97.

——. *Women's Work: Textile Art from the Bauhaus.* San Francisco: Chronicle Books, 1993.

Weltge, Sigrid Wortmann, Kathleen Nugent Mangan, and Lenore Tawney. *Lenore Tawney: Celebrating Five Decades of Work*. Wilton, CT: browngrotta arts, 2000. Exh. cat.

"What's New for Living." *House & Garden.* September 1967, 40.

Whitney Museum of American Art. *Nine Artists/Coenties Slip.* New York: Whitney Museum of American Art, 1974. Exh. cat.

Winter, Amy. "Lenore Tawney." *Arts* 60, no. 5 (January 1986): 108.

Woolfolk, Anne. "Dream Weaver." *New Jersey Monthly,* April 1980, 112–13.

——. "Tawney Creates with Bliss." *Princeton Packet: Time Off,* November 14–20, 1979, 1, 6–7.

World Crafts Council. *The First World Congress of Craftsmen.* Proceedings. New York: World Crafts Council, 1964.

Contributors

GLENN ADAMSON is a senior scholar at the Yale Center for British Art and an independent curator who works across the fields of design, craft, and contemporary art.

KATHLEEN NUGENT MANGAN is executive director of the Lenore G. Tawney Foundation and curated the 1990 retrospective of Lenore Tawney's work in addition to being a personal friend to the artist.

KAREN PATTERSON is the curator at the Fabric Workshop and Museum in Philadelphia. Until recently she was senior curator at the John Michael Kohler Arts Center, where she worked with artists and collections to present contemporary art exhibitions and site-specific installations.

MARY SAVIG is curator of manuscripts at the Smithsonian's Archives of American Art, where she has organized numerous exhibitions and written broadly on its collections.

SHANNON R. STRATTON works in contemporary art and craft—curating, writing, teaching, and building frameworks and platforms for cultural production and presentation.

DR. FLORICA ZAHARIA is conservator emerita of the Metropolitan Museum of Art and co-owner and director of the Muzeul Textilelor in Baita, Romania.

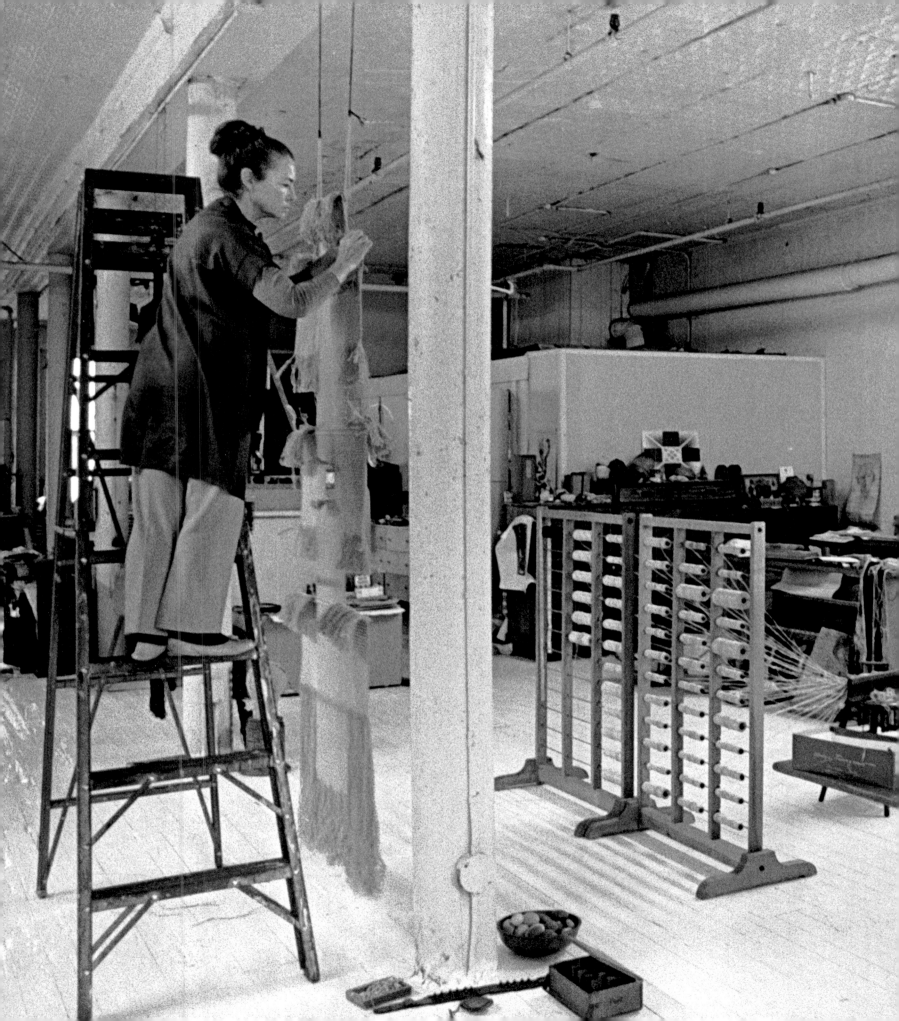

Index

Italicized page numbers indicate illustrations. Works by Lenore Tawney appear by title while works by other artists appear only under the name of those artists.

Abakanowicz, Magdalena, 114, 128, 141
abstract art, 60, 122, 135, 193
Abstract Expressionism, 63, 109, 234
Adams, Alice, 121, 122, 144
Adele Bednarz gallery (Los Angeles), 136
Albers, Anni, 51, 56, 62–63, 121
Albers, Josef, 121
Allegra, Indira, 173, 254, 264–65; Body Warp series, 267; *Toys and Tools* (2017), 264, *265*
Amaral, Olga de, 141
American Craft Museum: Tawney retrospective (1990), 10, 13, 46, 231, 234, 278
And From His Footprints Flowed a River (collage 1968), 135, *135*
Andre, Carl, 132
And Whom Is My Dearest One (mixed media 1988), *168*
Archipenko, Alexander, 26, 52
archives, 88–93, 240, 244, 278
Archives of American Art (Washington, DC), 51; Tawney's oral history interview (1971), 88, 154, 281
Ark. See Maquette of Cubed Cube
The Art Fabric: Mainstream (1981 traveling exhibition), 142, 229

Art Institute of Chicago, 142, 195, 230; Midwest Designer-Craftsmen Show (1955), 62; School, 50, 254; Tawney retrospective on tour at (1990s), 231; *Woven Forms by Lenore Tawney* (1962 exhibition), 118
artist-built environments, 6
ARTnews on Willard Gallery exhibition (1967), 137–39
Asawa, Ruth, 136
Asilomar American craft conference (California 1957), 62–63, 191
Attie, David, 77, 77–81
Aurora, or Morning Redness (1974), 195, *195*
Auther, Elissa, 144, 227
avant-garde movement, 53, 56, 62, 67, 125, 142, 154
Azara, Nancy, 228

Baer, Steve: *The Dome Cookbook*, 182
Barron, Stephanie, 70
Bates, Kenneth J., 118
Bauhaus, 50–51, 128
Benson Gallery (Bridgehampton, New York), 114, 136, 141, 182; solo exhibition (1967), 137, *137*
Bernini, Gianlorenzo, 76
Betty Parsons Gallery (New York), 69
Beyond Craft (Constantine and Larsen), 141
Billeter, Erika, 128, 211, 227, 229

Birds and Flower (1955), 56, *57–58*
Bland, Julia, 254, 259; *Drink This* (2016), 259, *259*
Blavatsky, Helena Petrovna, 88
Blumenau, Lili, 56, 81, 118
Böhme, Jakob, 132, 154, 195, 229, 259–60
Book of Foot (1996), 33–37
Borgenicht, Grace, 137
Bound Man (1957), 63, *63*, 119
Bourgeois, Louise, 144
The Bride (1962), *24*, *105*, *107*, 119, *145*, *170–71*, *248*
Brookfield Craft Center (Connecticut): *Lenore Tawney: A Personal World* (exhibition 1978), 184
Brooks, Charles, 179
brown art, 254–56
Brussels World's Fair (1958), 63
Bryan-Wilson, Julia: *Fray: Art and Textile Politics*, 228
Buddhism. *See* Zen Buddhism
Buic, Jagoda, 128
Butler, Alban: *The Lives of the Saints*, 76, 226
buttons, *12*, 31, 90, 136, 192, 243–44, *244–46*, *270. See also* Tender Buttons shop

California State University (Fullerton), 142
Callaghan, Michael, *163*
Campbell, David, 56
Castle, Wendell, 178
The Cat Kind, The Dog Kind (collage 1967), 137, *139*

Celestial Messenger (mixed media 1978), 33, 37, *189*
Chamberlain, John, 234
Charlton, Maryette, 51, 88–90, *159*; films of Tawney by, 225–26; Tawney's letters to, 90, *161*, 185, 206, *206*; Tawney's mail art to, 90, 93, 135, 158, *159*, *192*
Chicago, Judy, 228
Chicago Public Library (1955 exhibition), 55
Chinmoy, Sri, 190
Christian themes, 112, 183, 226, 229
Chryssa (sculptor), 72
Cioffi, Vince and Pearl, 191, 224
Clark, Robert. *See* Indiana, Robert
Clawson, Lee, 133, 134
Cleveland Museum of Art, 142
Cloud Garment (2017–18), 229
Cloud series sculptures, 133, 192, 219, 222–25, 229–31, *272*, 278; *Cloud Labyrinth* (1983), *7*, 229, *230*; *Cloud Series IV* (1978), 224–25; *Cloud VI* (1981), *218*; undated sketch for, *281*
Coenties Slip artists' colony (New York), 51, 69–73, 115, 125
Coggin, James, 106
collage and assemblage work, 134–39, 141, 157, 192, 225, 231, 234, 243, 256, 264, 278. *See also* mail art and postcards; *individual works by title*
Collage Chest (kinetic sculpture 1974–97), 229, 264, *265*

Collage Chest I (mixed media 1974), 175, *188, 210*
Collage Chest II (mixed media 1974), *204–5*
Collingwood, Peter, 128
Constantine, Mildred, 129, 141–42, 229
Cooper Union (New York), 130
Cornell, Joseph, 134, 136, 231
Cotter, Holland, 132, 135, 234
craft-art distinction, 228, 231, 256
Craft Horizons, 13, 22, 37, 51, 60, 60, 62, 63, 122, 139, 142, 144
Cranbrook Academy of Art (Michigan), 54, 133, 141
Crow, Thomas: *No Idols*, 225
Crown of Thorns (mixed media 1966), *165*
Cubed Cube. See Maquette of Cubed Cube
Cummings, Paul, 154–57, *281*

Dadaism, 157
Dark River (1962), 114, *114*, 118, 119, 128, 129, 141, 226
Dass, Ram: *From Bindu to Ojas (or Be Here Now)*, 182
d'Autilia, Jean and Frank, 184, 224
Declaration (1962), *126–27*, 192
de Groat, Andy, *226*, 226–27
DePatta, Margaret, 53
Design Trends exhibition, 142
DeVille hotel (Catskills, New York), 183
DiMare, Dominic, 139
Dine, Jim, 136
Distilla (mixed media 1967), *214*
double weaving, 76, 134
Dove (1974), *177*, 216, *216–17*, 226, 259
Drawings in Air series (late 1990s), 230, 261; *Drawing in Air VI* (1997), *33*, 230, *232–33*
Drutt, Helen, 142, 229
A Dry Cry from the Desert (1970), *33*, 97
Duchamp, Marcel, 67–69, 134
Dunn, Frederick, 77
Durkee, Stephen and Barbara, 182

Ear Pillows (2017–18), 229
Egyptian Girl (1956), 26, 56–59, *59*, 62, 63
Egyptian influences, 119
Ehrman, Marli, 51
Emblem of Infinity (mixed media 1969), 259, *261*
Entablature (1974–94), 269
Epstein, Diana, 135–36, 158, 243, *243*
Erhard, Werner, 183

Esalen (Big Sur, California), 179
Espenscheid, G., *158*
Evans, Paul, 178
Even Thread Had a Speech (1966), 219, 254–56, *255*
Expressionism, 53, 54, 70. *See also* Abstract Expressionism

Fairweather Hardin Gallery (Chicago), 67, 136
Family Tree (mid-1950s), 59
Fanning, Leesa, 22
Fantin-Latour, Henri, 243
Feather Music (1967), 95, 139, *250–51*
Feminist movement and feminism, 46, 228
fiber art movement, 125–28, 139–44, 227, 235; echoes in artists who studied or worked in close proximity to, 254–68; women in, 19, 118–22, 228, 235, 256
First World Congress of Craftsmen (New York 1964), 130
flags, 192, *193*
Flight (1961), 109
Floating Shapes (1958), *78–79*
The Flower Lies Hidden (mixed media 1986), *238*
Foot Forms (mixed media c. 1984), *253*
formalism, 122, 125, 142
Forsberg, Charles, 129
Four Armed Cloud (1978–79), 222, 225–27, *226*
Four Petaled Flower (1973), 193
Four Petaled Flower II (1974), 193, *194*
Fuller, Buckminster: *4D Time Lock*, 182

gauze weaving, 81, 118, 170, *170*, 193
gender. *See* Feminist movement and feminism; sexism in art world
Giacometti, Alberto, 63
Gibbon, Edward: *Decline and Fall of the Roman Empire*, 135
Ginstrom, Roy, 56, 62–63, 118
Gods and Demons of the Himalayas exhibition (Paris, 1977), 191
Goethe, 259, 261
Gordon, Elizabeth, 70
Greenberg, Clement, 125
Grossen, Françoise, 128, 141
Grotta, Sandy and Lou, 191
Guermonprez, Trude, 56
Guru Gita, 240
Gurumayi Chidvilasananda, 229–30

Gush of Fire (drawing 1964), 130–32, *131*

Hallman, Ted, 139, 179
Hammond, Harmony, 228
Harris, Lis, 184
Harrod, Jesse, 19, 254, 261–63; *Mascot 1, 263, 263*
Hesse, Eva, 59–60, 130, 144, 227
Hicks, Sheila, 118, 121, *128*, 141
Higgins, Frances and Michael, 60
Hinduism, 50, 183, 229
Hoff, Margo, 51, 52, 60, 60–62, 69, 106, 125–28
Hoffman, Virginia, 142–44, 227
House Beautiful, 67, 70, 129
Howard, Richard, 135
Hüm (mixed media 1986), *202–3*

I am word woman (mixed media 1967–97), 257, *257*
Indiana, Robert, 69, *72*, 72–73, 125, 130
In Fields of Light (1975), *187*, 193
Inquisition (1961), 199
Inside the Earth, a Mountain (c. 1965), 263, *263*
In Silence (mixed media 1990), 169
Institute of Design (Chicago), 49, 50–53, 121
Interchurch Center (New York City), 76–77, 112
In Utero (1985), *33, 37*

Jacobi, Ritzi, 141
Jacobs, Ferne, 38, 73, 135, 158, 235
Jacobs, Jane, 244
Japanese influences, 56, 179, 228
Jenkins, Paul, 139
John Michael Kohler Arts Center (Sheboygan, Wisconsin), 13–14, 235, 264, 282
Johns, Jasper, 73
Johnson, Marna, 66–72, 76, 114, 137, 224
Johnson, Ray, 136, 158
Joyce, James, 229
Judd, Donald, 132
The Judge (1961), *86, 248–49*
Jung, Carl, 137, 229, 256, 259
Jupiter (1959), *108*, 109, 132, 193–95

Kabbalah, 263
Karasz, Mariska, 56
Kardon, Janet, 231
Karsh, Yousuf, 60, *61*
Kaufmann, Edgar J., Jr., 129
Kelly, Ellsworth, 69, 72, 115
Kempton, Sally, 183–84
Kester, Bernard, 139

kg, 254, 267–68; *The Red Parts* (2018), 268, *268*
Kidd, Robert L., 133–34
Kiesler, Frederick, 125
Kiesler, Lillian, 135, 154, *155*, 158, 161, *162*, 178
Kim, Po, 141
The King I (1962), 119, *121*, 129, 227
Knodel, Gerhardt, 229
Kobori Roshi, 179
Krishnamurti, Jiddu, 185
Kuh, Katharine, 51, 135, 139, 158, *158*, 193, 226
Kunstgewerbemuseum Zürich: collage exhibition (1968), 227; *Woven Forms* (1964 exhibition), 125–28, *128*, 227
Kushner, Robert, 125, 185, 190, 229

Landscape (1958), 109
Lange, Alexandra, 244
Larsen, Jack Lenor, 52, 54, 56, 62–63, 67, 118, 128–29, 141–42, 158, 229
"late style" of an artist, 222
Lausanne biennials (1967, 1969, 1983), 141, 229
Leemann, Judith, 219, 254, 256–57; *reading aloud: stories about a coyote* (2015), 256, *257*
Leen, Nina, 178
Lekythos (1962), 119, *121*, 122, *123–24*, 128, *147–49*
Lenore G. Tawney (LGT) Foundation (New York), 46, 234, 278
Leonardo da Vinci, 69, 193
letters, 133–36, 240. *See also* mail art and postcards; *specific recipients' names*
Lewitt, Sol, 132, 141
Lieberman, Rosilyn W., 178–79
Liebes, Dorothy, 53, 56, 62, 137
Lindberg, Anne, 254, 261, 267; *the eye's level* (2018), 261, *262*
Lippard, Lucy, 228; *Eccentric Abstraction* (1968 exhibition), 122
Lippold, Richard, 137
Little Egypt (1964), 141
Little River (1969), 141
Little Spring (1962), *36*
Littleton, Harvey, 178
"loft living," 69. *See also* Tawney, Lenore, homes and studios of
Lost and Proud (1957), *21*, 26, 47, 63–66, 98, *99–101*
Lost and Proud (pen drawing n.d.), *98*
Louis, Morris, 60

Mackenzie, Alix and Warren, 118
Macomber horizontal loom, 216
Maharshi, Ramana, 229
mail art and postcards, *90, 93, 134–36, 136,* 154, *155,* 157–62, *158–63,* 191, *192,* 234, 240, *241, 243*
Maillard, Dominique, 56
Mangan, Kathleen Nugent, *16,* 46, 70, 230–31, 234, 278
Manuscript Writing (mixed media 1980), *180–81*
Maquette of Cubed Cube (sculpture 1969), *132,* 132–34, 161, 224
Marshall Field displays (Chicago), 66
Martin, Agnes, 69, 72–76, 109–12, 115, 118, 119, 125, 130, 182, 226; *Friendship,* 73; *Homage to Greece,* 234; *White Flower,* 73
Maryland Institute College of Art (Baltimore) commencement address (1992), 278–80
McKay, Richard, 230
Médecins Anciens (or *Quantité Réelle*) (mixed media 1966), *137, 138*
The Megalithic Doorway (1965), *111*
Menil, Dominique de, and Menil Collection (Houston), 139, 235
Metropolitan Museum of Art (New York), 119
Milano, Michael, 254, 257; "Propositions on Cloth," 258; Untitled (color study) (2011), *257, 258*
Milan Triennale (1964), 128–29
Miller, Judith, 129
Minimalism, 70, 125, 132–33, 193, 224, 225, 258. *See also* Post-minimalism
Mitchell, Fred, 69
Mohamedi, Nasreen, 130
Moholy-Nagy, László, 50, 52, 53
Mokotoff Gallery show (New York 1986), 231
Monhegan Island (Maine) spiritual retreats, 179
Montgomery, Chandler, 178
Moore, Ahza, 184–85
Morning Dove (1962), 139
Morris, Robert, 227
Mother Goddess (1970), *42*
Mowinckel, Cheryl and John, 234–35
Muktananda Paramahansa, 183–85, 190–91, 228, 229
Munro, Alice, 31

Munro, Eleanor, 53, 114
Museo de Bellas Artes Caracas (Venezuela), 125
Museum of Contemporary Crafts (New York), 63; *Craftsmanship in a Changing World* (1956 exhibition), 56; *Denim Art* (1974 exhibition), 192; *Wall Hangings and Rugs* (1957 exhibition), 56; *Woven Forms* (1963 exhibition and subsequent traveling exhibition), 119–22, 125–28, *128,* 141, 227, 231
Museum of Modern Art, New York (MoMA), 51, 114, 141–42, 226; *Beyond Craft,* 141; *Good Design,* 52, 142; *Wall Hangings,* 129, 141–42, 184

National Council of Churches, 76
Native American culture, 109, 139–41
Nativity in Nature (1960), 76, 77
Nemerov, Alexander, 234
Neumann, Erich: *The Great Mother,* 228
New Jersey State Museum (Trenton), 142; joint exhibition of Tawney and Takaezu (1979), 225–26, *226; Soft Art* (1969 exhibition), 227
Newman, Barnett, 112
Night Bird (1958), *64–65*
Nin, Anaïs, 73–76
Nityananda, Bhagawan, 183
Nordness, Lee, 132, 133, 161, *162*
Nottingham, Walter, 139

Objects: USA (1969 exhibition), 132, 161, 184, 224
Ode to a Sparrow (mixed media 1987), *237*
O'Keeffe, Georgia, 244
Oldenburg, Claes, 227
The Opening Forth (mixed media 1966), *167*
open-reed weaving, 115–19, 170
open-warp tapestry, 56, 59–60, 63–66, 77, 98, 109, 118–21, 224. *See also individual works by title*
Orenstein, Gloria, 228
Orinoco (c. 1967), *152–53*
Or to an Illegible Stone (mixed media 1989), *239*
Oshima, Kazuko, 161
O Sing (mixed media 1966), *186*

Palmer House hotel (Chicago 1955 exhibition), 55

Pansy (cat), 129, 161, *161,* 178, 265, *266*
Parrott, Alice Kagawa, 112, 178
Parsons, Betty, 125
Pasadena Art Museum, 141
The Path (1962), *116–17,* 119
Pattern and Decoration movement, 185, 228
Peach Hüm with Threads (mixed media 1979), *151*
Penland School of Crafts (North Carolina), 31, 53–54, *54*
Pepe, Sheila, 254, 264; *Short Stack* (2017), *264, 264*
Persian Poet (c. 1984–86), 33
Personnages (mixed media 1976), *200*
Peruvian (1962), 132, *133*
Peruvian and Mexican weavings, 33, 81, 118, 119, 132
Philadelphia Museum College of Art, 129
Philadelphia Textile Institute, 130
Pia Avis (mixed media 1969), *150*
Plate I (mixed media 1966), *212–13*
Plath, Sylvia, 70
Pomeroy, Ralph, 227
Ponti, Gio, 125
Pop art, 134
postcards. *See* mail art and postcards
postmarks, 136
Postminimalism, 144, 224, 227
Primal Garment (1961), 109, 122
primitivism, 141
Princenthal, Nancy, 109

The Queen (1962), 119, 129, 227

Rauschenberg, Robert, 73, 134, 141
Red Sea (1974), 259, *260*
Reflections (1959–60), 70, *71,* 109
Renk, Merry, 53
Renwick Gallery (Washington, DC), 231
Richards, Eleanor Hartshorne, 54
Riesman, Evey, 10–13, 176–78
Rilke, Rainer Maria, 229
Ringling Museum of Art (Sarasota, Florida), 142
Ripley, George, 195
The River. See Dark River (1962)
Riverside Museum (New York), 182
Roche, Mary Alice, 157
Roethke, Theodore, 229, 254
Rosenquist, James, 69
Rossbach, Ed, 122
Rothko, Mark, 139

Round and Square (drawing 1966), 259, *261*
rugs: (untitled, 1959), *34–35;* Moroccan style, 53

Safro, Millicent, 135–36, 158, 243, *243*
St. Francis and the Birds (1954), 26, *48, 49,* 54–55, 109
San Francisco Museum of Modern Art, 142
Santa Rosa Federal Building (California), 191, 224–25, 227, 231
Sax, Bill, 178
Schapiro, Miriam, 228
Schlanger, Jeff, 182, 191
Schuyler, James, 22
Schwitters, Kurt, 231
Scripture in Stone (1990), 225
Seaman, Donna, 77
Seattle World's Fair (1962), 114
Seaweed (1961), 26, *28–29,* 109, *110*
Seelig, Warren, 55, 141
Sekimachi, Kay, 56, 144, *160,* 161
Selver, Charles and Charlotte, 158
Selver, Charlotte, 179
sensory awareness movement, 179
sexism in art world, 46, 72, 142, 256
Shadow River (1957), 60, *61*
Shah, Haku, 240, *242*
Shield IV (1966), 33, 139, 267, *267*
Shimano, Eido, 179
Shining in Vacant Space (1975), *94*
Siddha Yoga, 183–85, 226, 228, 230
Siskind, Aaron, *17, 18,* 60, *60*
Slivka, Rose, 62, 125
Sloan, John: *The Wake of the Ferry II,* 154
Smith, Paul J., 56, 59, 60, 62, 119–22, 132, 141, 231, 278
Smith, Roberta, 231, 234
Smith, Tony, 132
Sneed, Samantha, 158
Solel Synagogue (Highland Park, Illinois), 77
Staten Island Ferry, 106, 282; Tawney photograph of (1961), *282*
Staten Island Institute of Arts and Sciences (1961–62 exhibition), 106, 109, 112, 114, 122
Stedelijk Museum exhibition (Amsterdam), 234
Stein, Gertrude, 109, 135, 192
Stern, Kalika, 244
Stewart, Malcom, 184
Still, Clyfford, 112

Stocksdale, Bob, *160*, 161
Surrealism, 134, 176

Tacoma Art Museum, 142
Taipale, Martta, 53–56, 122
Takaezu, Toshiko: as close friend, 31, 38, 63, 191; in joint exhibitions with Tawney, 137, 141, 142, 225, 226; sharing Quakertown home with Tawney, 136, 191, 224; Tawney's artwork stored ("temporarily lost") with, 230, 234; Tawney's letters and mail art to, 90, 134, 158, *158*, 190, 195, 227
Tate Modern (London), 119, 235
Tau (1974), *198*
Tawney, George Busey (husband), 50, 234
Tawney, Lenore: age of, 46, 49; approach of, 22–25; archives of, 88–93, 240, 244, 278; art education of, 31, 50–51, 81, 121; birth and early years of, 31–32, 46, 49, *49*; in Chicago (1927–57), 50–53, 178, 281; chronology of, 284–90; counterculture interests of, 33, 50, 182–91; critical reception of, 22, 51, 60, 72, 76, 114, 125, 132, 157, 193, 231, 234–35; death of (2007), 13, 234; discriminatory attitudes toward, 46, 72; echoes in artists who studied or worked in close proximity to, 254–68; employment history of, 49–50, 257; financial independence of, 50, 90; foundation created by, 46, 234, 278; humor of, 70, 161, 162, 228, 244; journals, sketchbooks, and artist books of, 88–93, *89*, *90*, *91–92*, 206–11, *207–9*, 229, 234, 240, 281; language and textual interests of, 50, 135, 158, 161, 195, 206, 257; late works of (1980–2007), 222–35; legacy of, 235, 256, 278; loss of eyesight, 25–26, 30, 230, 243, 280; marriages of, 50; move to New York (1957), 10, 30, 69, 208, 211, 278, 280, 281; née Leonora Gallagher, 49; painting smocks of, 244, *245–46*; photographs of, *11*, *16–18*, *23*, *25*, *33*, *39–40*, *49*, *51*, *54–55*, *60–61*, *77*, *80*, *83*, *102*, *115*, *123*, *128*, 134, *156–57*, *172*, *185*, *218*, 244, *247*, 265, *266*, *279–80*, *283*, *297*; politics and, 192; on search for sources, 206–8, 280, 281; sexuality of, 73–76; solitude and simplicity desired by, 10, 13, 118, 129, 133–34, 157, 178, 179, 191; spirituality and meditative practice of, 22, 25–26, 77, 112, 144, 179, 182–85, 190, 193, 206, 225, 226, 229, 235, 256, 263; travels of, 33, 50, 52–53, 56–59, 73, 179, 190, 229, 235. *See also individual artworks by title*
Tawney, Lenore, homes and studios of: Beekman Street, 22, 130, 176, 265, *266*; choosing nonresidential structures to convert, 13, 176; Coenties Slip loft, 10, 22, *27*, *33*, *40*, 69–76, 77; compared to Zahn's home, 38; decoration and painting of, 10–13, 154, 157, 176; East Cedar Street, *17–18*, *51*; East Fourth Street, 141, *143*, 154–57, 176; Gurumayi visiting, 229–30; Muktananda devotion in, 190; Quakertown home (shared with Takaezu), *13*, *23*, *185*, 191, 224; self-exhibition at East Fourth Street (1972), 184; South Street, 22, *22*, *41*, 69, 81, 114, *115*, 118, 130, 158, 176; Spring Street, 22, *157*, 176, *297*; studio objects and collections, 10–13, *12*, 22, 30, *31–32*, 33, 38, *43–45*, 90, 129, 154–57, 176, *201*, *215*, *236*, *252*, *270–71*; Thomas Street, 22, 176; West Twentieth Street, 10–13, *11*, *13*, *25*, 33, *38*, *43–45*, 157, 176, 234, *276–77*, *279*; Wooster Street, *156*, 176, 185
Taylor, Diana, 240
Tender Buttons shop (New York), 135–36, *136*, 158, 243, *244*
Teresa of Ávila, Saint, 76
Textiles USA (1956 exhibition), 142
Thread Box (1968), 230
Thurman, Christa C. Mayer, 142, 231
Tiso, Barbara, 230
Trend House (Chicago), 66
Triune (1961), 112–14, *113*, 193–95
Troy, Virginia Gardner, 142
Tuttle, Richard, 227
20½ (1958), *68*

UCLA Art Galleries: *Deliberate Entanglements* (1971), 141
Udjat (1968), *96*

Umberger, Leslie, 13, 37
The Union of Water and Fire (1974), 259, *259*
The Union of Water and Fire II (drawing 1964), 130, 258, *258*
Untaught Equation (1962), 114, *115*, 122, 137, 231
Untitled (1961), *2–3*, *74–75*
Untitled (c. 1965), *120*
Untitled (Bird) (c. 1965), *146*
Untitled (collage 1964), 135
Untitled (early sculptures, c. 1947–48), *52*
Untitled (flag) (1974), *193*
Untitled (Lekythos) (1962), *147–49*
Untitled (Shield) (1967), 139, *140*
USCO (artist collaborative), 182
Useful Objects exhibition, 142

Vespers (1961), 81, *82–85*
The Virgin, 119
Vivekananda, Swami, 50, 182–83, 185, 190
Voulkos, Peter, 62, 157, 178

Waiting like a Fern (1969), *87*
Walker Art Center's Everyday Art Gallery (Minneapolis), 51
Waterfall, *196*
Waters above the Firmament (1976), 154, 195, *195*
Webb, Aileen Osborn Vanderbilt, 60, 122, 130
Weise, Frank, 229
Weitzman, Susan, 184, 190
When the Two Shall Be One (mixed media 1966), *164*
Whitney Museum of American Art (New York), 229; *Anti-illusion: Procedures/Materials* (1969 exhibition), 144
Whose Number Is Without Beginning or End (drawing 1964), *166*
Wild Grass (1958), 109
Wilding, Faith, 228
Willard Gallery (New York), 136–39, 141, 142, 178, 191–92, 231
Wilson, Ann, 103, 179
Wilson, Anne, 69, 73, 128, 226
Wilson, Robert: *Einstein on the Beach*, 226
Winslow, Kirk, *158*
Winsor, Jackie, 141
Woelffer, Emerson and Diane, 51
women's stereotypical work, 122, 154, 228
Wood, Beatrice, 191
Woolf, Virginia, 229
Woolfolk, Anne, 228

Woven Field with Deity (mixed media 1994), 264, *264*
Written in Water (1979), 9, *221*, 223, 272, *272–75*

Yellows (1958), 77, *80*, 81
Youngerman, Jack, 30, 69, 72, 115

Zachai, Dorian, 121, 122, 178
Zahn, Albert, 37–38; angel by, *13*, 13–16, 37
Zeisler, Claire, 52, 114, 121, *128*
Zen Buddhism, 179, 182, 183, 229
Zürich Kunsthaus: *Weich und Plastisch: Soft-Art* (1964 exhibition), 227

John Michael Kohler Arts Center Board and Staff

Established in 1967 by the Sheboygan Arts Foundation, Inc., the John Michael Kohler Arts Center is nationally recognized for its nurturing of artists in the creation of new work; for its concentration on art forms, artists, and ideas that have received little critical attention; and for its ability to involve underserved audiences as well as the general public in innovative programming that helps realize the power of the arts to inspire and transform our world. Each year, Arts Center programming includes up to fifteen exhibitions curated by staff; several performing arts series; Connecting Communities commissions to create major new works by national dance companies, composers, musicians, visual artists, filmmakers, and other artists in collaboration with the region's youth and adults; Arts/Industry, an internationally renowned residency program providing opportunities for artists to create new bodies of work and public commissions using the technologies and facilities of an industrial pottery, foundry, and enamel shop; a wide variety of educational programming, from an arts-based preschool and a hands-on, drop-in program for families to national conferences; and exuberant special events.

This catalogue is published on the occasion of *In Poetry and Silence: The Work and Studio of Lenore Tawney*, presented October 5, 2019, to March 7, 2020, as part of *Lenore Tawney: Mirror of the Universe*, a series of four exhibitions exploring Lenore Tawney's life, work, and influence at the John Michael Kohler Arts Center. The series also celebrates the donation by the Lenore G. Tawney Foundation of many elements of Tawney's studio to the Arts Center to support the Arts Center's mission to facilitate a wider understanding of art environments and to generate a creative exchange between artists and the public.

Published by the John Michael Kohler Arts Center in association with The University of Chicago Press, Chicago and London
John Michael Kohler Arts Center
608 New York Avenue
Sheboygan, WI 53081
www.jmkac.org

The University of Chicago Press, Chicago 60637
The University of Chicago Press, Ltd., London
Copyright © 2019 John Michael Kohler Arts Center
All rights reserved. Artwork published under permission from lenders and fair use. No part of this book may be used or reproduced in any manner whatsoever without written permission, except in the case of brief quotations in critical articles and reviews. For more information, contact the University of Chicago Press, 1427 East Sixtieth Street, Chicago, IL 60637.
Published 2019

28 27 26 25 24 23 22 21 20 19 1 2 3 4 5

ISBN-13: 978-0-226-66483-5 (cloth)
ISBN-13: 978-0-226-68069-9 (e-book)
DOI: https://doi.org/10.7208/chicago/9780226680699.001.0001

Library of Congress Cataloging-in-Publication Data

Names: Patterson, Karen (Karen E.), editor. | Tawney, Lenore. | John Michael Kohler Arts Center, host institution, issuing body.
Title: Lenore Tawney : mirror of the universe.
Description: Sheboygan, Wisconsin : John Michael Kohler Arts Center ; Chicago ; London : The University of Chicago Press, 2019. | "This catalogue is published on the occasion of *In Poetry and Silence: The Work and Studio of Lenore Tawney*, presented October 5, 2019, to March 1, 2020, as part of *Lenore Tawney: Mirror of the Universe*, a series of four exhibitions exploring Lenore Tawney's life, work, and influence presented in 2019 and 2020 at the John Michael Kohler Arts Center."—Title page verso. | Edited by Karen Patterson. | Includes bibliographical references and index.
Identifiers: LCCN 2019008636 | ISBN 9780226664835 (cloth) | ISBN 9780226680699 (e-book)
Subjects: LCSH: Tawney, Lenore—Exhibitions. | Textile artists—United States—Biography. | Women artists—United States—Biography. | Art, American—20th century—Exhibitions. | Textile crafts—United States—Exhibitions. | Collage—United States—Exhibitions. | Tawney, Lenore—Influence. | LCGFT: Biographies. | Exhibition catalogs.
Classification: LCC N6537.T38 L46 2019 | DDC 746.092 [B]—dc23
LC record available at https://lccn.loc.gov/2019008636

All photography of works from the Lenore G. Tawney Foundation and the John Michael Kohler Arts Center is by Rich Maciejewski, 2018–19, unless otherwise noted. Additional photography: Jenna Bascom: 262; Ferdinand Boesch: 22, 124; John Carlano: 263 left; Geoffrey Clements: 139; Courtesy of American Craft Council Library & Archives: 60; Courtesy of Columbia College Center for Book and Paper Arts: 256; Harvey Croze: 132; George Erml: 121 top and bottom, 136, 195 left, 259 left, 263 right; Nancy Finn: 52; Matt Flynn: 71; Robert Chase Heishman: 268; Christine Martens: 13 right; Dan Meyers: 225; Clayton J. Price: 13 left, 137; Jack Ramsdale: 230; Adam Reich: 131, 258 right; Paul J. Smith: 14–15, 276–77; Stella Snead: 143 top and bottom; Emet Sosha: 259 right; Alan Wiener: 264 left

Cover: Detail of *Night Bird*, 1958. Full view page 65.
Pages 2–3: Detail of untitled, 1961. Full view page 75.
Page 18: Tawney in her studio on East Cedar Street, Chicago, 1957. Photo by Aaron Siskind. Lenore G. Tawney Foundation, New York.
Page 21: Detail of *Lost and Proud*, 1957. Full view page 46.
Page 102: Tawney in her studio on Coenties Slip, New York, 1958. Photo by David Attie. Michael Ochs Archive/Getty Images.
Page 105: Detail of *The Bride,* 1962. Full view page 107.
Page 172: Tawney at the loom in her studio, c. 1950s.
Page 175: Detail of *Collage Chest I*, 1974; mixed media; 8¾ × 7¼ × 8½ in. Lenore G. Tawney Foundation, New York.
Page 218: Tawney installing *Cloud VI* at the Frank J. Lausche State Office Building in Cleveland, Ohio, 1981. Lenore G. Tawney Foundation, New York.
Page 221: Detail of *Written in Water*, 1979. Full view page 223.
Pages 276–77: Tawney's studio on West Twentieth Street, New York. Lenore G. Tawney Foundation, New York.
Page 297: Tawney in her studio on Spring Street, New York, n.d. Photo by Edward Pieratt. Lenore G. Tawney Foundation, New York.

♾ This paper meets the requirements of ANSI/NISO Z39.48-1992 (Permanence of Paper).

Produced by Lucia|Marquand, Seattle
www.luciamarquand.com

Edited by Tanya Heinrich
Designed by Ryan Polich
Typeset by Tina Henderson
Proofread by Carrie Wicks
Indexed by Enid Zafran
Color management by iocolor, Seattle
Printed and bound in China by Artron Art Group